THE POST-COLONIAL QUESTION

The Post-Colonial Question brings together renowned and emerging critical voices to respond to questions raised by the concept of the 'post-colonial'. The essays range from imperial histories to today's hybrid metropolitan youth cultures, from African-American writings to uneasy mixtures of nationalisms and religion in the post-colonial city. Together, they explore the diverse cultures and disparate narratives which are shaping our volatile global future.

In confronting the concept and condition of post-coloniality, the contributors move beyond overworked metaphors of integration, the melting pot and multi-culturalism. Instead, they present a plurality of voices, bodies, populations and histories coming from 'elsewhere' to disrupt the Euro-American sense of where the 'centre' lies.

The collection includes a new piece of fiction by Hanif Kureishi.

Iain Chambers and **Lidia Curti** both teach at the Istituto Universitario Orientale, Naples.

interdependence between Center & Margins

if ideas are too transparent they're oversimplified

new cosmopolitanism: we're all citizens of the world
particularism: the local moment - kinds of food, etc.

Narratives: what "makes" America
 ex. "America. the way it used to be" (Hatch campaign)

agree w/me or its off to the margin with you!

THE
POST-COLONIAL
QUESTION

Common Skies, Divided Horizons

*if the public can understand what you're saying,
you must not be saying anything important*

*Edited by Iain Chambers
and Lidia Curti*

WITHDRAWN

London and New York

FLIP

First published 1996
by Routledge
11 New Fetter Lane, London EC4P 4EE

Simultaneously published in the USA and Canada
by Routledge
29 West 35th Street, New York, NY 10001

Typeset in Times by LaserScript, Mitcham, Surrey
Printed and bound in Great Britain by
Biddles Ltd, Guildford and King's Lynn

British Library Cataloguing in Publication Data
A catalogue record for this book is available from the British Library

Library of Congress Cataloguing in Publication Data
A catalogue record for this book has been requested

ISBN 0–415–10857–8
ISBN 0–415–10858–6 (pbk)

CONTENTS

CONTENTS

Part III Frontier journeys: the space of interrogation

Part IV Whose world, whose home?

NOTES ON CONTRIBUTORS

Wanda Balzano, a graduate of the Istituto Universitario Orientale, Naples, and Dublin University, is currently completing her Ph.D. in Irish literature at University College, Dublin. She has published on Samuel Beckett, Angela Carter, P. D. James and the Irish post-colonial dimension.

Homi K. Bhabha is Professor at the University of Chicago in both the English and the Art History departments. His previous books are *Nation and Narration* (1990) which he edited and *The Location of Culture* (1994). He is currently working on issues of culture, community and cosmopolitanism.

Iain Chambers is Professor of History of English culture at the Istituto Universitario Orientale, Naples. His most recent book is *Migrancy, Culture, Identity* (1994).

Lidia Curti is Professor of English at the Istituto Universitario Orientale, Naples. She is the author of a book on Shakespeare in avant-garde theatre and of *Female Fabulations* (forthcoming, Macmillan).

Marina De Chiara is researching her Ph.D. in Literatures in English at the University of Rome and the Istituto Universitario Orientale, Naples. She has published articles on W. H. Auden and Jeannette Winterson.

Laura Di Michele is Professor of English at the Istituto Universitario Orientale, Naples. Her publications include *L'educazione del sentimento: la crisi del romanzo inglese fra gotico e sentimentale, 1750–1800* (1977), *La scena dei potenti: teatro politica spettacolo nell'età di Shakespeare* (1988) and various essays on the eighteenth century. She is currently working on a book on the poetry of James Thomson.

Clara Gallini is Professor of Ethnology at the University of Rome, La Sapienza. She is the author of several books on Italian popular culture – *Feste lunghe di Sardegna*, *La ballerina variopinta*, *La sonnambula meravigliosa* – as well as essays on exoticism and racism in the media.

Paul Gilroy teaches at Goldsmiths' College, University of London and in the Program for African and African-American Studies at Yale University. Author of *The Black Atlantic* (1993) and *Small Acts* (1993), he is presently writing a book on multiculturalism and fascism.

Lawrence Grossberg is Distinguished Professor of Communication Studies at the University of North Carolina at Chapel Hill. He is editor of the journal *Cultural Studies* and co-editor of the volume *Cultural Studies* (1992) with Cary Nelson and Paula Treichler. His latest book is *We Gotta Get out of this Place: Popular Conservatism and Postmodern Culture* (1992).

Catherine Hall is a feminist historian. She is a Professor in the Department of Sociology at the University of Essex and is on the collective of *Feminist Review*. She has written extensively on the nineteenth century, including *White, Male and Middle Class: Explorations in Feminism and History* (1992).

Stuart Hall was for a decade Director of the Centre for Cultural Studies, Birmingham, where he edited and co-authored such volumes as *Resistance through Ritual*, *Policing the Crisis* and *Culture, Media, Language*. Presently Professor of Sociology at the Open University, among his recent publications is *The Hard Road to Renewal: Thatcherism and the Crisis of the Left* and the co-edited volume *New Times*.

Hanif Kureishi is a writer and film-maker. After a residency at the Royal Court Theatre he wrote the script for *My Beautiful Laundrette* (1986) and *Sammy and Rosie Get Laid* (1988). He is the director of the film *London Kills Me* (1991), and author of the novel *The Buddha of Suburbia*, subsequently transformed into a successful television series, and *The Black Album*.

Marie Hélène Laforest teaches post-colonial literature at the Istituto Universitario Orientale, Naples.

Amedeo Maiello is a researcher in Modern Indian History at the Istituto Universitario Orientale, Naples. His main field of research is Islam in South Asia, and he has published several articles on the argument.

Stefano Manferlotti is Professor of English at the University of Naples. His publications include *George Orwell* (1979), *Anti-utopia. Huxley, Orwell, Burgess* (1984), *Aldous Huxley* (1987) and *Dopo l'impero. Letteratura ed etnia in Gran Bretagna* (1995).

Angela McRobbie is Reader in Sociology at Loughborough University of Technology and is the author of *Postmodernism and Popular Culture* (1994) and of *Fashion and the Image Industries* (forthcoming, Routledge).

Trinh T. Minh-ha is a writer, film-maker and composer. Her more recent works include the books *Framer-Framed* (1992), *When the Moon Waxes Red* (1991), *Woman, Native, Other* (1989); a collection of poetry, *En minuscules* (1987); and the films *Shoot for the Contents* (1991), *Surname Viet Given Name Nam* (1989),

Naked Spaces (1985) and *Reassemblage* (1982). She has taught at the Dakar Conservatory of Music in Senegal, and at the Universities of Cornell, San Francisco State, Smith and Harvard. She is presently Professor of Women's Studies and Film at the University of California, Berkeley.

Annamaria Morelli is completing her Ph.D. on the baroque at the University of Rome and the Istituto Universitario Orientale, Naples. She has published several articles on Shakespeare, and on the languages of contemporary television and cinema.

Alessandro Triulzi is Professor of African History at the Istituto Universitario Orientale, Naples. He is author of *Salt, Gold and Legitimacy* (1981).

Vron Ware is author of *Beyond the Pale. White Women, Racism and History* (1992) and currently teaches in the School of Humanities at the University of Greenwich in London.

Demetrio Yocum is an English Language assistant at the Istituto Universitario Orientale, Naples. He has published on post-colonial literatures and is currently completing a critical essay on Caribbean and African appropriations of *The Tempest*.

ACKNOWLEDGEMENTS

We want to thank the Istituto Universitario Orientale of Naples for providing the physical and financial structures that allowed us to organise the conference that led to the present book. We also want to thank the British Council of Naples, Rahim Shirmahd for bringing his video from Germany, Trinh T. Minh-ha for showing her beautiful film *Surname Viet Given Name Nam*, and John Koumantarakis for the translations. Finally, our biggest thanks go to the students of the Orientale who participated in the two days of discussion and debate, and whose own videos, questions and presence enthusiastically witnessed the event.

For the eventual preparation of the manuscript we want to express our deep gratitude to Jim Clifford and everyone at the Center for Cultural Studies at the University of California at Santa Cruz for welcoming us into an environment that made editing this book such a relaxing task.

PREFACE

This volume is composed of papers and contributions that were initially delivered at a two-day conference held in Naples in May 1993 and subsequently developed into their present form. They are joined by other voices – those of Homi Bhabha and Hanif Kureishi – who had spoken earlier in the year at the same institute.

The meeting of different generations, backgrounds and cultures that met that May in Naples recalls traces of previous cosmopolitan encounters that remain scattered in the Neapolitan locale, in its language, custom and cooking (Norman, Arab, Spanish, French). More pertinently, such hybrid precedents return when we focus attention on this city's contemporary existence as a simultaneous centre and periphery. Situated on the edge of Western Europe, and urban planning, Naples has a syncopated presence in the orchestration of global culture and capital that persistently opens up an interval in the score of progress, so that the confident rhythms of hegemonic projects and government rarely manage to override the off-beats of autochthonous tempos and temperaments. Viewed and lived in this manner, Naples provides a fitting place in which to consider the emerging art and politics of living in-between worlds, seeking and ratifying the potential of such openings.

This collection brings together varied views, experiences and perspectives, sometimes into disagreement, often into significant tension, that are nevertheless bound into a frame of reference that exposes us all to a series of interrogations which – as intellectuals, citizens and historical beings – we can no longer refuse or ignore. Whether apparently coming from another world into the one we are most familiar with (but what world now is not in some profound sense also a part of our own, and we of theirs), or emerging within the very languages and streets of 'our' cities to disturb and disorient us, the emergence of other voices, desires and bodies reveals a sense of culture and politics, of history and identity, that can no longer be referred to the old myths that once assured us of our presence. Our previous sense of our selves, with its presumptions of centre and of 'home', has been irrevocably interrupted.

No longer restricted to the far-off worlds of the colonial frontier, the violent immediacy of famine, poverty, genocide, migration, fervent religious sentiments

and nationalist identities may still be reduced to the ephemeral in our distracted reception of the world in the mass media. Yet the insistent noise of these events return, again and again, forcing us to confront the fact that the local, that 'our' sense of place and belonging, is now inextricably bound up with these other histories. For every still-distanced Rwanda and Haiti there is the issue of the *chador* in French schools, of the burning of Salman Rushdie's *The Satanic Verses* in the Muslim community of Bradford, of racial attacks on the shanty towns of black agricultural workers in southern Italy, of Latin American illegals forced to work without shelter or health care in the San Joaquin Valley in central California.

In this return of the repressed, where the peoples and frontiers of empire now inhabit and divide the centre, the co-ordinates that constitute historical and cultural identity – those performative cultural immediacies that rely on the proximate and what comes to hand – are irretrievably compounded and extended. Here occidental identity often responds by retreating into stale comforts, ultimately viciously designated in local blood and soil, in misogynist mythologies of womanhood, domesticity and of purity in danger, as it descends into the abyss of Europe, and into streets surveyed by Nazi skins and Serbian snipers. Yet, to counter such myopia with the pious promise of communal connection merely helps us to avoid confronting the political interrogation of the intractable and incommensurable. For historical and cultural differences are not always necessarily translatable nor exchangeable; they can remain dramatically distinct in their powers and in their purchase on economic, political and cultural capital. Their hold on mind and body can be equally devastating as liberating. The simultaneity of time and space, even of perspectives, does not automatically augur the solace of a benevolent liberal solution, nor a synchronised overcoming, or healing, of previous wounds, injustices and exploitation. These remain. But under common skies and before divided horizons, the exposure to difference, division and worldly alterity can encourage in us all an attempt to seek a response, and a responsibility, in the insistent, ultimately interminable, reworking of the knowledge and culture, hence power and politics, that constitutes our sense of being. In their small way, the energies and ethics expressed in this book seek to be part of this possibility.

Part I

CRITICAL LANDSCAPES

1

THE UNDONE INTERVAL

Trinh T. Minh-ha
in conversation with Annamaria Morelli

Annamaria Morelli: When I read your writings, or watch your films, what often comes to my mind is the image you evoked at the very beginning of *Woman, Native, Other*, that of the people of a remote village meeting to speak in the market place at nightfall. You say, 'Never does one open the discussion by coming right to the heart of the matter . . . to allow it to emerge, people approach it indirectly by postponing until it matures, by letting it come when it is ready to come. There is no catching, no pushing, no directing, no breaking through, no need for a linear progression which gives the comforting illusion that one knows where one goes.' Do you find that this image of the way people discuss in that remote village might describe the way you proceed in the composition of your texts?

Trinh T. Minh-ha: Yes, I would very much say so. Not only such a practice is reflected all along in the approach, but also in the writing of the book. The second chapter ('The Language of Nativism: Anthropology as a Scientific Conversation of Man with Man') begins, furthermore, with a specific suggestion of how I proceed in theorising and exposing the West's approach to its 'others'. The work constantly reflects back on itself, and everything written in the book can be said to be equally critical of my own activities as writer and thinker. It is important to remember that if one goes directly to an object, if one tries to seize it, one would always somehow lose it, and this is for me one way towards understanding truth. As I have stated elsewhere, 'a creative event does not grasp, it does not take possession, it is an excursion'.

With the expansion of a market-intensive economy of movement, there is a tendency in the mainstream media to emphasise speed as a goal of inventive people or, rather, of smart consumers. To save time and energy, one is told to 'go at it' and devise short-cuts so as to take hold of the desired object as quickly as possible. So, anyone who makes a detour, opts for indirectness, and takes time to move on his or her own can neither gratify the reader or viewer right away nor expect any immediate gratification in return. But for me, to be able to maintain a certain independence, and to pace one's movement accordingly, is always a necessity if one is to meet cultures other than one's own, and to embark in any

3

artistic or creative venture – theory, for example, is also a form of creativity. One can only approach things indirectly. Because, in doing so, one not only goes toward the subject of one's focus without killing it, but one also allows oneself to get acquainted with the envelope, that is, all the elements which surround, situate or simply relate to it.

To start a story, for example, not in a linear fashion 'from the beginning', or to come into a story without a preconceived beginning and ending, but rather with anything that emerges at a specific moment in one's thinking process, that relates back to one's intimate experience, and then, to proceed slowly from there – just like the way the village meeting that you have just quoted unfolds – means letting things come to you rather than seizing or grasping them. Such an attitude is necessary for any creative venture; otherwise all that one has to offer the reader or the viewer is the empty skin of a fruit. There is, in other words, no reverberation, no resonance. With this also comes the much-debated notion of subjectivity which has regained all its complexities in contemporary theories. If one merely proceeds by opposing, one is likely to remain reductive and simplistic in one's critical endeavour. Whereas in an approach where things are allowed to come forth, to grow wildly as 'controlled accidents' and to proceed in an unpredictable manner, one is compelled to look into the many facets of things and is unable to point safely at them as if they were only outside oneself. It is in indirection and indirectness that I constantly find myself reflecting back on my own positions.

Annamaria: You say that your films are not materialisations of ideas or visions that precede them, and that the way they take shape depends entirely on what happens during and in between the processes of producing them. I wonder if the way your written texts take shape is similar to the practice you describe in the making of a film. If so, to what extent and what are the differences, since what happens in the producing of a film has also a lot to do with the fact that one lives and creates with other people, while in the writing process one is unavoidably alone in the reassemblage of voices, tales, thoughts, memories.

Minh-ha: I guess I will start with the last statement, which is that one is alone in writing, whereas, in film-making one is with other people. I think the difference is very small, actually. It is just a question of physically working with other people, confronting them on a daily, one-to-one basis, whereas in writing, one may be immediately isolated and yet, with every word or every sentence one writes, I think one is always endlessly conversing with a huge number of people, reading and hearing from as many ears and eyes as possible, whether they are immediately present or absent. Yes, I would say that although images and words are two different worlds, there are many similarities in the way my films are made and my books are written. I am thinking here of *Woman, Native, Other* and *When The Moon Waxes Red*. With *Framer Framed*, it is a slightly different situation since interviews (which form part of that book) are encounters between two individuals and the discussions generated usually deal with the more generalised concerns of a certain audience and readership.

When I write, I never know ahead of time where the writing is going to lead

4

me. I never proceed by having a plan (with an introduction, a development and a conclusion, for example), by mapping out the terrain of the arguments I wish to sustain, or even by compiling ahead of time all the points I want to discuss; I never work that way. Perhaps I can start here with an anecdote and then see where I can go with it in articulating my own practice. It is a story which the African-American poet and activist June Jordan told us in her recent book, _Technical Difficulties_. June was having a conversation with her aunt whom she loved dearly, but who apparently could only explain June's political stance by accusing her of being 'a Communist'. Such a label came about when June expressed her desire to go to Nicaragua at a time when she was supposed to celebrate Thanksgiving at her aunt's home. They argued heatedly about the way Nicaragua had been spoken of in the mainstream media via 'his Highness, the American King' – Ronald Reagan – and since they strongly disagreed with one another, the aunt simply deduced that June was 'a dupe of their [the Communists'] propaganda' and remarked: 'It's a matter of East and West, can't you see that?' To which June replied: 'East and West! But if I got on a plane tomorrow, heading for Managua, I'd be flying south and west. West!' And this just made her aunt even more angry (_laughs_), as she exclaimed: 'That's just geography!'

For me the story is extremely revealing because at the same time as it is hilarious, it also offers a marvellous example of how wars burning nations are fundamentally linked to the way meanings are produced and fixed. With the playful insertion of one single word – 'south' – June succeeded effortlessly in introducing a shift of meanings that remains remarkably plural in its scope. In other words, she not only disrupted the East–West axis by opening it up to a third terrain and by implying the connection between geography and ideology, or between politics and economics, but she also displaced the binarism of such an axis by juxtaposing 'south' and 'west'. For me, the poet in June is always at work. In a rather banal fragment of a family argument, the potentials of politics and poetry are simultaneously woven and unfolded. Such a practice of speech and writing would appeal to anyone who does not use language as a mere instrument of thought and is aware of how the same word can acutely shift its meaning when put in a slightly different context, as in this example.

Word as idea and word as word. These two movements of language are interdependent and always at work in the space of writing. When the telling and the told remain inseparable, the dichotomy between form and content radically loses its pertinence. This is how I would try to describe the way I proceed in writing. The way a thought, a feeling, an argument, a theory, or a story takes shape on paper is at the same time 'accidental' and very precise, very situated, just like a throw of dice. The fact that, radically speaking, 'language only communicates itself in itself' (Walter Benjamin) has not only been much theorised among the so-called anti-humanist thinkers today, it is also nothing new to writers for whom writing, which refers to and is drawn from reality, constitutes a material reality of its own. How one renders this reality is another matter. For me, if one of the two movements mentioned is atrophied in writing, if language

5

is subjected to being a vehicle for thought and feeling, or if the emphasis is only placed on the told, the message, or the object of analysis, then the work will never resonate. And without resonance, writing becomes primarily a form of information retrieval or of administrative inquisition. Its ability to constantly reflect on itself, hence to generate new meanings along the process, to surprise both the writer and the reader, and to lead them to unexpected places, remains atrophied.

It is not enough to master a language in order to serve a vision or an idea. There are many dimensions in language and it is by constantly playing with these dimensions that words keep on displacing themselves from their intended or given meanings. And as words communicate among themselves, the writer who is the first reader of her text-in-progress will have to remain *actively* receptive to their interactions, for displacement causes as well as intensifies and multiplies resonances. Because of the sharp balance maintained between these two movements external and internal to language, writing proceeds by scrutinising itself and by constantly undoing the previous contextual meanings arrived at. What I mean by 'resonate' is therefore not simply a question of aestheticising language or a formalistic concern. Working with resonance is to resist diverse forms of centralisation – the indulgence in a unitary self, in a locus of authority, or in words and concepts whose formulation comes to govern the textual (and extratextual) space.

In my case, working with resonance is also, more specifically, to explore and develop the ability to speak to very different groups of people without having to name them all. For example, although *Woman, Native, Other* focuses mainly on the realities of women of colour in the US and Third World women, the critical tools it offers have been taken up by many other groups of resistance. These include, not surprisingly, marginalised groups across cultures and nations which I have not anticipated, but which can relate to the situations discussed, whether they are men or women, whites or non-whites. For me, if the book has inspired readers to use the tools offered to carry on their struggles on their own terms, their responses to the book have also been most inspiring to me as I move on in my work. It's a reciprocal way of resonating. And it is exciting to write, as I said, with many ears and many eyes, even though you do not know exactly where all the possibilities lie.

Because of the multiple dimension of language, I often do not know how a sentence will end; I never know exactly where I will be in the next paragraph (*laughs*), not even to mention the next chapter, or the entirety of the book. This is something that applies on the most minute scale of the book as well as on the largest scale of the book. I have no idea how a book is going to begin and end when I start my writing journey. The story, as I wrote in the opening pages of *Woman, Native, Other*, is headless and bottomless but one has to enter somewhere, one has to go out somewhere, and even though there is a beginning and an end to every story, the readers can actually enter and exit on any page they wish without the feeling that they have missed 'the intrigue' or the 'main point'. By turning yourself constantly into a reader while you write, you can see how your

words can always be read differently, how language resonates differently from one context to the other and, according to the way it resonates, I'll decide on the turns I'll be making or the courses I'll engage in. This being said, the book is certainly not chaotic (*laughs*), because you can take the last page of the book and the first page of the book and they do speak to each other in the contextual links created. The process constantly allows things to build on one another, and you as a receptor never lose sight of the many possibilities generated or of the continuous weaving of the many threads initiated. Ultimately one can talk about at least three movements, rather than the two movements I mentioned earlier. One movement is to go forward in an argument; another movement is to constantly come back to oneself; and the third, for example, is to create from, and with, the unintended reflexive communication among words themselves.

Annamaria: It seems exactly what is happening right now. I mean the way you have just answered seems to be articulated in the very movements you have just mentioned. These movements contribute to creating a rhythm that also comes out of different timbres and tones that modulate your voice. Different voices, in both the metaphorical and literal sense of the word, as well as silences, also constantly cross your voice, your work. As far as silence is concerned, while in your films, or while listening to you, the crossing and resonance of silences is clearly audible, it is apparently more problematic to listen to them in your written texts. Personally I find them in the way you put images in among the printed pages, sometimes in the way you play with the layout, or in the movement from prose to poetry, and vice versa, or in the overlapping of theorising and storytelling. For me, all these things create, in the otherwise overtly compact printed space, different rhythms and cadences which break the linearity of the composition and invite the reader to take a pause, to stop and listen to the soundless re-creation of his or her own associations, imagination, reflections. Here I'm talking of my experience as a reader, but I would very much like to hear from you about the possibility of creating silences in the written text.

Minh-ha: Well, your description is really great (*laughs*); it is a very acute way of describing how one can work with silences. Because for me, how should I say this . . . rhythm can only be created if one works on relationships, which means that you do not just focus, as I said earlier, on the object of observation or on advancing an argument, but musically as well as conceptually, on the reverberations and the links created in the process you have initiated. It is in drawing new relationships among old objects that changes can be effected on these very objects and that an unspoken space can be opened up. If I take music as an example, what is important for me in composing a piece of music is not just to select the sounds to be included, but also to select the silences. In other words, not merely to focus on the musical notes, but to have a feel for and to work with the intervals and the transitions between notes, phrases and movements, and how these take shape in relation to one another. Without an ear for the way tone, timbre, dynamics and duration (the latter includes both sound and silence) enter into relations with one another, your rhythm is bound to come out weak, flat or derivative. The piece

7

d be just like a stream of notes and phrases put one after the other, whose onship – you can hear this immediately – is not working out because they have not found a way of coming together and coming apart.

The same thing occurs, for example, when one reads aloud in delivering a lecture. You can hear how certain sentences are not fully lived, because they don't seem to know how to find their tones, their pauses, their cadences. So, I would say that creating rhythm is a way of working with intervals – silences, pauses, pacing – and working with intervals means working with relationships in the wider sense of the term: relationships between one word, one sentence, one idea and another; between one's voice and other women's voices; in short, between oneself and the other. What you are creating in relationships is not the mere product of an accumulative process, but rather, a musical accuracy – the precise rhythm and tuning that allow what you say and don't say to find its reverberation in other people. This leads us back to the point that I made earlier about how, when you let things resonate and approach them indirectly, you are opening up a space in which absence and presence never work as mere opposi- tions. So, although you cannot be exhaustive and totalising, you are not excluding either. Silence here resonates differently. It is not equated with absence, lacuna or emptiness; it is a different sound, or to use a pertinent word of yours, a 'soundless' space of resonance, and a language of its own.

Working with silence is also very much linked to the notion of multiplicity of meaning, which has become a commonplace in contemporary thinking. Of course, a number of people would continue to say, 'but what's the use of having many meanings; why don't we use words and sentences in a clear-cut manner so that nobody is mistaken about the message put forth?' But here multiplicity of meaning, as I have already elaborated, is not a question of cultivated ambivalence and ambiguity; it does not derive from a lack of determination or of incisiveness. It radiates from language, whose fictional nature is precisely what tends to be denied in every attempt to subject it to the ideological norms of clarity and accessibility. A further example is, let's say, the fundamentally different mean- ings that may be given to the same word, the same sentence, when it is read by a member of the dominant group and by a member of a dominated group of a culture. Since marginalised people are always socialised to understand things from more than their own point of view, to see both sides of the matter, and to say *at least* two things at the same time, they can never really afford to speak in the singular.

This is why the use of the term 'West' in the context of my writings is always strategic, because 'the West' is both outside and inside me. For example, when I used capital 'I' in *Woman, Native, Other* and more specifically in Chapter Three, I was compelled to use small 'i', 'I/i', and actually to resort to the whole gamut of personal pronouns – we, they; he, she; you – while addressing the complex issues of identity and difference I was facing in writing from a non-unitary, multi-vocal place of subjectivity. 'I' reads as the voice of a white male dominant member in the context of that chapter, but the fact that I chose 'I', instead of

pointing to 'Them' in an 'Us' context, was a deliberate gesture to resist such clear-cut division and to acknowledge that the oppressor is not necessarily only outside of 'i', 'she', and 'we', but is also well and alive within each oppressed self. So the use of 'I' is very ironical both toward He-the-Master and toward myself, or the He-in-me.

While these tactics inevitably run the risk of being misread and may enrage certain Euro-American readers, they are easily understood by many members of marginalised groups. Not only does language radically lend itself to multiple readings, but the plurality of meaning here is also bound to the readers' different socio-political contexts. Recently in Bologna, one of the responses that Paola Bono, who writes for the newspaper *il Manifesto*, had to the talk I delivered at the *Centro di documentazione delle donne* was that she was disturbed by the difficulty she faced in trying to figure out when she was being included and when she was being excluded in my use of 'they' and 'us'. Such a reading was very perceptive and I was glad to hear it discussed in public. Needless to say, the feeling *was* disturbing, especially when the person who experienced it was a member of a dominant culture and who, as a feminist, also resisted that location. But then, when you think that people of colour across nations have always found themselves struggling in similarly charged situations, where they constantly have to decide whether words like 'man', 'mankind', 'human' and even 'woman' include or exclude them! When you realise this, you also understand that what I usually offer the reader or listener through my writings and lectures are experiences that are being lived on both sides. So it was not just Bono who was being put on the spot, it was myself as well, even though our subject positions in the experiencing of that disturbing feeling were markedly different. This anecdote may give you another example of working with multiple meaning and silence. Something was being conveyed that was unsaid in the text – the space, as mentioned earlier, that resonates without being named.

Annamaria: Hybridity, interstices, voids, intervals, in-betweenness . . . these words circulate in all your works and are actually inherent to your practices of writing and filming, so that your texts (politically, strategically) resist closures and classifications. I wonder if you would relate the recurring use and naming of these words, each time in a different context, not only to what someone has called your 'theoretical project', but also to another way of playing with differences in repetition; that is, as a further tool to keep on opening up meanings. I mean that these words also probably need to be constantly displaced to prevent them from becoming another set of fixed categories, a sort of theoretical commodity, a fashionable theoretical passport.

Minh-ha: Yes, I would agree with that. To give you an example: the word 'marginality'. In 'Cotton and Iron' (a chapter of *When The Moon Waxes Red*), the immediate concern I had while addressing the question of marginality was how to avoid reproducing, in the writing itself, the same model of the centre–margin power relationship that has prevailed in the existing system of cultural and political representation. So at the same time as the discussion evolved around the

notion of marginality, it was not 'centred' on it, in the sense that marginality here remained an 'empty' site – thanks to which, however, the movements of the text could unfold. 'Empty', in that the meaning of marginality remained constantly in progress or in-the-making throughout the text. With each new paragraph, I began again with a different departure on marginality. The set of specific and contextual meanings arrived at in the previous paragraph was in the next one either refuted or pushed further, to the point of running the risk of losing the term and invalidating its 'useful' function in the struggle of 'marginalised' people. In other words, there was, with every re-departure, a return and a new take on the same notion, which kept on growing with differently situated meanings as it was repeatedly slightly displaced. What may come out of such a spherical advance-and-return movement are ways of understanding marginality whose complexities can reach us in our heterogeneity, our different everyday situations and thinking habits, and lead us beyond the simplistic negation or assertion of marginality as mere opposition to a locatable centre.

But I really share the same concern as the one you have just voiced, which is that, after a while, one becomes tired of hearing concepts such as in-betweenness, border, hybridity, and so on. It's like the word 'difference': it is so old a word and yet we keep on using it again and again in widely varied contexts of struggle. Diversity, identity, ethnicity. The more these terms are popularised, the more difficult the challenge we encounter when we use them. But we will have to keep on using them so that we can continue what Mao called 'the verbal struggle'; and the link to Mao here, for me, is to draw attention to the fact that the theoretical project is not '*just* a theoretical project', but one that, despite its reality as theory, grows out of a social, cultural and political context. Unless we abide by the prevailing compartmentalised view of the world, our life activities are inseparable. Whether we articulate it or not, many of us are aware of the fact that the words mentioned and the difficult emerging space we are trying to open up are being quickly co-opted by the mainstream. So the constant appropriation and re-appropriation of these terms, as I have stated elsewhere, needs to be further re-appropriated, and the struggle is endless because you'll always have to be on the alert to resist easy consumption. You'll have to keep on undoing and redoing what tends to be hastily encased.

Of course, the temptation is always to go and look for new words, which a number of theorists have done. Roland Barthes, for example, came up with a lexicon in which many of the words coined are retrieved from Latin; they are, to quote a number of French thinkers, Barthes' 'barbarisms' (*laughs*). But one can understand such an operation when one tries to invent new words, and realises one can't really invent them from nowhere. A rather common way to take up this challenge is to go back to one's 'roots', one's remote traditions, or in the case of people of colour, one's denied heritage, in order to invent anew. Here one runs the risk, as with Barthes, of coming up with words and concepts that sound so archaic, 'backward' or 'barbarian' to some people that one is bound to have to negotiate one's ground very tightly.

To come back fearlessly to the 'old' in order to bring out the 'new' and to re-open a different space of meaning is something that the women's movement has devoted much energy to. Here the same terminology is used with a differed meaning. The notion of 'difference' itself is a famous example. Difference on the Master's terms has always been given to His others. But this does not mean that 'difference' should be banned from women's language. So, while some of us continue to ask, 'What's the use of reclaiming difference when it is already given to us?', some others among us refuse to concede theory and history to the Master all over again, and work carefully at expanding the term from within as we continue to displace it. A new hearing may then be produced on our own terms that makes difference not an inherited attribute but a politics of articulation (or disarticulation). For the time being, then, we should continue to use words like 'in-betweenness' and 'hybridity' as tools of change, and we should keep on redefining them until their spaces become so saturated that we would have to couple them with other words or invent some kind of hybrid word (*laughs*) in order to go a little further. This is the verbal struggle we constantly have to face.

Annamaria: I think the way you use these terms in different contexts, and for different goals and aims, as I said earlier, might be a good strategy for displacing them and preventing them from undergoing a short-term saturation. In your work you may sometimes use these words in a piece of poetry or among fragments of pictures; at other times you use them while talking about women, or while talking about storytelling. For me, you stubbornly face the verbal struggle not only as you continue to re-appropriate and reuse these words, but also when you reuse them time after time in different contexts, so that, repeating them in differences, their meanings continue to be mobile and shifting. I guess this might be one of the possible ways to prevent these words from becoming part of a fixed terminology.

Minh-ha: You remind me of the other part of your question, which is the use of repetition. Actually, repetition has been a notion frequently debated in both artistic and theoretical milieus. It is a technique very familiar to avant-garde film-makers. One of its functions, for example, is to emphasise something that may be lost otherwise, therefore drawing attention to the negligible, the unessential, the marginal. Another function is to fragment, because repetition can interrupt, hamper or delay the flow of a narrative, an event or an argument. In musical practices that are passed on through oral transmissions, repetition is linked to collective memory and its social function may be said to be that of uniting a community, ritualising its cyclical activities, marking its life passages, and providing it with a sense of identity. It is here a process of memorisation rather than an individual technique of structuring, as it is often the case in Western works. In the political realm, repetition as a means to gain voice and to reclaim certain rights among marginalised groups can, at times, become so expected to members of dominant groups that it is simply heard as a naïve reproduction of the same. Such a repetition consequently tends to block the space of critical thinking, for it does not go, does not lead us anywhere; it just stays in one place and marks time. For me, this is where the point you made on short-term saturation comes in.

11

It's very important to understand the diverse functions and effects of re-petition. One way of challenging mechanical repetition, as I have said elsewhere, is to proceed by unceasingly introducing difference within repetition. So that, reproduction is never quite the reproduction of the same, and viewers or readers are invited to return to a familiar ground only to find themselves drifting some-where else. Repetition with displacements means, for example, that one can use again and again the same statement while differing the objectives (if any), the contexts, the tones, the punctuations. In my film work, I did this, let's say, in the soundtrack by working on the whole and the parts of a commentary, a con-versational fragment or a musical phrase. A complete statement is written and recorded more than one time on tape. This is a mere point of departure, for in the editing process that same statement may come out whole, in parts or with certain parts missing. According to the contexts in which it is placed, I may decide to leave this statement as recorded, to make two statements out of it, to cut off a part of it, or to cut just one word in it, and thereby change the entire meaning of the sentence. By letting this statement come back each time in a slightly different form, I may have given the spoken words what a viewer called 'a ritual charge'. And by repeating a sentence in its multiple, and at times incomplete, form, I not only suspend its meaning, alleviating it from the weight of correct syntax and definite affirmation or negation, I also find great pleasure in exceeding my own intentions, 'rediscovering' the statement and, by the same token, offering the viewer a wider range of possible interpretations.

Now, in a situation of political activism, whether the repetition of the same slogans over and over again helps to change things or simply saturates the space of critical hearing would have to depend on the ability both of the speaker and the listener to work with difference. In other words, the questions, 'Why are they always pounding the same things into our head?' and 'Are they really listening? What do they hear?' continue to be raised separately on the two sides instead of being experienced both at the same time on the one side or the other. In certain contexts, one may need to repeat many times in order to be heard; still, one can use exactly the same slogan while diversifying the contexts, the tones, the volumes (*laughs*), and the elements of duration. I'm thinking here, for example, of the many speeches delivered by African-American leaders, which come from places like the churches and other communal settings. It suffices to remember the speeches of prominent figures of resistance like Malcolm X and Martin Luther King, or to attend to those of Angela Davis or June Jordan (to name only a few) to understand how repetition works and how complex the social, political, psychological, as well as artistic, role it plays proves to be.

What you have is a practice in which not only differences are deliberately introduced into repetition, but repetition is also deliberately used to punctuate and ritualise a speech, thereby optimising, through the building of rhythmic patterns around pivotal statements, its ability to empower while raising the consciousness of a community. Here, the more times you repeat, the further along you build the ties that bind the listeners. Repetition is thus used to emphasise as well as to

create a different kind of relationship both among the listeners, and between the listeners and the speaker. Every time you repeat, you also build up and, in the process, people come to understand what you say differently from when they first heard you make the same statement. In my own work, I had to resort to a wide range of tactics and strategies with the use of repetition. One example is the way I work with stereotypes. Sometimes the text of *Woman, Native, Other* is spun around stereotypical English expressions that may irritate certain readers – academics, for example – because these popularised expressions tend to stand out sorely in the context of scholarly and theoretical writing. But to use stereotypes in order to attack stereotypes is also an effective strategy, for irony here needs no lengthy explanations or rationalisations. This is another example of how repetition is used to produce a different hearing. In short, repetition has an important and extremely complex political function, but it can easily be dismissed because it has often been understood and practised in a very limited way.

Annamaria: Referring to the notion of 'writing the body', you also say that 'it is a way of making theory in gender, of making of theory a politics of everyday life; thereby re-writing the ethnic female subject as a site of difference'. I wonder if you could elaborate a little further on this, in particular as it concerns the making of theory as a politics of everyday life.

Minh-ha: It's such a vast question (*laughs*)!

Annamaria: Well, if you are tired we could have a break or we can talk about that another time.

Minh-ha: No, let's try. Just give me a try (*laughs*). To start somewhere, what usually bothers me most is the tendency to reduce politics to the most evident sites and sources of power, such as institutions or government officials and personalities. Being political, for a great number of people, is merely to focus on things that relate directly to the body politic. I think that the women's movement in the 1970s and the gay and lesbian movement in the 1980s are, for example, movements that truly opened up a space in which politics is no longer simply to be located in these all-too-visible sites. It infiltrates every aspect of our lives, and this is where your point on theory as a politics of everyday life comes in. For me, if theory has a function, or if the intellectual has a role to play in society, it would mainly have to be that of changing the frame of thought with which we operate in every single activity of our lives; so that, instead of remaining isolated within the family context or within the individual space, these activities reflect our social function – the way we situate ourselves vis-à-vis our society, as well as vis-à-vis the world around us.

So every single tiny action we carry out reflects and affects our politics. In *Woman, Native, Other*, for example, nothing can be taken for granted. Everything, down to the smallest and most banal detail of our lives, can be politicised: the way, for example, we perceive ourselves, the way we define our activities, the way we write, do research, bend down in the field picking tomatoes, interact with others, tell stories, fight with our mothers, and go on transmitting their truths. And here we are led back to the question of relationships we discussed earlier,

because to understand the political dimension of our personal lives, we constantly have to look into the ways we position ourselves and the different contexts in which we operate. Thanks to this awareness of our positionality in everything we do, our activities are no longer compartmentalised as if they could be sufficient in themselves, and what is thought to be personal can no longer be limited to the individual and the singular. In other words, what is being constantly challenged are the unquestioned partitions, boundaries and binary divisions, including those between the individual and the society, or the self and the other. What is political and what is apolitical, for example? This does not mean that we can no longer make the differentiation, but rather that it has become much more difficult to take the licence to decree what is political and what is not, when the criteria that serve to define it have been radically and thoroughly undermined.

Now, to relate politics further to the question of body-writing that you started out with, you have here another die-hard binary opposition: that of the body and the mind or, let's say, the specific and the general, the personal and the impersonal. The literary and the art world, for example, have been taken to task for having used the term 'political' too loosely. As some who are eager to guard the territory for themselves would argue, 'political' should be attributed to investigations of specific historical contradictions. Well, the body *is* a site of particularity and specificity, at the same time as it is a site marked by historical 'contradictions'. As such, it is as intimately personal as it is impersonally social. With all the work that has been done in this area, it is difficult to deny this without reverting to the old dualist frame of reasoning which opposes the concrete to the abstract, or the body's reality to the mind's unreality. The politics of writing the body precisely breaks down such an opposition because, as many writers have already elaborated on, thinking and writing is a very physical process that constantly speaks of and speaks to the body of the person writing. Again, that body does not simply point to an individual terrain; it is the site where the individual and society meet. And it is by working on this relationship that the tension between the personal and the political is maintained and kept alive in writing.

Annamaria: Euro-Americans' attempts to classify their Other in a unitary and monolithic category have been rightly deconstructed by post-colonial practices and theories. Yet it seems to me that an unquestioned category still continues to survive; that of the West. The West is a sort of unitary category which perhaps should be further displaced and deconstructed, not so much because of the complex realities of postmodern cultures, as some people say – a notion that might sound and in some cases really is very self-indulgent according to me – but because, once again, it fails to undermine a politics of mere opposition and binarism. Further, and I know you are very aware of this, the act of naming the other, even if this time it is the Other of the Other, relies on a sense of a delimited and fixed identity. So perhaps also this category needs to be displaced to prevent, let's say, hyphen realities from becoming fixed identities in the moment they name their Other. For one of the main challenges brought about by hyphenated

cultures to the dominant cultures is precisely their capacity to be mobile and to baffle categorisations. Hyphenated cultures need to be vigilant in the act of naming their Other in an unitary way, because the risk is that of freezing their own movement, name and identity, which leads to the danger of re-creating the conditions in which, once again, they are easily compartmentalised by the dominant cultures.

Minh-ha: I think it is important that the undermining and displacing of 'the West' be carried out on both sides. Although I have already clarified my position on this matter earlier in our discussion, I would add that the situation you raise here is quite complex. Your question could be read, for example, as a critique of the simplistic way marginalised groups, marginalised cultures, name the cen-tralised cultures. Such a naming fixes the West in the same manner that the West has been fixing its others. But the question could also be read more subtly as a form of denial that is necessary to certain members of Western cultures, but that can appear as merely defensive and redundant to members of non-Western cultures. (As elaborated earlier, it may be useful to keep in mind here that terms such as 'West', 'non-West' and 'marginal' are strategically used in my context.) For example, when a member of the dominant culture tries to break down the monolithic concept of the West, isn't it necessary that the person also tries to face – rather than to escape – the historical situation that contributes to understanding how the notion of the West can, or has become, monolithic to its 'others'?

Members of dominant groups have always defined their subjectivity as mobile, changing, flexible, complex and problematic – in other words, 'safe for democracy' – whereas the subjectivity of their others remains uncomplicated, unsophisticated, unproblematic, verifiable and knowable, that is, incapable or undeserving of 'democracy'. So to say the West is non-monolithic can be a redundancy in this context and, although no culture can in reality be monolithic, one can still talk about an acceptable Western ethos, about Western empires, European imperialism, or about the metropolitan West and its overseas territories. Perhaps nowhere is the residue of imperialism better seen than in the way 'natives' are represented in the Western media. It suffices to read the many books by cultural experts and to follow the news or any cultural-economical programme, to notice how Western systems of representation continue to assume the primacy and the centrality of the West, how they exclude even as they include, consolidate and package.

For me, the predicament of naming 'the West' is tightly related to the dilemma of naming oneself in the politics of identity and difference. When do we mark our boundaries with markings already given to us, and when do we refuse them? A well-known example is South Africa's naming of its black nations, which serves to control their movements while allowing its members of European descent to move about unrestricted. Naming and confinement go together. But even in the US or in the UK, for example, self-naming among marginalised groups is no less problematic. When some of us call ourselves Asian Americans, or gays and lesbians, are we simply endorsing the labels that we have been given, or are we

re-appropriating these labels, thereby situating politically such namings, not in the phase of assimilation-for-survival, but rather, in a phase of struggle, where marking is also affirming ourselves critically? Here, what is given rise to is a certain consciousness that empowers second-class citizens and allows them not only to assume without shame their denied cultural heritage, but also to conceive of identity as a political marking rather than a mere inherited marking.

Now the danger, as you said, is that, when we name ourselves, we are also bound to work with closures and to use all-encompassing names such as 'the West' to designate the site of dominance; or if you prefer, 'the non-African-Asians' to refer to those who largely occupy this site. Of course, this simply leads us back to the danger of perpetuating binary oppositions and hence to the necessity for members of Western cultures to face the challenge, and to unceasingly undo this monolithic notion of the West through their own disengagement with the most confident master discourses, and with all imperialist undertakings. Just as in the women's movement where, for example, it is important that women not be the only ones to solve women's problems and to deal with gender politics, it is also crucial that Westerners work with differences, and learn to rename and exile themselves so as not to be lumped together under a unitary label. They would have to participate, as an other among others, in the process of constant renaming and displacing that marginalised groups cannot afford to ignore in this moment of history. This is a task that has to be carried out on both sides. The West has been responsible for the reactive, monolithic naming of the West; through its historical imperialist deeds, it has created its own unacknowledged unitary classification. So we are not dealing here with a situation of equal power relationship, and in that sense, we cannot really talk about 'the Other of the Other.' We have learnt this lesson with the feminist struggle, for when men talk about men's liberation, nobody should be led to believe that an equal, reverse form of oppression or of sexism is at work, but rather that men do, indeed, need to liberate themselves from their own privileged status in male-dominated societies.

2

ROUTE WORK: THE BLACK ATLANTIC AND THE POLITICS OF EXILE

Paul Gilroy

History is sea
> Derek Walcott

Never believe that a smooth space will suffice to save us.
> Gilles Deleuze and Félix Guattari

There is no chance that we will fall part
There is no chance
There are no parts
> June Jordan

One hundred and three years ago, a 24-year-old black American, W. E. B. Du Bois, set out across the Atlantic *en route* for Europe. He traversed the ocean in the opposite direction to the forced journeys undertaken by his enslaved and traumatised ancestors. Four hundred years after Columbus had inaugurated Atlantic commerce in live human beings, this creole descendant of both slaves and slave-holders was a Harvard history and philosophy student holding a prestigious scholarship to continue his elite education in Berlin. There, he would study politics and turn the disciplinary basis of his critical, liberationist thought away from history and towards the novel scientific pretensions of sociological rationality, which he sought to harness in the emancipation of racial siblings whose plight he understood in resolutely Germanic terms. Du Bois spoke for many other black American travellers – before and since – when he described the significance and impact of his time in Europe thus:

> Europe modified profoundly my outlook on life and my thought and feeling toward it . . . something of the possible beauty and elegance of life permeated my soul; I gained a respect for manners. I had been before, above all, in a hurry. I wanted a world, hard, smooth and swift, and had no time for rounded corners and ornament, for unhurried thought and slow contemplation. Now at times I sat still. I came to know Beethoven's symphonies and Wagner's *Ring*. I looked long at the colors of Rembrandt and Titian. I saw in arch and stone and steeple the history and striving of men and also

17

Raymond Williams →

'identity': Structure of feeling

their taste and expression. Form, color and words took new combinations and meanings.[1]

The black Atlantic, my own provisional attempt to figure a deterritorialised, multiplex and anti-national basis for the affinity or 'identity of passions' between diverse black populations, took shape in making sense of sentiments like these which are not always congruent with the contemporary forms assumed by black political culture.[2] However, Du Bois' remarks typify the experiences of numerous other African-American wanderers particularly those who were transformed by their journeying outside the closed world of racialised being that had been configured in their New World homeland by slavery and maintained there during its white supremacist aftermath.

The distinctive pattern of crossing and cultural production in which Du Bois appeared seems to have begun with Phyllis Wheatley, the eighteenth-century slave poet whose outer-national career has been repeatedly cited as a symbol of the dilemmas and difficulties that attend the distinctive plight of black intellectuals. The Wheatley story is still a powerful means to mediate the relationship between black Americans and Britain. The African-American rhythm and blues singer Carleen Anderson, who has built a substantial career in Britain that contrasts with the indifference of her compatriots to her work, recently revived popular interest in the poet's life when she appropriated a phrase used to describe Wheatley and named her own latest release 'Dusky Sappho'.

> The title relates to an 18th century African slave girl called Phyllis Wheatley . . . She became a poet, but wasn't allowed to publish her work in America, she came to England where she was received by the Queen. I can identify with her life: the separation from her parents, not being accepted by your country and having to seek your future elsewhere. 'Cause I know my country isn't interested in what I have.[3]

In Wheatley's extraordinary creativity, the narrative of her acquisition of literacy and struggle for the right to publish imaginative literature, several generations of black thinkers have discovered a means to work through their own conflicts, obligations and opportunities within and sometimes against modernity.[4] It is worth emphasising that their musings on modernity, its potentials and its disappointments, have contributed to the formation of a distinct counter-culture entwined with, but not reducible to, the histories of the left and other anti-capitalist and emancipationist movements of the last two centuries. I have started a genealogy of these relationships elsewhere.[5]

The tragic details of Wheatley's short life are well known. She was enslaved in her native Senegal at about seven years of age and brought to Boston where she was purchased by the household of John Wheatley, a prominent tailor, who had wanted to use her as a special slave to his wife. Having noted Phyllis' exceptional predisposition to learn, her eccentric owners arranged for the girl to be educated. Her progress was so rapid and so dazzling that she was soon being described as

'a kind of poet laureate in the domestic circles of Boston'.[6] Manumitted after the death of her mistress, Wheatley died in misery unable to publish further work. She is important here not just because the volume of poetry *Poems on Various Subjects Religious and Moral* that she published in London in 1773 was reviewed by Voltaire, Thomas Jefferson and George Washington, or even because of the extraordinary oral examination that Henry Louis Gates Jr reminds us was arranged for her by some of Boston's most learned and prominent citizens to ensure the authenticity of her work and the legitimacy of her entitlement to circulate it. She matters not even because, with her, writing became an important test of the slave subject's cognitive and creative capacities as well as any moral personality. She is important above all because, within her servitude, she was able to articulate the possibility of being outside the compass of slavery and thereby to provide both a model and an illustration of the characteristic modes of ambivalence that are repeatedly described in the cultural circuitry of the black Atlantic. June Jordan is correct in drawing attention to the assertion of autonomy that leaps out halfway through 'On Being Brought from Africa to America', a poem that she published at the age of sixteen. The memory of a pre-slave past in which the redeeming opportunities afforded by Christianity are irrelevant suggests this powerfully:

> Twas mercy brought me from my Pagan land,
> Taught my blighted soul to understand
> That there's a God, that there's a *Saviour* too:
> Once I redemption neither sought nor knew.
> Some view our sable race with scornful eye,
> 'Their color is a diabolic die.'
> Remember, *Christians, Negroes*, black as *Cain*,
> May be refin'd, and join th' angelic train.

Wheatley's life and the wide range of critical responses to her achievements can also be used to focus the conflict between theories of racialised identity premised upon notions of African-American particularity and exceptionalism and other possible approaches that operate outside the assumptions of nation-ness and the nation state, on inter-cultural and outer-national social and political processes. The forms and sentiments of her poetry raise these issues while the succession of commentaries on her work and life display intense political conflicts over the limits of localised racial identities and in particular over the relationship of 'races' to nations. Richard Wright's characteristically contentious 1957 commentary on her significance in the analysis of 'Negro literature' in the United States touched on both these themes:

> Phyllis Wheatley was at one with her culture. What a far cry this is from the Negro Seabees who staged a sit down strike a few years ago on the Pacific Coast when the war against Japan was at its hardest! What makes for this difference in loyalty? . . . Then, what is a Negro? what is Negro writing?

19

. . . we can use [Phyllis Wheatley] as a guide a yardstick to measure the degree of integration of other Negro writers.[7]

It is no surprise that Wheatley's intellectual capacities had been hotly contested in eighteenth-century discussions of the relationships between races, culture and aesthetics. Her achievements were cited routinely as a pointer to what blacks might achieve in debates over the moral economy of slavery and the legitimacy of abolition. In his history of early black settlement in Britain, Folarin Shyllon points out that Wheatley's work was still being reprinted in the press around the time of William Wilberforce's first motions against the slave trade in the House of Commons.[8] The enthusiasm for the revolutionary dreams of American modernity that is revealed in Wheatley's paean to George Washington or her first published work, a hymn 'To the University of Cambridge, in New England' produced when she was just fourteen years old, has sometimes been an embarrassment to those thinkers who have sought to design and arrange the counter-canonical output of Western blacks in the form of a regimental parade for which she provides both a figurehead and a benediction or use her extraordinary work as an ethnocentric cornerstone for the emergent national tradition of African-American literary production.[9] Against these dismal attempts to capture her itinerant spirit and confine its complex and contradictory legacy within the fixed borders of black American exceptionalism, it is important to draw out the significance of her visit to England in 1773, to note that her work was first published in London rather than Boston, and that she crossed the Atlantic for the second time in her life in the opposite direction to the journey that had brought her into American racial slavery. Peter Fryer, James Walvin and others have demonstrated that her vital memory can be claimed from a European location as readily as it can from the Americas.[10] It is essential to appreciate both her formal opposition to slavery and the interpretations of her celebrity made by the other black intellectuals who were her contemporaries.[11]

Today, there are still significant differences between the ways in which blackness, race and nationality are understood in the different locations whose complex interactions composed the black Atlantic system. Contrasting black identities remain routed through distinct local histories and projected on to various landscapes. The complex of difference and similarity that gave rise to the consciousness of diaspora inter-culture has become more extensive in the era of 'globalisation' than it was in the high period of imperialism. New communicative technologies dissolve distance and transform time, changing the basis on which spatially separated groups can connect and identify with each other. The circulation of people, ideas and things made the idea of diaspora a plausible one through which to comprehend the modern history of blacks in the Western hemisphere. A sense of identity-making as a process has been enforced by the enduring memories of coerced crossing experiences like slavery and migration. These factors combine and interact. They can also be used to bring another – less innocent – understanding of modernity into view. This Other modernity demands

20

its own periodisation and syncopated temporalities. It is, for example, repudiated by an altogether different modernism that we can begin to reconstruct from the fragments that link Phyllis Wheatley to her better known successors. This un-benign modernity is waiting to be possessed and understood, to be theorised. It was ushered in by conquest, slavery and extermination. First heathen savages, then animal primitives constituted the resistance against which its ruthless and sanctified self-consciousness was defined. Comprehending it today is a useful means of dispelling the aura of novelty and surprise which stubbornly hangs around the barbarisms that flow through European and American civilisations. However, it would be wrong to view this profane modernity as something that Western blacks can readily stand outside. Its foundational destructiveness no more belongs to Europeans than the history of slavery is the exclusive property of blacks. The idea that European barbarity might be negated by the superior moral worth of a pure, anterior essence of non-European alterity is itself a distinctly modern fantasy born from European secularism. Changing the labels around, so that the savages and primitives are seen as civilised scientists, may be valuable as a short-term corrective to the conceits of white supremacy but it is not sufficient basis for a coherent politics. It leaves the bitter dualistic coding of racial politics absolutely intact.

Like Wheatley's, W. E. B. Du Bois' life encompassed freely chosen rather than coerced travel. Though he did end his long life as an orthodox Communist in Ghanaian exile, he is sometimes seen through the lens of his famous antipathy towards Garvey. In this light, he is viewed as one of the many black folk who somehow journeyed in the wrong direction and practised a form of racial treason because they did not necessarily seek cultural and political restitution for the wrongs of slavery via return to the original scene of dispersal, preferring instead to move between locations and across borders while struggling to create a political vision adequate to their restless condition. A battle is still raging be-tween those who make the pluralising inner logic of the diaspora idea their starting point for theorising black identity, refusing its simple negation in return to the motherland or fatherland, and others who seek to terminate the frag-mentation and dissipation of Africans abroad and favour the ruthless simplicity of undifferentiated racial essences as a solution to growing divisions inside black communities. This essentialism re-articulates black cultural nationalisms that have been appropriated without much modification from the standard European sources. It views Atlantic peregrinations against the martial tides of heroic nation-building activity in Liberia and elsewhere as misleading occurrences that generate regrettable consequences. Itinerant lives and the dissident political observations which they facilitate can only disappoint and frustrate absolutist understanding of racialised cultural forms and the overintegrated conceptions of self, kinship and community to which they remain invariably bound.

The activities of Wheatley, Du Bois and the rest of their black Atlantic peers can be used to construct a welcome supplement to existing theories of the modern African diaspora into the Western hemisphere. This change of perspective is

aimed at transforming the more familiar uni-directional notion of diaspora as a form of dispersal which enjoys an identifiable and reversible originary moment, into a much more complex 'chaotic' model in which unstable 'strange attractors' are also visible. These nodes are misunderstood when they are identified as fixed local identities. They appear at unexpected points and mark out new under-standings of self, sameness and community, but they are not markers in a simple genealogical account of kin relations. Instead they provide cues and clues for the elaboration of a social ecology of cultural identity and identification. The cele-brated 'butterfly effect' in which tiny, almost insignificant forces can, in defiance of conventional expectations, precipitate unpredictable, larger changes in other places is a commonplace happening in this approach. Seamless propagation of cultural habits and styles is rendered radically contingent. A different mode of linkage is suggested between the forms of micro-political agency exercised in cultures – and sometimes movements – of resistance and transformation and the (anti-)political processes that occur on a different, bigger scale. Thus the black Atlantic valorises something more than a protracted condition of mourning over the ruptures of exile, loss, brutality, stress and forced separation. It highlights a more indeterminate mood in which natal alienation and cultural estrangement are capable of conferring insight as well as precipitating anxiety. Contrasting forms of political action emerge to create new possibilities and new pleasures where dispersed people recognise the effects of spatial dislocation as rendering the issue of origin problematic, and embrace the possibility that they are no longer what they once were and cannot therefore rewind the tapes of their cultural history. The obsession with origins which appears all too regularly in black cultural history is itself an expression of some particularly and peculiarly modernist intellectual habits.[12]

As a supplement to existing formulations of the diaspora idea, the black Atlantic provides an invitation to move into the contested spaces between the local and the global in ways that do not privilege the modern nation state and its institutional order over the sub-national and supra-national networks and patterns of power, communication and conflict that they work to discipline, regulate and govern. The concept of space is itself transformed when it is seen less through outmoded notions of fixity and place and more in terms of the ex-centric com-municative circuitry that has enabled dispersed populations to converse, interact and even synchronise. What Manuel Castells has called a 'space of flows' was prefigured as the 'trialectics' of triangular trade, and gave way to modern move-ments that aspired towards the abolition of racial slavery, the acquisition of citizenship and the disaggregation of Euro-American modernity's colour-coded utopias. These struggles have taken different forms on all the shores of the Atlantic.

Similarity and differentiation in the cultural habits and gestures of separated yet connected black populations can be identified as local and non-local proper-ties of a non-linear system in which complexity is itself a powerful factor in fixing the limits of possibility. The transverse and the diagonal, the self-similar,

the fractal and the multiple are exalted here over the simplicity and unnatural purity of straight lines that simply cannot express the constitutive asymmetry of the insubordinate political cultures nurtured in what Homi Bhabha calls 'the in between'.[13] At this point, the unhappy dialectic between an expressive, reversible diaspora and its predictable, authoritarian negation (in the building of national counter-powers) is terminated abruptly. The distinctive diaspora (eco)logic of identity and non-identity can, however, be borrowed and set to work so that neither effortless sameness nor absolute differentiation can be safely assumed. What Leroi Jones once named 'the changing same' provides the central motif here. Neither squeamish essentialism nor lazy, premature post-modernism – the supposedly strategic variety of essentialism – are useful keys to the untidy workings of creolised, syncretised, hybridised and impure cultural forms that were once rooted in the complicity of rationalised terror and racialised reason. This changing same is not some invariant essence that gets enclosed in a shape-shifting exterior. It is not the sign of an unbroken, integral identity protected by a camouflaged husk. The phrase names the problem. The same is present, but not as an essence generating the merely accidental. Iteration is the key to this process in the same way that a linear fractal like the Von Koch 'snowflake' can be actively distorted from the basic form of a triangle, or the Julia set from a circle.[14] The same is retained but not reified. It is recombinant, ceaselessly reprocessed in the glow of its own dying embers. It is maintained and modified in what becomes a determinedly non-traditional tradition, for this is not tradition as mere re-petition. Invariably promiscuous and unsystematically profane, this is a mutable hetero-culture orchestrated by the historic injunction to keep on moving. It suggests the complex, dynamic potency of living memory: more incorporated than inscribed.

Which of the five different mixes of SWV's 'I'm So Into You' that I am listening to while I write this can justly claim to be considered the original? Which version of a 'standard' song, say 'Someone to Watch Over Me', 'Some Day We'll All Be Free' or even 'Always There' provides the definitive model for all the other permutations assembled by means of the individuality of anyone who dares to possess and utilise them in innumerable discrepant settings? The irreducible plurality of these sub-cultural phenomena makes this line of questioning irrelevant. A changing same. The sterile idea of origin and the assumption that culture is wholly sedentary lose their special glamour as different scales of enquiry point to other beginnings that require new modes of recollection and new conceptions of movement.

If Wheatley represents something like the start of black Atlantic crossings and Du Bois comes towards the end, Martin Robison Delany represents a halfway point. If he is remembered at all these days it is as an early architect of pan-Africanism: the political mentality that furnished today's Africentrists with a disposable ladder up which they could climb.[15] Among his many other accomplishments, Delany attempted to theorise the role of the male soldier/citizen in the redemptive, nation-building projects necessary to ending slavery and bringing

white domination to an end. In his work the integrity of the race was first defined through the proper authority of its patriarchs. He wore his Dashiki uniform a full century before Black Power animated a global movement. Though his stay in Cambridge was considerably shorter than Du Bois', he too was a Harvard student whose life can be used to exemplify some of the paradigmatic instances of crossing – mixing and moving – that make the idea of the black Atlantic a plausible and attractive alternative to the narrow certainties of merely nationalist histories. In Delany, the crossings are experienced but their effects are not acknowledged to be useful.

Like Du Bois', Delany's life touched Africa and Europe as well as several different locations in the Americas. It can be triangulated between the Niger Valley, Chatham Ontario and London where he attended the international statistical congress in 1860 and obtained the patronage of the Earl of Shaftesbury. Delany is relevant here not simply as an example of the early pan-Africanist consciousness that found actually existing Africans something of a disappointment because they were seldom Christian and usually insufficiently enthusiastic about the prospect of speaking English as a condition of their elevation. It is significant, though not decisive, that his sense of Western hemisphere blacks as a 'broken people' whose unexceptional but catastrophic status as 'a nation within a nation' had been worsened by the fact that their purity had been despoiled was explicitly derived from European nationalist thinking. Jewish history and experience also provided him with a continual point of reference for the long labour of social and familial reconstruction necessary to re-building corrupted and diluted blackness in the austere and strictly gendered configurations necessary to racial redemption and recovery.

> We must MAKE an ISSUE, CREATE an EVENT, and ESTABLISH a NATIONAL POSITION for Ourselves; and never may expect to be respected as men and women, until we have undertaken, some fearless, bold, and adventurous deeds of daring – contending against every odds – regardless of every consequence.[16]

Delany would later distinguish himself as the leader of the first scientific expedition to Africa from the Western hemisphere. He had other detailed plans of what such an historic event would entail. His dream of building a great railroad capable of modernising Africa and providing the economic infrastructure necessary to overthrow slavery in the same grand gesture exemplifies this:

> . . . [the railway] terminating on the Atlantic ocean West; . . . would make the GREAT THOROUGHFARE for all trade with the East Indies and Eastern Coast of Africa, and the Continent of America. All the world would pass through Africa on this railroad, which would yield a revenue infinitely greater than any other investment in the world.[17]

The desire to prove racial manhood by means of heroic enterprise has gone out of fashion. Today a different fantasy of power and domination, centred on the idea

of anteriority rather than modernity, lends a dismal vitality to the activities of black absolutists for whom the family rather than the nation is the key to the *(perilous)* future. Black politics in the modern, Western, overdeveloped world is in a parlous state. Its oppositional core has been rendered inert by the increased internal differentiation of racialised communities in which the poor no longer share the same social or physical space with the privileged. The drug economy has taken hold and the residues of past disadvantage are compounded by ongoing marginality and immiseration. The fragile and volatile condition of black political culture is betrayed by the desperate theories of selfhood, kinship and community drawn from nineteenth-century sources that have begun to circulate and create a model of identity politics in which what you are counts for rather more than what you do. Confused, bitter and angry people struggle vainly in pursuit of certainty about the limits of their racialised identities, and the purity of their origins. The latter confers a special legitimacy on their political hopes. This is second only to that of victimhood and the moral axiology of tradition, understood here as mantric repetition.

A general crisis in thinking about the nation has achieved a particular, post-colonial articulation in the secret sociality of the black public sphere. The movements towards citizenship and liberation that characterised black political culture in earlier periods have all but disappeared. They have been replaced by an imploded ethnicity that routinely represents racial difference – just as Delany did long ago – through the ideal category of masculine heroism, and presents the anti-modern as the pre-modern in its frequent appeals to the legitimating potency of African alterity and anteriority. Some of the terms of white supremacist thinking are modified, but important elements of its conceptual and tactical logics are retained and confirmed. The anti-capitalism that grew from racial slavery and was preserved as a political resource for so long has evaporated. The scope for political agency dwindles first to the limits of the family and then begins to coincide with the exterior surface of the body. Therapy is a trivial surrogate for the inescapable difficulty of politics. The narrative of civilisation as progress towards perfection is claimed in the name of an imaginary African homogeneity that mimics the worst aspects of European thinking about self and community.

This is the historical context in which the concept of the black Atlantic grew. It emerged out of several distinct politically engaged polemics. It stands against the occultism involved in so many contemporary theories of nationality – especially the racialised figurations of kinship and connectedness that have appeared in the political discourses through which blacks in the Western world have worked to answer the brutal potency of white supremacy. It repudiates the forms of cultural history produced as a means of legitimating black political claims for nationhood and autonomy. It was shaped by the need to supply a counter-narrative of modernity that could offset the wilful innocence of those Eurocentric theories that ignored the complicity of terror and rationality and in so doing denied that modern racial slavery could have anything to do with the sometimes brutal practice of modernisation or the conceits of enlightenment. It therefore

replies to the nationalisms evident in the writing of sedentary cultural history by both blacks and whites. But it is especially antagonistic to those complacent Europe-centred studies of culture that were at best indifferent to the notion that blacks had been involved in anything European. It embodies a more general argument about where the nation state fits into the big story of modern culture and points towards more pluralistic – decentred – ways of understanding not contemporary racial problems in Europe, but the constitution of Europe itself by the flows that acted upon it.

This emergent counter-history of Europe should enjoy a close and dynamic connection with the development of initiatives that could make anti-racism the premise of politics rather than a distracting and disreputable sideshow to the principal action. However, it requires several adjustments of perspective in contemporary anti-racist politics. Firstly it needs a new understanding of Fascism and anti-Fascism which, on the theoretical level, poses awkward questions about bourgeois humanism in general and its relationship to nationalism in particular and, on the political level, prompts a change of the scale on which histories of Fascism have been conceived so far. This will mean comprehending Fascism in ways that allow the colonial adventures of European states to be more important than they have appeared to be when Fascism was presented as Europe's private, internal drama.[18] It will certainly involve exploring the connections and the differences between anti-semitism and anti-black and other racisms and assessing the issues that arise when it can no longer be denied that they interacted over a long time in what might be seen as Fascism's intellectual, ethical and scientific pre-history. Most importantly of all, this counter-history must operate in a mode of diligence associated with the work of J. A. Rogers; a laborious orientation, but one that allows blacks to appear in our irreducible plurality, in the very lineaments of Europe. Soldiers giving their lives in the actions of the Abraham Lincoln Brigade in Spain and film extras spared the worst regimes of brutality in Hitler's Germany thanks to the Nazi need to feature real black people in their imperial propaganda are two of the most obvious examples of what this might entail.[19]

The life and writings of that great black European, Richard Wright, must also be cited here as a source of further clues as to what this counter-history might involve. Wright's itinerary not only crosses the Atlantic but confounds the linguistic barriers between Francophone and Anglophone worlds. He was the first black thinker to use Fascism explicitly as the central issue in his ambivalent responses to modernity and to warn that the fact of having been victimised by racism did not render those who suffered it immune from the lure of racist thinking. Blacks could, from his perspective, be Fascists too. Wright was a black American from Mississippi, who spent the last decade of his life in Parisian exile. The most celebrated black writer in the world during the 1940s and early 1950s, Wright was also a Communist who shed his affiliations and found a new vehicle for his political hopes in the trans-national and inter-cultural structures created around the journal *Présence Africaine*. His status as a hard-boiled proletarian author had conducted his writings into Europe long before he arrived there

himself. The underground resistance to the Nazis in France and Italy had circulated his books. Wright saw post-war Europe's enthusiasm for elements of African-American culture as an integral part of the cultural response to Fascism:

> To the degree that millions of Europe's whites were terrorized and driven by Nazism, to that degree did they embrace the Negro's music and his literary expression. Here was a development that white America did not foresee or understand. Hence, the Negro became to a large measure for Europe the one and only human aspect of an otherwise brutally industrialized continent.[20]

The gulf between this diagnosis and the material that has been produced on the use of African-American culture under the Nazi regime will have to be explored elsewhere.[21] It is more important for my purposes here that Wright's enthusiasm for European cultural and political aspirations fractured along the fault that divided his own political sensibilities. The orientation appropriate to the overdeveloped countries was inapplicable in the underdeveloped ones, where the urgent obligation to industrialise created a different set of pressures. Wright's essays on 'Tradition and Industrialisation' are particularly useful in clarifying this important tension.[22] They manifest their author's hope that in the context of anti-colonial struggles in Africa and Asia the 'spirit of the Enlightenment and Reformation, which made Europe great' is being extended so that 'a part of the non-west is now akin to the west' and 'what is good for Europe is good for all mankind'. In America these noble hopes and dreams were undone, contaminated and damned thanks to their historic association with white supremacy. Wright tried to find a means to bridge this political and experiential gulf. It is characteristic of both the problems and the opportunities that arose in the interstices of the black Atlantic world that one of these attempts was his application of theoretical models derived from Octave Mannoni's Kojevian work on the social psychology of French colonial societies to the analysis of relations across the colour line in the segregated South. This innovative framework features in his final published novel *The Long Dream*. Whatever one thinks of these bold and conspicuously premature efforts, the erasure of Wright's full participation in the intellectual sub-cultures of post-war Paris is almost as striking as the devaluation of his European writings by American critics. Wright's life and death raise a number of other significant questions for the contemporary heirs to the anti-tradition of inter-cultural ambivalence in which he stands. All articulate the problems of politics in a direct form and suggest that the cultural networks that found the black Atlantic attained a new and distinct political significance in the cold war setting.

The first of these issues is the freedom of movement. The denial of travel documents to Wright, Du Bois, Robeson and others by the US State Department, and the refusal of rights of settlement to Wright by the British government shortly before his death, draw attention to a geopolitical conflict to which black intellectuals were central and in which the relationship between black Americans and

the movements against colonialism was absolutely pivotal. Whether the govern-
ments they excoriated and embarrassed were actively instrumental in their deaths,
the intrusive surveillance and harassment to which these men were subjected was
a factor in their immiseration and loss of morale. Wright, like Frantz Fanon, was
one of many important figures in this half-hidden political formation who met a
premature death which remains enveloped in controversy. Elements of his story
have been told in fictional form by John A. Williams in his novel *The Man Who
Cried I Am* and partially reconstructed in Addison Gayle's political biography
Ordeal of a Native Son. This history will have to be reconstructed on a broader
framework than the tragic narrative of any individual life can supply. It is an
urgent matter that will not wait until the British Government files on Wright's
case are made available in 2059.

NOTES

1 W. E. B. Du Bois, *Dusk of Dawn*, in *Dubois Writings*, New York, Library of America,
 1986, p. 587.
2 See G. Deleuze and F. Guattari, *Kafka: Toward a Minor Literature* (trans. Dana
 Polan), Minneapolis, University of Minnesota Press, 1986, Chapter 3.
3 Chris Wells' interview with Carleen Anderson, *Echoes*, 6.11.93, p. 18.
4 See for example, Martin R. Delany, *The Condition, Elevation and Destiny of the
 Colored People of the United States Politically Considered*, Philadelphia, 1852,
 published by the author, pp. 87–88; W. E. B. Du Bois, 'On the Damnation of
 Women', in W.E.B. Du Bois, *Darkwater*, New York, Harcourt, Brace and Co, 1921,
 p. 177; Richard Wright, 'The Literature of the Negro in the United States', in W. E.
 B. Du Bois, *White Man Listen!*, New York, Anchor Books, 1964, pp. 76–78; June
 Jordan, 'The Difficult Miracle of Black Poetry in America or Something Like a
 Sonnet for Phyllis Wheatley', in W. E. B. Du Bois, *On Call*, Boston, South End Press,
 1985; Henry Louis Gates Jr, 'Writing Race and the Difference it Makes', in W. E. B.
 Du Bois, *Loose Canons*, Oxford & New York, Oxford University Press, 1992, pp.
 51–55.
5 Paul Gilroy, *The Black Atlantic*, London, Verso, 1993; Cambridge, Harvard
 University Press, 1993.
6 Sterling A. Brown *et al.* (eds), *The Negro Caravan*, New York, The Dryden Press,
 1941, p. 283.
7 Wright, op. cit., p. 77.
8 Folarin Shyllon, *Black People in Britain 1555–1833*, Oxford, Oxford University
 Press, 1977, pp. 195–198.
9

 'Twas not long since I left my native shore
 The land of errors and Egyptian gloom:
 Father of mercy! 'twas thy gracious hand
 Brought me in safety from those dark abodes.

10 Peter Fryer, *Staying Power*, London, Pluto Press, 1982, pp. 91–93.
11

 Phyllis's poems do credit to nature – and put art – merely as art – to the blush. – It
 reflects nothing either to the glory or generosity of her master – if she is still his
 slave – except that he glories in the low vanity of having in his wanton power a
 mind animated in Heaven – a genius superior to himself. – The list of splendid

titled – learned names, in confirmation of her being the real authoress – alas! shows
how very poor the acquisition of wealth and knowledge is – without generosity –
feeling and humanity. – These good great folks – all know – and perhaps admired
– nay, praised genius in bondage – and then, like the Priests and the Levites in
sacred writ, passed by – not one good Samaritan amongst them.

Ignatius Sancho, letter LVIII to Mr F., 27 January 1778.

12 I am thinking here of Martin Robison Delany's late nineteenth-century attempts to
 answer Darwinian arguments in his last published work, *Principia of Ethnology: The
 Origin of Races and Color with an Archaeological Compendium of Ethiopian and
 Egyptian Civilisation from Years of Careful Examination and Enquiry*, Philadelphia,
 Harper and Brother, 1879.
13 Homi K. Bhabha, 'Culture's In Between', *Artforum*, September 1993.
14 Benoit B. Mandelbrot, 'Fractals and the Re-birth of Iteration Theory', in H. O. Peitgen
 and P. H. Richter, *The Beauty of Fractals*, Berlin, Springer Verlag, 1986.
15 Molefi Kete Asante, *Kemet, Afrocentricity and Knowledge*, Trenton, NJ, Africa
 World Press, 1990, p. 112.
16 Delany, op. cit., p. 215.
17 Ibid., p. 213.
18 William R. Scott, *The Sons of Sheba's Race. African Americans and the Italo-
 Ethiopian War 1935–1941*, Bloomington, Indiana University Press, 1993.
19 William Loren Katz and Marc Crawford, *The Lincoln Brigade*, New York,
 Atheneum, 1989; May Optiz *et al.* (eds), *Showing Our Colors*, Amherst, University
 of Massachusetts Press, 1900, p. 69.
20 Richard Wright, 'The American Problem – Its Negro Phase', in D. Ray and R. M.
 Farnsworth (eds), *Richard Wright Impressions and Perspectives*, Ann Arbor, Ann
 Arbor Paperbacks, 1971, p. 12.
21 See for example, Michael H. Kater, *Different Drummers Jazz in the Culture of Nazi
 Germany*, Oxford, Oxford University Press, 1992.
22 Richard Wright, 'Tradition and Industrialisation' in Wright, op. cit., p. 63, and in a
 different draft in *Presence Africaine*, 8-9-10 June–November, 1956.

3

DIFFERENT, YOUTHFUL, SUBJECTIVITIES

Angela McRobbie

This essay has three purposes: first, to review and update work on youth falling within the fields of both sociology and cultural studies; second, to consider in more depth questions of ethnicity and questions of sexuality within this overlapping field; and third, to argue for a new convergence of cultural studies and sociology where each might benefit from the strength of the other, and in so doing overcome the tendency to disciplinary boundary-marking and hostility which has become disappointingly commonplace over the last few years. Cultural studies has been characterised as excessively concerned with texts and meanings and has been seen by many sociologists as lacking in methodology and rigour. Sociology in turn is often regarded in cultural studies as being uninterested in questions which cannot be contained within the existing language of 1970s Marxist/ feminist theory. Cultural studies flaunts its wild style while sociology prides itself on its materialist steadfastness.[1] This is not a conflict which has come out in the open. Instead it has bubbled underneath and has taken the form of barbed references and footnotes, with occasional outbursts of overt hostility. The debate has emerged more clearly in the contents of the academic curriculum, where sociology sees itself as concentrating on the real world while castigating cultural studies for daring to suggest that there is no 'real' world.

Both sides, it will be suggested, need to consider issues which have been marginalised in the course of their own development. Cultural studies, while continually on the cutting edge of theory, must be willing to substantiate this interest, not necessarily through recourse to empiricism, but through a mode of research and analysis which explores more fully the rich suggestiveness of theoretical work. Sociology in turn must be willing to consider two possibilities. The first is that culture, however it is defined, now exists in a position of dominance in a world where the TV and visual image have become the primary means through which the mass communications industry works, and where, alongside this the map of the world, its borders and boundaries have been redrawn by the international corporations, for whom the production of culture and information is the 'logic of late capital' (Jameson, 1984). The second is that the consequences of Jameson's view are that one of the marks of postmodernity

is that it is no longer possible to conceptualise and analyse society as a whole, or even as a layered and uneven totality. There can no longer be one big picture, and that kind of theoretical imaging of 'society' which gave sociology its existence is exactly what is now being disputed.

Calls for a convergence of these two disciplines have begun to appear, the most notable being Michèle Barrett's chapter 'Words and Things: Materialism and Method in Contemporary Feminist Analysis' in the collection she coedited with Anne Phillips (Barrett and Phillips, 1992). In this piece Barrett argues that sociology needs to engage more directly with those strands of poststructuralist thinking which it has, in the past, consigned to the field of literary studies. This is all the more important given the extent to which there seems to have been, within academic feminism over the last ten years, a 'turn to culture'. Barrett is referring here to a shift in interest away from sociological 'things' to 'processes of symbolisation and representation . . . and attempts to develop a better understanding of subjectivity, the psyche and the self . . . and towards a more cultural sensibility of the salience of words' (1992: 2).

While it is also the intention of this article to propose that sociology might regard more favourably concepts like subjectivity and difference in relation to youth, it will equally be argued that sociology continues to offer not just the valuable sound of 'spoken voices' in much of the work on youth, something which is largely absent from cultural studies, but that it has also insisted on the importance of institutional practices as key forces for shaping continuity and change in the experience of young people in Britain today. This too is something that should not be ignored. In short the purpose of this chapter will be to set a new agenda for the sociology of youth, informed not only by recent developments in cultural theory but also by that emphasis on lived experiences and on spoken voices which continues to be found in sociology.

To begin such a discussion it is assumed that, without presenting youth as an essentialist category, there are nonetheless a sufficient number of shared age-specific experiences among young people which still allow us to talk meaningfully about youth. And while it is recognised that differences of social class continue to play a considerable role in determining the landscape of opportunity for young people, the emphasis here will be on questions of ethnicity and questions of sexuality. Drawing on Stuart Hall's category of 'new ethnicities' (Hall, 1992a) and with what I have elsewhere referred to as 'changing modes of femininity' (McRobbie, 1993), and adding to this the admittedly clumsy notion of 'different, youthful, subjectivities', I will indicate in what follows some areas for further discussion and research.

This does not mean that there is a singular youth experience, but rather that there is a range of 'different, youthful, subjectivities', and what we have to be able to do as sociologists is to move beyond journalistic terms like 'Thatcher's children' or 'the rave generation' and understand those factors which appear to reach to the unconscious of young people and re-emerge in their socially perceptible subjectivities.

While sociology has been interested in the social characteristics of expressions of 'generational consciousness' (Murdock and McCron, 1977), it has implicitly relegated detailed questions about subjectivity to the field of psychology (see the work of Valerie Walkerdine, 1991, for example). It has also treated the voices of young people, as reported in ethnographic studies, as transparently meaningful and as evidence in themselves, rather than as complex social constructs which are the products of pre-given discourses, in effect 'written' in advance as scripts made available by dominant culture for their teenage speakers. This is how structuralists and many within the field of cultural studies would now approach the same material. By taking elicited responses as generally unproblematic at this level, while being alert to methodological issues, sociology has no vocabulary for asking the sort of questions which cultural studies has been asking. Among these questions is the way the discourses of popular culture, including those of music, magazines and youth TV, position their readers or viewers in a particular relationship to the text and its meaning and in doing so play a concerted role in constructing and organising subjectivity as it comes into being in the 'inter-discursive space' where these cultural forms and their meanings meet and interact with each other.

The difficulty with this approach, as I will go on to argue later, is that it too easily slides into analysis of the specific discourses, most often forms of mass media, which then look as though they do virtually all of the positioning work. What gets ignored are the interactions between the various discourses, and also between the young people and the wider social and institutional relations which they inhabit. It is this kind of exclusive concentration on specific texts which then gives cultural studies a reputation for being closer to film and media studies and which also encourages sociology to consider itself as more grounded in social reality and more concerned with observable social behaviour.

Meanwhile youth remains a key point for social and political anxiety. It has been one of the areas for concerted government attention right across the spectrum of social affairs: in law and order, where there have been moral panics about the 'new juvenile crime'; in education, where there is an endless debate about declining standards; in the family and in the field of public morality where both marital breakdown and the growth of teenage motherhood are taken as symptoms of social decay; and finally in leisure where rave parties, and particularly those organised by young squatters and travelling people, are subjected to intensive policing and surveillance. Issues around the state, social institutions and governmentality, however, are much too important to ignore. It was the regulative and repressive practices of social control which gave an urgency to the early work in cultural studies on youth. Perhaps it is not so much that cultural studies has abandoned youth in the intervening years; more that a moment of convergence marked by the emergence of cultural studies represented the drawing together of such a diversity of concepts and ideas that this was quickly followed by a splintering, and then by a reconvergence and realignment of interests. If we look at the work of the Centre for Contemporary Cultural Studies (CCCS) in Birmingham we could suggest that the publication within a few years

32

of each other of six volumes – *Resistance through Rituals* (Hall and Jefferson, 1977); *Learning to Labour* (Willis, 1977); *Policing the Crisis* (Hall *et al.*, 1978); and *Subculture: The Meaning of Style* (Hebdige, 1979); followed by *The Empire Strikes Back* (Centre for Contemporary Cultural Studies, 1982) and then by Gilroy's *There Ain't No Black in the Union Jack* (Gilroy, 1987) – led to an emphasis on four areas of key importance, not just to the study of youth but to the whole future development of cultural studies. These were race, state and nation; sexuality and representation; education and ethnography; and more recently post-coloniality and postmodernism.

What can also be witnessed during the 1980s is a rejection of the primacy of the youth and social class couplet which had underpinned the development of 'subcultural theory' (Hall and Jefferson, 1977) and its replacement by another set of concerns, the most significant of which are race and sexuality. One problem is that feminist work on youth in the 1980s, with a few exceptions, is more interested in representations of sexuality than in sexual behaviour, sexual activity, or the way in which sexuality is spoken about by young women themselves. The new 'Madonna scholarship' (Wichewicz, 1992) exists almost entirely within the framework of media or film studies. In her earlier work Madonna performed very much for a young female audience, but this dimension tends to get buried when her music, her videos and her film and TV appearances are understood as 'texts of sexuality' in a language which draws on feminist film theory. In Jackie Stacey's analysis (1988) of *Desperately Seeking Susan*, for example, the film is not so much about patterns of female adolescent identity formation through friendship and fascination as about what happens when one woman (Susan, played by Madonna) becomes the object of another woman's gaze (Roberta, played by Rosanna Arquette).

A similar process of textualisation has taken place in the cultural analysis of music. With the exception of Keith Negus's recent account of the music industry (Negus, 1993), Finnegan's work on young musicians (Finnegan, 1989), Sara Cohen's ethnography of musical production in Liverpool (Cohen, 1987) and Sarah Thornton's account of subcultures, youth and music (1995), we find a reduction of a whole field of social activities, including the participation of fans, audiences and young musicians in the production of musical culture, to that of musical texts. This has admittedly been encouraged by the visualisation of pop music through the growth of commercial pop videos, but it does not excuse the narrowing of focus in the study of MTV, for example, to that of the status of texts of postmodernity.

The suggestion is therefore that during the 1980s the focus on youth, which had been such a visible characteristic of cultural studies in the 1970s, was replaced by a number of other interests which overlap with or touch on youth without really acknowledging this fact. The overshadowing of youth as a useful sociological or cultural category can even be seen in the work around 'new ethnicities'. It is after all black *youth* who have been making much of the music Paul Gilroy examines in *There Ain't No Black in the Union Jack* (1987) and also

in his new volume *The Black Atlantic* (1993a). Despite this the processes of what Stuart Hall has described as 'becoming not being' (1992a) have not been explored in relation to the experience of black or Asian young people. We have to look almost exclusively to the sociology of education to find any recent material on this important subject. This is a pity because the whole question of identity which is posed by the new ethnicities work has a special resonance for youth. There is a particular intensity to the processes of separation and detachment from parents and the simultaneous attachment to symbols of freedom and adventure such as those provided in music and found in the spaces of the street and nightclub. If this is not directly theorised in the work of the new ethnicity writers (with the exception of Cohen, 1992), it is possible to see a good deal of the work of the new black writers and film-makers as engaging directly with the experience of being young and black. *Young Soul Rebels* (1991) is a 'youth movie'. It records the sense of fear, adventure and freedom experienced by the film's central character as he explores the city, his own homosexuality and his blackness, against a backdrop of Britain in the late 1970s.

While these processes of identity formation (in the examples offered above, a largely male phenomenon) remain to be more fully explored in the new ethnicities work, writing on race, at a more general level, has moved cultural theory away from its focus on textuality. Neither Stuart Hall nor Paul Gilroy has ever been an exponent of the kind of purely structuralist or poststructuralist approach which otherwise has been so dominant in the field. In recent work by both Hall and Gilroy there is an even more noticeable shift away from emphasis on the text. Gilroy shows how consistently black expressive cultures refuse the framework of the 'Eurocentric' structuralisms as useful tools of analysis. Structuralism, post-structuralism and even psychoanalysis are urgently in need of critique if they are to be of any use in dealing with the hybridic, inter-textual and antiphonic forms of black popular culture. These forms, he argues, require at least an approach which integrates text and context through the social practices of performance, production and participation. The antiphonic (call and response) aesthetic of much of Afro-Caribbean musical culture means that its meanings are open-ended rather than closed. Answering back or talking back in an improvised or immediate way is what gives black expressive culture much of its character. This feature can be found in jazz, in rap, in sampling, in hip-hop music, and in the whole technology of musical production which is, of course, participated in and produced by young people.

This is also a way of creating new meanings by adding and replying to the cultural 'bank' of black history. Thus the Was Not Was remix (two white American producers, with black musicians) of the soul classic 'Papa Was a Rolling Stone' has 'Papa's children' rapping back at him for failing in his parental obligations, for leaving 'Mama' to work to provide for her family and for letting his children down. This example of 'generational consciousness' is indicative of a desire to rewrite the classics from the viewpoint of youth who have grown up aware of questions of sexual inequality.

34

The idea of extending existing cultural forms in this way and, in so doing, producing new forms and new meanings is central to Gilroy's analysis of black expressive culture. His analysis tends to be restricted to music, but the same process can also be seen in dance, and since this is where the participation of young girls is perhaps more visible, the culture of ragga girls in Britain in the 1990s serves as a good example. If the cultural analysis remains at the level of ragga music as a text (an import from the dance-halls of Jamaica), then the question of the sexism of the lyrics and the overt homophobia found in the music of the singer and performer Shabba Ranks requires that this be engaged with directly. But the sexist meaning of the lyrics is challenged by ragga girls in their highly enthusiastic embracing of ragga as well as their distinctive 'calls and responses' to it through dance. Shabba Ranks's sexism is talked back to. Ragga girls, as the *Sunday Times* recently reported (Willis, 1993), recognise ragga style as the strongest and fiercest reference point in contemporary youth subcultures. It conveys an uncompromising sense of blackness and for this it has already provoked a string of attacks in the press. This moral panic has made ragga all the more attractive to young people, and it has been taken up by young Asians (raggastanis or bhangramuffins) and also by white girls, with their hair scraped back tightly into buns, wearing gold jewellery, trainers, leggings and fake-fur winter coats. The particular fusion of ethnicity and masculinity which dominates this subculture, however, virtually bars white boys from being raggas. (Though there is always the rare exception, slightly self-conscious in his baggy string vest, even baggier trousers, and baseball cap.)

Black ragga girls participate in and energise the music through a form of dance which has been described as sexually explicit, even obscene. Its display of 'virtually simulated sex' has provoked outcries from black and white moral guardians alike. Spencer argues, in relation to the sexually explicit lyrics of rap, that this is a means of retaliating to the old white fears of black 'illicit sexualities' by verbalising these fears and through appearing to celebrate precisely such a 'subjugated sexuality' in what he describes as an 'irruption of speech'. This argument can be extended to ragga music and also to the 'irruption of dance' (Spencer, 1993). The *Sunday Times* journalist who described the girls 'hitching their skirts and wining on to men's faces' conceded that there is more, it seems, to this kind of dancing than sexism. As the anthropologist quoted in the article says, 'This is more about women enjoying their own sexuality than about seduction. I suspect they end up going home alone.' The journalist also included a quote from one of the girls: 'So long as you realise that a lot of it is tongue in cheek it isn't really offensive' (Willis, 1993). If we then connect to ragga music the participatory dynamics of its greatest fans, young teenage girls, we can see that this adds a further dimension of meaning not visible in the music or the lyrics alone. While these girls are so rude that they would almost make Madonna blush, they also seem to have learned something from Madonna. The clothes are strikingly similar (bra tops and tight Lycra shorts) and the rhetoric of a proud young female

35

sexuality is combined with the sheer physical enjoyment of dance, working together to produce a euphoria of pleasure and of power.

This reflects a new, bold, visible and hybrid ethnicity, where young black British girls participate directly in the language of sexual relations and sexual conflict which has been prominent in Jamaican dance music, producing for themselves in the process a 'loud' and provocative image and identity. Likewise they could also be seen as participating in a 'changing mode of femininity' where their blackness and their sexuality are forged in a striking visual image which is both excessively and transgressively feminine and includes, for example, a school uniform of bright blonde wigs, gold catsuits, heavy jewellery and trainers.

INTERACTIVE CULTURAL SOCIOLOGY

What is needed, then, in relation to the study of youth, with particular reference to ethnicity and sexuality, is a research mode which prioritises multiple levels of experience, including the ongoing relations which connect everyday life with cultural forms. This would be a way of breaking down the division which has emerged between the study of cultural texts and the study of social behaviour and experience. It has been argued in this chapter that questions of the state and social control, questions of institutional practice and policy, and also of lived ex-perience, have been neglected in cultural studies over the last few years and that as a result there has been little opportunity to ground the concepts of difference, identity and subjectivity in these experiences.

At the same time cultural studies has wrongly been characterised, in sociology and in related fields such as social policy, as being a subdiscipline of literary studies, or else as a field which is much closer to the arts and the humanities than to the 'hard' social sciences. But what cultural studies needs to think about is how ideas like difference, subjectivity and other even more troublesome concepts – fascination, for example – which also figure frequently in discussion on race and sexuality, need to be fleshed out and explored within the landscape of everyday social relations. Sociology, meanwhile, needs to give more time to the concept of culture itself. If culture is dominant, then the social sciences need to find a way of engaging with this, other than either relegating it to the field of the arts and literary criticism or else packaging it up within the political economy of mass communications. The main crossover text in this context has been Paul Willis's *Learning to Labour* (1977) and, given the central place which it still seems to occupy in the sociology syllabus, it is surprising that no social scientists have embarked on a project of updating or revising this material which was published almost two decades ago.

One potential solution to the dilemmas outlined above and to the cleavage which has developed in an area that might usefully provide common ground, is suggested through the kind of work which Gilroy proposes (Gilroy, 1993a). He argues that black expressive culture, particularly music, exists as a set of open-ended structures which invite and find creative cultural responses in the form of

various styles of sampling, rapping, dance and performance, which in turn emerge as distinctively new aesthetics. This argument allows for the posing of more sociological questions of practice and production in what would otherwise be seen, more traditionally, as a set of closed cultural forms. In the section that follows I will make a number of suggestions about what might be important areas to study, and I will consider some of the work which has been carried out on patterns of inter-ethnic friendship, an area which is precisely one that deserves more attention. Do the shared cultures of music, fashion and style offer the possibility for a kind of popular anti-racism? If so, what are the gender dynamics which bring black and white youth together, and how sustainable are such relations within a wider social context of racial and sexual inequality?

INTER-ETHNIC FRIENDSHIP

Cultural studies has insisted on the importance of anti-essentialist approaches to the study of both race and sexuality through the concept of difference (i.e. there are many ways of being black, just as there are many ways of being a woman), but what is missing is a clear sense of what these different identities look like, how they are lived, and within what institutional frameworks they are pursued. What are the discourses within which 'different, youthful, subjectivities' are constructed? How are they expressed? One of the most noticeable changes in the commercial world of women's magazines and advertising is the way in which the male body has become commodified and sexualised to such an extent that Richard Dyer's seminal argument (Dyer, 1989) about the extreme discomfort men feel through being made the 'object of the gaze' seems quite outmoded. No longer do male pin-ups look abstractly out and beyond the look of the viewer, as though to counteract the subordination of the camera through refusing to meet the female viewer's gaze. Now they engage directly with the camera, displaying a whole range of responses from the flirtatious and friendly to the overtly sexual, and then also to the purely narcissistic and seemingly self-absorbed.

How are these changing modes of masculinity reflected in language and social experience? It seems that for women ways of looking at and talking about men have changed. Overhearing a couple of female students exchange comments about whether or not the boy in the holiday snapshot had a good body, where all that could be seen across the picture was an expanse of chest, men appear to be enjoying the kind of attention which in the past has been part of how men view women and not the other way round. The beauty stakes have gone up for men, and women have taken up the position of active viewers. For feminists it seems ironic that sexual equality, with the support of the commercial world of magazines, commodities and advertising, should be 'won' along precisely the lines upon which it had always been most obviously lost. However, while this phenomenon of the 'new man' has attracted attention in cultural studies (Chapman and Rutherford, 1988), it needs to be backed up by more sustained empirical work than is at present available.

Earlier I pointed to the way in which an initial focus on youth in the CCCS work carried out in Birmingham in the late 1970s and early 1980s quickly gave way to a series of other concerns. Of those mentioned on this list, the least developed was that of education and ethnography. These two areas of study straddled both sociology and cultural studies, but became increasingly the focus of attention in sociology. It is here that we have to look if we want to fill in the spaces left behind by cultural theory. In the sociology of education there has been a consistent interest in ethnicity in the school and in the shared environment of the multicultural classroom. Most of this work is also quite clearly anti-essentialist in its understanding of the relations between ethnicity and education. Donald and Rattansi (1992) provide an exhaustive account of how essentialist categories of various 'racial types' have been damagingly applied even in the conventional sociology of race as well as in the realm of popular common sense as a way of explaining 'underachievement' in education. By drawing on ethnographic methods of research, the new sociology of race and education demonstrates how the direct experience of institutional exclusion and powerlessness means that ethnicity exists as a complex and fluid mechanism and resource for negotiating structures of both success and failure.

In Gillborn's work (1990), for instance, ethnicity on the part of young black males is expressed as a distinctive style which is on display in the school and taken by the teachers as an index of perceived or predicted failure. Other writers including Fuller (1982) and Mac an Ghaill (1989) point to the tightrope along which young black girls walk in their bid to succeed in school without surrendering their ethnicity. In each case ethnicity is also the point at which racial hostility is aimed and responded to. It is thus a moment of tension and a focus for identity. It is in and through this particular 'difference' that inequality and disadvantage are resisted and perpetuated, and nothing could be more obvious to the young black people themselves. Heidi Safia Mirza (1992) connects these processes with the wider structural forces which depress the aspirations of black and Asian girls by channelling their expectations and limiting their opportunities. These include inadequate careers advice, compounded by teachers' complicity in supporting a culture of underachievement through adherence to essentialist categories.

However, work like this would need to be extended to the whole variety of educational institutions, including art schools, drama schools, medical schools, etc. There would have to be a shift away from the bare interface of success and failure towards a more extended ethnographic mode which sought to capture the interactive web of relations bringing young black and white people together and also keeping them apart. Thus, while the sociology of education and ethnicity is immensely important, it is weakened by two factors. The young people who are the focus of attention tend to be presented as virtually ethnically exclusive in their day-to-day experiences, and their interaction with white students is not explored. Attention to institutional practices is important in explaining the way in which inequality is reproduced but this mode of research is also constrained by the

exclusive emphasis on the frameworks of the school, the teachers and the dynamics of achievement. There is another connected world of cultural and social relations, at home, on the street and in leisure, which also impacts on how ethnicity is experienced and used.

My suggestion is, then, that to understand the three issues which are being addressed here – new ethnicities in relation to youth, the changing modes of youthful femininity and masculinity which have emerged in cultural forms, and with these the constellations of 'different, youthful, subjectivities' – it would be necessary to pay greater attention to the space of interracial, interactive experience and to explore the processes of hostility, fascination and desire which penetrate and shape the nature of these encounters. Sociologists might immediately object that concepts like fascination and desire have no place in the discipline as organising categories. It is true that in terms of existing debates around ethnicity such terms have been drawn from psychoanalysis and from the theoretical language of film and media studies, and used in understanding, for example, the repetition and recurrence in culture of the racial stereotype (Bhabha, 1983). But feminist sociologists have also used 'desire', 'fascination' and similar terms to understand the appeal of romance, and the social construction and organisation of sexuality, and these have been explored in empirical work; for instance, Radway's work on female readers of romance (Radway, 1985). What is at stake in the interest in fascination and desire is the deep absorption of subordinate self-images so that even when these are recognised and understood as oppressive they continue to exert a strong and powerful influence which impedes change. Sociological studies of domestic violence, for instance, have shown how such deeply internalised 'structures of feeling' (fascination with and desire for the abuser) produce patterns of complicity and collusion. In relation to race, cultural theorists like Stuart Hall and Homi Bhabha (Hall, 1992a, 1992b; Bhabha, 1990) would argue that any understanding of the experience of ethnicity which does not take into account the psychic complexity of blackness as explored in the work of Fanon remains partial (Fanon, 1992).

In relation to youth this would mean taking much further the rich and suggestive comments made by Dick Hebdige in *Subculture: The Meaning of Style* (1979) where he explains British youth subcultures as a response to the presence and experience of young black people in the UK in the post-war years. The implication, which remains somewhat cryptic in the book, is that white subcultures show an overt fascination with black culture and music, a fascination which may, as in the case of the skinheads, tip over into hostility, rivalry and hatred. Only two British studies since Hebdige's go any way in engaging with ethnic relations and interaction among young people. One is sociological in focus (Hewitt, 1986), while the other exists more firmly within the field of cultural studies (Jones, 1988).

Hewitt's study of interracial friendship patterns among boys in South London shows such friendships to be strained to the point of breaking as the short-lived shared space of the school gives way to the more segregated spaces of adult life

and employment. Racial aggression on the part of white boys is only constrained in those areas where they perceive themselves to be in a minority. Where they outnumber their black counterparts their language shows itself to be more openly racist. They see black boys 'encroaching' on their territory, which includes 'their' girls. And they see white girls who go out with black boys as 'niggermeat'. So much for inter-ethnic friendship. White women emerge as less overtly racist, but here, too, tensions appear; a mother who has put up with one of her daughters going out with a black boy is relieved when her other daughter finishes a mixed-race relationship and finds a new white partner (Hewitt, 1986).

Simon Jones's study (1988) was much smaller in focus and carried out in the Balsall Heath area of South Birmingham. He pays more attention to the dynamics of mixed-race relationships and he gives a much fuller account of the hostility and aggression which white girls who fall in love with black boys have to endure, often from their own families. Jones shows how in this run-down area of Birmingham where young black and white people have been living alongside each other and going to school together for many years, black expressive culture, in particular, music, is a resource, as well as a source of envy and admiration on the part of young whites. This is because of its strength of feelings, its cultural richness, its ability to offer and confirm to young black people a sense of their own identity. *Black Culture, White Youth* is also important because it is more hopeful. The enduring friendships and relationships which he describes take place in a cultural space which is far removed from the institutional language of anti-racism or from the politics of race relations. He sees fascination translate into friendship, and desire into love, commitment and children. If there is a connection here with broader social processes beyond the neighbourhood, it is with the emergence of the TwoTone youth culture and style and in particular the music of the Specials, UB40 and the Selecter in the early 1980s, when Jones was carrying out his research. The problem with the book is that the sample is so small that the enthusiasm of a few of the respondents for black culture and Rastafarianism verges on the idiosyncratic and obsessive. These white Rastas, immediately identifiable by their careful re-creation of Rasta style, do not strike the reader as reflective of the less exaggerated adoption of elements of black culture by ordinary white people in Balsall Heath. This makes it difficult to feel that the study reveals a full picture of inter-ethnic friendship and relationships.

WHO GOES OUT WITH WHOM?

There seems to be no work to date that takes as its object of study the experience of black and white girls as they sit next to each other in the classroom, as they read the same fashion magazines, as they listen to the same music, as they go to the same clubs, as they inhabit shared 'cultures of femininity' (McRobbie, 1991), as they negotiate the fear of sexual violence and as they also negotiate the battles of separation from their parents and the move into independence. The concluding

pages of this chapter will make some attempt to suggest how such work might be framed within the fields of both sociology and cultural studies.

We can see signs of both 'new ethnicities' and 'changing modes of femininity' in the field of popular culture. *The Oprah Winfrey Show*, for instance, offers rich opportunities for thinking about a community of women, of all ages, and across ethnic and social backgrounds, brought together within the orbit of popular entertainment, and for whom the opportunity afforded by this occasion emerges from their shared experiences as women. Painful personal stories are exchanged in front of the cameras, on the expectation of a strong response both from the audience and from Oprah Winfrey herself. But the programme is not just about telling or confessing, it is also about personal transformation and empowerment. The underlying logic of the programme is to encourage change. Framed inevitably within the language of American pop psychology, this show nonetheless engages with social and political issues including those of race and ethnicity. Winfrey's success as presenter cannot be separated from her distinctive political voice. While the programme is not wholly given over to women's issues, these do provide the framework, and as they are explored they also provide, within the context of global television, a new environment for bringing black and white women together.

At a more local level it is possible to point to the representation of mixed-race relationships in the British mass media and the way these construct spaces for subjectivity and identity on the part of viewers and passers-by. The billboard advertisements, for instance, for Joe Bloggs jeans ('You can snog in Joe Bloggs'), which became collectors' items and quickly disappeared from their bus-stop sites, showed a young, mixed-race couple locked in passionate embrace. The long overdue but now increasing visibility of black and Asian models in fashion magazines also allows for these processes of projection and identification. But this should not be seen as an exclusive one-to-one relationship between text and reader. It is not simply a question of looking at the images. Instead these circulating images have to be considered as potentially extending the notion of shared cultures of femininity. They also portray images of friendship and intimacy between girls from different ethnic backgrounds. It might therefore be suggested that in the contemporary youth cultural media there are clear signs that British society is mixed-race and that this in turn produces a new vocabulary of interracial desire.

But this still leaves the question of how ethnicity is lived out by girls and young women. How is 'difference' understood by girls of different ethnic origin as they come together in some situations, and remain apart in others? How do black girls experience subordination and inequality in and through a culture of femininity they share by virtue of gender with their white female counterparts; a culture, for example, that still offers them only a token presence in the magazines, in the glossy images and in the written text? Once again there is little ethnographic material which deals with these kinds of exchanges and experiences. As a starting-point some research questions can at least be formulated. What, for

example, is the dominant language of white female racism? Alternatively what is the language of white female 'disidentification with racism' (Mercer, 1992). How do young white women let it be known that they are not racist and that they do not want to be associated with such practices? How do young black and white women share the mixed-race space of the school and the college? Do the same kind of patterns of relatively ethnic exclusive friendships appear within girls' groups as they do in Hewitt's study of young males? Or, less competitive than their male counterparts, do girls find it easier to break the ethnic divides?

Friendship, fascination and shared cultures of femininity are not, however, unstructured processes. Post-school experience raises the same question of different ethnic pathways for girls as it does in Hewitt's study of boys. In many respects the labour market, especially at the upper end, remains ethnically as well as sexually segregated. The institutions of higher education also show clear signs of ethnic boundary-marking with the old universities remaining overwhelmingly white and the new urban universities attracting much higher numbers of black students. Equally important is the question of sexual identity and the familial and social processes which often seek to confirm intra-ethnic sexual relationships. The sexual dynamics of interaction between young people in a mixed-race culture are heavily codified within a sometimes latent and sometimes overt language of difference. Who 'goes out with whom' is not an innocent question.

What also remain problematic are the concepts which, though now comfortably ensconced in cultural studies, are still relatively untranslated into the world of contemporary sociology. Fascination and desire, difference and subjectivity, continue to present a challenge to a field of study which is more concerned with the material structuring of social processes than with, for example, the psychic processes which underlie the social practice and articulation of racist behaviour. How then can we usefully employ these terms which have emerged from Lacanian psychoanalysis, feminist film theory and theories of post-coloniality in the more sociological field of ethnicity, sexuality and youth? And how can we do this while avoiding the temptation to move back to the texts of culture as the sites where subjectivity is constructed? Such a move leads too easily into reading the texts and ignoring the interactive relationship of social groups with the texts of culture.

In recent work on identity and subjectivity it is argued forcibly that, since full identity is never achieved, the question of the self is never resolved and fixed and is therefore always open to change, to transformation and to realignment. The deconstruction of the 'real me' has been a major theoretical task for feminist psychoanalysis, as for writers like Stuart Hall who recently showed how the search for subjectivity was always predicated on the ideological premise that it could be found. Once that is exposed as mistaken, identity becomes much more fluid, much more open to change. This work challenges notions of full subjectivity and replaces it with fragile, 'shaggy', hybrid identities. It is surely significant that it is young people who seem to be at the forefront of exploring and inventing these categories, often within the language of popular music,

and that, as Paul Gilroy has pointed out, such new identities show signs of endless diversity and intensive cultural cross-over (Gilroy, 1993b).

Different, youthful, subjectivities, for all the reasons of generational and institutional powerlessness which are the product of age and dependency, require and find strong symbolic structures in youth cultural forms, through which 'who you are', 'who you want to be' and 'who you want to go out with' can be explored, not in any finalised way, but rather as an ongoing and reflective social process. This is to suggest that there is no clear sociological divide between 'lived experience' and 'texts and representational forms'. The one is always merging with the other, sometimes socially, in the club, listening and dancing to the music, at other points alone, in front of the television, or else with book or magazine in hand. The sounds and images addressed almost exclusively to young people represent identity-formation material, the success of which lies in its ability to reach into the adolescent unconscious and literally form a generation through the shared experience of particular books, records, films, videos, TV programmes and social activities such as dance. But old 'material' must endlessly be replaced by new sounds, new images, new faces, new 'kids on the block'. The commercial requirement of novelty as a condition for profitability reflects precisely the uncertainty of subjectivity, the need for more images to look at and the need for further confirmation about who you are and what you look like, a set of needs more than responded to by teenage magazines. The sociological line separating lived experience from representational forms is definitely broken in the space of fantasy, in the state of distraction, in the daydream, as the eye flickers across the advertising billboards. In this important context fascination and desire acquire a particular force, a peculiar intensity. We cannot ignore the strength of these privatised (but also social) experiences. To be 'lost in music', for example, is to be absorbed in a complex process of working out who to be. In this way whole subjectivities can come to be projected (usually for boys) into the possession of a 'record collection' as Gilroy describes (Gilroy, 1987).

The power which black cultural forms have for young black people is reflective of the historical processes of exclusion and marginalisation experienced in high culture. These processes occur within the education system as well as in the traditions of British popular culture, which have been recently reconsidered in cultural studies precisely on the grounds of their frequent confirmation of a simplistically monolithic notion of national culture and national identity. But what is also important about black cultural forms, in opposition to the more closed forms of British popular cultures, is that these also 'reach out and touch' many, often socially subordinate, white young people, male and female, as Alan Parker's film *The Commitments* (1991) showed. Such young white people can also 'disidentify with racism' through strongly identifying with aspects of black culture. Music, fashion and style thus make available a symbolic language for popular anti-racism.

If this appears optimistic to the point of losing track of the whole range of forces which maintain and underpin the perpetuation of racial inequality and

injustice, then it has to be said that, within the narrow confines of this discussion, such a strategy is deliberate. The emphasis indeed has been on the upside rather than the downside of inter-ethnic exchanges between young people, simply to make the case that such a possibility is rarely considered as of interest to the sociologist or cultural theorist. It is largely cultural theory that provides a language for beginning to understand fascination and desire. The anti-racist subjectivities of young white people which can and do emerge from participating in these open-ended forms come into being therefore in and through the 'seats' available for them in this non-stop performance of black expressive culture (Gilroy, 1987).

The questions raised in this chapter relate to young people, and to the social conditions and experiences which play a role in constituting their subjectivities and identities. Although cultural studies has been, since its inception, a subject which engages with ideas and material arising from very contemporary social phenomena, and is sometimes criticised for having a journalistic tone, the issues raised here, while they are of a contemporary nature, require a much more detailed ethnographic and historical approach. Indeed it would be both refreshing and helpful to have available also some good participant observation studies on youth in Britain today, particularly if such material was able to explore the emergent and 'hybridic' cultural and ethnic crossovers described above. The overall focus here has therefore been on the work that should be done and also on the sort of theoretical questions which would have to be asked. For instance, participant observation might gain something from the cultural studies' critique of the transparency of meaning in relation to spoken language. This would mean that producing the kind of work which Paul Willis carried out with young working-class boys in the late 1970s in the West Midlands might now entail a different kind of interpretative mode. Structuralist criticism would require that what the boys say be considered as potentially having been already said for them. They would be seen as activating certain given structures which accord with their position as gendered, 'classified' and ethnicised subjects in language. But this would not mean that they be seen as captives of language or as victims of their social position. What they said would be 'read' by the author and this would be presented not as the truth but as an account. Likewise other critics would be free to produce other readings of the same material. In some ways this is exactly what happens in 'Settling the accounts with subcultures: a feminist critique' (McRobbie, 1991) where Willis's material is reconsidered from a feminist perspective. It would have been equally possible to produce a reading of Willis's ethnography from the viewpoint of race.

In short, ethnographic work would have at least to consider post-structuralist critiques of language as a way of producing a more complex understanding of meaning. And so, although the emphasis in this chapter has been to encourage cultural studies away from an exclusive concern with texts and meanings, this is not to say that such an approach has no value whatsoever. Here I have been arguing for a return, not to the real world, as it is sometimes seen, but rather to the

terrain of how young people live and how they experience the changed world around them. If we, as sociologists or as cultural theorists, cannot do this then we must, in some way, be failing not just the disciplines we represent but also the politics which has underpinned so much of the most valuable work in these fields. A new sociology of youth would then need to demonstrate 'material stead-fastness' while also being attentive to the 'wild style' of cultural studies.

NOTES

1 For a good example of this kind of boundary-marking and scepticism towards cultural studies, see Stan Cohen's recent introduction to the new edition of his classic study *Folk Devils and Moral Panics: The Creation of the Mods and Rockers*, Oxford, Blackwell, 1990.

REFERENCES

Barrett, Michèle (1992) 'Words and things: materialism and method in contemporary feminist analysis', in Barrett and Phillips.

Barrett, Michèle and Phillips, Anne (eds) (1992) *Destabilising Theory: Contemporary Feminist Debates*, London: Polity Press.

Bhabha, Homi (1983) 'The other question: the stereotype and colonial discourse', *Screen* 24, 6.

Bhabha, Homi (ed.) (1990) *Nation and Narration*, London: Routledge.

Centre for Contemporary Cultural Studies (1982) *The Empire Strikes Back*, London: Hutchinson.

Chapman, Rowena and Rutherford, Jonathan (eds) (1988) *Male Order: Unwrapping Masculinity*, London: Lawrence & Wishart.

Cohen, Phil (1992) '"It's racism what dunnit": hidden narratives in theories of racism', in Donald and Rattansi.

Cohen, Sara (1987) 'Society and culture in the making of rock music in Liverpool', Ph.D. thesis, Oxford University.

Donald, James and Rattansi, Ali (eds) (1992) *'Race', Culture and Difference*, London: Sage.

Dyer, Richard (1989) 'Don't look now', in McRobbie (ed.) (1989)

Fanon, Frantz (1992) 'The fact of blackness', in Donald and Rattansi.

Finnegan, Ruth (1989) *Hidden Musicians*, Cambridge: Cambridge University Press.

Fuller, Mary (1982) 'Young, female and black', in Ernest Cashmore and Barry Troyna (eds) *Black Youth in Crisis*, London: Allen & Unwin.

Gillborn, David (1990) *Race, Ethnicity and Education: Teaching and Learning in Multi-ethnic Schools*, London: Routledge.

Gilroy, Paul (1987) *There Ain't No Black in the Union Jack*, London: Hutchinson.

Gilroy, Paul (1993a) *The Black Atlantic*, London: Verso.

Gilroy, Paul (1993b) 'Between Afro-centrism and Euro-centrism: youth culture and the problem of hybridity', *Young: Nordic Journal of Youth Research* 1, 2, May.

Hall, Stuart (1992a) 'New ethnicities', in Donald and Rattansi.

Hall, Stuart (1992b) 'The question of cultural identity', in Stuart Hall, David Held and David McGrew (eds) *Modernity and Its Futures*, London: Polity Press.

Hall, Stuart and Jefferson, Tony (eds) (1977) *Resistance through Rituals*, London: Hutchinson.

Hall, Stuart, Critcher, Chas, Jefferson, Tony, Clarke, John and Roberts, Brian (eds) (1977) *Policing the Crisis: Mugging, the State and Law and Order*, London: Macmillan.

Hebdige, Dick (1979) *Subculture: The Meaning of Style*, London: Methuen.

Hewitt, Roger (1986) *White Talk – Black Talk: Inter-racial Friendship and Communication amongst Adolescents*, Cambridge: Cambridge University Press.

Jameson, Fredric (1984) 'Postmodernism, or the cultural logic of late capitalism', *New Left Review* 146.

Jones, Simon (1988) *Black Culture, White Youth*, London: Macmillan.

Mac an Ghaill, Mairtin (1989) *Young, Gifted and Black*, Milton Keynes: Open University Press.

McRobbie, Angela (ed.) (1989) *Zoot Suits and Second-hand Dresses: An Anthology of Fashion and Music*, London: Macmillan.

McRobbie, Angela (1991) *Feminism and Youth Culture: From 'Jackie' to 'Just Seventeen'*, London: Macmillan.

McRobbie, Angela (1993) 'Shut up and dance: youth culture and changing modes of femininity', *Cultural Studies* 7, 3.

Mercer, Kobena (1992) '"1968": periodising postmodern politics and identity', in Lawrence Grossberg, Cary Nelson and Paula Treichler (eds) *Cultural Studies*, London: Routledge.

Mirza, Heidi Safia (1992) *Young, Female and Black*, London: Routledge.

Murdock, Graham and McCron, Robin (1977) 'Consciousness of class, consciousness of generation', in Hall and Jefferson.

Negus, Keith (1993) *Producing Pop*, London: Edward Arnold.

Radway, Janice (1985) *Reading the Romance: Women, Patriarchy and Popular Literature*, London: Verso.

Spencer, Jon Michael (1993) 'Introduction', in *Emergency of Black and the Emergence of Rap*, Durham, NC: Duke University Press.

Stacey, Jackie (1988) 'Desperately seeking difference', in L. Gamman and M. Marshment (eds) *The Female Gaze: Women as Viewers of Popular Culture*, London: Verso.

Thornton, Sarah (1995) *Club Cultures: Youth, Media, Music*, Oxford: Polity Press.

Walkerdine, Valerie (1991) *Schoolgirl Fictions*, London: Verso.

Wichewicz, C. (1992) *The Madonna Connection*, Boulder, CO: Westview Press.

Willis, Paul (1977) *Learning to Labour*, London: Saxon House.

Willis, Tim (1993) 'Young, gifted and black', *Sunday Times*, 2 May.

4

SIGNS OF SILENCE, LINES OF LISTENING

Iain Chambers

As we challenge a dominant discourse by 'resurrecting' the victimized voice/self of the native with our readings – and such is the impulse behind many 'new historical' accounts – we step, far too quickly, into the otherwise silent and invisible place of the native and turn ourselves into living agents/witnesses for her. This process, in which we become visible, also neutralizes the untranslatability of the native's experience and the history of that untranslatability.

Rey Chow[1]

History has its dimension of the unexplorable, at the edge of which we wander, our eyes wide open.

Edouard Glissant[2]

I will begin from the name of the room and the story of the building in which the event that led to this book occurred. The room carries the name of Matteo Ripa, and the building, which announces in its very title a precise political intervention and cultural construction, is the Istituto Universitario Orientale or Institute of Oriental Studies. Matteo Ripa was a scholar and a missionary who founded the 'Chinese College', recognised by Pope Clement XII in 1732 and subsequently destined to become the Oriental Institute. This is the oldest school of oriental studies in Europe and was originally intended for the preparation of Asian missionaries and the propagation of Catholicism, along with the commercial interests of the Kingdom of Naples, in China. Within a few years the project had been enlarged to include a three-year course in Oriental Studies, and in particular the study of China and India.

This founding gesture clearly contributed to the making of that more extensive disposition of intellectual and political powers which since Edward Said's magisterial work we have learnt to call 'Orientalism'.[3] As such it was also a direct participant in the repertoire of 'epistemic violence' (Gayatri Chakravorty Spivak) that formed the emerging constellation of modernity in which the West, like every conqueror and empire, objectified the rest of the world and constituted itself as the Subject of History. The self-assured tone, critical distance and

academic or 'scientific' neutrality of the narrative that purports to describe and explain the world flowed without interruption towards meaning. The threat of an interruption, of the violence that constitutes the chronology of events and the semantic disposition of power, is effectively obliterated. In the aseptic and sterilised accounts of history, sociology, anthropology, the 'pain of violence' is written out of the narrative and forgotten.[4]

EL MORRO, NUEVO MÉXICO

The particular configuration of hegemony that emerged in the wake of European conquest and colonialism after 1500 was effectively sealed from the onset in the spreading power of writing secured through the rise of the mass medium of print. The global circulation of goods, and their supervision by institutions of government, trade and learning, enter a new phase in a political economy able for the first time to represent and articulate its goals on a world scale. Such discursive power permitted the effective articulation of universals or abstractions, whether preached in the name of religion, economics, science or history, able intellectually to transform, institutionally regulate and physically reduce the world to the power of the word.

In central New Mexico there is El Morro or Inscription Rock. Numerous signs cover the sandstone walls of this small mesa: the local signatures of twelfth-century Anasazi symbols, or petroglyphs, of sheep and bear claws are overtaken by the global ambitions of seventeenth-century Spanish and nineteenth-century English. In 1605 Don Juan de Oñate inscribed on the rock:

> Paso por aquí el adelantado Don Juan de Oñate del descubrimiento de la mar del sur a 16 de Abril de 1605.

> Governor Don Juan de Oñate passed by here on 16 April 1605 after the discovery of the sea of the south [Gulf of California].

From Madrid to an isolated rock outcrop in Nuevo México, as later from Washington and the eastern seaboard, lines of power were inscribed in composing an imperial geography that rewrote the land, establishing both its centre and its margins. Here, in the 'masculinity of the universal and conquering *logos* that stalks the very shadows . . .' (Lévinas) of the world and seeks to hand it over to the inhumanity of Absolute Reason, to borrow a further phrase from Emmanuel Lévinas, we confront those binary oppositions that authority invariably deploys in reducing the surrounding world to its point of view: reality/appearance, truth/falsehood, male/female, centre/periphery. While the former element is considered the stable bearer of truth, the fluctuating aspects of the latter can only be rendered comprehensible, and *represented*, once it has been subjected by the logic of the former to its wording-worldling.

In this book, one of the central themes is clearly to return to this space, and to reconsider the archaeology of its powers: the power to name, identify, classify,

domesticate and contain that simultaneously doubles as the power to obliterate, silence and negate. For the recognition of other histories, of other people, languages and sounds, of other ways of dwelling in the same space that have been consigned to the shadows, obliterated by the bright light of the unswerving beam of 'progress', also invokes the recognition of their place, however obscured and repressed, in the very constitution of our own histories and culture; in our national and individual identities, in our psychic and social selves.

This is to engage in a 'third space' (Gregory Bateson/Homi Bhabha) in which asymmetrical powers, dissonance and the unsaid are inscribed in a rendezvous in which the West and its others emerge modified. *Neither* term is guaranteed by presumptions of an autonomous history and identity; and neither term can simply be added to the other – Anglo-Indian, Asian-American – to create a facile composite. Both, despite the consistent manoeuvres of Euroamerican cultural hegemony to discursively intern the excess of that hyphen, become part of a doubled and compounded condition that 'does not limit itself to a duality between these two cultural heritages'.[5]

We are perhaps beginning to learn that in order to look towards this potential horizon it is no longer possible to seek refuge, what used to be called critical distance, in the supposedly neutral languages of science and knowledge: those discourses that previously nominated alterity and then reduced it to the tyranny of the logic of the same in the name of civilisation, culture and progress. We are learning to substitute the violence of that translation with the disturbing recognition that translation – mine of an other, an other's of me – is never a transparent activity but always involves a process of re-citing, hence cultural and historical re-siting, and is therefore a travesty, a betrayal, of any 'original' or 'authentic' intention.

TO LEND OUR EARS

So, a linguistic and literary context such as 'English', which has historically stood in Britain, or at least in metropolitan London, for a specific cultural, historical and national identity, comes to be re-written, re-routed and re-sited. Inhabiting English, other stories, memories and identities cause metropolitan authority to stumble. For they talk back to it, take the language elsewhere, and then return with it to interrupt the nation-narration at its very 'centre'.[6] An earlier imaginary unity is challenged and complicated by other traditions, other voices, other histories, now seeking a home and looking for an accommodation in this state.

Here language clearly 'turns against the assertion of property secured in an ethnic source, in the techniques and technologies of ownership and control, all energetically seeking to guarantee claims to rational transparency, causal agency, historical direction and finality'.[7] It is in the visceral transitivity of language, which erupts most starkly across the hyphen of hybridity, that the bondage of the Word, of a particular scriptural economy and its claims on the World, is interrupted. The narrative unwinds, and the transcendental pretensions of reason, of

the Western *ratio*, that continually attempts to regulate unruly equivocations and render differences decidable is decentred.

The proprietary rights of language, history and truth are no longer able to hide in the metaphysical mimicry of universal knowledge or national identity. Such claims are now exposed through a radical historicity as partial, and partisan – accounts whose destiny is never to add up, to arrive at complete comprehension or an exhaustive account. They will always remain incomplete, mutable, historical, open. To inhabit the multiplicity of cultural borders, historical temporalities and hybrid identities calls for a state of knowledge, an ethics of the intellect, an aperture in politics, able to acknowledge more than itself; a state of knowledge that is prepared to suffer modification and interrogation by what it neither possesses nor can claim as its own. In this late twentieth century we register a tear in the languages in which we are accustomed to dwell. This discloses the times and rhythms that exist between the insistent beats of 'progress', and permits us to lend our ears to what is unsaid in the discourses we employ.

WORLDING THE WORD

After Nietzsche the Western journey into language takes us to Joyce, Heidegger, Wittgenstein, Artaud, Blanchot, Barthes, Foucault, Kristeva and Irigaray, while being consistently intersected by a Jewish worldling of the word in Rosenzweig, Kafka, Benjamin, Lévinas, Celan, Jabès, Derrida and Cixous. Each of these voices propose diverse articulations around the shared idea that 'the essential *being* of language cannot be anything linguistic'.[8] Such a journey can transport us from the solipsistic clearing in the forest to the dazzling light of the desert and the naked immediacy of confronting another face (that is, from Heidegger to Lévinas and Jabès). This is to suggest that Saussure and the logic of semiotics is but a brief parenthesis in an altogether longer and deeper turn into language as the site of our being. For it is the uncanny property of language not merely to expose the 'structure' of the mind but to both reveal and occlude the world in which we are constituted.

To return to language, to ambiguity, opaqueness and the shadows of being, is to confront the myth of modernity with what, through its virulent nationalisms and desire for transparency, it has sought to obliterate. The testimony of literature, of the dream-like essence of so much modern life (Walter Benjamin), and of 'art as a haunting of history' (Toni Morrison), brings language to the point where it is shaken apart, and the habitual meanings of words are exposed and sacrificed as custom and the prescribed is unsettled by an unsuspected shift into the elsewhere of the possible.[9]

THE ELSEWHERE OF SILENCE

The emergence and insistence of an elsewhere in the heart of the languages, cultures and cities we presume to be our own forces us to relocate ourselves, and

with it our sense of individual and national identity. The links that previously positioned us in our privileges, and located the others elsewhere, are loosened. They become disturbing, even threatening in their fluidity. So all our studies, not merely and most obviously those of a cultural, literary and historical 'elsewhere', can no longer be considered the site of the ratification and reification of an abstract 'truth', but rather the place in which knowledge is forced to face a worldly response, a historical response-ability (Edward Said/Shoshana Felman).

I slip – in historiography, in anthropology, in critical thought – from the positivist dream of a science, and the presumption of an independent empirical world waiting to be captured by observation, to partisan, or partial, inscriptions in which language becomes the ambiguous factor of 'truth'. In the dispersal of a single History, whose omniscient word legislates the world, I begin to hear composite voices crossing and disturbing the path and patterns of the once seemingly ineluctable onrush of 'progress'. In the movement from concentrated sight to dispersed sound, from the 'neutral' gaze to the interference of hearing, from the discriminating eye to the incidental ear, I abandon a fixed (ad)vantage for a mobile and exposed politics of listening – for a 'truth' that is always becoming.

In the ruins of previous anthropology, sociology, history and philosophy, in the interstices of these torn and wounded epistemes where the rules of disciplinary genres are blurred and betrayed, the object disappears to be replaced by intimations of a potential space in which all subjects emerge modified from encounters that are irreducible to a unique point of view. As authority slips from my hands into the hands of others, they, too, become the authors, the subjects, not simply the effects or objects of my ethnography.

But sometimes we fail to hear and merely register a silence. For our loss of authority is not usually the result of our benevolence (as opposed to the simulation of loss through patronage); it is invariably the outcome of struggle, contestation and a refusal on the part of another being to register our presence. So, silence can also be a marker of agency, particularly among women.[10] 'Silence as a will not to say, or to unsay, and as a language of its own has barely been explored.'[11] The refusal to respond can mark the refutation of a language in which one is being addressed. To reply in this mode is to adopt a voice that refuses to participate in the official record. This refusal of the 'vocal mandate' disrupts the positioning of power through the irruption of silence.[12]

To speak in this manner is no doubt to mark the gap between cosmopolitan intellectuals, both from the 'First' and the 'Third World', and the locally placed; between those who can speak in and through the West and those who remain its distanced and invisible interlocutors. Such an absence articulates a presence. For the resources of 'enabling silences' (King-Kok Cheung) permits others to be, existing apart, irreducible to a common syntax. In acknowledging silence, the interval of the unsaid (and the unsayable), the shadows of the subaltern are thrown across the transparency of words accustomed to ignoring the ontology of silence; a silence which they invariably colonise as pure absence, absolute lack.

51

In the historical performances and cultural speech that silence enacts, previous prescriptive grammars (individual, narcissistic and nationalist) are forced not merely into compromise, but also into interrogation, weakening, even dispersal. As the inhabitants of 'peripheries' and 'marginality' come to challenge and dislocate subjects who once centred themselves by creating the necessity for such categories, so the very conditions of these others become proximate and integral to the state of the subject, to our selves.

Pursuing this line of thought – from silence to the increasing saliency of the previously marginal in the constitution of ourselves – is not merely to couple the nation state to the rise of modernity. It is to link the critique of one to the critique of the other.

In the troubling projection of Jewish identity in the conclusion to Steven Spielberg's film *Schindler's List* (1994) we witness this disturbing collusion at work. Extending and transferring the ending of Thomas Keneally's novel from the individual destiny of Oscar Schindler to the collective destiny of a people, Spielberg portrays the contemporary state of Israel as bearing testimony to the Shoah. Whether inadvertently or deliberately, this invokes and extends the cruel paradox of returning us to the constitutive framing of modernity – the nation state – among whose consequences was the vicious ideology that led to the Holocaust. My discomfort watching this final sequence was that I felt it unconsciously bore witness less to the victims than to the ultimate victory of an avid and aggrandising nationalism. What appeared to endure was less the resilience of Jewish culture and more the hegemony of identities secured in the modern nation state. In viewing this 'symptom of a common pathology', I found myself asking whether to have an identity and to be the subject, not the object, of history, was inevitably to be part of a nation state, part of a Eurocentric ideal?[13] I would like to think that here a critical opening has been overlooked and obscured in the name of modernity. (Of course, for some traditionalist 'pre-moderns' the very existence of present-day Israel is heretical as it rudely anticipates the return of the Messiah, just as for many radical Jews it represents the submission of Jewish culture to a reductive state.) Or is this not merely me asking Jewish culture to carry *my desire*, and to shoulder the historical burden for the hope of humanity as *I* understand it? In other words, to ask of the Jewish experience to represent, in a life and ethics established between homelessness and redemption, the utopic alternative and the radical alterity of Europe, of the West and the modern nation state. However, in acknowledging these limits, my desire may come to be transformed – translation invariably evokes transit – into an excess that exceeds me, permitting a mutual interrogation to emerge. Here the alternative to explore may be that of how the 'Jewish experience in the twentieth century (not just the experience of genocide) itself challenges the modern European conception of the proper of politics'.[14]

This is perhaps to recognise, rather than refuse, Edmond Jabès' question: 'What if this difficulty in being wholly Jewish were the same as everybody's difficulty in being altogether human?'[15] When the elect or 'chosen people' are butchered in their millions by the state machinery of those who considered

themselves to be more elect, and when perhaps the post-Holocaust contribution of being a Jew 'stems largely from an ancient notion of partial and shared human responsibility for redemption', it then surely becomes necessary for all of us to exceed our particular inheritances, to broach the categories that author and authorise us, and become more than 'male', more than 'white', more than 'English', more than 'European', more than 'black', more than 'Jew'.[16]

To be attached to, without fully identifying with, such locations is to evoke the critical necessity to slacken the rope of such moorings; it is to navigate, sometimes to drift, between the seeming security of the shore and the hazy promise of the horizon, where narratives of identity and belonging are compounded and rendered composite, complex. 'The stranger's vision is enlightened, not because he has transcended his origins but because travelling has revealed the chiasmus within the certitudes of belonging.'[17] Here the narrow promise of progress, and the narcissistic dream of utopia, is sundered by the deferring persistence of the atopic. The oppressive clarity of a projected utopic future, always in place and yet for ever negated, is deviated as it is traversed by heterogeneous pressures plunging us into the potential of the present.

These altogether less obvious and more complicated modes of identification hint at a sense of 'flexible citizenship'.[18] Identities are articulated across the hyphen, the transition, the bridge or passage between, rather than firmly located in any one culture, place or position. Of course, this is both an unequal and often unexamined relationship. In being Franco-Maghreb or Anglo-Asian the latter inheritance is located and worked through in the context of the former; this challenges the national configuration for *all* who inhabit it. For if, as Vijay Mishra insists, diasporas do not have a teleology then they invariably disturb narratives of national identities, and their particular utopias, by failing to register such local, invariably ethnically bound, futures. They scramble and confuse the teleological narrative of national identity.[19] To insist on this doubling, and displacement, of culture and nationhood is to focus on the side of modernity that is linked less to nationalism and more to trans- and extra-national worlds. This interrogates the understanding of culture as a site of belonging with the idea of culture as a process of transition and becoming. In the double movement of globalisation – both from above (automobile and media cartels, finance and futures capital) and below (once the ship now the plane, the sound system, the video and audio cassette) – there can emerge counter-histories (of the black Atlantic, of the Jewish, Arab, Indian and Chinese diasporas), counter-memories (the forced communalities of slavery, indentured labour and racisms), and counter-communities (cosmopolitan and local) that persist in the counter-discourse of a non-linear or syncopated understanding of modernity.[20] Such a modernity is maintained not by the stable physicality of a permanent home but by the risky experience of travel and transit sustained by 'imaginary homelands' (Salman Rushdie) and disrupted patrimonies. These latter forms of habitation are not so much projected into the future as introjected into the present, thus both interrupting and multiplying it.

Historically constituted in movement and mutation, such identities suggest modalities of globalisation and modernity that intersect and interfere with the predictable pulse of both progress *and* tradition. As a third way, neither 'progressive' nor 'traditional', the effects of this configuration are neither restricted to the 'centre' nor to the 'periphery', or 'Third World'. To hold on to the uncertainties of this mutual interrogation is imperative. Otherwise my desire continues to reproduce the cycles of hegemony that subject the other to *my* categories, to *my* need for alterity. Then my recognition of difference merely becomes the prison for the object of my desire. Requested to carry the burden of 'authenticity', of 'difference', of 'post-coloniality', the other continues to be exploited, to be colonised, in another name. So, if I refer to the critical horizon of 'post-coloniality', I am referring, to echo Heidegger, to what both unfolds towards me and away from me, to what both envelopes and exceeds me.[21] As a differentiated but syncretic presence post-coloniality does not simply nominate the irruption of intellectuals of 'Third World' provenance into the agendas and syllabuses of cosmopolitan academia, nor does it merely provide a fashionable tag for registering cultural differences on my doorstep.[22] For the radical refashioning of global modernity is equally challenging to societies and cultures once considered to be 'backward' and 'peripheral' as they, too, experience self-interrogation when their own languages and identities return to them in 'modern', mixed, composite and hybrid forms:

> As do all other world musics, zouk creates much stress in its countries of origin by underscoring how its relation with the international market reformulates local traditions and creative processes. As it emphazises the workings of world political economy at the local level, zouk renders more problematic for Antilleans the definition of the 'we' as a site of difference. It challenges in fact the traditional way of thinking about the 'we' as a self-enclosed unit by highlighting its relational character.[23]

CRACKS IN THE MIRROR

When Heidegger quotes Hölderlin to characterise modernity's mixture of danger and saving power he can be appropriately doubled in this context by 'the cryptic Chinese term *weiji*, which is made up of the characters for "danger" and "opportunity", and which means "crisis"'.[24] This brings me into the interruption of fields of study, where doubt is sown as I listen to the wind that disturbs the crops of academy. Here, for example, emerges the striking scene of occidental scholars admonishing contemporary Chinese poets for their failures in language and aesthetics by producing a poetry that is seemingly indifferent to the previous grandeur of their own national heritage.[25] Inevitably, this is where historicism is challenged. As Walter Benjamin noted many decades ago, 'the adherents to historicism actually empathise . . . with the victor'.[26] For:

> Historicism implies control over the past, comprehension of all its aspects,

54

confidence that it will not surprise us by coming to life in the present. In the triumphal view of universal history and unidirectional progress, the European can comprehend the spatially distant Other because the savage is contained in the history of civilisation.[27]

Further, historicism and the teleology of 'progress' are mutually dependent and both are deeply wedded to the Christian capture of time:

Time does not bounce off Christianity as it does off the Jewish people, but fugitive time has been arrested and must henceforth serve as a captive servant. Past, present and future – once perpetually interpenetrating each other, perpetually transforming themselves – are now become figures at rest, paintings on the walls and vaults of the chapel. Henceforth all that preceded the birth of Christ, prophets and Sibylline oracles included, is past history, arrested once and for all. And the future, impending hesitantly yet inescapably attracted, is the Last Judgement. The Christian world-time stands in between this past and this future as a single hour, a single day; in it all is middle, all equally bright as day.[28]

To break with that symbolic and political positioning of marginality, exotica and the other in which so many occidentals locate their displaced desires and neuroses for pristine 'authenticity' and 'origins', is to relocate those margins, those other 'times' and places, within a shared differentiality of unequal and unjust powers. It is to embody 'a refusal to be numbed by terror in a terrifying world'.[29] And it is to recognise in the production of difference orchestrated around the archaic and alterity an almost necessary historical (and psychic) condition for the realisation of occidental modernity: a modernity which represses, while all the time producing, that difference. Sometimes, however, the allegory becomes flesh, and the chimera is transformed into the intractable, occasionally indecipherable. Then the tempo and the linear calculus of 'modernisation', 'knowledge' and 'progress' is radically unsettled by a diverse rendering of a myth that is unavoidably translated into localised realities and forced to accommodate travesties, transgressions and the particular tenacities of asymmetrical ways of being and inhabiting the apparently universal shaping of the world. Here the imposed comes to mean less, and inadvertently mean more, in the process of being simultaneously imposed and (de)posed. Consider the complex agency of Uma Adang, a Meratus Dayak woman living in the Meratus Mountains of South Kalimantan, Indonesia, as transmitted by Anna Lowenhaupt Tsing:

I saw in her leadership what officials see in all Meratus: the transformation of state policy into exotic ritual. Only then could I begin to appreciate the link between submission and claims of autonomy. Her opposition occurred in the mimicry, hyperbole, and distortion of her attempts to get closer to power, rather than in defining herself against this power. In her obsession with ceremony, Uma Adang overfulfilled state requirements for attention to order.[30]

History, understood as the progressive exchange between the word and the world in the accumulation of knowledge (hence power), is disturbed and desecrated by voices and histories that Western modernity and modernisation presumes to simultaneously present, sometimes preserve as *objets trouvés*, but ultimately to subsume within itself. Today, however, their noise and insistence threatens to crack the mirror of occidental conceit. Within the global regime of productive forces that have accumulated through the 'progress' of capital – 'the universality of intercourse, hence the world market as a basis' (Karl Marx) – these voices, these histories, these beings, despite the multiple modes employed to muffle and silence and appropriate them, cannot be so readily dismissed; for there is now nowhere else to go.[31]

DISPUTING MODERNITY

This is to dispute a modernity that, as Nietzsche insisted, achieves the apex of nihilism in its reduction of the multiplicity of life to the singularity of a metaphysical universalism encased in the apparent sovereignty of individual identity. For modernity is consistently deviated by its own languages interrupting its productive rationale, thwarting it and taking it elsewhere. So, the nation state, the language of the master and the logic of capital are regularly punctuated and perverted when contingent 'identities' flow down telephone lines and modems as the latest digital 'ragga' mix is transmitted from Jamaica to London, and then on to New York for further mixing, eventually travelling back to Kingston and on to floppy disk and the dance floor in a matter of days. From DJ to DJ via computer technology, a black, metropolitan language carrying the name 'Jamaica' is broadcast across frontiers, all the while refusing to acknowledge either border customs or semantic unity in 'the ontological space of sound'.[32]

Complementing this passage and turning the ethnographic gaze inwards on ourselves, or at least myself, my own culture – for so long presumed to embody the inevitable 'progress' and 'universal' values of humankind – is rendered particular in its limits, even 'exotic' in its obsessions. I am forced to think again: 'fieldwork' is transformed into 'homework'.[33] Simultaneously, for those we may designate our 'others', it is increasingly clear that it is not a question of their requiring protection from our 'progress' because they do not have the autonomy, the imagination, or political acumen, to render themselves visible and articulate in the modern world. No, it is not that. It is rather a question of them only intermittently having the power and resources to permit their histories and voices to disturb and deviate what we mistakenly consider to be our personal property.[34]

So the claims of property – our history, our language, our story: all wrapped up in *our* sense of modernity – are a fatal illusion. The prescriptive protocols of progress, the linear rule that marks Western modernity off as it strives to supersede itself, are undone, or else occupied in such a manner as to veer off into the oblique and unexpected. Such ambiguities disseminate instability in the very core of the West for whom modernism is invariably, if reductively, the surrogate.

When occidental sounds, images, icons and languages travel elsewhere what remains peculiar to the West? What, in global transit, translation and transvaluation can be purified of its subsequent passage to reveal a pristine, original and essential core? Perhaps nothing. So the West, however violently and neurotically it seeks to preserve its powers and position, its centrality, is paradoxically destined to be deluded by its apparent global presence. In travelling elsewhere its languages return in other forms, following other rhythms, bearing other desires. They cannot go home again. They are home.

This disturbance in the heart of a modernism that the West claims its own is not restricted to a particular physical place or language. It is neither an experience peculiar to the 'periphery' nor the 'centre', although it is invariably configured by local co-ordinates. To return to music, it is impossible to discuss the sonorial architecture of imaginary homelands, North African raï music for example, without relating such sounds to a simultaneous response and resistance to becoming part of the West/the world: a complex relay and reply to rock music, to urban life, global capitalism and the conditions of the contemporary Arab diaspora.[35] Many still consider all this to be simply the reality of the 'periphery' temporarily asserting itself. But this is to avoid confronting a global process that affects all musics, all languages, all forms of cultural and historical being, both 'ours' and 'theirs', both at 'home' and 'abroad'. For the cultural identity sought here in the cultural economy of sounds punctuates everyone's sense of the domestic, both here and there. As a threat and an opening – the raï music that disturbs and incurs parochial wrath while continuing to resonate on both shores of the Mediterranean – as a simultaneous instance of instability and potential empowerment, local details *everywhere* remind us of their global positionality.

Such journeys among the uneven and unexpected effects of these 'contact zones', that have now expanded to compose much of metropolitan culture throughout the world, challenge the myth of modernism as a homogeneous movement and moment, restricted to a centralised economic power and a particular geopolitical population and place.[36] The predator of progress, establishing the ratio of the West, today encounters transmutation and travesty in the very languages it assumed were its own. Propelling itself forward in pursuit of linear redemption, ever newer, ever brighter, ever better, and constantly forgetting itself in order to overcome itself, western modernity underwrites an alterity located elsewhere in backwardness, in a back cloth of darkness, to both underline and justify its movement. Here is Paul Connerton glossing Paul de Man on this point:

> 'This combined interplay of deliberate forgetting with an action that is also a new origin reaches the full power of the idea of modernity.' The justification offered for this principled forgetting is automatically linked to what it negates: that is, historicism.[37]

In absolute difference the rhetoric of alterity locates a pure otherness waiting to be filled by the presence of our desires, a blank page awaiting our words, like the 'empty' wilderness – from the African *veldt* to the American West – waiting to

be settled and domesticated and brought into the redemptive time of our history.[38] Today, the coeval presence of the archaic and the hyper-modern, not simply in the same world, but increasingly in the same cities, screens and streets, most dramatically underlines the asymmetry of cultural and economic powers in global modernity. But it also reminds us that the anterior state of the archaic, although explicitly discarded and repressed, is the essential id of the latter. Once again, to recognise this 'other', negated, side of modernity is to be drawn away from the single base line of 'development' and 'progress' against which the rest is measured. It is to contest the 'capitalisation of silence', and to step into the discrete instances of the heterotopic.[39]

UNDER OTHER EYES

So, I perhaps begin to learn to curb my pretences and to recognise myself not in the rational autonomy and strength of the subject, my 'identity', but in the contingent communality and dispersive aperture of language. There, no longer prisoner of the ubiquitous desire for pure 'alterity', I begin to undo and dispense with the allegorical use of the other. For this use of the other is:

> a use dictated not by the identity of those others and what may be known about them, but by an autonomous ideological project, conceived independently of any contact with the people called upon to serve solely as example and illustration.[40]

This means, to listen to Rey Chow, to read in the West's assurance in positioning the other (as native, primitive, aboriginal, underdeveloped, Oriental . . . original) its own, anxious neuroses about where it is placed; the fear of slipping across the border and becoming an object: an 'I' finding itself under the judgement of other eyes.

> What I am suggesting is a mode of understanding the native in which the native's existence – i.e. an existence before becoming 'native' – precedes the arrival of the coloniser. Contrary to the model of Western hegemony in which the coloniser is seen as a primary, active 'gaze' subjugating the native as passive 'object', I want to argue that it is actually the coloniser who feels looked at by the native's gaze. This gaze, which is neither a threat nor a retaliation, makes the coloniser 'conscious' of himself, leading to his need to turn this gaze around and look at himself, henceforth 'reflected' in the native-object. It is the self-reflection of the coloniser that produces the coloniser as subject (potent gaze, source of meaning and action) and the native as his image, with all the pejorative meanings of 'lack' attached to the word 'image'. Hegel's story of human 'self-consciousness' is then not what he supposed it to be – a story about Western Man's highest achievement – but a story about the disturbing effect of Western Man's encounter with those others Hegel considered primitive. Western Man henceforth

58

became 'self-conscious', that is, uneasy and uncomfortable, in his 'own' environment.[41]

According to Tzvetan Todorov we are called upon to inhabit a 'tragic duality', caught between the ethics of humankind and the narrow nationalism of citizenship where nation and culture more or less coincide.[42] But against that duality needs to be set the emergence of a supplement, that further, 'third space', in which those very terms are rendered unstable, problematic, although by no means dismissed. In my response to an impossibility, the impossibility of speaking for the other, I mark the particular, the particularity of my voice, body of thought and way of being, and from within the global web or 'Westernisation' of the world speak from somewhere, not everywhere. This is to seek to inscribe that impossibility into my language, understanding it not as a critical failure or closure but rather as something that exposes me to the interrogation of the presence of the other, and thus to the historical bounds, cultural specificity and political limits of my self. It perhaps means to live in another country where 'to confront the subaltern is not to represent them, but to learn to represent ourselves'.[43] To live in another place, is to begin to inhabit the ambiguous territories that draw us out of our actual being towards a way of becoming in which no one history or identity is immune from a new and diverse 'worldling of the world' (Martin Heidegger/ Gayatri Chakravorty Spivak). Travelling in this direction, towards this opening, I now find myself listening to the voice of someone who moved in language as though it were a foreign country – Paul Celan:

Käme,
käme ein Mensch,
käme ein Mensch zur Welt, heute, mit
dem Lichtbart der
Patriarchen: er dürfte,
spräch er von dieser
Zeit, er
dürfte
nur lallen und lallen,
immer-, immer-
zuzu.
(<<Pallaksch. Pallaksch>>)

Should,
should a man,
should a man come into the world, today, with
the shining beard of the
patriarchs: he could,
if he spoke of this
time, he
could

only babble and babble
over, over
againagain
('Pallaksh. Pallaksh')[44]

NOTES

This paper owes much to the Californian conversations and company of Chris Connery, Ulla Haselstein, Vijay Mishra, Kathy Biddick, Jim Clifford, Anthony Chennells and Rey Chow.

1 Rey Chow, *Writing Diaspora. Tactics of Intervention in Contemporary Cultural Studies*, Bloomington & Indianapolis, Indiana University Press, 1993, pp. 37–38.
2 Edourd Glissant, *Caribbean Discourse. Selected Essays*, Charlottesville, University Press of Virginia, 1992, p. 66.
3 Edward Said, *Orientalism*, Harmondsworth, Penguin, 1978.
4 Rustom Bharucha, 'Around Ayodhya. Aberrations, Enigmas, and Moments of Violence', *Third Text*, 24, Autumn 1993, p. 46.
5 Trinh T. Minh-ha, *When the Moon Waxes Red*, London & New York, Routledge, 1991, p. 159.
6 See Homi Bhabha (ed.), *Nation and Narration*, London & New York, Routledge, 1990.
7 Iain Chambers, 'Leaky Habitats and Broken Grammar', in George Robertson, Melinda Marsh, Lisa Tickner, Jon Bird, Barry Curtis and Tim Putnam (eds), *Travellers' Tales. Narratives of Home and Displacement*, London & New York, Routledge, 1994.
8 Martin Heidegger, 'A Dialogue on Language', in Martin Heidegger, *On the Way to Language*, New York, Harper & Row, 1971, pp. 23–24.
9 As a challenge to the myth of modernity the motif of the dream is central to Walter Benjamin's understanding of political salvation and historical redemption. See Tyrus Miller, 'From City-dream to the Dreaming Collective: Walter Benjamin's Political Dream Interpretation', forthcoming. Miller quotes from *Das Passagenwerk*: 'The modern has antiquity as a nightmare, which came over it in sleep.'
10 Kamala Visweswaran, *Fictions of Feminist Ethnography*, Minneapolis, University of Minnesota Press, 1994, p. 51.
11 Trinh T. Minh-ha, 'Not You/Like You: Post-colonial Woman and the Interlocking Questions of Identity and Difference', *Inscriptions*, 3/4, 1988, pp. 73–74.
12 King-Kok Cheung, *Articulate Silences. Hisaye Yamamoto, Maxine Hong Kingston, Joy Kogawa*, Ithaca & London, Cornell University Press, 1993, p. 8.
13 Jonathan Boyarin, *Storm from Paradise. The Politics of Jewish Memory*, University of Minnesota Press, Minneapolis, 1992, p. 123. On the occlusion and displacement of genocide in the constitution of a nation state, for example that of Native Americans in a country that houses a Holocaust museum in its capital, see Jonathan Boyarin's discussion 'Europe's Indian, America's Jew' in ibid. Also see Ella Shohat, 'Staging the Quincentenary: The Middle East and the Americas', *Third Text*, 21, Winter 1992–1993.
14 Boyarin, op. cit., p. 117.
15 Edmond Jabès, *The Book of Questions*, Middletown, Wesleyan University Press, 1976, p. 359.
16 This supplement, this 'being more', cannot find easy accommodation in the homogeneous narrative of nationalism. So, a Jewish culture – Sephardic – that desires to acknowledge its Arab and Middle Eastern formation is inevitably subsumed, even denied, by an official sense of Israeli identity that continues the myth of a pristine

cultural continuity, despite its own 'contaminated' conservation in the heartlands of European bourgeois society before it was murderously terminated in the Holocaust. See Ella Shohat, op. cit.

17 Nikos Papastergiadis, *Modernity as Exile. The Stranger in John Berger's Writings*, Manchester, Manchester University Press, 1993, p. 112.

18 Aiwa Ong, 'On the Edge of Empires: Flexible Citizenship among Chinese in Diaspora', *Positions*, 1 (3), 1993, quoted in James Clifford, 'Diasporas', *Cultural Anthropology*, 9 (3), 1994.

19 Vijay Mishra, 'The familiar temporariness (V. S. Naipaul): theorizing the literature of the Indian diaspora', talk in the Feminist Studies/Cultural Studies Colloquium, University of California at Santa Cruz, 2 February 1994.

20 Much of this paragraph is but a gloss on James Clifford, op. cit., as well as Paul Gilroy's *The Black Atlantic*, London, Verso, 1993, and Salman Rushdie's *Imaginary Homelands*, Harmondsworth, Granta/Penguin, 1992.

21 Martin Heidegger, 'Building Dwelling Thinking', in Martin Heidegger, *Basic Writings*, New York, Harper & Row, 1977.

22 This clearly means to argue with the theses of Aijaz Ahmad and Arif Dirlik and their condemnation of thinkers such as Gayatri Spivak, Homi Bhabha and Rey Chow for seeking to undo the ideological rationale that national identities require. In their defence of the centrality of Marxism and the state, both Ahmad and Dirlik seem unwilling to contemplate a contaminated (and complex) politics in which the presence of 'Third World' intellectuals in 'First World' institutions is not the point of analytical conclusion, i.e. the proof that Bhabha and others have been co-opted and corrupted by the cosmopolitan logic of capital ('post-coloniality is the condition of the intelligentsia of global capitalism', Arif Dirlik), but rather represents an interrogatory presence proposing a new and necessary point of analytical departure from within the very languages of the global knowledge/power nexus. See Aijaz Ahmad, *In Theory: Classes, Nations, Literatures*, London & New York, Verso, 1992, and Arif Dirlik, 'The Postcolonial Aura: Third World Criticism in the Age of Global Capitalism', *Critical Inquiry*, 20 (2), 1994, p. 356.

23 Jocelyne Guilbault, *Zouk: World Music in the West Indies*, Chicago & London, University of Chicago Press, 1993, pp. 209–210.

24 Chow, op. cit., p. 25.

25 Harvard's Stephen Owen, 'The Anxiety of Global Influence: What is World Poetry?', *The New Republic*, 19 November 1990; and Oxford's William Jenner's review of Bei Dao's collection of poems *The August Sleepwalkers* in *The Australian Journal of Chinese Affairs*, 23, 1990. For incisive commentaries on these attempts to put contemporary Chinese poetry in its place by holding modern Chinese hostage to the authority of a dead, unspoken language – classical Chinese – see Chow, op. cit., and Gregory Lee, *Troubadours, Trumpeters, Troubled Makers. Lyricism, Nationalism and Hybridity in China and its Others*, forthcoming, Duke University Press. However, a more recent review of modern Chinese poetry by Stephen Owen suggests a response to such criticisms and a certain change of heart, see his review of Michelle Yeh's *Modern Chinese Poetry* in *New Republic*, 208 (8), 22 February 1993.

26 Walter Benjamin, 'Theses on the Philosophy of History', in Walter Benjamin, *Illuminations*, London, Collins/Fontana, 1973, p. 256.

27 Boyarin, op. cit., p. 89.

28 Franz Rosenzweig, *The Star of Redemption*, trans. William W. Hallo, New York, Holt, Rinehart and Winston, 1971, p. 340.

29 Anna Lowenhaupt Tsing, *In the Realm of the Diamond Queen. Marginality in an out-of-the-way Place*, Princeton, Princeton University Press, 1993, p. xi. This whole book is organised around an important discussion of marginality within a differentiated but inescapably global context.

30 Ibid., pp. 26–27.

31 The quote continues: 'The basis as a possibility of the universal development of the individual, and the real development of individuals from this basis as a constant suspension of its barrier, which is recognised as a barrier, not taken for a sacred limit', Karl Marx, *Grundrisse*, Harmondsworth, Penguin, 1973, pp. 541–542. Here the Hegelian *geist* is transformed into the concrete embodiment of Capital, which is itself, of course, another version of the inevitable teleology of 'progress'. However, it does help us to think through 'productive forces' rather than simply against them.

32 Louis Chude-Sokei, 'In the Ashes of Pan-Africanism: Raggamuffin Realities, Post-national Geographies', in Bennetta Jules-Rosetti and Juliet Flower MacCannell (eds), *On the Cutting Edge: Art, Aesthetics and Politics in Africa and the Caribbean*, San Diego, University of California, 1994. A further variant is that of individuals and groups releasing their music directly on computer networks via the Internet Underground Music Archive (IUMA) based in Santa Cruz, California. Music, photos and information can be downloaded and the sound played back at CD-level quality on any computer with a sound card and a pair of speakers. For further information via e-mail the address is: info@iuma.com.

33 Visweswaran, op. cit., p. 102.

34 See Tsing, op. cit., pp. 295–300.

35 Joan Gross, David McMurray and Ted Swedenburg, 'Arab Noise and Ramadan Nights: Raï, Rap, and Franco-Maghreb Identity', in *Diaspora*, 3(1), Spring 1994.

36 Mary Louise Pratt, *Imperial Eyes: Travel Writing and Transculturation*, London & New York, Routledge, 1992.

37 Paul Connerton, *How Societies Remember*, Cambridge, Cambridge University Press, 1989, p. 61. The quote is from Paul de Man's 'Literary History and Literary Modernity', *Daedalus*, 99, 1970.

38 See Mary Louise Pratt, op. cit., and Donald Worster, *Under Western Skies*, New York & Oxford, Oxford University Press, 1992.

39 The phrase is Jacques Derrida's: see 'The Deconstruction of Actuality. An Interview with Jacques Derrida', *Radical Philosophy*, 68, Autumn 1994, p. 37.

40 Tzvetan Todorov, *On Human Diversity. Nationalism, Racism, and Exoticism in French Thought*, trans. Catherine Porter, Cambridge & London, Harvard University Press, 1993, p. 341.

41 Chow, op. cit., p. 51.

42 Todorov, op. cit., p. 385. Todorov rightly insists on '. . . the necessity of postulating a horizon common to the interlocutors in a debate, if this debate is to be of any use', and continues with Montesquieu's declaration that 'the unity of the human race must be recognised, but also the heterogeneity of the social body', Todorov, ibid., pp. 390–391. However, I would insist on the supplement to that duality in order to render it unstable, decentred and leakier.

43 Visweswaran, op. cit., p. 77.

44 Paul Celan, *Tübingen, Jänner/Tübingen, January*, in *The Poems of Paul Celan*, trans. Michael Hamburger, New York, Persea Books, 1989; note the alternative possibility in the translation from German would be: 'only stammer and stammer'. The word 'Pallaksch'/'Pallaksh' is a sign of undecidability. It was apparently used by Hölderlin in his later years to mean 'yes' and 'no' according to context; see Aris Fioretos, 'Nothing. History and Materiality in Celan', in Aris Fioretos (ed.), *Word Traces*, Baltimore & London, Johns Hopkins University Press, 1994, p. 317.

Part II

POST-COLONIAL TIME

5

HISTORIES, EMPIRES AND THE POST-COLONIAL MOMENT

Catherine Hall

In the late twentieth century questions about cultural identity seem to have become critical everywhere. 'Who are we?' 'Where do we come from?' 'Which "we" are we talking about when we talk about "we"?' Such questions are always there, intimately connected to but distinct from the insistent questions of origin that engage every child, but they have a new salience in the contemporary moment. The global changes of the last fifty years have involved the movements of peoples on an unprecedented scale, the break-up of empires and decolonisation, the creation of the New Europe and other new power blocs, the destruction of old nations and the re-formation of new ones. Such shifts, taking place on such a scale, are profoundly destabilising. They provide the context for the contradictory tendencies which surround us – globalism alongside localism, new nationalisms and ethnic identities alongside the international communication highways. Questions as to roots and origins haunt the imaginations of disparate peoples across national and inter-continental boundaries.

Such questions raise critical issues for historians. Eric Hobsbawm in a recent lecture at the Central European University reflected on the role of historians in the contemporary world. Until 1989 Hobsbawm was a confident believer in the emancipatory purpose of history, but in the post-communist world he takes a more sombre and pessimistic stance. 'History', he argues:

> is the raw material for nationalist or ethnic or fundamentalist ideologies, as poppies are the raw material for heroin addiction. The past is an essential element, perhaps *the* essential element in these ideologies. If there is no suitable past, it can always be invented . . . I used to think that the profession of history, unlike that of, say, nuclear physics, could at least do no harm. Now I know it can. Our studies can turn into bomb factories. This state of affairs affects us in two ways. We have a responsibility to historical facts in general, and for criticising the politico-ideological abuse of history in particular.
>
> (Hobsbawm, 1993: 63)[1]

Hobsbawm goes on to argue that it is the historian's responsibility to stand aside

from 'the passions of identity politics', a politics associated for him with the women's movement and the gay movement, movements which he sees as incapable of transforming societies unlike the communist politics with which he was engaged. For Hobsbawm a belief in historical truth and reason provides one way to resist the barbarism which he sees around him and to have a sense of history may be one way of dealing with the present (Hobsbawm, 1994). Historians must separate themselves from inventions of the past, insist on the difference between fact and fiction, stand aside from national narratives or rituals, distinguish between myths and history. I am sceptical about such distinctions, distinctions which post-structuralism has profoundly disrupted. If we are interested in the ways in which history is lived, how it offers answers to the questions as to who we are and where we came from, if we want to know how we are produced as modern subjects, what narratives from the past enable us to construct identities, how historical memories and the shadows and ghosts of memories are internalised in our lives, then 'the passions of identity politics' may drive us to ask new questions of old and new sources, fiction may give us necessary tools, the construction of new myths may be part of our work.

George Steiner, in a very different mood, has discussed the ancient power of myth and wondered whether the 'New Europe' could provide us with a new myth that will enable us to face our past and, therefore, our future (Steiner, 1994). The past that was on his mind was the Holocaust. But there are other European pasts that have also been repressed, in particular imperial pasts, which, to the mind of many in the present, are best remembered only though the mists of nostalgia. Many Europeans, concerned to forget that past, look to a future which focuses on Europe and discards the uncomfortable memories of colonialism. Perhaps before we can embark on the construction of new myths we need to do some 'memory work' on the legacy of Empire. Memory, as we know, is an active process which involves at one and the same time forgetting and remembering. Toni Morrison's *Beloved* powerfully evokes a past which African-Americans as well as white Americans have found too painful to remember but which needs to be recovered through what she calls 're-memory' if that society is to reorient itself in such a way that it can come to terms with its own raced history. If such memories are not 're-membered' then they will haunt the social imagination and disrupt the present (Morrison, 1988).

In Britain the traces of those imperial histories appear everywhere – in the naming of streets, the sugar in tea, the coffee and cocoa that are drunk, the mango chutney that is served, the memorials in cemeteries, the public monuments in parks and squares. Such traces are frequently left unexplored, or are refracted through a golden glow of better days, days when Britons led the world. If it is to be possible to construct myths which could bind Europeans together in ways that are inclusive not exclusive, not reminiscent of 'Fortress Europe' with its boundaries firmly in place against brown, black and yellow migrants, then we need to begin the work of remembering empires differently. Such a project might begin from the recognition of inter-connection and inter-dependence, albeit structured

through power, rather than a notion of hierarchy with the 'centre' firmly in place and the 'peripheries' marginalised.

The legacy of the British Empire is immediately visible in contemporary Britain, where 6.3% of the population are now classified as ethnic minorities. In urban areas such as London and Birmingham, where ethnic minorities make up over 20 per cent of the population, African-Caribbean and South-Asian people constitute the majority groupings. The decolonised peoples of Jamaica, Trinidad, Barbados, Guyana, India, Pakistan, Bangladesh and other once colonies of the Empire who have made their home in Britain, together with their children and their children's children, act as a perpetual reminder of the ways in which the once metropolis is intimately connected to its 'peripheries'. Both colonisers and colonised are linked through their histories, histories which are forgotten in the desire to throw off the embarrassing reminders of Empire, to focus instead on the European future.

In Britain questions about cultural identity have been at the forefront of the national imagination since it became clear that Britain no longer had an Empire and had become, in a very particular sense of the term, a post-colonial nation. For centuries white identities in Britain have been rooted in a sense of superiority derived from the power exercised over racialised others. The loss of that power, the recognition that Britain was only a minor player in the great affairs of the globe, has been a long-drawn-out and difficult affair. Since the 1960s the right of the Tory party has been central to the articulation of Britain as a white nation, its black population only acceptable on the basis that they become culturally British, or indeed English (Gilroy, 1987). English, because while Britain has always been a multi-ethnic nation the hegemony of England has signified the historic marginalisation of the 'Celtic fringes'. With a well-established discourse of 'race' and nation articulated by the Tories, the Labour party has been singularly weak on these issues. Nervous of being identified with black people, or the Irish and the 'Celtic fringes' (despite its dependence on their votes), the Labour party has clung to its conviction that it must respond to the right's agenda on the nation, rather than imagining a different kind of future. At best it has a weak multicultural position and is certainly not in the business of envisioning Britain as what might be described as a 'post-nation': a society that has discarded the notion of a homogeneous nation state with singular forms of belonging. In this context Islamic cultural nationalisms flourish, as do some elements of black cultural nationalism: responses in part to the difficulties associated with articulating an identity that is both black and British.

A re-thinking of the British imperial legacy needs input from the 'peripheries' for it would be very limited to re-think that history only from the 'centre'. Australia and Jamaica, in very different ways, provide my counterpoints which allow me to begin to re-map the history of Empire. Australia was a white settler colony where it was widely assumed in the nineteenth century that the Aboriginal population would die out. Jamaica was colonised by the British in the seventeenth century, when its indigenous peoples had already been wiped out by the Spanish,

and was populated mainly by enslaved Africans and white settlers. In Australia it is quite as difficult to be black and Australian, despite a very different history from that of Britain. In Australia debates about cultural identity have been focused by particular moments. First the bicentenary in 1988, when two hundred years of settlement were celebrated by some in the face of considerable Aboriginal outrage. More recently, 2001, the centenary of Australian federation, has provided the site for a national debate about the future of Australia as a republic, with the associated threatened demise of the monarchy. At play in those debates are definitions of citizenship, of nation, of community. While some long for a safe return to the old white nation and some Aboriginal people are turning to forms of separatist nationalism, there is a felt need amongst others to pioneer 'a 'post-nationalist' political concept of citizenship free from ethnocentric notions of political identity' (Hudson and Carter, 1993: 3).

Prime Minister Keating's new notion of citizenship is one that is dependent on the notion of mix, one that refuses ethnic purity and that argues for a national 'act of recognition', recognition of the wrongs done to Aboriginal peoples in the seizure of their land, the destruction of their cultures (Hudson and Carter, 1993: 140). Rejecting the idea of an Australia composed, as in the moment of Federation, by European peoples with Aboriginal peoples denied citizenship, he calls attention to the waves of immigration of the twentieth century and the impact of the Asian presence on this society perched on the Pacific rim. Australia, as a popular postcard proclaims, is no longer 'down under', for mapping from a different perspective places Australia differently in the global frame. As Ann Curthoys and Stephen Muecke argue, while the earlier nationalism of the Australia of Federation was based on the unity of 'race', the exclusion of others (particularly Aboriginal people) and white exploitation of the land, one dream is that the post-nationalist new settlement should be predicated on difference (both internal and external), inclusion (that would not be confined to Europeans but would be multicultural) and Aboriginal sovereignty over land (in Hudson and Carter, 1993: 179).

In Jamaica, another 'periphery' of the erstwhile British Empire, cultural identity is a critical issue too. The Caribbean, as Stuart Hall has argued, has something to offer in terms of the movement which has been possible towards what Rushdie might call, in an intentionally provocative term, the mongrel, post-colonial society (Hall, S., 1991). In the Caribbean almost all the indigenous population was destroyed in the first wave of colonisation. Consequently almost everyone who lives there has come from somewhere else, whether through slavery, the enforced movement of peoples from Africa, the semi-enforced movement represented by indentured labour from one part of the British Empire to another (South Asians to Trinidad and Guyana in particular), or by persecution, as in the case of Portuguese Jews. Then there were the colonisers – the British, the Spanish, the French, the Dutch, who stayed and became the white creole presence. But 'the stamp of historical violence and rupture' is central to any Caribbean narrative (Hall, S., 1991: 3).

Fanon has been crucial to our understanding of the internal traumas of identity which are associated with colonisation and enslavement. For colonisation is never only about the external processes and pressures of exploitation. It is always also about the ways in which colonised subjects internally collude with the objectification of the self produced by the coloniser (Fanon, 1986). The search for independence and the struggle for decolonisation, therefore, had to be premised on new identities. In the Caribbean the reinvention of Africa was crucial to this process as was a re-worked and syncretised Christianity. The Christianity of the missionaries was re-invented by slaves and emancipated peoples, utilising the story of the Exodus and the journey to freedom (Turner, 1982; Da Costa, 1993; Stewart, 1992). From the mayalism of the late eighteenth and nineteenth centuries to the Rastafarianism of the 1960s and after, black people in Jamaica decolonised their minds with the tools of the colonisers turned to new uses. As Stuart Hall puts it,

> What they felt was I have no voice, I have no history, I have come from a place to which I cannot go back and I have never seen. I used to speak a language which I can no longer speak, I had ancestors whom I cannot find, they worshipped gods whose names I do not know. Against this sense of profound rupture, the metaphors of a new kind of imposed religion can be reworked, can become a language in which a certain kind of history is retold, in which aspirations of liberation and freedom can be for the first time expressed, in which what I would call the imagined community of Africans can be symbolically reconstructed.
>
> (Hall, 1991: 10)

So out of the traditions and myths which were available new fictions and new histories were constructed, telling stories of new identities for men and women, enabling Caribbean peoples to recognise themselves as Africans and diasporised, as Indians and diasporised, imaginatively connected in complex ways to the histories of slavery and indenture, as well as colonisers who were also diasporised: all having made new identities in societies with no easy myth of origins, no simple way of defining who belonged and who did not, who was included, who excluded.

At a time when some are insisting that nations must only comprise one ethnicity, that they must be exclusive and racially pure, there is a vital alternative project which developments both in the Caribbean and Australia might help us to think through. That is to imagine a British 'post-nation' which is not ethnically pure, which is inclusive and culturally diverse. This necessarily involves a re-working of the history of Empire for the Empire has been central to the ways in which British national identities have been imagined and lived. It matters, therefore, how the Empire is remembered and what kind of historical work is done. A re-read, re-imagined imperial history, focusing on inter-dependence and mutuality as well as on the patterns of domination and subordination which are always inscribed in the relations between coloniser and colonised, might provide some resources from which new notions of twenty-first century British cultural

identities might be drawn. For cultural identities are always a construction, are never fixed or essential and new identities could draw on new repertoires.

There is an important task here for feminist and left historians. Some male left historians have found it difficult to establish new languages with the certainties of Marxism gone and with the impact of feminism and post-structuralism. They have lost their sense of the laws of history, the truth of their narratives, the conviction that class provides the key, 'the motor of history'. Feminist historians have been much less traumatised by these changes. They have been more open to theory, and necessarily had less investment in established narratives for their narratives have been built on critique. Yet neither group has been at the forefront of 'imperial history' in the last twenty years. Marxist historians combined a commitment to internationalism with a relatively benign view of the nation. So, for example, E. P. Thompson celebrated English traditions with all their in-built ethnocentrism (Thompson, 1967). Feminist historians have been too preoccupied with rewriting histories through gender or recovering women's worlds and have been very slow to respond to the black feminist critique which has insisted on the interconnections between the power relations of 'race' and gender and the implications of imperial history. But histories and historians have always been central to the project of constructing cultural and national identities. We need now to re-think what this agenda might be in the context of the end of Empire, decolonisation, and new patterns of migration and settlement.

RE-THINKING EMPIRE

One way of re-thinking the Empire in a post-colonial frame might be to focus on the inter-connections between the histories of 'metropolis' and 'peripheries' and refuse the simple binary of coloniser and colonised. As post-colonial theorists have argued, the projection of 'the other' is also always about repressed aspects of the self. Relations between coloniser and colonised are characterised by a deep ambivalence, 'the other' is both an object of desire and derision, of envy and contempt, with the coloniser simultaneously projecting and disavowing difference in an essentially contradictory way, asserting mastery but constantly finding it slipping away (Bhabha, 1983, 1994). Similarly, the political and institutional histories of 'the centre' and its outer circles may be more mutually constituted than we used to think. The retreat from grand narratives may have made us re-think totalities, we may not be able to map whole cultures and social formations in the ways that once seemed possible, but it might be important to think about connection and dependence as well as fragmentation and particularity.

The history of the extension of the suffrage in Britain, for example, has conventionally been told as the progressive inclusion of those once excluded, middle-class men, working-class men and eventually women. An examination of the different moments in that history reveals the ways in which the Empire served as a lens through which the specificities of the British nation with its unique constitution could be viewed, how the Empire framed the English imagination

and provided sets of ideas about the English in relation to colonial 'others'. Take the Parliamentary Reform Act of 1867, which enfranchised respectable working men and constituted a new subject, the working-class male citizen (Hall, C., 1994). The debates around the passing of this legislation, both inside and outside Parliament, provided a site for discussion as to who was to be included, who excluded, from the nation in its new moment of definition. Such boundaries were not set in stone, indeed they were no sooner established than they were challenged, particularly by the new women's suffrage groups which sought to reverse their exclusion from the franchise. Nevertheless, the 1867 Act marked a moment of closure, when some men were brought into the political community, others kept out, on lines associated with gender and class.

The debates as to who belonged to the nation in its new manifestation were framed by the Empire, for it was impossible to think of the 'mother country' with its specificities without thinking of the colonies. The colonies provided the benchmarks which allowed the English to determine what they did not want to be and who they thought they were. Through the construction of imagined others in Australia, in Ireland, in the ex-colony of the United States (America, as it was always called) and, most importantly, in Jamaica, the English reached a settlement as to who was to belong to the new nation. Property was no longer to be the basis of the suffrage, but gender, 'race' and the level of civilisation were now understood as determining forms of political belonging and citizenship. While Anglo-Saxon men with jobs, with families and with homes could claim the right to vote, women of the same 'race' could not. John Stuart Mill's attempt to amend the legislation to include women was roundly defeated after a short debate which contrasted sharply with the hours of discussion as to precisely which men were to be included.

At the same time, in the wake of the black rebellion at Morant Bay in Jamaica in 1865, the British Parliament followed the planters' abolition of their own representative institution, the House of Assembly, with the imposition of crown colony status on the island. In future Jamaica was to be ruled from London for the spectre of black self-government was too dangerous to contemplate. White men, 'Englishmen', as the Liberal mayor of Birmingham insisted, were 'essentially fitted by their nature to guide the government of the country'. Furthermore, they were 'adapted peculiarly for self-government', he believed (*Birmingham Daily Post*, 14 December 1865). These essential characteristics separated them from other 'races' and from women. Those who were opposed to reform believed that the example of the ex-American colonies and that of Australia, where something close to universal male suffrage existed, gave plentiful evidence as to the decline which went with such political forms. Robert Lowe, the eloquent protagonist of no change and one-time populist politician in New South Wales, evoked the horrors of the colonial experience to threaten the House of Commons with anarchy and the spectre of losing 'all that was dear to us as Englishmen' (Patchett-Martin, 1893: Hansard, vol. 182, cols. 147–148). Meanwhile those in favour of reform celebrated colonial democracy in support of their cause. For

John Bright, the acknowledged leader of the reform movement outside Parliament, the Anglo-Saxon race was one race across the Empire and it was a cause of shame that Englishmen in Canada or Australia could vote while Englishmen at home could not.

The interwoven chain of connections linking England, and what might have been thought of as its domestic politics, with Jamaica, Australia and other parts of the Empire can be seen at work also in the construction of what might be termed 'imperial identities'. Individual histories can be mapped across the Empire. The different theatres of Empire, the different colonial sites, constructed different possibilities. Metropolitan society, white settler societies, societies with non-white majority populations, each provided sites for the articulation of different relations of power, different subject positions, different cultural identities. White Englishmen were able to use the power of the colonial stage to disrupt the traditional class relations of their own country and enjoy new forms of direct power over subject peoples. Across the Empire, the construction of new gender orders was central to the project of 'civilising subjects', whether those subjects were slaves or emancipated black people in the Caribbean, or the convicts and settlers who displaced Aboriginal peoples in Australia. As 'imperial men' moved across those societies their own identities were ruptured, changed and differently articulated by place.

Take Edward John Eyre, explorer of Australia and Governor of Jamaica at the time of the Morant Bay rebellion, the man whose actions in suppressing the rebellion resulted in a blood bath and provoked a major controversy in the metropolis (Hall, C., 1995). Eyre was born in Yorkshire in 1816, the third son of a Rector. First destined for the army, he chose instead an imperial destiny in Australia 'which was just then beginning to be known . . . [as] a desirable field for a young man commencing life' and set out, aged seventeen, with a modest capital. As he later constructed it in his autobiography, his Australian adventures were to prove his manhood and make his mark. A child of the Evangelical revival, with its particular association of religious masculinity with independence, one of his first lessons was that 'a man must act' and he cherished the idea that soon he was to be his 'own master, free from all contracts and taking an independent position in life' (Eyre, 1984: vol. 1, 3; Davidoff and Hall, 1987).

But Australia was not England and his encounters with Aboriginal and convict society and with frontier life raised new questions and demanded different inflections. Running a sheep farm and working as an overlander taking stock to South Australia meant living without female service and Eyre had to learn to cook and sew on buttons as well as catching his own food and making his own wool. Living with convicts and 'natives' on whom he relied he constructed a defensive wall of English gentility and separated himself from what he saw as their rude ways and base instincts. All that they wanted was drink, while he had tasted of knowledge and the better things of life and could engage in scientific inquiry and reading. But at the same time Eyre knew that many of the convicts were trustworthy men and that his Aboriginal guides, on the explorations that he began to

undertake, had forms of knowledge without which he could not survive. He was shocked by the behaviour of some colonists, by the brutal treatment of convicts and the 'sport' of shooting 'dingos', as Aboriginal people were called. Thus the boundaries between coloniser and colonised were not secure, settlers might be more violent than 'natives' and 'civilisation' a less clear category than once thought. 'The simple kindness of the inhabitants of the wilds to Europeans . . . stand contrasted', he noted, 'with the treatment he experiences from them when they occupy his country, and dispossess him of his all' (Eyre, 1984: vol. 1, 224).

Eyre became strongly identified with paternalist policies towards Aboriginal people and was the first to serve as their official Protector in the new colony of South Australia. Hoping for an appointment from the Colonial Office he returned to England in 1845 and on his return journey wrote up the *Journals* of his travels, including a long appendix on the 'Manners and Customs of the Aborigines of Australia'. This text was firmly anchored within the humanitarian philanthropic discourse of the 1830s and 1840s, shaped by the antislavery movement, honed by the Australian experience. Eyre constructed the original inhabitants of the land as 'poor untutored children of impulse' who had been 'misjudged and misrepresented'. The task of enlightened Englishmen was to raise such people to a higher state of civilisation, educate them, provide for them, 'adopt a system which may at once administer to their wants, and at the same time give to us a controlling influence over them'. 'Englishmen', he fondly believed, 'have ever been ready to come forward to protect the weak, or the oppressed' (Eyre, 1984: 479, 458–459). He would do his best to persuade the English that this was how they should behave, that the task of settlers and officials was to enlighten and improve, that the colonial stage required control that was firm but kind rather than a theatre of cruelty.

Eyre was a 'somebody' in the Australian context: well known as an explorer, a master of lands and men. In the metropolis such colonial fame counted for little: Australia was a place for convicts and 'natives'. He found himself a small fish in a big pond, hoping for favours, looking for high appointments which were not forthcoming. Eventually he was sent to New Zealand as Lieutenant Governor of the South Island, and there he pursued an approach to the Maori which was similar to that which he had followed in Australia. In 1853 he returned to England, but the England that he returned to was a different place. The humanitarian discourses of the 1830s and 1840s, their agenda structured by the doctrine that black people were brothers and sisters who could be led to better ways by their kindly white elders, were in decline, displaced by the new language of racial difference (Knox, 1952; Stepan, 1982). The 'Indian Mutiny' of 1857 confirmed the English view that other 'races' could not be trusted.

It was on the stage of the British Caribbean that Eyre was to test his authority as a white man and re-think his vision of the family of man. Posted to St Vincent in 1854, Antigua in 1859 and Jamaica in 1861, Eyre encountered the freed black peoples of those islands with dismay. His zeal to improve the 'savage' Aboriginal and Maori peoples was rooted in an understanding of those peoples as 'children',

willing to learn, in danger of extinction because of the violence done to them by the European dispossession of their lands. In the Caribbean he met prosperous black people, with land bought with money they had earned, with skills, with businesses, even 'coloured' men who sat in representative institutions and engaged in government. These were not 'primitives'. They were men who claimed membership in the modern world, who demanded the right to property, respect and the vote. Faced with such demands Eyre's conception of black people began to change. The language of the white settlers which had offended him in Australia increasingly inflected his own. A harsh vocabulary of racial difference which emphasised the 'excitability' and dangerously 'primitive habits' of the African-Jamaican population dominated his imagination. The language of brotherhood disappeared and the fear now articulated was that black people would sink back into the barbarism from which they had been briefly lifted by their enforced enslavement and encounter with Europe. The assertion of established white authority, the insistence on a sharp distinction between the 'races', the notion of a beleaguered white community bound together by their common experiences in the colonies, experiences which people at home could not possibly understand, became his new common sense. The sentiments expressed in his early memorandum on the Aborigine, his respectful recognition of their separate and different culture, were abandoned in favour of a view of West Indian negroes as 'savages' and 'barbarians' without culture and unable to adapt to the requirements of civilisation. Mastery and control, by white men, were the only solution.

Given this construction of 'them' as utterly different from 'us', Eyre's panic at the events in Morant Bay in Jamaica in 1865, when a court-house riot threatened to become a rebellion, was hardly surprising. His assumption was that 'the blacks' had risen and that the massacre of white people would follow. Terrifying spectres filled his imagination – of Haiti, a successful slave rebellion where white people were driven from the island, and Cawnpore, when British men, women and children were tricked, trapped and brutally murdered. He responded by ordering in the troops and imposing martial law. The subsequent brutality became legendary and provoked a debate in England about colonial rule which shifted the terms of both governmental and popular thinking on questions of 'race'. Jamaicans, it became clear, were not black Anglo-Saxons (Semmel, 1962; Hall, C., 1992; Holt, 1992). Eyre as a young man in Australia, while never questioning white supremacy, had been inspired by the language of brotherhood and the universal family of man. His sympathies could sometimes lie with 'natives' and convicts rather than with other white settlers. As an older man in the Caribbean such rhetoric was deserted in favour of a more retrenched and defensive language of racial difference, a language which asserted new forms of authoritative white masculinity, and which attempted to draw different lines of demarcation between coloniser and colonised.

Different sites of Empire could then produce their subjects differently. Even the most seasoned abolitionists could forget their English liberalism when faced with white settler worlds or societies with black majority populations. R. W. Dale

was a prominent Congregationalist, the minister of the celebrated Carrs Lane Church in Birmingham, and a staunch Liberal. He was associated with abolitionist causes, from support for the Freedmans Associations in the aftermath of the American Civil War to the Birmingham Committee which was formed to raise critical questions as to Eyre's conduct in the aftermath of Morant Bay. Throughout his life he was an enthusiast for missionary work in the colonies. By the 1890s, when he visited Australia, his rhetoric had hardened in ways that were characteristic of England in the late nineteenth century. But Australia dramatically sharpened that process for there he encountered a society about to declare itself as white. 'White Australia' was the signature of the new state founded in 1900, a signature never spelt out in the United Kingdom for there was no significant non-white population there to be symbolically erased.

Dale's account of his Australian sojourn was written for the English and was predicated on the view that 'Englishmen' had much to learn from those other branches of their stock in the antipodes. Dale found a new energy there and believed that it was the most 'fearless and adventurous' of the English who had gone there. 'In these days', he argued, we have learned to appreciate the immense importance of race'. Australians 'are ourselves, but ourselves with a difference'. Those differences were healthy ones and the English needed some of that enthusiasm and moral excellence. Dale, who had served on numerous committees dealing with abolitionist causes, erased from his account the Aboriginal presence in Australia. He did not see aboriginal men and women as he travelled around the country and was shown the marvels of the land. 'Its peoples' for him were the European settlers. The racial question which troubled him concerned the labour which would be required to work the new territories of the North for he was aware that there was not sufficient white labour available.

> The descendants of the settlers who have gone out from England, Scotland, and Ireland may become a proud aristocracy, and may have their work done for them by inferior races. These new social and economic conditions if they arise . . . will greatly modify the national character . . . Will the high-tempered Australian people, with their splendid visions of the future greatness and glory of their country, consent to share the control of its legislation and its policy with races of weaker fibre and inheriting neither the ethical nor political traditions which inform the manners and which inspire the laws of the Australian commonwealth? . . . what is to happen if a half, or a third, or even a fourth of the inhabitants of a group of democratic states are refused all political rights?
>
> (Dale, 1899)

This rhetorical question from a radical nonconformist who had fought for the extension of the suffrage in Britain makes clear the extent to which raced thinking permeated Dale's mind. Supporting some rights for the oppressed from the metropolis was one thing, encountering a white society in danger of 'invasion' by 'inferior races' was quite another. Dale's metropolitan liberalism, always

underpinned (as liberalism was) by assumptions about the capacity of the English to improve and civilise others, crumbled with his colonial encounter. Always a prophet for his own people he returned from white Australia with a more determinedly white voice than he had ever had before (Dale, 1899: 28, 40–43, 209–210). Men were made white by the Empire in a way that was never articulated 'at home'.

A DIFFERENT WAY OF BELONGING

The post-colonial moment in Britain is the moment after Empire, when British identities have to be imagined anew, when 'we' are no longer the centre. A moment of potential, when 'we' could come to terms with the myth of homogeneity, when 'we' could recognise the inequalities associated with the different raced and gendered ways of belonging to the British nation/state, when 'we' could build a different kind of future which was inclusive rather than exclusive, when whiteness would not be a condition of belonging. History and memory are central to that process. Unpicking imperial histories, grasping the raced and gendered ways in which inter-connections and inter-dependencies have been played out, developing a more differentiated notion of power than that which focuses simply on coloniser and colonised, can have emancipatory potential. It is a history which involves recognition and the re-working of memory. A history which shows how fantasised constructions of homogeneous nations are constructed and the other possibilities which are always there. A history which is about difference, not homogeneity. In re-imagining the past and re-evaluating the relations of Empire 'we' can begin to understand the ties which bind the different peoples of contemporary Britain in a web of connections which have been mediated through power, the power of coloniser over colonised, that have never moved only from 'centre' to 'periphery', but rather have criss-crossed the globe.

NOTES

1 Thanks to Sally Alexander for drawing my attention to Hobsbawm's lecture and Steiner's article. The symposium on Cultural History organised by Bill Schwarz, Sally Alexander and myself in July 1994 has been very helpful to my thinking. A version of this paper was given at the Australian Historians Association Conference in Perth in September 1994.

REFERENCES

Homi K. Bhabha, 'Difference, Discrimination and the Discourse of Colonialism', in Francis Barker, Peter Hulme, Margaret Iverson and Diana Loxley (eds), *The Politics of Theory*, Colchester, University of Essex, 1983.
—— 'Of Mimicry and Man: The Ambivalence of Colonial Discourse', in Homi Bhabha, *The Location of Culture*, London & New York, Routledge, 1994.
Emilia Viotti Da Costa, *Crowns of Glory, Tears of Blood. The Demerara Slave Rebellion of 1823*, Oxford, Oxford University Press, 1993.

Leonore Davidoff and Catherine Hall, *Family Fortunes: Men and Women of the English Middle Class 1780–1850*, London, Hutchinson, 1987.

Edward John Eyre, *Autobiographical Narrative, 1832–39*, edited and with an introduction by Jill Waterhouse, Caliban, London, 1984; Edward John Eyre, *Journals of Expeditions of Discovery into Central Australia and Overland from Adelaide to King George's Sound in the Years 1840–41*, London, T. and W. Boone, 1845, 2 vols.

Franz Fanon, *Black Skins, White Masks*, Pluto Press, London, 1986.

Paul Gilroy, *There Ain't No Black in the Union Jack*, London, Hutchinson, 1987.

Catherine Hall, 'Competing Masculinities: Thomas Carlyle, John Stuart Mill and the Case of Governor Eyre', in Catherine Hall, *White, Male and Middle Class: Explorations in Feminism and History*, Cambridge, Polity, 1992.

—— 'Re-thinking Imperial History: The Reform Act of 1867', *New Left Review*, 208, December 1994.

—— 'Imperial Man: Edward Eyre in Australasia and the West Indies 1833–66', in Bill Schwarz (ed.), *The Expansion of England: Essays in the Cultural History of Race and Ethnicity*, London & New York, Routledge, 1995.

Stuart Hall, 'Myths of Caribbean identity', Walter Rodney Memorial Lecture, Centre for Caribbean Studies, Coventry, University of Warwick, 1991.

Eric J. Hobsbawm, 'The New Threat to History', *New York Review*, 15 December 1993.

—— *Age of Extremes. The Short Twentieth Century 1914–1991*, London, Michael Joseph, 1994.

Thomas C. Holt, *The Problem of Freedom: Race, Labor and Politics in Jamaica and Britain 1832–1938*, Baltimore, Johns Hopkins University Press, 1992.

Wayne Hudson and David Carter (eds), *The Republicanism Debate*, Kensington, New South Wales University Press, 1993.

Robert Knox, *The Races of Men: A Philosophical Inquiry into the Influence of Race over the Destinies of Nations*, 2nd ed., London, Henry Renshaw, 1952.

Toni Morrison, *Beloved*, London, Picador, 1988.

A. Patchett-Martin, *Life and Letters of the Right Honourable Robert Lowe Viscount Sherwood*, London, Longmans, Green and Co, 1893, 2 vols.

Bernard Semmel, *The Governor Eyre Controversy*, London, MacGibbon and Kee, 1962.

George Steiner, 'The Ancient Power of Myth, the Birth of Europa and Zeus's Kinship to Don Quixote, Sancho Panza and Laurel and Hardy. Can the New Europe Provide a Folklore to Match its Symbolic Past?' *Guardian*, 6 August 1994.

Nancy Stepan, *The Idea of Race in Science: Great Britain 1800–1960*, London, Macmillan, 1982.

Robert J Stewart, *Religion and Society in Post-emancipation Jamaica*, Knoxville, University of Tennessee Press, 1992.

E. P. Thompson, *The Making of the English Working Class*, Harmondsworth, Penguin, 1967.

Mary Turner, *Slaves and Missionaries: The Disintegration of Jamaican Slave Society 1787–1834*, Urbana, University of Illinois Press, 1982.

6

AFRICAN CITIES, HISTORICAL MEMORY AND STREET BUZZ

Alessandro Triulzi

Rumor divided by lies plus witnesses equals history

D. Boyles

In Zaire's Second Republic . . . talking politics was dangerous

B. Jewsiewicki

It has often been difficult to talk politics in Africa in the last thirty years, but not to do so has been impossible (Jewsievicki and Moniot 1988; Coulon and Martin 1991; Copans 1992). Politics has weighed too heavily on daily life, has had too strong a grip on society, and on the very consciousness of its citizens, for it not to be the cause of intense conflict and unappeased rancour. Against this excessive, invasive presence of politics in their institutions, economy and daily life, impoverished and alienated peoples have had only one means open to them to react and place a distance between themselves and authoritarian and despotic régimes: word of mouth. In the 1980s in particular, the darkest years for post-colonial Africa, 'politics' in the mass consciousness of Africans was not what their government or its opposition, legal or otherwise, appeared to be doing, but the constant 'hum and buzz', the whispered, disguised and derisory words of the street (Toulabor 1991; Yoka 1984; Ellis 1989; Kivilu 1988; Nkanga 1992).

It was the pavements, the squares, the village neighbourhoods and the run-down fringes of the city that elaborated and transmitted this new form of orality that I shall term 'urban': the word inscribed, drawn, on the walls of Mogadishu, the word spread by pavement radio in Kinshasa, the satirical word, traded like goods, in the market place of Lomé. This return of orality and its shift from the country to the city is one of the new signs of contemporary Africa and its strategies of identity. It is no longer the fixed, ennobled word of oral tradition, passed on by the *griots* and dynastic narrative-charters in the political power-centres of Africa, old and new. Rather, it is the living word, profane and multiform, of the new, urban generations of independent Africa.[1]

The various forms of oral transmission found in urban contexts and the spread of new multiple and bonding traditions make the contemporary African city a privileged site for observing the new representation codes of the 'post-colonial

78

situation' on the continent. In the words of the Senegalese singer-songwriter Youssou N'Dour who sings in Wolof, French and English, it is the cosmopolitan and polyglot city that is teaching the people in the villages how to dance.

> I am from the village
> These city people showed me
> how to dance . . .
> I have lost my goal
> I am turned around
> I have lost my soul
> I am upside down
> I was a country boy
> Now I'm a city man.[2]

It is, then, in the urban context and above all in the ex-colonial capitals of independent Africa that we need to identify the new texts that can pinpoint and communicate to us the essence of what A. Mbembe, historian of Cameroon, has defined as 'the post-colonial event' (Mbembe 1988: 12). By this he means the sum of events experienced by the native peoples after independence, which they are best equipped to recount or recite since they were 'witnesses, actors and sometimes victims.'

It is in the cities that political scientists, finding little formal politics, today seek traces of the interaction between governor and governed in 'unidentified political objects' (in jargon UPO). These are the verbal expressions of the political (most Africans think and talk about politics in vernacular languages and not those bequeathed by colonisation) and the politically relevant forms of non-verbal expression such as graffiti, 'popular art' or dance (Martin 1991: 59–161; Diouf 1992; Vail and White 1983).

Since the post-colonial cities, in their advancing state of decay, with their increasing violence and their mix of traditional and modern, are the new sites for the symbolic production of the 'post-colonial', it is there that we must look for the new urban rites and languages, the multiple memories and a rediscovered identity. These are not to be found in the 'traditional' culture, nor in the 'modern' one inherited from colonialism, but in the 'apparent chaos of the everyday', produced by a so-called informal economy: small traders, smuggling, recycling and all the numerous forms and means of urban survival. It is the world of barter and neighbourhood markets, peddlers, artisans, shoeshine boys and windscreen washers; all those 'for whom the arrival of the police is something to be feared'. There, African societies reveal not only their unruliness and 'pagan genius', but also the new symbols and constructed identities of their urbanised communities (Mbembe 1988: 106–107).

The attempt to trace a new grammar of urban communication in such hetero-geneous and differentiated contexts necessarily implies that we must discard two classic postulates of research into oral traditions. First, the organic connection between individual and collective memory, and secondly the reading of oral

sources as testimonies or 'traces', and not as 'interpretations', of what is narrated or represented.[3]

The starting points of this urban memory are, in fact, multiple and contradictory, as are its languages, symbolic representations and identity groupings.

The 'post-colonial' memory that I am trying to elicit here is not, therefore, the genetic and formalised memory of the post-colonial years but a contestatory memory, or better memories, based on aggregation/exclusion that have characterised the African political scene, particularly in the cities, since the late 1980s. In these years, 'post-colonial events', and their multiple interpretations by their actor-subjects, increasingly became the space into which new tales, new identities fixing and transmitting the 'rediscovered memory' of these events were projected.[4] Since the post-independent African state, as it has developed after 1960, has been essentially a 'theological State; that is, one that officially announces and interprets revealed truths' (Mbembe 1988: 13), the birth of new histories and the creation of new memories are, furthermore, seen as fundamentally 'heretic', being rooted in individual and group identities that no longer recognise themselves in the Great Tale of the unified Nation-State.

Here lies the importance of studying and re-evaluating the various forms of the so-called 'revenge' of African societies following their 'withdrawal' during the continent's darkest years (Bayart, Mbembe and Toulabor 1992: 65–125), by examining their manifestly 'pagan modalities' in the face of state structures so 'total' in character: 'to rethink through these the whole series of relationships between political domination and symbolic insubordination' (Mbembe 1988: 13). In this context of institutional crisis, and the wider crisis that involves national historiographies themselves, new battlegrounds open up for the clashes between official traditions and group memories, between social praxis and the building of identities, that in some way restore to post-colonial society a negotiating power that was earlier supplanted or removed. Its recovery is part of that 'revenge' on the State.

The post-colonial African city is the symbolic site of this clash. The second half of the twentieth century has seen the greatest demographic explosion in the history of humankind. Between 1950 and 1985 the world population trebled overall, while quadrupling in developing countries. By 2015 half of the 'Third World' population will be living in cities and already today the population of many African cities, such as Nairobi, Dar es Salaam, Lagos, Lusaka and Kinshasa, has multiplied sevenfold (UNDP 1992–1993; UNFPA 1993). Forty per cent of today's African population lives in cities. The question then is: what kind of cities?

It is well-known that, in contemporary Africa's structural and productive crisis, the urban and social fabrics are under severe strain, and the ceaseless human flow from the country to the city has transferred the greater burden of poverty and environmental degradation to urban areas. There is on the African continent an increasing urbanisation of poverty, indicated by high unemployment, housing shortages, inadequate road grids and sanitation and an

ever-diminishing investment in social services. This was particularly acute in the 1980s as a result of the 'structural adjustment' measures imposed by the World Bank as part of debt repayment plans.

The urban poor (the majority being recent immigrant youths under 30 and many single women, some with children) predominate in the city population, crowded into suburbs and shanty towns which generally lack essential services. The congestion in their living spaces is such that only one urbanised family in nine finds regular accommodation (in Kumasi, Ghana, three out of four families have one room to live in); the rest live by improvising survival systems, sometimes taking turns with others to use the same living space, sometimes illegally occupying other land or spaces not recognised as habitable and so contributing to the further environmental and sanitary degradation of the city (Balbo 1992).

In this context, the African city becomes the visual symbol of post-colonialism, both meeting place and battleground for two opposed worlds, with their contrasting features: power and impotence, poverty and ease, new immigrants and old inhabitants, centre and fringe.

It must be remembered that the contemporary African city is, by definition, the visual space of the political. It is also the 'site of memory' of colonisation, with its divisions (the colonial city was conceived and grew opposite to and separate from the native town), its visible remains (buildings, town plans, statues) and its obligatory 'synthesis' of tradition and modernity (Coquery-Vidrovitch 1992). The post-colonial city is, then, *the* site for the challenge to the political and at the same time the locality for negotiation and agreement where new freedoms, new services, autonomous spaces and the delegation of previously centralised powers can be gained.

But it is also the space for the migration and refuge of ever larger numbers 'banished' by hunger and/or the dismantling of agricultural production in a rural economy no longer able to sustain an excessive population. Today's urban Africans are no longer 'strangers in the city' as they were called in colonial literature: frightened peasants in an environment not their own, that was not *for* them who were passing through. Now most of them are born in the city or have adapted to it and redefined their own role in the urban context, elaborating new ways of survival, new forms of communication and connection.

It is in this polymorphous and apparently chaotic post-colonial city that we need to search for the new 'rules of chaos' and seek the signs and new codes of expression of these urban identities in formation. In particular, we must find the 'generative, recitative and iconic texts' that give them life and reconstruct their grammar, identify their narrative structure and analyse its connections to power (Jewsievicki and Létournean 1992).

I shall now examine some of the urban texts that seem to me indicative of the new 'post-colonial memory'. Like every collective memory these texts constitute 'a production of sense that belongs to the field of politics'. Therefore, they prescribe 'a semantic code of memorisation' of facts, events and 'sites of memory' that link the past to the present; but beyond that, they produce 'both a

communal illusion of power and powerful effects of exclusion for those who do not share in this memory' (Jewsievicki 1991a: 59).

The *Set/Setal*, a movement made up of youths and the unemployed which emerged in Dakar's poorer districts at the end of the 1980s, has both made formal protests against the urban decay of the most impoverished areas of Senegal's capital and challenged the moral and political behaviour of the power élites at a symbolic level.[5] A local movement centred around *le coin*, the neighbourhood, and born in the wake of the prolonged student demonstrations of 1987–1988 against the government policy of spending cuts (in education, health, and urban renewal) and the increasing pauperisation of society, *Set/Setal*'s protests range from holding collective clean-up days to iconography in the form of murals drawing attention to issues such as urban space and questioning the formal values left behind by French colonisation. Their graffiti is a 'representational form of painting' and reflects a historical memory whose connection with the nationalist memory of independence has been severed. So they call for a 'reorganisation/ recomposition of the historical patrimony' of the nation (Diouf 1992: 41–44).

The wall paintings of Dakar, iconic in type, recall figures from everyday life or popular and symbolic neighbourhood characters: a footballer, a historical figure from the anti-colonial resistance, an Islamic leader or *marabout*, a film star. These wall paintings often have no 'text'; they and their comments are left to free interpretation, 'sanctioned' by the neighbourhood. Thus, the *Set/Setal* is at the same time a 'deconstruction' of the nationalist memory with its 'one tale' and a 'reconstitution of identity' that explicitly rejects the formal and aesthetic canons of Senghor's État-Nation. Through the urban graffiti of Dakar a new 'urban culture' is finding expression, offering a new aesthetic of the city and a new history.

The 'talking walls' of Dakar express new idioms and styles of communication; further, they offer an aesthetic that has consciously broken with the French tradition of the *beaux-arts* (colonial statues have been replaced by constructions composed of coloured car tyres). They urge a shift to root values that reflect the economic base of the neighbourhood: the use of scrap objects made of steel and their mixing with the sculpted tree trunks and hollowed-out pumpkins used in rituals. They depict the new urban 'heroes', no longer selected by the nation, but chosen by the neighbourhood. Streets and meeting places are named after local characters, well-known or successful personalities.

Set/Setal offers, then, a pluralist and hybrid culture that fuses World Music with tradition, 'fast food' culture with protest. Through the heterogeneity of symbols and languages, new life is given to a true 'mixage' of plural histories while the national/local history debate reveals the new urban imaginary of this 'generation of adjustment'. So, 'history and the city become the locus for the building of identity and a memory suited to the economic and social crisis and moulded by it' (Diouf 1992: 41–54).

The example of Dakar is not unique. The revolt of the urban edges of the post-colonial city is manifested not only in decay and breakdown, if not armed

violence, but also in new forms of solidarity and resistance, and in a new symbolic expression of protest against governors and politicians, from Mogadishu to Nairobi, from Kinshasa to Lomé. Mogadishu still lies trapped in a clan war that, in a few months, devastated the entire cityscape of this ex-colonial capital. From the moment the conflict began, wall posters appeared mocking the hated régime: rabid dogs with red berets (the symbol of the Presidential Guard) surrounding the dictator Siyaad Barre, his family depicted as 'vampires dripping blood'. These wall posters were everywhere, but most concentrated around the hotel headquarters of the United Somali Congress, the party that inspired the new and no less fierce 'warlords'. Thus, though the graphic style may be 'naïf', the message and the captions reveal an anger long repressed and show that people 'for the first time are not afraid to express their ideas'.[6]

In Mogadishu the political current has a clearly anti-Presidential tinge, challenging the twenty-year-long glorification, via spoken word and wall poster, of the Socialist Trinity 'jaalle Markis, jaalle Lenin, jaalle Siyaad' (*jaalle* is Somalia's 'comrade').[7] In post-colonial Nairobi, by contrast, the revolt of the suburbs is expressed by unemployed youths in symbolic and behavioural forms that are closer to those of Newcastle 'mods' and 'skinheads' than to those of *mooriyaan*, the armed street youths of Mogadishu.[8] The young Luo from Kaloleni Estate, a Nairobi suburb, divide into *wazuri* (Swahili for 'good') and *wakori* (Swahili for 'bad'), each adopting contrasting linguistic styles and symbolically different group names (the 'good' choose names of football teams such as Benfica or Black Santos, while the 'bad' choose more evidently political names such as Biafra or Black Power). The very choice of the name *wakori*, 'bad', is a symbolic one that, in its ambiguity, seems to carry differentiated messages: 'We are bad according to conventional standards of good and bad but if you accept us as we are, we won't bother you – we will be good' (Frederiksen 1991: 234).

These are new symbolic and behavioural modes, but they also involve a demarcation of new territories and languages of identification. It is a development involving new 'identities', a recomposing of the self, by re-proposing texts and paths that are strictly linked to urban hardship and discontent. This is exemplified in a graffito on the wall of a church in Pumwani in the suburbs of Nairobi, recorded by the Kenyan writer Thomas Akare in *The Slums*:

> Vietnam . . . El Fatah, Black September, Ku Klux Klan, Black Panthers, Fu Manchu, Black Sunday, Dracula, The Suicide Commando, CIA, FBI, Peace-makers, Harlem, Black Ghetto.
>
> (Akare 1981: 6)

The bizarre, compound list goes on, and Eddy, hero of Akare's novel, an illegal car washer in the Nairobi slums, from his neighbourhood hang-out (significantly named Katanga), fails to understand 'to whom the names belong' (Akare 1981: 7). And yet, as Bodil Frederiksen comments, they speak:

The text is written on a wall – it is writing on the wall: a warning. But a writing on a wall also means that the city speaks, or that the city is a text which can be read. It is difficult to understand – the city is difficult to understand . . . It certainly connotes militancy, solidarity and resistance – Viet Nam, Black Power, Harlem – but also marginality. The objective lack of power is dreamed away in grandiose fantasies of crime and subversion: Ku Klux Klan, Black September, Dracula.

(Frederiksen 1991: 235)

Many names, many identities. The fluidity of Nairobi's urban culture is an example. By definition a colonial city, Nairobi after independence swiftly filled with the lumpenproletariat, peasants stripped of their land, women without husbands, youths seeking their first job, Africans returning to the city after the state of emergency and the British repression that followed the Mau Mau revolt of the 1950s.[9] In this heterogeneous and multi-ethnic context, ethnic and group identification came to resemble the fluid, shifting choices of the informal economy. They involve choices for survival; more choices of necessity than indications of preference.[10] Signs of recognition and identification codes are, therefore, changing, and with them, claims for identity, belonging or exclusion. It is to these multiple and varied identities that the church walls are talking in Pumwani, home of the 'two-shilling boys', children of the prostitution and urban decay of Nairobi.

But other, more dispersed and anonymous texts exist, marked by the 'culture of silence and fear' that prevailed in Africa in the 1980s (Toulabor 1991: 136). These texts first circulated within the closed circles of orality but, over time, have played an important part in the symbolic challenging of power: the rumours, voices, gossip and street talk came to be a weapon of destabilisation and to challenge the government's 'absent information'.[11] In the Mogadishu of Siyaad Barre, as Nuruddin Farah recounts:

People talked and said a lot of things. The politics of mystification rendered rumours credible. Nothing was ever confirmed. Nobody knew what had happened to and become of so-and-so. The politics of mystification kept everybody at bay. People were kept in their separate compartments of ignorance about what happened to other people and what became of other things.

(Nuruddin 1980: 196)

The post-colonial city is a disinformed city. The 'public' news, in the absence of any information worthy of the name, is the free comment of the street that replaces what the government releases. Pavement radio, 'radio trottoir' or sometimes *télé-guele*, is the self-defence system found in every authoritarian régime. Its function is to gather and transmit the voices, gossip and rumour of the street and to challenge, sometimes complete or even replace, the information released by the notoriously reticent or silent government media.[12] Pavement radio, like urban graffiti, is an elusive system of information that develops in anomie, but it

is its very imponderability that reinforces its mythical character and strengthens its impact on the collective conscience (Yoka 1984: 156). In this sense, the street rumours are a popular tale, a symbolic narration and interpretation of everyday events. They help people define the undefinable. They give expression to a fear, or meaning to a crowd (White 1974: 135–137).

The 'inauthenticity' of street information is, in the context of the imponderable African city and its official information system, absolutely irrelevant. Pavement radio is a typical product of an anomalous urban context, where the informal economy of orality fills an empty space, responds to a widespread need and substitutes a non-existent information system with an 'informal one of parallel information' (Yoka 1984: 155). That is why its ideal environment is the streets, markets and places where people meet and communicate. It is here that its texts spread as they are repeated and then sent and expanded along an open chain of transmission.

Pavement radio is the modern form of oral tradition, its street version. At a time when oral history is weakened by the politicising of the powerful, popular 'oral discourse', with its continual commenting on those in power, continues to grow in the cities of the continent. Pavement radio should be seen in the light of oral tradition and treated as a descendant of the more formal oral histories and genealogies associated with ruling dynasties and national rituals. Just as those older oral histories enshrined national constitutions, with king-makers, priests or others able to pronounce upon the legitimacy of royal claims and actions, so does pavement radio as its modern equivalent. For the poor and the powerless, pavement radio is a means of self-defence (Ellis 1989: 329).

As with oral tradition, pavement radio crosses the traditional space between producer and consumer, between announcer and listener. No one can be singled out as the initiator of a rumour, everyone involved is a necessary relay point in mouth-to-ear communication; everyone is at the same moment repeating, communicating and transforming. Indeed, it is in the very transformation of the message that its cathartic force lies. At every stage of the communication, every repeater, consciously or unconsciously, loads the message with his own anxieties, expectations or disappointments. Pavement radio draws modules and themes from oral tradition, follows channels and models, enriches itself with formulae and elements from myth, transmits clichés and stereotypes and the picaresque element of the popular imaginary on which it feeds. It propagates the judgements of the community it serves on the events it considers important. And so these pavement rumours, as they are spread, assume new meanings, reflecting the expectations, fears and protests of the man in the street. It is the 'pipe-dream rumour' of the unfulfilled dreams of the ordinary citizen (Nkanga 1992: 5).

For all these reasons, *radio-trottoir*, although an uncontrolled system of counter-information, spreads its message more rapidly and more widely than the government's. It is indeed more 'democratic': gossip or rumours spread only if judged interesting, credible or worthy of repetition by a significant number of people. For this:

Politicians and news managers may disagree, but the African public reserves the right to decide what is interesting and important. This can make pavement radio highly subversive.

(Ellis 1989: 323)

Thus, as D. N. Nkanga notes, in Zaire and Gabon, political leaders spend a considerable amount of time in their public appearances denying information which, though never released officially, by the authorities, is being debated widely by the people:

In this case there is an opposition between the private facts, hidden by the official aspects of any political decision, and the public representation. The public plays a game of searching for the reality that does not seem to exist in the official version.

(Nkanga 1992: 8)

The result is the paradoxical situation often found in Nairobi and described by Ahmed Rajad, where (private) rumours and (public) warnings clash around an 'unidentified political object':

You rise with rumours and go to bed with rumours. In between you read the dailies. Banner headlines on the front page deny the main rumour. Down the page 'rumour-mongers' are warned. As always the reports never question the existence of this species.

(Ahmed Rajad 1984: 25–29)

Once more, the submerged text of street buzz covers the official text and annuls it. This is perhaps why nothing in Africa is more subversive than the street tam-tam, the *télé-guele*. In September 1984, a *coup d'état* failed in Yaoundé (Cameroon). In the obstinate government silence that followed, rumours filled this information vacuum. The alarmed head of state, President Paul Bya, in person, warned his fellow citizens against those spreading unchecked rumours:

As for truth, many of you confuse it with rumours. But rumour is not the truth. Truths come from above; rumour comes from below. Rumour is created in unknown places, then spread by thoughtless and often malicious people, people who want to give themselves a spurious importance. Cameroonians, pay no heed to the rumours which are spreading in the country.

(Ellis 1989: 325)

Indeed, rumours do come 'from below'. That is why they are dangerous, and are not to be confused with 'high' truth. It is for this reason that artists and con-temporary composers draw on 'rumour-texts' for inspiration for their creative work. Urban artists and singer-songwriters help to spread and further 'consecrate' the so-called 'popular' or street imaginary; its convictions and its 'truth' as well as its utopias.[13] A song, titled in the Ki-kongo language 'Tuba-Tuba' (literally

'talk-talk' but also 'talk bad'), by Lwambo Makiadi from Zaire, proclaims the power of *radio-trottoir* and the so-called 'wicked' *radoteurs* (literally 'inane' from *'radoter'*, to rave, repeat senselessly). 'Tuba-tuba', in fact, warns against the politicians' disabling use of informal systems of transmitting news through controlled information leaks, so as to have a foretaste of reaction on the street (Nkanga 1992: 5).

In General Siyaad Barre's Mogadishu, Loyaan, the tormented intellectual in *Sweet and Sour Milk*, has this to say about public rumours:

> No information was released until a rumour had been published, and nothing was made official until the General's informants had reported back the mood, the feeling of the general public. If the action was unpopular, one heard an unconfirmed report that so many persons of that tribe, or that class of people, or that pressure group had been imprisoned. The papers didn't carry the news, the radio neither.
>
> (Nuruddin 1980: 196)

In the absence of freely accessible public information, the transmission of 'free' rumours depends on the receiving-transmitting public. This is what makes pavement radio like the informal economy of the street: both are products of need, both are rooted in the immediate and everyday, both directly reflect the ambiguous nature of the governor–governed opposition. Rumour is a representation of the nature of power relationships that exists between people who control everything, including the media, and those who are restricted to word of mouth, whose mode of transmission is from mouth to ear (Nkanga 1992: 8).

In Zaire, where a vigorous painting tradition goes back to colonial times, 'popular' painting joins pavement radio in representing the immediate. The city painters studied by S. Vogel 'function like *radio-trottoir* . . . Urban artists and their publics see themselves suspended in their own time . . . continually inventing themselves and their culture by drawing on the here and now' (Vogel and Ebong 1991: 128). That is why Chéri Samba's city-inspired paintings were 'the centre of every conversation in Kinshasa at the time' (Jewsiewicki 1991: 135). Through the pot-holed road in 'La rue des Lacs', the children blowing up used condoms and throwing them in front of the hotel-bordello in 'Les capots utilisés', Samba denounced the city's decay and the apathy of its people. The urban artist, like the rural sculptor:

> resembles the jazz musician: he develops a theme without pretending to exhaust it. Neither the painting nor the performance is an attempt to surprise its public; instead, it recreates what everyone already knows, and invites the participation of all present . . .
>
> (Jewsiewicki 1991: 130)

If pavement radio is the logical consequence of the government monopoly on information and the absence of real political debate, then political derision, irony and caricature are other ways of challenging 'official political adulation' in the

post-colonial world. There, too, a number of modes of behaviour and orally spread texts contribute to the symbolic destabilisation of power. The ambiguity of political satire is well-known: reactions of escape and disguise for some, an act of awareness for others. The base language of political derision is 'hermetic, clandestine, trivial . . . In contrast to "compact" official discourse, political derision is scattered over social space.' Yet, for Toulabor:

> It circulates parallel and perpendicular to the official Word of nation-building. Running parallel, it re-translates or recovers official terms, giving them different meanings. Perpendicular, it pierces right through the official word, radically opposing it.
>
> (Toulabor 1992: 127)

The President of Togo, Eyadéma, and his government, studied over a decade by the French researcher Comi Toulabor in Lomé, were subjected to a volley of phrases of false praise and distorted meanings of the political slogans of the official single party, the '*Rassemblement du Peuple Togolais*' (RPT). On the street the RPT became the *Rassemblement des Profiteurs Togolais* and the term in the Ewe language *fiohawo* 'administration' became *fihawo*, an 'association of thieves'.

The President himself did not escape the arrows of satire. Exploiting the semiotic flexibility of the Ewe tongue, the man proclaimed in hagiographies as 'the father of the nation', 'older brother' and 'Guide of the People' is transformed, through the assonance of the name of his ethnic group Kabye (pronounced *kable* in Ewe) and that for 'gorilla' (*kabli*), into 'Great Ape' or 'Governor Gorilla'. Even the sexual attributes of the President, exaggerated to mask a widely suspected impotence, are the object of derisory comment: the 'Helmsman of the Nation' becomes the 'Bull of the Nation'. The 'Black Christ of Pya' from the name of the President's home village is represented on the walls of Bé, the poor neighbourhood nicknamed Soweto for its notorious rejection of the government, in graffiti and obscene drawings as 'No. 1 in the hit-parade of crime, vice and violence' (Toulabor 1991: 138).

On the walls of Lomé, as in the streets of Dakar or the suburbs of Nairobi, it is the 'libidinal economy' (Bayart 1989) of post-colonial governments that is laid bare by these ambiguous and polymorphous texts. Decoding them is not easy for the outsider. It must be remembered that even the avid readers and listeners of these texts have to work hard over their interpretation. These texts of political derision that *radio-trottoirs* carry from mouth to ear, and which the 'perfidious graffiti' of Lomé visually immortalise, are not sophisticated irony or affected satire; most importantly, they helped to spread the new consciousness that accompanied and helped to sustain the 'revenge' of African societies on the state at the end of the 1980s.

That is why, if President Eyadéma is still in power in Lomé, it is important that in the same city, from the riotous neighbourhood of Bé-Soweto to the GML (the department store of the capital), meeting places have become in Toulabor's words:

like a political tribunal where amusing stories are put up for sale, puns are traded like stocks and bonds, information is bartered for gossip and vice-versa.

(Toulabor 1991: 137)

So, wall drawings and the buzz of the street merge in an anti-institutional stand in the degraded post-colonial capitals of the African continent. The new texts of urban orality, so often unintelligible to the post-colonial political class, are not really oppositional texts; nor do they suggest a move to seize power. They do, however, demand recognition and represent, in a sense, a real political challenge to power in the 1990s:

il me semble raisonnable de supposer que les modes populaires d'action politique visent surtout à imposer au pouvoir la reconnaissance de leur existence, et donc une négotiation politique.

(Jewsiewicki and Moniot 1988: v)

It was these texts that in the last decade openly displayed the anxieties, disappointments and expectations of many streets and neighbourhoods in Africa. They also revealed a new political presence in the ever more crowded metropolises of our time. It is crucial that they can continue to do so.

NOTES

1 A wide literature exists on the political legitimation of the oral tradition. As S. Bayagogo (1992: 37) writes on Mali:

Bards, singers, but above all advisers of princes, the greatest of them carry on their old work today, with the same effectiveness, for the rulers of the State . . . What emerges is not history . . . but histories of clans and princely lineages . . . a representation-legitimation, and therefore an explication of political theories as they have been historically demonstrated. This selective memory and praising of past events have served to hold together the contradictions that caused schisms throughout the history of Mali.

See also Hale (1990: 1–16); Okpewho (1990: 1–20).
2 From 'Country Boy', *Xippi, Eyes Open*, CD, Dakar, 1992.
3 Much has been written on these two postulates. On the first, see Dakhlia (1992: 73–83); Okpewho (1990: 160–184); Hale (1990). On the second, see Jewsiewicki and Létourneau (1992: Introduction); Vansina (1985, 1986: 105–110).
4 For an effective summary of similar processes in Eastern Europe, see A. Brossat *et al.* (1990).
5 *Set/Setal* in Wolof means simply 'clean, clean up'. The movement's name comes from the song of the same name by Youssou N'Dour. Listen to Youssou N'Dour *Set*, Productions Saprom, Dakar. On the Dakar movement, see Bugnicourt and Diallo (1990); Diouf (1992).
6 See Hassan (1993: 52). He writes of the many clandestine leaflets circulated after July 1989: 'the walls of the city are painted with offensive drawings like those of Barre about to eat a new-born infant in a bath filled with blood'.
7 The exalting of the trilogy of Marx, Lenin and the head of the 'Socialist government'

was not restricted to Somalia's autocratic régime. See Lewis (1989) on this point.

8 Marchal (1993: 295–320) makes some interesting points in his essay on the *mooriyaan* of Mogadishu.

9 On the growth of Nairobi and the 'moral economy' of Kikuyu society that inspired the Mau Mau revolt and dictates the historical memory, see Berman and Lonsdale (1992: vol. 2).

10 This term is used by Stuart Hall: see his essay in this volume.

11 A growing body of literature exists on this theme. See Rosnow (1974) and Scott (1990).

12 On 'pavement radio' in Africa, see Keita (1986); Kivilu (1988); Ellis (1989); Nkanga 1992.

13 Many scholars have pointed out the ambiguity of the term 'popular'. For Vogel, 'In the context of African art, the name "popular" causes immediate confusion' (Vogel and Ebong 1991: 128). Jewsiewicki is more circumspect:

> il faut reconnaitre qu'en faisant du populaire un objet de notre connaissance et en le couchant par écrit – donc en le rationalisant – nous l'inventons . . . A l'encontre du rêve populiste, il s'avère que le populaire n'est ni plus honnête que l'institutionnel; l'inégalité, l'avantage et le profit s'y ajoutent autrement et s'y maintiennent en suivant des voies spécifiques. Il faut en être conscient pour éviter d'investir le populaire de nos utopies.
>
> (Jewsiewicki and Moniot 1988: iii)

REFERENCES

Ahmed, R. (1984) 'Rumours, Threats and Sackings in the Press', *Index on Censorship*, 1.

Akare, T. (1981) *The Slums*, London: Heinemann.

Bagayogo, S. (1992) 'Littérature orale et légitimation politique au Mali 1960–1990', in Jewsiewicki and Létourneau (1992).

Balbo, M. (1992) *Povera grande città. L'urbanizzazione nel Terzo Mondo*, Milan: Angeli.

Bayart, J. F. (1989) *L'État en Afrique. La politique du ventre*, Paris: Fayart.

Bayart, J. F., Mbembe, V. and Toulabor, C. (1992) *La politique par le bas en Afrique noire*, Paris: Karthala.

Berman, B. and Lonsdale, J. (1992) *Unhappy Valley. Conflict in Kenya & Africa, Book 2: Violence and Ethnicity*, London: Currey.

Brossat, A. *et al.* (1990) À l'Est la mémoire retrouvée, Paris: Le Découverte.

Bugnicourt, J. and Diallo, A. (eds) (1990) *Set: Des murs qui parlent. Nouvelle culture urbaine à Dakar*, Dakar: Enda.

Copans, J. (ed.) (1992) 'L'histoire face au politique', *Politique Africaine*, 46.

Coquery-Vidrovitch, C. (1992) 'The Process of Urbanization in Sub-Saharan Africa', Occasional Paper No. 5, Roskilde University, Institute for Development Studies.

Coulon, C. and Martin, D. C. (eds) (1991) *Les Afriques politiques*, Paris: La Découverte.

Dakhlia, J. (1992) 'L'historien pris au piège de la mémoire?', in Jewsiewicki and Létourneau (1992).

Diouf, M. 1992: 'Fresques murales et écriture de l'histoire. Le Set/Setal à Dakar', in Copans (1992).

Ellis, S. (1989) 'Tuning in to Pavement Radio', *African Affairs*, 88.

Frederiksen, B. (1991) 'City Life and City Texts', in P. Kaarsholm (ed.), *Cultural Struggle and Development in Southern Africa*, London: Currey.

Hale, T. (1990) *Scribe, Griot and Novelist. Narrative Interpreters of the Songhai Empire*, Gainesville: University of Florida.

Hassan, O. A. (1993) *Morire a Mogadiscio. Diario di guerra*, Rome: Iscos.

Jewsiewicki, B. and Moniot, H. (eds) (1988) *Dialoguer avec le léopard? Pratiques, savoirs et actes du peuple face au politique en Afrique contemporaine*, Paris: Harmattan.

Jewsiewicki, B. (1991) 'Painting in Zaire; From the Invention of the West to the Representation of the Social Self', in Vogel and Ebong (1991).

Jewsiewicki, B. and Létourneau, J. (1992) *Constructions identitaires: questionnements théoriques et études de cas*, Actes du Célat No. 6, Québec: Université Laval.

Keita, T. (1986) 'Radio-trottoir', *Index on Censorship*, 15.

Kivilu, S. (1988) 'La radio-trottoir dans l'exercice du pouvoir politique au Zaire', in Jewsiewicki and Moniot (1988).

Lewis, I. (1989) 'The Ogaden and the Fragility of Somali Segmentary Nationalism', *African Affairs*, 88.

Marchal, R. (1993) 'Les *mooriyaan* de Mogadiscio. Formes de la violence dans un espace urbain en guerre', *Cahiers d'Études Africaines*, 130.

Martin, D. C. (1991) 'Les cultures politiques', in Coulon and Martin (1991).

Mbembe, A. (1988) *Les Afriques indociles, Christianisme, pouvoir et État en société postcoloniale*, Paris: Karthala.

Nkanga, D. M. (1992) 'Radio-trottoir in Central Africa', *Passages*, 4.

Nuruddin, F. (1972) *Sweet and Sour Milk*, London: Heinemann.

Okpewho, I. (ed.) (1990) *The Oral Performance in Africa*, Ibadan: Spectrum Books Ltd.

Rosnow, R. (1974) 'On Rumour', *Journal of Communication*, 24.

Scott, J. C. (1990) *Domination and the Arts of Resistance*, New Haven: Yale University Press.

Toulabor, C. (1991) 'La dérision politique en liberté au Mali', *Politique africaine*, 43.

Toulabor, C. (1992) 'Jeu de mots, jeu de vilains', in Bayart, Mbembe and Toulabor (1992).

UNDP (1992–1993) *Rapporto sullo sviluppo umano* (Rapporto annuale a cura del Programma per lo Sviluppo delle Nazioni Unite), vols. 1–3, Turin: Rosenberg & Sellier.

UNFPA (1993) 'Lo stato della popolazione mondiale' (Rapporto annuale del Fondo per la Popolazione delle Nazioni Unite), Rome: Associazione Italiana Popolazione e Sviluppo.

Vail, L. and White, L. (1983) 'Forms of resistance; Songs and Perceptions of Power in Colonial Mozambique', *American Historical Review*, 88.

Vansina, J. (1985) *Oral Tradition as History*, London: Currey.

Vansina, J. (1988) 'Afterthought on the Historiography of Oral Tradition', in Jewsiewicki and Moniot (1988).

Vogel, S. and Ebong, I. (1991) *African Explorers. Twentieth Century African Art*, New York: Center for African Art.

White, D. (1974) 'The Power of Rumour', *New Society*, 30.

Yoka, L. M. (1984) 'Radio-trottoir/discours camouflé', *Le Mois en Afrique*, October–November.

7

IRISHNESS – FEMINIST AND POST-COLONIAL

Wanda Balzano

Irishism (Roget) paradox sophism equivocation nonsense untruth error lapse lapsus linguae
Woman (Aristotle/Aquinas/Freud/Lacan) defect lack absence lapse lapsus linguae
Identity tautology id-entity non-entity in-sense non-sense ab-sense sense absconded

<div align="right">Ailbhe Smyth</div>

An ancient Celtic legend tells of a woman who dared to look into the depths of a forbidden well. The water rose up out of the well and covered her, giving birth to a stream that made the earth fruitful (Smyth 1989[a]). The metaphor is clear: woman is not permitted to examine her own depths, to draw freely on the source of her own imagination. Creative expression, intimately connected to that source, is severely forbidden; the punishment for disobedience is absolute: certain annihilation by the patriarchal flow.

For Irish women the attempt to (re)discover their feminine identity has been overshadowed not only by the dictates of patriarchy but also by the 'otherness' of Ireland. The anonymity of the feminine; that is, the difficulty of defining themselves as women, has been further complicated by a national history of colonisation, deprivation and struggle.

As Ashis Nandy's critical model has shown, a history of colonisation is one of feminisation (Nandy 1983). Colonial power tends to identify subject people as passive, in need of guidance, incapable of governing themselves, romantic, passionate, having a disregard for rules, barbaric. For all of these characteristics the Irish on one hand and women on the other have traditionally been both praised and scorned. Retaining the image of the relationship between Great Britain and Ireland as one between masculine and feminine, the metaphors most frequently used have been those of robbery and rape.

Further, it was the Irish poets themselves, above all in the era of romantic nationalism, who reified woman in their works, likening her to Ireland and thus celebrating the rebirth of a nation defeated, but reborn with the face of a woman

dreamed of in eternity: Dark Rosaleen, Cathleen Nì Houlihan. The nation as woman, the woman as nation. And so the female population of Ireland has increasingly merged with the passive projection of Irishness: purely ornamental, a rhetorical element rather than an existing reality. National Sybil or fictional queen.

The reification of such an abstract concept has been the main cause of the 'invisibility' of Irish women: women rendered invisible, like personal and national colonies. Linda Anderson, in 'Blinding', writes:

> I must be invisible. Out of your sight. Now you dare not see me. I am what you cannot countenance. Rape of the head.

> (Anderson 1989: 111)

Obviously, to this absence of a real image corresponds the absence of a voice. The exclusion of woman from Irish, or more precisely Anglo-Irish, writing (literature written in Hiberno-English, the English spoken in Ireland) is equally evident in the Republic at all levels. In both the case of literature and the State, woman is only a sub-text. Even in the currency of the state, women remain hidden, in a highly subtle filigree design, as if placed in the shadows and enclosed in the bank note on which the eminent figure of the patriarch of the hour looms large, solemn and undisturbed; Swift, Yeats, Scotus, O'Connell. Not only is she excluded from public space but she herself becomes the terrain over which power is exercised. The Irish obsession with control over the body of woman is today the object of conflict between Church and State.

Dispossessed of her body and for long hidden under negative imperatives, the 'colleen' (cliché of Irishwoman) has been doubly denied her voice.

On the one hand silenced and marginalised by patriarchal power as a woman, on the other hand devalued and minimalised by British imperialist culture as Gaelic-speaking (or Irish if one wishes). This double verbal deprivation makes it more difficult to express personal or national experiences adequately, so complicating the notion of 'Irishness' that Eilìs Nì Dhuibhne derives linguistically from that of 'Englishness':

> The very word, small and plain as it is, rolled around my mouth, smooth as ivory. What a delicious English word it is: Bath. The a is a test, the th the trial that tells the sheep from the goats, the cultured from the masses, the old from the nouveau and, let me admit it, the English from us.

> (Nì Dhuibhne 1989: 146)

The position occupied by the Irish woman as active subject in speech and writing is contained within the bounds of the patriarchal. As Nuala Nì Dhomhnaill expresses it:

> We've all internalised this patriarchal thing. It would be a lie for me to say that I'm out of the woods, because I'm not.

> (Nì Dhomhnaill 1986: 7)

In this way, in considering language as a way of internalising the patriarchal, Nuala Nì Dhomhnaill echoes Hélène Cixous when she affirms that as soon as women begin to speak, they learn from received teaching that their territory is black: 'As soon as they begin to speak, at the same time as they're taught their name, they can be taught that their territory is black: because you are Africa, you are black. Your continent is dark. Dark is dangerous' (Cixous 1976: 877–878). The image of the female as colonised territory is by now a commonplace, but in the Irish context this association between language and colonialism acquires a particular significance. For both Nì Dhomhnaill and Cixous the patriarchal language colonises the horizon, the self-image of woman, by presenting the male as the norm and the female as an aberration. While in the public sphere, which is the monopoly of men, this discourse proliferates, in the traditionally female private sphere the hidden and the unsaid reign.

In patriarchal territory, the only escape route from male language is, according to Nì Dhomhnaill, 'the language of our mothers'; the use of the Irish mother tongue.

In bestowing value on this absolute language, certainly one runs the risk of a return to insular Irishness, but its use offers an important alternative: the option of another channel of expression. The use of Irish by a woman like Nuala Nì Dhomhnaill, poet and literary critic, not only challenges misogynist patriarchal assumptions and myths but also puts into question the very formulation of the concept of a national identity in which the Irish language and the silence of women have been fundamental.

Other contemporary women writers are entering the territory of Irish literature by various means: Biddy Jenkinson by refusing the imperialism of the English tradition, Eithne Strong in moving from one tongue to another in the conscious search for a language.

Monologues, dialogues, polylogues. Interminable voices . . .

The search for a language, an identity and a voice of their own may be one of the reasons why the women of Ireland have been so strongly attracted to poetry since, after all, as Medbh McGuckian says, 'poetry concerns taboos. Poetry is what we are not allowed to talk about' (McGuckian 1989: 11). Poetry, perhaps, allows women to move out of and beyond the borders within which patriarchs and colonisers have placed them.

As Ailbhe Smyth comments on marginalisation:

Living and creating on the margin makes you sharp, tough, sometimes wise, but it's still a hard, lonely, dangerous place to be. . . .
The margin leaves its scar on those who survive. And the survivors are often angry.

(Smyth 1989a: 13)

And Nì Dhomhnaill, once more, affirms, this time in reference to Alice Walker's 'In Search of Our Mothers' Gardens' (Walker 1984):

There is an awful lot of rage and it's not just a personal rage, it's a transpersonal rage. It's my mother's rage and my mother's mother's rage and it goes back for generations.

(Nì Dhomhnaill 1986: 8)

The Irishwoman is today emerging from her patriarchal-colonial shell and is becoming self-aware and conscious of her own capacities, liberating herself from the monolithic and passive image in which she has been imprisoned for centuries. She is doing so by rewriting the same stories and myths that have kept her in the background. The image of 'Mother Ireland', for example, no longer corresponds to the model of suffering, abnegation and passivity that aided imperialism and a prevailing 'machismo'. Instead, it is returning to its 'origins', thus rejecting each of the succeeding patriarchal mystification. Through identifying with the mother-goddess Sheela-na-gig (Gaelic for 'Sheelagh of the Breasts'), goddess of fertility in Celtic mythology, the image of 'Mother Ireland' increasingly corresponds to the real image of contemporary woman. In this sense, Patrick Pearse's 'Mise Eire' ('I am Ireland') becomes, in Eavan Boland's poem with the same title, 'I am the woman':

I am Ireland:
I am older than the Old Woman of Beare.
Great my glory:
I that bore Chuchulainn the valiant.
Great my shame:
My own children that sold their mother.
I am Ireland:
I am lonelier than the Old Woman of Beare.

(Pearse 1917: 323)

I won't go back to it –
my nation displaced
into old dactyls,
oaths made
by the animal tallows
of the candle –

land of the Gulf Stream,

the small farm,
the scalded memory,
the songs
that bandage up the history,
the words
that make a rhythm of the crime

where time is time past.
A palsy of regrets.

No. I won't go back.
My roots are brutal:

I am the woman –
sloven's mix
of silk at the wrists,
a sort of dove-strut
in the precincts of the garrison –
who practises
the quick frictions,
the rictus of delight
and gets cambric for it,
rice-coloured silks.

I am the woman
in the gansy-coat
on board of the 'Mary Belle',
in the huddling cold,

holding her half-dead baby to her
as the wind shifts East
and North over the dirty
water of the wharf

mingling the immigrant
guttural with the vowels
of homesickness who neither
knows nor cares that

a new language
is a kind of scar
and heals after a while
into a passable imitation
of what went before.
 (Boland 1989a: 71–72)

And so, as Irish women are themselves recasting their role, in search of a new, different identity for themselves, the significance of national identity changes. Political consciousness is being reinforced and women, instead of rocking the cradle, are shaking the system: women such as Mary Robinson, President of the Republic, whose political stances are in line with lay feminism, or like the Irish Lesbian Organisation who, in parading the streets of Dublin on St Patrick's Day, ideologically challenge the traditional Ancient Order of Hibernians; women singers like Sinéad O'Connor, with her openly provocative attitudes or like Enya, whose ancient melodies evoke the primordial world. Women like Anne Crilly, director of the controversial documentary 'Mother Ireland', censored by British television station Channel 4 because of its subversive and revolutionary content;

or like the writer Eilìs Nì Dhuibhne who, in the post-colonial, post-nuclear world of her novel *The Bray House*, accuses England of having assassinated Ireland:

> Ireland . . . suffered . . . much more from radioactive waste leaking from English container vessels and from English power stations and pipelines than from anything situated in Ireland itself. Similarly, the violence in Northern Ireland could be, and must be, to some extent, blamed on Britain, whose rulers have mishandled the Ulster situation so badly over a period of at least a hundred years, if not more. . . . Besides these internal factors, Ireland was [. . .] suffering from severe emigration problems . . .
>
> Ireland did not die a natural death. As a country, she was murdered. And who was the murderer? The usual one, it seems to me.
>
> (Nì Dhuibhne 1990: 167–168)

Women within the borders of the republic and beyond. To the South, North, East and the West. Women who continue to write. Subversive women. Survivor women. Women, women, women.

Irish women – *Bean Eireannach* – can today allow themselves to gaze into the forbidden well. The water is rising, rising, but this time it is submerging ancient oppression and flowing once more to give life to a broader, more complete concept of Irishness.

To conclude this brief contribution I would like to refer to my personal experience which has allowed me to closely participate with these women (mothers, daughters, granddaughters), transmitting and renewing the signifiers and signs of Irishness, raising a cultural barrier in defence of their very identity, to the point where I have been able to share their passions, their colours, their reasons, and sometimes, if you will allow me, to have felt, 'Irishly', one of them.

REFERENCES

Anderson, Linda (1989) 'Blinding', in Ailbhe Smyth (ed.), *Wildish Things*, Dublin, Attic Press.

Boland, Eavan (1989[a]) 'Mise Eire', in *Selected Poems*, Manchester, Carcanet.

—— (1989[b]) *A Kind of Scar: The Woman Poet in a National Tradition*, Dublin, Attic Press LIP Pamphlet.

Cixous, Hélène (1976) 'The Laugh of the Medusa', trans. Keith Cohen and Paula Cohen, in *Signs: Journal of Women in Culture and Society*, 1(4).

Conlon, Evelyn (1988) 'Millions Like Us', in *Graph*, 5, Autumn.

Coulter, Carol (1990) *IRELAND Between the First and the Third Worlds*, Dublin, Attic Press LIP Pamphlet.

Crilly, Anne (1991) 'Banning History', in *History Workshop Journal*, 31, Spring.

Donoval, Katie (1988) *Irish Women Writers. Marginalised by Whom?*, Dublin, The Raven Arts Press – Letters from the New Island.

Kearney, Richard (ed.) (1988) *Across the Frontiers: Ireland in the 1990s*, Dublin, Wofhound Press.

Longley, Edna (1990) *From Cathleen to Anorexia. The Breakdown of Ireland*, Dublin, Attic Press LIP Pamphlet.

McGuckian, Medbh (1989) quoted in Ailbhe Smyth (ed.), *Wildish Things*, Dublin, Attic Press.

Meaney, Gerardine (1991) *Sex and Nation. Women in Irish Culture and Politics*, Dublin, Attic Press LIP Pamphlet.

Nandy, Ashis (1983) *The Intimate Enemy. Loss and Recovery of Self under Colonialism*, Oxford, Oxford University Press.

Nì Dhomhnaill, Nuala (1986) 'Making the Millennium', interview with Michael Cronin, in *Graph*, 1, October.

Nì Dhuibhne, Eilìs (1989) 'The Wife of Bath', in Ailbhe Smyth (ed.), *Wildish Things*, Dublin, Attic Press.

—— (1990) *The Bray House*, Dublin, Attic Press.

O'Donnell, Mary (1989) 'Suburban Blitz', in *Graph*, 6, Summer.

Pearse, Patrick (1917) 'I am Ireland', in *Collected Works*, Dublin and London, Maunsel and Co.

—— (1930) 'Mise Eire', in *Collected Works*, Dublin, The Phoenix Publishing Co.

Smyth, Ailbhe (ed.) (1989[a]) *Wildish Things. An Anthology of New Irish Women's Writing*, Dublin, Attic Press.

—— (1989[b]) 'The Floozie in the Jacuzzi', in *The Irish Review*, 6, Spring.

Walker, Alice (1984) 'In Search of Our Mothers' Gardens', in *In Search of Our Mothers' Gardens*, London, The Women's Press.

8

ETHNIC CONFLICT IN POST-COLONIAL INDIA

Amedeo Maiello

If an observer were to search for those events that have brought the European press to abandon its deep-rooted stereotyped portrayal of Indian reality, undoubtedly these would be the 1984 storming of the Golden Temple and the bare-handed destruction of the Babri Masjid in 1992. India's growing communal violence has not only stimulated the interest of scholars but also appears to be at the very forefront of public concern throughout the world today.[1] Previous European complacency, nurtured by the muting of its marginal ethnic conflicts and by the tendency of relegating such manifestations to an 'Oriental' nature, has been shattered by ominous events: there is hardly a modern state that is not confronted with such strife as it looms in the very heart of Europe.[2] This being the situation it could be argued that such a global issue necessarily entails a theoretical understanding of violence and of the psychological processes that underlie such collective actions.[3] But, as Jonathan Spencer has recently underlined, this approach, though valuable to fathoming how ethnic violence manifests itself, appears to lack the explanatory power necessary to furnish answers to the more basic question of why it occurs.[4]

The current wave of ethnic–regional confrontation in the advanced world itself appears to be primarily a product of the process of global transformation.[5] Although such a linkage in the case of South Asia tends to be obfuscated by the colonial-induced perception of the endemic nature of the problem in this area, proper explanation for the recent upsurge of communal conflicts in India may be found in delineating the impact of the country's past development policies on ethnic relations, and of how present post-colonial restructuring processes have tended to aggravate such relations. In fact, the progress achieved in the theoretical understanding of ethnicity has led most scholars to move away from the threadbare notion of ethnicity as an expression of mere primordial ties. Instead the tendency is to adopt a view which considers ethnicity as primarily a modern manifestation determined by changing socio-economic and political factors. This perspective, with its emphasis on dynamic concrete realities, has induced many to partially retreat from overarching explanations and to opt for an approach which welds the issue to those peculiar socio-economic factors that act as catalysts in precipitating ethnic confrontation.

However, within this very perspective the tendency to place the problem of ethnicity within a general socio-political theory remains strong. But, especially in the case of India, it appears highly reductive to rely simply on an optic that unduly emphasises the deterministic influence of external constraints, as is the case with the dependency paradigm. Such an approach tends not only to shift the problem out of the hands and control of the Indian actors, but also to veil the influence of concrete internal transformations and of the more proximate determinants of such conflicts. Nevertheless, to gain a proper understanding of these processes, notwithstanding the tendency of authors like Booth, who, in their critique of the dependency model refute the generally accepted view 'that the development problems and hence the social structure and politics of less-developed countries are explained by the . . . nature of their insertion into the international system of capitalism', there is still the need to place such factors within the framework of a changing global system.[6] This does not in the least imply the acceptance of what has been aptly called the 'tyranny of globalism', but it is to recognise the reality of a transnational capitalist order which, although contributing, does not appear to completely or fully determine the development of ethnic confrontation.[7]

Colonial rule and the ensuing freedom struggle set in motion complex processes which, with the subtle complicity of the imperial regime's unrelenting recourse to 'scientific' methods of identifying and classifying the different communities, transformed the nature and significance of existing cultural diversities and led to the growth and crystallisation of pronounced ethnic and regional identities. The traumatic epilogue of Partition, rather than thrust the problematic to the forefront of Indian consciousness, appeared simply to have exorcised it. In the wake of the general optimism of the independence period, an illusive self-perception of a morally superior society anchored in the ethos of tolerance and brotherhood came to remove the harsh reality of the communal identity.

This self-perception had been a basic trait of the Congress ideology.[8] It was expressed in political terms by Rajni Kothari:

> Indian Unity is essentially polycentric, based on a continuing accommodation of diverse peoples and their diverse life-styles, and resulting in a remarkable capability for assimilation and 'agglomeration'. The consequence of such an approach to social aggregation – an approach that emphasised agglomeration more than segmentation, accommodation more than segregation, consensus more than confrontation – was that when the national movement and still later the nation-state came to be organised, it was possible for the new elite to incorporate all the more important segments of Indian society and culture in the framework of the Congress.[9]

This outlook came to prevail not only among the intellectuals of both liberal and Marxist orientation, but it also percolated among the masses. The depth of such a process is attested to by the literature of the period, in particular in the writings on Partition.[10] More significant was the role played by the popular film industry which, employing an efficacious homily tone, made this message the guiding

theme of the Indian cinema in the two decades following independence.[11] But such self-perception, more than mirroring a budding new national identity, was most likely a manifestation of the consensus enjoyed by the national leadership and its ideals of territorial integrity and professed nationalistic, often anti-Western, goals. This leadership which undoubtedly was the expression of a promising era, but as Clifford Geertz asserted, was itself a source of the prevailing optimism:

> The near-millennial hopes of political deliverance once invested in a handful of extraordinary men are not only now diffused among a large number of distinctly less extraordinary ones but are themselves attenuated. The enormous concentration of social energies that charismatic leadership can, whatever its other defects, clearly accomplish, dissolves when such leadership disappears. The passing of the generation of prophet-liberators in the last decade has been nearly as momentous, if not quite as dramatic, an event in the history of the new states as was their appearance in the thirties, forties and fifties.[12]

Such widespread sentiment came to be utilised as a powerful, legitimating tool in the creation of state that functioned according to the designs and priorities of the Indian leadership. The creation of Pakistan had in fact delivered the final blow to the marginal request for a pluralistic structuring of the Indian polity and removed the major obstacle to the adoption of a form of co-operative federalism which assigned to a propulsive centre the dominant role in the decision-making process and in the control and allocation of resources. The Delhi-based power structure retained the colonial state bureaucratic framework that was to have a growing and more political role[13]: a power structure ever ready and willing to crush, in reference to the ethnic issue, not only secessional movements but also any demands for concrete institutional recognition of ethnic-religious identities.[14] Brass in his *Language, Religion and Politics in North India*, written in the late 1960s, put forward a rather different view of the nature of the Indian state.[15] Not wanting to disparage the value of the liberal-democratic system, the author's perspective of an Indian state anchored to pluralistic policies today appears non-tenable.

This latter conclusion may also be substantiated within a wider historical view. Although the British undoubtedly often made political use of the communal question they nevertheless left a legacy of community-oriented policies. On the other hand, the Gandhian goal of transforming the nationalistic struggle into a mass movement had relied on a strategy based on the recognition of the distinctiveness of religious-linguistic groups. But this legacy of what may be called constructive pluralism was transformed by an iconoclastic ideological position into a mere division. The new Indian state, constrained by political exigencies, was forced to acknowledge such divisions and the cultural diversity of the country but adopted what at best can be described as a policy of benign neglect.

This basic orientation of the Federation was further accentuated by the adoption, in pursuit of the declared priority of a viable political integration of the country, of an electoral system intended to curb factious tendencies. It thus proceeds not only to eliminate separate electorates but also never envisaged any form of proportional representation.[16] The subsequent decentralised structuring of the system could not compensate for the distortion, especially the question of minority representation, inherent in such a system. On the other hand, this decentralisation was subservient to Delhi's ultimate control of the purse, and was lubricated by a form of political clientelism whose magnitude cannot be measured even by Italian Christian Democratic standards.[17] Though this became a source of political stability it undoubtedly permitted a tighter control over dissenting social-ethnic groups. The political institutional arrangements were thus geared to the establishment of a strong state wanted by the nationalist leadership which, following the death of Patel, came to be personified by Nehru. It was not only to promote general welfare but also to have the function of creating a shared and uniform national culture whose secular values were to be furnished by the rapid modernisation of the country. It was staunchly believed that only by implementing such a radical transformation a viable integration of the nation could be accomplished, and the malaise of communalism be uprooted.[18]

But internal contradictions and external constraints were to thwart this design and in time transform the constitutive elements of this process into channels of heightened communal confrontation. The crucial elements of this national ideology were secular parliamentary democracy and a planned economy. I will focus primarily on the disruptive effects of the latter economic policy. The following intends to be only a thumbnail sketch whose aim, drawing heavily on the work of specialists, is to furnish a partial insight into some of the complex processes that lie at the root of a problem which calls for a more nuanced and detailed study.

The cornerstone of the envisaged process of modernisation was the implementation of an economic policy which, ignoring Gandhi's ideal of true swaraj and thus the adoption of a development strategy directly geared to India's socio-economic peculiarities, aimed to accelerate growth through the guiding role of capital-intensive industrialisation and the state ownership of strategic sectors.[19] On this point Nehru had been prepared to break with Gandhi.[20] Nehru considered that this strategy represented the road to the fulfilment of real independence for, to use his words, 'no country can be politically and economically independent, even within the framework of international interdependence, unless it is highly industrialised and has developed resources to the utmost.'[21] In its initial post-independence phase this option came thus to represent the nationalist effort, although it depended heavily on foreign aid to develop the internal productive forces relatively free of the constraints of the hegemonic capitalist powers.[22] Such an attempt at 'self-reliant growth', often referred to as the Bandung Project, was to be frustrated, following the crisis of the early 1970s, by the capitalistic restructuring of the world order that put an end to the possibility of India relating to the global system with the same degree of autonomy. But as Amin has

underlined, such attempts at a 'national control of accumulation' failed not only because of Western hostility but also due to 'the historical insufficiencies and limitations of the local bourgeois leadership itself'.[23] Thus, to understand the basic causes of the failure of this development policy, alongside the evaluation of often pervasive global constraints, it is necessary to attend to domestic factors, and to the role of those internal forces that determined them. In Nehru's vision this development policy was to lead to the solution of India's poverty, an objective which he emphasised repeatedly. As far back as the 1929 Presidential address to the National Congress he said:

> We have to decide for whose benefit industry must run and the land produce food. Today the abundance that the land produces is not for the peasant or the labourer who work on it, and industry's chief function is supposed to be to produce millionaires. However golden the harvest and heavy the dividends, the mud huts and hovels and nakedness of our people testify to the glory of the British Empire and of our present social system.[24]

J. N. Bhagvati, a leading figure of the neo-classic position that has been highly critical of aspects of this policy, relying on his own personal reminiscences, underlines that in the immediate post-independence period such a goal was still dominant and that the guiding idea was to consider growth 'an instrumental variable which would enable one to impact on the central and ultimate objective of reducing poverty'.[25] But the failure to accomplish this goal cannot be simply attributed to the negative effects of the prevailing managerial policies so strongly condemned by the neo-classic paradigm. This factor undoubtedly aggravated the inherent weaknesses of a strategy that was basically the product of the struggle and contradictions ensuing from the very question posed by Nehru in 1929: for whose benefit?

The radiating foci of these contradictions were, on one hand, the power of the dominant social classes to determine the very nature of the development process, on the other, the relative weakness of the political élite, a trait which in fact barred Congress from realising its own ideological and political commitments. Pranab Bardhan thus deems the conflict over scarce resources among the dominant social groups – industrial capitalists, rich peasants and the professionals – to be the basic obstacle for achieving a substantial growth and consequential redistributive goals.[26] He writes:

> The politics of buying support with patronage and of accommodating the conflict demands of a large and heterogeneous coalition of interests has had serious adverse implication for the pace and pattern of economic growth in India. . . . The bulk of public resources are being frittered away in non-development expenditures and political and administrative mismanagement of public capital. When diverse elements of the loose and uneasy coalition of the dominant proprietary classes pull in different directions and when none of them is individually strong enough to dominate the process of resource

allocation, one predictable outcome is the proliferation of subsidies and grants to placate all of them, with the consequent reduction in available surplus for public capital formation.[27]

Such a failure, argues Kohli, is evidence of the basic feebleness of the regime.[28] The author, shunning the 'organic' class content approach, traces this to the dominant party's inclusive ideology and its ensuing multi-class alliances, as well as to its organisational deficiencies and, not least, to its uncompromising attachment to power. Therefore, 'this state was increasingly incapable of extricating itself from the grip of the propertied groups and consequently could not utilise legitimate compulsion as a tool of social reform.'[29]

So, in India there emerged a paradoxical system in which there was simultaneously too much state and too little state. On one hand, in pursuance of its indirect strategy of achieving basic economic goals, the state became the primary agent of a systemic transformation; on the other, the state abstained from enacting really incisive social policies aimed at alleviating existing and emerging contradictions. This aloofness of the state cannot be explained by postulating a lag in the development of a political system able to respond to the aspirations of emerging and marginal groups.[30] This is simply a manifestation of a deeper cause which, although undoubtedly determined by the constraints dictated by this development strategy, was basically rooted in the limits of the hegemonic nationalist ideology and its inability to contemplate truly innovative state policy.

Against this backdrop, unruly competition for material interests, instead of leading to overt class antagonism, came rather to have severe ethnic repercussions in an ingrained system of social stratification characterised by a strong correlation of class and communal division.[31] Thus the expectation that development would integrate Indian society by fostering broad aggregations which would undermine the saliency of primordial ties proved a fallacy. Apart from the general question of how effective is class consciousness in weakening traditional social moorings, or the linking by neo-Marxists such as Immanuel Wallerstein of such recurring conflicts directly to the economic distortions fostered by the global capitalist order thus making ethnic struggles far more relevant than class conflicts, in the Indian context the conflicts caused by a development strategy based on a substantially indirect trickle-down effect tended indeed to aggravate existing social and economic disparities and to polarise further communal rivalries.[32] Within this broad socio-economic context, as Brass has repeatedly underlined, competing élites have indeed had a dynamic role in precipitating ethnic conflicts, and of mobilising masses of people often on the basis of fragile ethnic-regional identities, as the Telengana–Andhra dispute clearly illustrates, so as to better safeguard their own class privileges.[33]

Another structural feature of the Indian economy which has had major negative repercussions on ethnic-communal relations is the differential in economic growth of the different areas of the country.[34] The gap left by the colonial regime has, according to most commentators, been steadily growing since Independence.[35]

To a foreign audience it is hardly necessary to underline that such uneven spatial development, often presented in neo-Marxist writings as a symptom of a wider global imbalance, is not a peculiarly Indian phenomenon.[36] However, in the Indian context, such distortions tend rapidly to acquire ethnic overtones. The diffused potential for inter-regional tension eased by the granting of the linguistic specificity of the states and by the postponement, following a strong Southern reaction, of the Hindi issue can be only too easily rekindled by the stress caused by such economic disparities. A primary objective of planning had been the promotion of regional balance. However, the policy based on the often resented transfer of resources from the centre, and on the lever of fiscal and other forms of incentives to induce a substantial spatial dispersion of the manufacturing industries, has not produced the desired goal of a regionally balanced growth.[37] In the early 1970s the Planning Commission candidly reported that there 'has been a natural tendency for new enterprises and investments to gravitate toward the already overcrowded metropolitan areas because they are better endowed with economic and social infrastructures.'[38] In the next decade there was a change; however, the very nature of the industrialisation process blocked a solution of the underlying disparity while continuing to aggravate the communal problem. As Suranjit K. Saha observes:

> Such industrialisation has usually meant the installation of plants related to standardised mass production technologies and simplified input–output structures which produce little in the way of developmental side-effects for the population. The industries with strong regional multiplier effects . . . most subsidiaries of the Western multinationals and the headquarters establishment of most major corporate houses, are however mainly concentrated in the core areas of Maharashtra and West Bengal. Continuous restructuring of the private capital nationally and the massive investments made by the public sector . . . have hastened the process of the emergence of localised, capital intensive and geographically disarticulated territorial production complexes like Bhilai, Rourkela, . . . And yet it is precisely in the areas that the conditions of poverty and socio-economic deprivation, indicated by such things as infant mortality, illiteracy, malnutrition, organised atrocities on the poorer sections of the population like the scheduled tribes and scheduled castes, have worsened relative to the states with long-standing traditions of industrialisation like Maharashtra and West Bengal.[39]

Such skewed development, and the ensuing struggles for limited resources, has led to a form of pronounced regionalism which has generated strains and conflicts between different areas of the country. It is a polarisation that is aggravated by the tendency for this phenomenon to go beyond its local state level and acquire a wider macro-regional perspective. This latter trend has been rather limited and the danger of Balkanisation is remote; however, when economic grievances deriving from a lop-sided distribution of development resources ignite strong

primordial sentiments, secessionist movements, as is the case in north-east India and Kashmir, take root.[40]

The creation of the linguistic states, as has often been observed, has provided a valid institutional bulwark to the crystallisation of such zonal sub-nationalistic sentiment.[41] In fact, if the removal of the volatile linguistic issue has defused a potentially dangerous situation, the growing entanglement of the states in their own parochial interests and conflicts has barred the possibility for a wider zonal solidarity to develop. Further, this institutional arrangement has transformed the states into the primary foci of communal rivalry. This latter development flows primarily from the constitutional role of the states in the field of public employ-ment and the control of resources. The states have in fact often been led to squander scarce resources which many observers think could be used for more productive purposes, thereby becoming uncontrolled centres of public expend-itures. As Brass observes: 'Not only have they been spending more, but they have been spending both money they do not raise and money they do raise. Moreover, the control of the central government over state expenditures has decreased.'[42]

In such a manner each single state becomes an incubator of communal conflicts, activating at the local level persistent and ingrained divisions. Apart from local peculiarities, single states display a pronounced inclination to adopt assimilative and discriminatory policies in relation to their own internal minority groups. This is especially the case with linguistic minorities which, in the absence of any policies to accommodate existing cultural differences, are often discrimin-ated against both in the field of instruction and employment. It is the state's competence in these two sectors, with politicians carrying out a broker-like role for the allocations of limited resources, that has transformed the states into an arena for conflicts between different caste groups. The central government has been unable to enact policies capable of discouraging such trends. On the contrary, with the growth of rampant factionalism, religious and caste interest have become intertwined with the very fabric of political parties, and they have come to abandon their ideological commitments in favour of more partisan considerations. The profound communalisation of the Indian political process has been a major factor in the resiliency of the communal issue, as well as transform-ing the system of parliamentary democracy, originally envisaged as a cohesive force, into a source of division and factious tendencies.[43]

There is no space here to dwell on this problematic but it must be underlined that narrow partisan considerations appear to have determined the role of the leading actors in the 1984 Punjab drama. Here was a prime minister, apparently oblivious to the case of national unity, exploiting the Sikh problem to cultivate the Hindu backlash, only to find death at the hands of her Sikh bodyguards. Simultaneously, the self-defeating factionalism of the Akali Dal permitted the rise of the fundamentalist demagogue who, from mere puppet, reached the glory of martyrdom in the Akal Takht itself. But the real tragedy is that there are now no more Punjabis in the Punjab, only Sikhs and Hindus.[44]

The interesting fact to note, underlined by the same Punjab problem, is that

often regionally-rooted communal tensions appear to gain intensity more in leading regions than in those lagging behind. An issue that has become interlaced with strong communal feelings in these advanced areas is the violent migrant/ non-migrant confrontation. The spatial hierarchisation of the Indian economy has set in motion a complex process of internal migration which has often acquired strong ethnic significance. Apart from the relevance that the issue has assumed in Assam where the recent influx of Bengali Muslims from Bangladesh has further polarised the historical conflict between the economically subordinate Assamese majority and the Bengali speakers, the migration question has acquired a strong relevance with the Shiv Senà-endorsed 'sons of the soil' movement in Bombay.[45]

The basic aim of the movement is to have preferential treatment for Maharashtrians in the recruitment for employment in both the public and private sector. The movement was inspired by the needs of the Marathi middle class which felt especially threatened by a consistent South Indian influx of educated migrants. However, the overall effect has been to heighten communal feelings, in a highly volatile urban setting, among all sections of a composite population.[46] The 'son of the soil issue' has become even more explosive by its close en-tanglement with the backward caste issue. Apart from the settled designation of Scheduled-castes and Scheduled-tribes, the individual state's competence in the identification of backward caste has transformed affirmative action programmes, envisaged by the Constitution (article 355), into veritable channels of abuses. Here is Myron Weiner's description:

> There was thus a progression in the application of the principle of reser-vations: from scheduled-castes and scheduled-tribes minorities to that of the more numerous and somewhat better-off backward castes, to autochthonous population, a majority diverse in its social and economic characteristic yet backwards in relation to its migrant competitors.[47]

This issue which for years has been the object of heated intellectual and political controversies has, against a background of rising caste consciousness, led to open violence. Recently the prospect of the implementation of the recommendations of the Mandal commission which if 'followed half the posts in the public sector and universities will be filled by people who could not get in on merit, providing they belong to the right caste', generated widespread violence with more than a hundred students killing themselves in order to have such measures repealed.[48]

The distortion and strains delineated above can also be set in the context of a more basic contradiction. The Nehruvian development strategy was determinant, but it could also be argued to be the product, of a more radical rural–urban divide. Without endorsing the Lipton urban-bias paradigm which postulates the view of the state as instrumental in catering to the interests of an urban bloc identified with the urban employers, urban workers and major farmers, there remains the fact that the projected goal of achieving an integrated rural development, a priority of the Gandhian vision, was undermined not only by the dearth of resources that had been massively diverted to the basic-industries sector until the

late 1960s, but also by the limited and contradictory nature of land-reform legislation.[49] The Rudolphs, who offer a positive judgement on the limited effects of the land-reform policies in the dominance of the new 'bullock capitalist' that benefited from this agrarian legislation, observe:

> The abolition of intermediaries transformed agrarian relations by shifting the focus of rural power from feudal landlords to market oriented cultivators, whom we categorised earlier as bullock capitalists. Marginal tenants, dwarf holders and agricultural laborers did not benefit from inter-mediary abolition. Change occurred at the top and near the top of the agrarian pyramid.[50]

This situation provides the backdrop for recurring manifestations of widespread agrarian unrest. Though such struggles were often spearheaded by leftist parties, they also often witnessed the very active participation of non-party ethnic organisations. The composite nature of the agrarian movements is clearly evident in the well-known Naxalbari revolt of the late 1960s. Here there was mobilisation along class lines, with backward-castes often in open conflict with landlords or rich farmers of their own caste. Of a similar nature was the concerted action promoted by a coalition of low castes and Muslims who, to the cry of 'Harijan-Muslim bhai bhai', forged a united response to the prevailing exploitation of rural labourers.[51] But within such movements, appeals to ethnic solidarity were also quite common. Apart from the rallying of Muslims to 'religion in danger' slogans, communal appeals were particularly effective among the Tribals, always resentful of the encroachment of what they considered to be alien Hindu culture.

The rise of rural communal discontent is also to be linked to the substantial failure of different rural projects such as the Community Development pro-gramme. Considered a key to the solution of existing rural disparities, this project faltered on the inability to break the power of the dominant village groups who, by gaining control of the substantial resources allocated for rural improvement purposes, transformed the programme itself into a source of growing social-ethnic conflicts. As Tomlinson observes:

> The effective units of social organization in most Indian villages were hierarchical in structure, based both vertically on patron–client relation-ships and interlinked markets for credit and labour, and horizontally on bonds of common social, ritual and economic status. As a result, group-based and interest-based competition for resources within the village undermined the integrative purpose of the CD programme.[52]

In the late 1960s the Nehruvian strategy gave way to more rural-oriented policies. The new trend, rather than mirroring an emerging orientation in the Shastri cabinet, was virtually imposed in the midst of the 1965–1967 food crisis by the United States. The Johnson administration, resentful of India's position on the Vietnam war and, more importantly, pursuing its design of promoting the liberal-isation of the Indian economy, used food aid as a powerful weapon:

The President reacted by tightening to the point of strangulation the short tether on PL-480 aid to India. He doled out wheat on a month-to-month basis, which made rational planning by the Indian food ministry impossible. Johnson did not publicly tie his action to Gandhi's stand on Vietnam, instead he cited the need for India to expedite its agricultural reforms.[53]

The ensuing Green Revolution which was to transform India into a grain exporting country by the late 1980s, fostered radical changes in rural India. These were not limited to the introduction of those technological inputs necessary for the new high-yielding crops, but also included such innovations as the creation of an extensive rural credit network and new marketing facilities and procedures. The resulting scenario has been the object of heated controversies with leftist observers forwarding severe and often scathing criticism.

> In India the contemporary differentiation of the peasantry according to the rule, that to him that hath shall be given, from him that hath not shall be taken the little that he hath (not), is reflected almost weekly in the pages of the *Economic and Politically Weekly* . . . is an important cause in the displacement of labour from land and its ownership, as well as in the relative and often absolute decline in real income for the most adversely affected – thereby contributing politically to the intensification of the class struggle in the countryside.[54]

The Rudolphs, among others, refute such a polarisation thesis by pointing out that 'independent cultivators using their own household labor (bullock capitalists) are likely to remain a large and politically more influential economic class than wage workers or capitalist farmers'.[55] Though one may agree with the Rudolphs' thesis, the profound impact of this transformation in terms of ethnic antagonism can hardly be doubted. It must be underlined that the new agrarian policy has accentuated existing regional imbalances, favouring the already advanced areas endowed with irrigation infrastructures. But far more traumatic has been the effect on traditional social relations. The countryside has been the stage of recurring local civil wars with high castes perpetrating violence against landless Harijans labourers who refuse to passively accept the sexual harassment of their women and refuse unjust wages and other forms of exploitation. In such a context communal antagonism, as Kohli points out, acquires a new dimension:

> Changing roles have created a growing awareness of the individual's position in society. Long established inequalities and beliefs about the legitimacy of these inequalities are thus increasingly under challenge . . . conflicts along traditional cleavages of caste and community have been around for quite some time, but what is new is the changing character and intensity of such conflicts. . . . Traditional conflict is thus evolving into new types of conflicts and increasingly the theme is class conflict.[56]

The unleashing of such a disruptive ethnic climate appears to be a manifestation

of a deeper social malaise which undoubtedly has been exacerbated by India's economic crisis and by the solutions proposed by the prevailing free-market policies. The adoption of far-reaching liberalisation was indeed induced by relentless external pressures; however, it must be underlined that such a trend had gained currency in Indian society, and thus among the political leaders, since the early 1980s.[57] In this context it is not possible to assess the overall effect of the new economic course, but the political and social legitimation of the interests of the dominant groups, whatever may be the end-result, has delivered a fatal blow to any lingering traces of social solidarity and undermined the very ideological fabric of the Indian state, namely secularism.

As a guiding principle, secularism in the Indian context has often become a source of controversy due to that thin line, often blurred, separating the presumed religious neutrality of the state and its constitutional duty to guarantee existing cultural identities. But the ideals of secularism, already weakened by callous partisan practices, are being swept away by the rise of parochial visions leading to the rise of aggressive Hindu revivalism and fundamentalism. Such an outlook which replaces questions with answers, doubts with certitude, uncertainties with stability, provides the ideological cement for a more aggressive and conflict-ridden society. It is often asserted that to postulate Hindu fundamentalism is simply nonsense, a paradox. However, the transformation of the fundamentally tolerant outlook of Hinduism goes back to the nineteenth century when, under the composite impact of Western culture, a new Hinduism, a religion 'the likes of which India had never seen' was moulded. What needs here to be emphasised is that Hindu fundamentalism does not represent an immediate challenge either to the other religious traditions or to the secular outlook of fully Westernised Indians. What is in dire danger, instead, is the survival of that traditional form of Hinduism which considers religion a key to toleration and co-survival.[58] The explosive mixture of religion and politics, and the recourse to techniques of mass mobilisation, has produced a communal frenzy which found in the destruction of the Babri Masjid its most violent expression.

India's present problems, of which communalism is a mere, though tragic, manifestation, have brought some scholars to speak of a systemic crisis. Surely the crisis is such that it cannot be solved by mere institutional engineering. There clearly is the need to evolve a new strategy of non-dependent development, an alternative path that many observers advocate. Here is S. C. Dube's explanation:

> While economic growth is necessary, *per se* it does not constitute develop-ment. It has to be linked to a set of well defined human-social and cultural objectives. Economic growth has to be understood as an instrument of human development. It should first be able to meet the basic needs of the people at large and then move on to improving and enriching their quality of life.[59]

Among these human-social and cultural objectives undoubtedly a priority must be allotted in India to the full recognition of diverse cultural and social identities.

110

What better guiding principle for such an endeavour than Gandhi's well-known observation:

Religions are not meant for separating men, they are meant to bind them.

NOTES

1 As it has been noted: 'Between 1980 and 1989 India witnessed close to 4,500 communal incidents in which over 7,000 people lost their lives, almost four times as many deaths of this type as in the 1970s,' P. C. Upadhyaya, 'The Politics of Indian Secularism', *Modern Asian Studies*, 26, 1992, p. 821.

2 For a general survey of the problematic inherent to the different European ethno-linguistic minorities see Colin H. Williams, 'The European Community Lesser Used Languages', *Rivista Geografica Italiana*, 100, 1993, pp. 531–564.

3 See Veena Das (ed.), *Mirrors of Violence: Communities, Riots and Survivors in South Asia*, Delhi, Oxford University Press, 1990.

4 Jonathan Spencer, 'Problems in the Analysis of Communal Violence', *Contributions to Indian Sociology*, 26, 2, 1992, pp. 262–279.

5 Referring to the contemporary manifestations of ethnic confrontation Samir Amin, in *Maldevelopment. Anatomy of a Global Failure*, London, Zed Books, 1990, observes:

> In the West and the East or in the Third World, the catalogue of these 'new' movements or old ones with a new lease on life, is extensive. These movements are a significant aspect of the crisis of the state, and more precisely of nation-state. . . . This crisis of state must be viewed as a manifestation of the increasing contradiction between the transnationalization of capital (and behind this of the economic life of all countries in the capitalist world) and the persistence of the state system as the exclusive political pattern in the world.

6 David Booth, 'Marxism and Development Sociology: Interpreting the Impasse', *World Development*, 13, 1985, p. 774.

7 S. Corbridge, 'The Third World in Global Context', in M. Pacione (ed.), *The Geography of the Third World: Progress and Prospect*, London, Routledge, 1988, p. 66.

8 On Nehru's basic creed, best summarised by the often repeated, but still dangerous, 'Unity out of diversity', see J. Nehru, *Discovery of India*, Calcutta, The Signet Press, 1946, p. 75. The Rudolphs opt to define this faith in secular nationalism as 'India's Founding Myth', Lloyd Rudolph and Susanne Hoeber Rudolph, *In Pursuit of Lakshmi. The Political Economy of the Indian State*, Chicago, University of Chicago Press, 1987, p. 39.

9 Rajni Kothari, *Politics in India*, New Delhi, Orient, 1970, p. 82. Also see Thomas Pantham, 'Interpreting Indian Politics: Rajni Kothari and His Critics', *Contributions to Indian Society*, 22, 2, 1988, pp. 229–246; Monoranian Mohanty, 'On Democratic Humanism: A Review of Rajni Kothari's Recent Work', *Contributions to Indian Sociology*, 25, 1, 1991, pp. 151–160; T. V. Sathyamurthy, 'A Unique Academic Understanding of Politics', *Economic and Political Weekly*, 7 September 1991, pp. 2091–2100.

10 See Muhammad Umar Memon, 'Partition Literature: A Study of Intizar Husain', *Modern Asian Studies*, 14, 3, 1980, pp. 377–410. For an introduction to Manto's quite different approach to the issue of Partition, see Keena Das and Ashis Nandy, 'Violence, Victimhood and the Language of Silence', *Contributions to Indian Sociology*, 19, 1, 1985, pp. 177–195.

11 Akbar S. Ahmed, 'Bombay Films: The Cinema as Metaphor for Indian Society and Politics', *Modern Asia Studies*, 26, 2, 1992, pp. 289–320.

12 Clifford Geertz, 'After the Revolution: The Fate of Nationalism in the New States', in Clifford Geertz, *The Interpretation of Cultures*, New York, Basic Books, 1973, p. 235.

13 See Hugh Tinker, 'South Asia at Independence: India, Pakistan and Sri Lanka', in A. Jeyaratnam Wilson and Dennis Dalton (eds), *The States of South Asia. Problems of National Integration*, London, C. Hurst, 1982, p. 13.

14 For a discussion of the issue against a backdrop of socio-economic changes and the state's response to its 'inability to enforce its own codes and norms', see Kuldeep Mathur, 'The State and the Use of Coercive Power in India', *Asian Survey*, 32, 4, 1992, pp. 337–349.

15 The study was published in 1974, but as the author asserts, it was written in the late 1960s and early 1970s. See Paul Brass, 'The Punjab Crisis and the Unity of India', in Atul Kohli (ed.), *India's Democracy. An Analysis of Changing State–Society Relations*, Princeton, Princeton University Press, 1988, pp. 169–214.

16 See Sudama Singh, 'Representation in Modern Democracies: Theoretical and Practical Perspectives', *The Indian Journal of Political Science*, 52, 4, 1991, pp. 509–529; and C. P. Bhambhri, *Political Process in India 1947–1991*, New Delhi, Vikas, 1991, p. 96.

17 Pranab Bardhan, 'Dominant Proprietary Classes and India's Democracy', in Kohli, op. cit., p. 217.

18 See Bidyut Chakrabarty, 'Jawarhalal Nehru and Planning 1938–41: India at Cross-roads', *Modern Asian Studies*, 26, 1992, pp. 275–278. It should be noted that many scholars, from Gunnar Myrdal to Samir Amin, have, though within radically different perspectives, been led to consider the State as the primary tool for development.

19 On Gandhi's economic ideas as expounded in his *Hind Swaraj*, Judith Brown observes (in Brown, *Gandhi – Prisoner of Hope*, New Haven, Yale University Press, 1989, p. 79):

> They were to differ not just from those currently accepted in India and the West on the desirability of economic growth based on industrial production, and on the operation of market forces, they differed profoundly, too, from traditional Indian assumptions about a radical inequality between occupations, displayed in the caste ordering of society and the horror of the higher castes at the thought of manual labour, and contemporary Indian display of wealth for the honor of family and community on such occasion as weddings.

> For a recent study that advocates a return to Gandhi as a solution to the constraints of the present global order, see J. D. Sethi, *International Economic Disorder and a Gandhian Solution*, New Delhi, Vikas, 1990. For a critique of Sethi's thesis, see Arun Ghosh, 'International Economic Disorder', *Economic and Political Weekly*, 5 January 1991, pp. 15–17.

20 For an introduction to the more salient aspect of the Gandhi–Nehru controversy, see Sarvelli Gopal, *Jawaharlal Nehru*, vol. 1, Cambridge, MA, Harvard University Press, 1976.

21 J. Nehru, op. cit., p. 413.

22 This was indeed the case in 1958 when multilateral and bilateral donors furnished the needed assistance to finance the second Five Year Plan. For a general survey of foreign aid to India with a particular focus on the motivations of the donor countries, see Ira W. Gang and Haider Ali Khan, 'Some Determinants of Foreign Aid to India, 1960–1985', *World Development*, 18, 3, 1990, pp. 431–442.

23 Samir Amin, *Delinking*, London, Zed Books, 1990, pp. 32–33.

24 J. Nehru, 'Presidential Address to the National Congress, Lahore, Dec. 1929', *India's Freedom*, London, Unwin Books, 1962, p. 15.

25 Jagdish N. Bhagvati, 'Poverty and Public Policy', *World Development*, 16, 5, 1988, p. 541. The emphases are in the original.

26 Pranab Bardhan, *The Political Economy of Development in India*, Delhi, Oxford University Press, 1984.

27 Pranab Bardhan, 'Dominant Proprietary Classes', p. 218.

28 Atul Kohli, *The State and Poverty in India. The Politics of Reform*, Cambridge, Cambridge University Press, 1987.

29 Ibid., p. 64.

30 For this aspect, see R. L. Hardgrave Jr, *India. Government and Politics in a Developing Nation*, New York, Harcourt Brace Jovanovich, 1975. The author in fact shifts attention to an 'emasculated' leadership, lacking a defined 'political will', pp. 13–14.

31 Bagchi seems, instead, to consider such ethnic struggles a sort of a surrogate of class conflicts. See Amiya Kumar Bagchi, *The Political Economy of Underdevelopment*, Cambridge, Cambridge University Press, 1982, pp. 150–151.

32 Immanuel Wallerstein, *The Capitalist World Economy*, Cambridge, Cambridge University Press, 1979.

33 Paul R. Brass, 'The Politics of India Since Independence', *The New Cambridge History of India* 4, Chapter 1, Cambridge, Cambridge University Press, 1990, pp. 233–237.

34 In the light of the many regional studies which stress the resilience of indigenous factors, such regional distortions cannot be considered simply a product of imperial policies.

35 Paul R. Brass, 'Pluralism, Regionalism and Decentralization. Tendencies in Contemporary Indian Politics', in Brass, op. cit., p. 127. Note that in an earlier version of the same article, Brass omits reference to such a widening gap. See Brass in Wilson and Dalton, op. cit., in particular pp. 232–233.

36 For an overview of the different theories of internal lopsided development, see J. Love, 'Modelling Internal Colonialism: History and Prospect', *World Development*, 17, 6, 1989, pp. 905–922.

37 See Hiroshi Satò, 'The Political Economy of Central Budgetary Transfers to States in India, 1972–84', *The Developing Economies*, XXX, 4, 1992, pp. 347–375.

38 Planning Commission, 1970, 2, par. 1.23 cited in Derbas Banerjee and Anjan Ghosh, 'Indian Planning and Regional Disparity in Growth', in Amiya Kumar Bagchi (ed.), *Economy, Society and Polity. Essays in the Political Economy of India Planning in Honor of Professor Bhabatosh Datta*, Calcutta, Oxford University Press, 1988, p. 109.

39 Suranjit K. Saha, 'Industrialization and Interregional Disparities in Postcolonial India: Towards a New Regional Policy', in D. Rothermund and S. K. Saha (eds), *Regional Disparities in India. Rural and Industrial Dimensions*, New Delhi, Manohar Publications, 1990, pp. 43–44.

40 See Prabhat Datta, 'Secessionist Movements in North East India', *The Indian Journal of Political Science*, 53, 4, 1992, pp. 536–558. For an approach that sets the Kashmir crisis against the background of Indo-Pakistan relations see Alastair Lamb, *Kashmir: A Disputed Legacy 1846–1990*, Hertingfordbury, Roxford Books, 1991. On the political and ethnic dimensions of the Kashmir question, see the volume edited by Asghar Ali Engineer, *Secular Crown on Fire. The Kashmir Problem*, Delhi, Ajanta Publications, 1991.

41 James Manor, 'The Dynamics of Political Integration and Disintegration', in Wilson and Dalton, op. cit., pp. 89–110.

42 Paul R. Brass, 'Pluralism', p. 230.

43 Communalisation may be seen as a manifestation, along with 'centralisation, authoritarianism, personalised power and populist rhetoric emanating from charismatic and plebiscitary politics', of the deep crisis of the Indian polity which Kothari sees 'highly wanting and indeed counterproductive in dealing with the rise of

an era of mass politics following the enormous politicisation of the Indian masses who took the democratic claims (some call them pretensions) of the first generation Indian élite seriously', R. Kothari, 'Political Economy of the Indian State. The Rudolph Thesis', *Contributions to Indian Sociology*, 22, 2, 1988, p. 276.

44 For this interpretation of the Punjab crisis, see Mark Tully and Satish Jacob, *Amritsar*, London, Pan Books, 1986. Brass, on the other hand, links the Punjab problem to the deep transformation in the centre-state relations.

45 Sanjib Baruah, 'Immigration Ethnic Conflict and Political Turmoil – Assam 1979 – 1985', *Asian Survey*, 26, 2, 1986, pp. 1, 184–206.

46 For a graphic description of such a situation in Bombay, see V. S. Naipaul, *India. A Million Mutinies Now*, London, Minerva, 1990, pp. 1–120.

47 Myron Weiner, 'Ethnic Equality through Preferential Policies', in Robert B. Goldmann, A. Goldmann and A. J. Wilson (eds), *From Independence to Statehood. Managing Ethnic Conflicts in Five African and Asian States*, London, Frances Pinter Publishers, 1984, p. 73.

48 Dharma Kuma, 'The Affirmative Action Debate in India', *Asian Survey*, 32, 3, 1992, pp. 291–292.

49 M. Lipton, *Why Poor People Stay Poor: Urban Bias in World Development*, Cambridge, MA, Harvard University Press, 1976. For a general critique of Lipton's thesis, see B. Koppel, 'Janus in Metropolis: An Essay on the Political Economy of Urban Resources', *The Developing Economy*, 24, I, 1986, pp. 3–25. For an analysis of Lipton's thesis from a specific Indian perspective, see J. Toye, 'Political Economy and the Analysis of Indian Development', *Modern Asian Studies*, 22, 1, 1988, pp. 97–122, in particular pp. 109–112.

50 Rudolph and Rudolph, op. cit., p. 315.

51 Ghanshyam Shah, 'Grass-roots Mobilization in Indian Politics', in Kohli, op. cit., p. 292.

52 B. R. Tomlinson, 'The Economy of Modern India', *The New Cambridge History of India*, 3, 3, Cambridge, Cambridge University Press, 1993, p. 191.

53 H. W. Brands, *India and the United States. The Cold Peace*, Boston, Twayne Publishers, 1990, p. 121.

54 Andre Gunder Frank, 'Reflections on Green, Red and White Revolutions in India', *Critique and Anti-critique, Essays on Dependence and Reformism*, London, Macmillan, 1984, p. 64.

55 Rudolph and Rudolph, op. cit., p. 347.

56 Kohli, op. cit., pp. 18–19.

57 Ibid., pp. 305–338.

58 On this problematic see the various works of Ashis Nandy, in particular *The Intimate Enemy. Loss and Recovery of Self under Colonialism*, New Delhi, Oxford University Press, 1992 (reprint).

59 S. C. Dube, *Modernization and Development. The Search for Alternative Paradigms*, London, Zed Books, 1988, p. 62.

9

BLACK CULTURES IN DIFFERENCE

Marie Hélène Laforest

The observations I intend to make stem from the often overt and crude racism I have encountered in England – as opposed to the more covert one I experience in the United States – and from the idea that blacks from Britain might find American racism just as unbearable. People of African descent adopt different survival strategies according to the societies of which they are a part. This is certainly true of day-to-day survival. Perhaps it is also true of more extensive resistance proposals.Within the black diaspora, despite claims to global brotherhood and sisterhood – not that solidarity between blacks conceptually exclude diversity – there is a constellation of blackness, different ways of being black. This was as true in the past as it is today.[1]

Already in the different terms used to name themselves today enormous differences are evident between African Americans and Black British. In Great Britain 'Black' has until very recently included all non-Europeans, from South Americans (classified as Hispanics in the United States) to West Indians and people from the Indian subcontinent (grouped with Far Easterners in the United States). It is therefore a term charged with political valence. In the United States, on the other hand, 'African American' designates people of exclusively African heritage born in the United States, or who have migrated from the West Indies and are classified as black by immigration authorities.[2]

Throughout their history in the West, American and British blacks have been torn between Frederick Douglass and Marcus Garvey, between assimilation and back-to-Africa movements, integration and nationalism. Two main courses of action have therefore persisted among blacks; radically opposed routes which, however, have always remained locked into the logic of race as established by the master or coloniser. Indeed both the master/slave relationship and the coloniser/colonised one were relations of power based on the belief in white superiority and black inferiority according to the well-known dichotomies which have characterised Western thought.

Numerous strategies have been tried to reverse the marginalisation and exclusion to which this has led. An important one has recently been that of dismantling the images of blacks as created by the white imaginary. Efforts at

115

self-fashioning and self-identification are evident in literary production, in tele-vision shows and the cinema. Recent fiction by African-American and Black British women, Toni Morrison and Terry McMillan among others, the writers of *The Heart of the Race* or *Charting the Journey* in England, American sitcoms like *The Cosby Show*, and social realist films of the new wave of African-American film directors, portray blacks from the 'inside', therefore humanising and individ-ualising the black experience.[3] Another not less important trend has been the re-inscription of blacks in history. This is especially significant since not only the participation of blacks in building the nations of which they are a part has been questioned but even their allegiance.[4]

However, today African Americans and Black British find themselves at a crossroads. They have to acknowledge the failure of integrationist policies in the United States and the strong resistance to ethnic plurality in Britain. Euro-Britons frequently refuse to accept ethnic plurality as a legacy of their colonial past, thereby cancelling the black experience and viewing the empire as a parenthesis in their own history. Concomitantly there is a fragmentation of blackness: divi-sions between Asians and West Indians in Britain, between Caribbeans and African Americans in the United States, with recent migration from the Caribbean leading to increasing diversity in the global upsurge of multiculturalism.[5]

The links between American and British blacks seem weak today although some degree of influence persists through the media, music, metropolitan styles and external signs of resistance; dreadlocks, for instance. Both groups find themselves dealing with racism as their primary concern, but they face radically different dilemmas, to which they provide radically different answers.

A first exploration of the two hyphenated identities, African American and Black British, reveals that in each case only one of the two elements is questioned – and not the same one. 'American' remains fixed in one case while discourses revolve around the 'African', and the constitution of 'Blackness'. In Britain it is not the signifier 'Black' which is being queried, but rather 'British'. The reason for this is to be found in the diverse historical formation of the societies. While the United States is a country of immigrants where ethnic diversity is constitutive of the society, British society has aspired and continues to aspire to mono-culturalism: the people of the empire have no claim on British territory. So, African Americans see a space for themselves in the United States Constitution while black British have to question the very *concept* of 'Britishness' in order to find an opening in that society.

Today African Americans have chosen to define their identities in terms of 'Blackness'. Proponents of Afrocentrism from the academic world, Molefi Asante and Leonard Jeffries, look back to an African past, to a single, harmonious culture which presumably existed on the continent, while Afrocentrists in the streets sport ethnic hairstyles and clothing and listen to rap music. Criticism of rap lyrics has been strong. Their incitement to violence – white-hating, cop-killing – has been condemned by the dominant society, whereas their male-centred, sexist philosophy has been criticised by women within the black community itself.[6]

It is probably true that all nationalisms are 'gendered, invented and dangerous' as Anne McClintock affirms, but what are the options open to African Americans?[7] Statistics leave no doubt that the Republican years at the White House have devastated American black youths – black males represent 33 per cent of the jail population and 'young black people lead the nation in the rate of increase suicide'.[8] Awareness that racism is a permanent feature of American life and that blacks will remain the scapegoats of American society has grown. Both Derrick Bell and Edward Said have convincingly argued this point.[9]

Once alternative radical solutions – like overthrowing the U. S. government or constituting a black state as was proposed in the 1960s – have been abandoned. And the calls for reorganisation of the social system subsided. And the failure of the civil rights movement was acknowledged; essentialism took over not out of choice but out of necessity. Other alternatives like class warfare, or another Rainbow Coalition like the one Jesse Jackson proposed in the 1980s, could also break down the walls of racism. But they imply inter-ethnic solidarity. Poor browns or yellows or whites will not want to coalesce with a group that has been ghettoised, criminalised, excluded and are the scapegoats of society. And such alliances have been systematically crushed in the past.

It is clear that the ethnocentric position of the United States is self-defensive and thus must not be seen as a mere reversal of the white/black binary logic which has marked race relations in the West. This would be side-tracking the problem. African Americans have turned back to themselves in order to have access to the basic rights of American citizenship: justice, liberty and the pursuit of happiness. But why should black essentialism today be considered a mere going back to Négritude, the 1930s movement which it has been accused of emulating and which has so obviously failed? The explanation for Afrocentrism must lie elsewhere.

Ethnicity has always meant power in the United States not only because ethnic grouping has functioned as a sort of mutual aid society, but also because each group has gained power by controlling certain sectors of the economy. The Jews control the textile industry, the Italians the construction business, today the Koreans the fruit and vegetable business. The Irish Day parade in New York is a folkloric relic of this. Ethnicity is what has traditionally led to inclusion in the American mainstream. Paradoxically, as African Americans seem to be more African-oriented with ethnic clothing, ethnic food and the like, they are actually displaying not their Africanness but their Americanness. This way of regaining self-pride, of empowering blacks living in American society, draws on the American tradition and as such does not break with the dominant discourse. Afrocentrism appears more like a last-ditch effort towards integration according to the rules of American society, following its integrationist model. After all the very name, 'African American' – like 'Black British' – denies essentialism. It clearly implies that they think of themselves as hybrid. They are not negating their 'double consciousness' to use W. E. B. Du Bois's words.

Interestingly enough, criticism of African-American ethnocentrism has come

not solely from the white world. With regard to race and ethnicity, the Black British purport their position to be more open inasmuch as it is pluralist. Black British intellectuals rightly argue that Blackness cannot be fixed and stable, that identities are not continuous, traversed as they are by other events: slavery then or the media today. 'All lives are made of fragments', suggested Black British women in their 1988 anthology *Charting the Journey*. Identities are always constructed, 'black' is a shifting signifier, maintains the cultural critic Kobena Mercer. The cinema language of Isaac Julien is emblematic. It is experimental, made of fragments, more avant-garde than Spike Lee's. The latter's vision has been accused of lacking complexity and it does seem to have entered a dead-end road with his either/or approach. Identities are crossed not only by race but also by the categories of class, gender and sexuality, shows the Anglo-Pakistani writer Hanif Kureishi.

But is it really the search for a black essence on the part of African Americans that has taken the two groups along different routes? Or is it rather the different societies to which they belong? The pluralist or fragmentary approach of blacks on this side of the Atlantic derives from a European post-structuralist, post-modern matrix. Not unlike African Americans, therefore, they are following an endogenous model. This post-modernist road being pursued in Britain leads to the questioning of all identities, including the white one. 'We are all ethnically located', says Stuart Hall.[10] Whiteness, like blackness, is neither pure nor mon-olithic. It must be seen as a racialised identity, if only in terms of the advantage that being white brings with it.[11]

The dominant white groups in both the United States and Britain have quickly responded to these radically different black positions in an eerily similar way. Paradoxically, the two radically diverse positions seem to elicit the same white response. To the African Americans who are making themselves an exception, by saying, 'It's a black thing' or 'You can't understand me', Euro-Americans are answering, 'You can't understand my experience either' – as was to be expected. Whereas in the United Kingdom, against all odds, white Britons have at once caught on to the pluralist proposal. Even if tentatively accepting the Britishness of blacks, they now define themselves as Anglo-Scot or Anglo-Welsh and thus manage once again to be at centre-stage, giving precedence to white hybridity and ignoring the colonial hybrids deriving from colonisation.[12] The barriers of racism shift and mutate to suit the needs of hegemony. The constant in all this is economic power and the key role it has played in the history of racism. The Jews, once discriminated against, have been accepted into the American mainstream. For example, before the dismantling of apartheid in South Africa, Chinese were considered non-whites while the Japanese, because of their investment potential, whites.[13]

Although the American ethnocentric road is fraught with dangers, blackness cannot be abandoned.[14] Blackness, however, must not be equated with black male culture and its attendant sexism and homophobia, nor can it mean the blanket acceptance of all things black.[15] This is a trap which American blacks have fallen

into and in which whites are happy to see them fall. What blackness should mean is pride in black culture, black solidarity and, when necessary, 'buying black'. Both in the United States and in Britain whiteness is played out against blackness and if the place assigned to blacks is at the bottom of the ladder in Western societies, economic and class warfare are essential in overturning discrimination.[16] This should not evoke the spectre of an outdated Marxism, but economic gains: a larger share of the nation's wealth in the hands of blacks would mean progress towards the social justice which they have been denied.[17]

NOTES

1 Marcus Garvey's project for the unity of the Negro peoples of the world faced strong opposition in the United States. See Frank Cass, *The Opinions of Garvey 1910–1920*, London, African Modern Library, 1, 1989.

2 In *No Telephone to Heaven*, Michelle Cliff describes the effects of this practice on a light-skinned Jamaican family (New York, Vintage, 1989).

3 Beverley Bryan *et al.*, *The Heart of the Race, Black Women's Lives in Britain*, London, Virago, 1986, and Shabnam Grewal, Jackie Kay, Liliane Landor, Gail Lewis and Pratibha Parmar, *Charting the Journey. Writings by Black and Third World Women*, London, Sheba Feminist Publishers, 1988.

4 In his autobiography Malcolm X refers to Elijah Muhammad's teachings of how history has been 'whitened' and 'the black man simply left out'. He adds: 'The teachings ring true – to every Negro. You can hardly show me a black adult in America – or a white one, for that matter – who knows from the history books anything like the truth about the black man's role.' Alex Haley and Malcolm X, *The Autobiography of Malcolm X*, New York, Ballantine Books, 1992, p. 174. On the questioning of black allegiance, see Paul Gilroy, *There Ain't No Black in the Union Jack*, London, Hutchinson, 1987, p. 47.

5 Philip Kasinitz, *Caribbean New York. Black Immigrants and the Politics of Race*, Ithaca, Cornell University Press, 1992, pp. 36–37. Multiculturalism 'aiming to bring together the incommensurable still remains elusive today'. George Marcus, Conference held at the École Française de Rome, 17 March 1993.

6 Frances White, 'Africa on My Mind: Gender Counter Discourse and African American Nationalism', in *Journal of Women's History*, Spring 1990.

7 Anne McClintock, 'No Longer in a Future Heaven: Women and Nationalism in South Africa', *Transition*, 51, 1991, p. 104.

8 'Until the early seventies black Americans had the lowest suicide rate in the United States. But now young black people lead the nation in the rate of increase suicide.' Cornell West, *Race Matters*, New York, Vintage, 1994, p. 24.

9 Derrick Bell is the Harvard University law professor willing to give up tenure and his job because no black woman was on the law faculty. See Edward Said, 'Conflitti USA. Politica estera e razzismo. Incontro con Edward Said', in *Linea d'ombra*, 75, October 1992, p. 10.

10 See Kobena Mercer, 'Black Art and the Burden of Representation', *Third Text*, 10, Spring 1990; Hanif Kureishi, *The Buddha of Suburbia*, London, Faber & Faber, 1990; Stuart Hall, 'New Ethnicities', in J. Donald and A. Rattansi (eds), *'Race', Culture and Difference*, London, Sage Publications, 1987.

11 See Vron Ware, *Beyond the Pale. White Women, Racism and History*, London, Verso, 1992.

12 At a 1994 conference on contemporary British culture organised by the British

Council in Istanbul, no mention was made of an Anglo-Indian or an Anglo-Caribbean literature while Anglo-Irish and Anglo-Scot emerged as new categories. Although this can be taken as exemplifying a conservative stance, it is surprising how quickly the conservatives have abandoned the idea of ethnic purity.

13 This was pointed out to me by Etienne Balibar.

14 Not least the risk of total isolation as Cornell West points out. 'If the best of black cultures wanes in the face of black anti-Semitism, black people will become even more isolated as a community and the black freedom struggle will be tarred with the brush of immorality.' West, op. cit., p. 115.

15 Blacks have not criticised the conservatism of Supreme Court judge Clarence Thomas as they would have, had he been white. Feature articles by major black and white publications on black women writers indiscriminately lump together Toni Morrison, Alice Walker, Toni Cade Bambara and Terry McMillan, negating their individualities and their different literary worth.

16 More evident today in the US since there is a greater diversity of white-skinned ethnic groups. As Toni Morrison affirms, the presence of blacks in the US has 'shaped the body politic, the constitution and the entire history of the culture' and 'the very manner by which American literature distinguishes itself as a coherent entity exists because of this [Africanist] unsettled and unsettling population'. Toni Morrison, *Playing in the Dark*, New York, Vintage, 1992, pp. 5–6.

17 This perception is clear in Toni Morrison's *Sula*, London, Triad/Granada, pp. 12–13. It is also clear in the name Spike Lee has chosen for his film company 'Forty acres and a mule': the prize blacks were promised, but never received, for fighting on the Union side in the American Civil War.

Part III

FRONTIER JOURNEYS: THE SPACE OF INTERROGATION

10

BETWEEN TWO SHORES

Lidia Curti

. . . for me fiction is the stitch masking the wound, the gap between two shores.

<div align="right">Leila Sebbar</div>

Some images

Two women with the same face, one in a sordid hotel room in New York, the other at the back of a car passing the frontier to the imaginary country of Annexia: both women place a glass on their heads as the target for a man's gun. In both cases the woman is hit and dies. The glass rolls to the ground without breaking.[1]

A country in Africa. A silent, absent woman, who does not remember her name ('everything's lost' is her only reply to all questioning), has no luggage or money but only a passport in the name of Katherine Moresby. A taxi takes her to an hotel where somebody is waiting to send her home. The colonial officer who is with her gets out of the taxi and enters the hotel; a few seconds later, when people come out to fetch her, they find it empty. Not too far off, a streetcar full of people can be seen slowly mounting the ascent towards the Arab district, the end of the line.[2]

Aicha Qandicha, the fierce blue-breasted goddess who hangs around springs and wells and steals men's souls . . . She appears to men, never to women who, however, are very afraid of her. She will call you from behind, often in the voice of your mother. If you turn around, you are lost as she is the most beautiful woman and once you look at her you have no power against her . . . 25 years ago 35,000 men in Morocco were said to be married to her. A lot of the people in Ber Rechid, the psychiatric hospital, are married to her.[3]

DEATH AND THE FEMALE TRAVELLER:
MALE VISIONS

Jane Auer Bowles, born in New York in 1917 of Jewish-Hungarian family, spent half her life in Tangier and died in a psychiatric institution at Malaga in 1973. She was a nomadic writer, in some ways a typical American intellectual, like – and at the same time unlike – other occidental women writers, who in the first half of this century went to Europe, particularly Paris, in search of their art and themselves. From a very early age she moved between New York and Paris, California and Mexico, North and South America.

In spite of this, her relationship to travelling is a mixed one, as is clear from her works. In the same way, love–hate, attraction–revulsion are the contradictory impulses that govern her relationship to writing, and bring about the writing block that was to afflict her. Her stories are reflections on travel rather than straight travel tales; descriptions of metaphorical journeys through sexual ambiguity and towards otherness.

She travelled widely, but more than anything she was *observed* travelling by the male gaze. Paul Bowles, her husband, friend and fellow traveller was the participant observer, as well as contemporary writers such as William Burroughs, Truman Capote, Tennessee Williams, Gore Vidal and others. More recently that 'observing' eye has been transformed into a camera, it being in contemporary cinema that portraits of hers can be found. I am thinking here of Bernardo Bertolucci's *The Sheltering Sky*, based on Paul Bowles's novel (1949), and of David Cronenberg's *Naked Lunch*, after the novel by William Burroughs (1959). In the latter film the literary derivation is more oblique, and it refers to other works by Burroughs as well as to general aspects and themes drawn from his life. The leitmotiv of *Naked Lunch* is the process of writing and the problem of the authorial block, somewhat buried in the novel and made more explicit by Cronenberg.[4] Further, contrary to Burroughs, he considers the presence of women in his films essential. One of the changes in the film in fact is the dilation of the female figure who in the novel is very tangentially present and thus summarily dispatched:

> In Cuernavaco or was it Taxco? Jane meets a pimp trombone player and disappears in a cloud of tea smoke. . . . A year later in Tangier I heard she was dead.[5]

The person Burroughs is referring to can be identified as Jane Bowles, whom he had repeatedly met in Tangier. Many years before her death, she is given as dead, under the dictates of Burroughs' poetical vision and perhaps under the influence of the news of her serious illness. The sentence seems to suggest a moral judgement, surprising in an anti-conformist who keeps company with 'wild boys'. Even stranger is that her loose ways are depicted as heterosexual since Jane in her turn prefers 'wild girls': Helvetia, Nora, Cory, Frances, Martha and Cherifa.

This distorted vision of Jane's sexual promiscuity is common to both Paul Bowles's novel and Bertolucci's film, where the encounters taking her away from her partner are heterosexual from the outset. Ethnic diversity, which in Burroughs is only hinted at, is here underlined:

> The young Arab who had told her the name of the other bordj walked by as they sat on the floor eating. Kit could not help noticing how unusually tall he was, what an admirable figure he cut when he stood erect in his flowing white garment.[6]

Though denying that the novel is autobiographical, Bowles admits that his wife Jane has been the inspiration for the heroine. The novel is centred on Port and Kit, an American couple travelling in Africa with their friend Tunner, who eventually becomes Kit's lover. The Sahara is the great adventure with a bitter ending. Port dies from typhus and Kit joins a passing Arab caravan led by the attractive Belqassim, becoming his lover and slave. In the end, driven away by his wives' jealousies, she drifts to despair and ruin, and then finally to the 'disappearance' predicted by Burroughs.

In Bowles's novel, the most important thing for the heroine is to escape the Western world and what she has left behind.[7] This is the sense of her final flight: on hearing that Tunner is waiting for her at the hotel, she decides to lose herself in nothingness, the nothingness that is the Western signifier for losing yourself: 'going native'. The desert, as the zeroing of the ego and/or a new beginning from zero, is the essential metaphor of this vision. Kit's voluntary annihilation starts very traditionally in her sexual enthralment with her Arab lover. Once more it is the woman who becomes the sign and symbol of such vision.

The attraction of ruin and death is often represented as female. Edward Said sees in this association one of the common traits of centuries of 'orientalism'.[8] As Meyda Yegenoglu notes, '. . . the process of Orientalisation of the Orient is one that intermingles with its feminisation'. She further stresses that 'the typography of femininity as enigmatic, mysterious, concealing a secret behind its veil is projected onto the iconography of the Orient'.[9] The novel and the film can be considered part of the historical and literary vision of the West's fatal attraction for the Arabian world, an essential aspect of the construction of the East that includes both the intellectual image found in the modernist avant-garde and the popular icon of the Arab in mass culture, from cinema to cartoons. In their representation of ethnic diversity, both Bowles and Bertolucci are not too distant from this icon. Deborah Root severely defines the film a 'colonialist nightmare' and a parody of desert adventure films, like *Lawrence of Arabia* and other spectacular versions of exotica.[10]

Again in Cronenberg's film the image of 'woman' is associated with death, though this time the colonial African city is very much in the background. The female character is a double representing two real figures: Joan Vollmer, William Burroughs' wife, killed by him in Mexico City in an accident similar to the one described in the film, and Joan Frost, wife of the writer Tom, both living in

Tangier and recalling Paul and Jane Bowles – the latter metaphorically also killed by Burroughs, at least in his novel. The film is inspired by the mythology of the American beat poets who were in Tangier with Burroughs in those years, and places Jane/Joan at the centre of this group. There is no proof that the inspiration of this character goes back to Jane Bowles: Cronenberg does not acknowledge it in his first interview on the film but, on the other hand, there are many concrete details from her life, and Paul Bowles's *Conversations* are repeatedly used.

It is not important to verify how and where fiction draws from reality in this case, or anticipates it in the novels. It is almost as though this group of people were writing the scripts of their lives. In an unreal play from one dimension to the other, reality metamorphoses into fiction in temporal and spatial anticipations. The foreboding in Bowles's novels, mostly written before Jane's arrival in Africa, are an uncanny instance of this, just as the horrid prevision of Jane's death was in Burroughs. An even stranger coincidence occurs with the obsessive images of typewriters in Cronenberg's film. For during the unhappy years of her illness Jane became more and more dependent on them, due to her progressive inability to speak and write. The writing block is a further link, even though in the film it refers to male characters.

The actress Judy Davis is reminiscent, in her features, expressions and dahlia-shaped hairstyle, of photographs of Jane. The drugs and alcohol, the sexual promiscuity, this time openly bisexual, and the unconventional personality, recall her while contributing to an image of the *femme fatale* so dear to *maudite* literature. From the outset the female icon is related to drugs and to literary inspiration. The hero Bill Lee, like Burroughs at one point, is a bug killer, an exterminator, and also 'the exterminator of all rational thought'. In the very first scene confronting the abominable speaking creatures, he finds himself without the essential insecticide powder. Soon after he discovers his wife in the act of injecting herself with it as she, like the creatures, has become addicted to the poison. From that moment the image of the giant bugs is linked to the woman in Bill's gesture of smearing the powder both on her mouth and on the animals' talking sphincters. Woman, writing and monstrosity are an inextricable triangle in Cronenberg's oneiric 'nightmare'.

There are further references to real events in Jane's life: her wanderings in the Casbah, her obstinate will to 'penetrate' the Moroccan world and culture, and, more importantly, her tie with a Moroccan woman she meets in the market. Cherifa, here called Fadela, is an important figure in the film, again a duplicitous icon alternating between feminine Arabian attire and masculine Western riding habit or colonial uniform. By representing magic, cruelty, transvestism and sexual ambiguity, she embodies crucial aspects of the film-maker's imaginary that have then become dominant in the more recent *M. Butterfly*. Fadela, divesting herself of her skin and coming out of her woman's body as Dr Benway (the actor Roy Scheider) – 'the manipulator of symbol systems' (Burroughs) – is a crucial image of this male/female split and the turning-point in the film *Naked Lunch*. Here the tie between the two women is not foregrounded, as Joan and, in

126

a different way, Fadela, are seen as symbolic mediators of anguished male artists such as Burroughs/ Bowles/ Cronenberg.

Bill is William Tell. The woman's death is brought about by a re-enactment of the apple game: she docilely places the glass on her head, he shoots and hits her, while the glass falls to the floor and remains intact.[11] But he is also Orpheus in search of his Euridice, who loses her for turning back, while he is taking her from the dangerous interzone to the safety of a utopic world, but actually exchanges her for his newly found inspiration. Writing is connected to the elsewhere, to death and woman. Both plots in the film end with the writer in crisis killing the woman. He loves her but must kill her so as his writing can exist: 'once in a lifetime, a man has to do a girl in', as T. S. Eliot's line goes.

A final image – San Francisco, May 1994

City Lights, San Francisco's famous bookstore, founded by Corso and Ferlinghetti in the 1950s, one of the intellectual centres of the city and monument to the poets of the Beat generation. On the first floor, a sort of sanctuary dedicated to the founding fathers, a picture representing five men on the beach at Tangier in 1959 can be seen. The five bodies – Kerouac and Orlovsky standing, Burroughs lying down, two Moroccan (wild) boys in the background and Ginsberg behind the camera – seem organised around an empty centre, an absence, a ghost, the ghost of a woman haunting the modernist imagination.

AN AFRICAN WITCH

'This Nazarene,' said Zodelia, gesturing in her direction, 'spends half her time in a Moslem house with Moslem friends and the other half in a Nazarene hotel with other Nazarenes'.

Jane Bowles, *Everything is Nice*[12]

I continue loving Tangier – maybe because I have the feeling of being on the edge of something that I will some day enter.

Jane Bowles, *Letters*, August 1948[13]

Jane Bowles arrived in Tangier at the beginning of 1948 to join Paul, who soon after left for New York to write the music for Tennessee Williams' *The Glass Menagerie*. Jane's long letters to Paul in this first period describe the fascination that Africa held for her:

The view of the Arab town from my window is a source of endless pleasure to me. . . . Here there's the water and the sky and the mountains in the distance and all the blue in the Casbah; even in the white, there's lots of blue. The grain market is blue – blue and green.[14]

What charmed and magnetised her was the difficulty of penetrating that culture. It engaged her in a long and slow battle that never ended. Her acquaintance with

two African women, and her attraction to one of them, is the emblematic initial *coup de foudre* and essential part of that drive: 'Perhaps I shall be perpetually on the edge of this civilisation of theirs. When I am in Cherifa's house I am still on the edge of it, and when I come out I can't believe I was really in it.'[15] The two women are Cherifa, who wears no veil and sells grain in the market, 'my little Cherifa, who is about twelve years younger than myself', and Tetum described at first as 'the older "Mountain Dyke", that yellow ugly one'.

> so God knows I'll probably stick around here forever, just for an occasional smile from Tetum or Cherifa. I wrote you how exciting it was to feel on the edge of something. Well, it's beginning to make me very nervous. I don't see any way of getting any further into it, since what I want is so particular (as usual); and as for forgetting them altogether, it's too late.[16]

Jane is obsessed by the grain market in which Cherifa has her stall, tormented by a social structure that she cannot quite understand, and by the tension of not being accepted. Her attitude towards the Arab world is mediated by the romantic possibilities she has found in it; all her letters express the difficulties of the relationship with Cherifa and of its beginnings with pressing anguish: 'I still have a dim hope that if I learned to speak Arabic she would be friendly maybe and I could sit in the hanootz with her when I chose to.'[17] Soon her Arabic improves and so does her social life with the women in the market: Tatum, Zodelia, Cherifa and Quinza. She takes them to the doctor, gives them all her scarves and money, and in exchange gets to be called 'sister'. This good moment is accompanied by one of the rare joys about her writing, as she has finished *Camp Cataract*, 'the best thing I've ever done', soon followed by the pain of the impossibility to go on writing attributed to the state of suspension she is in. Only in 1954 will Cherifa go and live with her, and even then her mysterious diversity will still baffle and torment her, as she says in a long, unusually intimate, letter to her friends Natasha and Katherine:

> I waited and waited before writing because foolishly I hoped I could write you: 'I have or have not – Cherifa.' The awful thing is that I don't even know. I don't know what they do. I don't know how much they feel . . . So hard to know what is clever manoeuvring on her part, what is a lack of passion, and what is fear . . . She is terribly affectionate at times and kissing is heaven.[18]

She describes moving forward, and sometime backward, in her cautious sexual approaches, as the threshold between tenderness and sex is unclear in the other culture, and she realises that Cherifa will yield mostly to please her rather than out of her own will; also, how important it is to have enough money:

> I love this life and I'm terrified of the day when my money runs out. The sex thing aside, it is as if I had dreamed this life before I was born. Perhaps I will work hard to keep it. I cannot keep Cherifa without money, or even myself, after all . . . I think of her in terms of a long time. How one can do

this and at the same time fully realise that money is of paramount importance . . . I simply don't know . . . Yet they are not like we are. Someone behaving the same way who was not an Arab I couldn't bear.[19]

The period that follows is the happiest in her life as she feels more integrated in that world. In spite of occasional violent clashes with Cherifa, the tension is over but it all has a short life. Towards the end of April 1957, at the age of 40, during Ramadan – which she always tried to observe – Jane has a stroke of uncertain nature, marking a step forward in that slow and painfully conscious journey towards the writing block and the mental deterioration, a journey that overlaps with all her other journeys. It was ten years after her first arrival in Africa, the events of her life seem to follow a ritualistic rhythm linked to the number seven.

From that moment the slow decline in her health goes with the substantial deterioration of the ménage, that includes part of Cherifa's large family, and the maid Aicha with her child. This Arab 'family' does not exclude her husband who is always in close proximity. Such coexistence is part of the extraordinary alchemy of her social life. It had already occurred with Jane's other lovers, particularly with Helvetia Perkins in New York at the onset of her marriage, but in this case it is more difficult because of the bad relationship between her two partners: Paul has accused Cherifa of manipulating and exploiting Jane, and after her death, like other common friends, of having slowly poisoned her.

In spite of the limits inherent in the relationship and added difficulties – its initial romanticism is soon submerged by the misunderstandings and the banalities of everyday life, the sexual liaison seems to be over after only two years, and Jane's interests in other women follows – their attachment uncannily survives. She goes on wanting to live with Cherifa who, in her turn, consents to going back to her even between one hospitalisation and another. Jane must have felt a deep sense of guilt for isolating her from her own culture (a responsibility that she never evaded, providing for her until and after her death) but this cannot be the sole explanation. For Jane living in Tangier means being with Cherifa, and Cherifa is the essential condition for making Tangier a sort of home.

Many voices have been heard on their relationship, those of Paul and Ahmed, of Jane's mother, and of Martha, a later lover, and they all speak of the very bad influence it had on Jane. Truman Capote says:

> The late Mrs Bowles lived in an infinitesimal Casbah house . . . with her Moorish lover, the famous Cherifa, a rough old peasant woman . . . an abrasive personality only a genius as witty and dedicated to extreme oddity as Mrs Bowles could have abided.[20]

Cherifa's voice is hardly ever heard, and if so indirectly: in pictures a few rare images of a woman with a set, unsmiling face, in European clothes; in writings a few sentences and reactions always related by hostile onlookers. Absent from Jane's letters as she was illiterate, she is the one voiceless ghost in a highly literate world, demonised and described as a witch.

The image of the witch or the malevolent goddess is a constant presence in African tales. The uncanny, the heart of darkness, is linked to the woman with magical powers, whether these are good (and then she has the power to heal, and is called a doctor) or bad (and then she is a witch). In Paul Bowles's interviews and diaries, Aicha Qandicha, the fierce Stone Age goddess described in one of the images above, a Moroccan version of Astarte, is often evoked. Cherifa, presented as the maid, is also recalled for her magical powers:

> 'this rather evil maid we had here gave her something . . . This maid was a horror. We used to find packets of magic around the house. In fact, in my big plant, in the roots, she hid a magic packet. She wanted to control the household through the plant. The plant was her proxy, or stooge, and she could give it orders before she left . . . A monster, a real monster. I could show you pictures of her that would freeze you.[21]

Once again the equation of woman and monster appears.

Additions to the tale were provided by Paul's Moroccan partners, whose close relationship to Jane coexisted with hostility towards their fellow countrywoman. In a recent interview given to Soledad Alameda and published in *El Pais* in 1990, Paul irritatedly replies to the usual annoying questions about Jane that such practices are very common in Africa, and that in any case what really killed Jane was alcohol; but the bewitched plant comes up again (it will reappear in Cronenberg's film). Unexpectedly, however, in this case he remembers the vision he had of Cherifa the first time he saw her: 'There she was, in the big straw hat with ribbons that the farm women wear, in a red and white striped apron. She had very wild eyes. . . . She said she was a saint, a virgin, that she had certificates to prove it.'[22]

'The bride is arriving' is a sentence that Cherifa is said to have pronounced when Paul and Ahmed send her away on Jane's return from the psychiatric hospital; it is a sarcastic pronouncement, brutal and at the same time revealing a subaltern condition. This kind of 'witch' was colonised twice: as the other, mirror of unattainable desire; and as the mistress, the eternal third party, mistress in relation to the husband Paul, mistress in relation to the 'bride' Jane.

THE JOURNEY TOWARDS SILENCE

Much has been written on the contradictory impulse present in travelling: the pull between the reinforcement and the loss of identity, clarity and mystery, knowledge and its refusal. It is a spiral movement – like that of Don Quixote, the baroque hero – rather than the linear progress of most accounts of travel. The wanderings of the subversive and the rebel, of the sick and the mad have always been placed outside the genre.

It is the spiral dialectic of travelling, rather than the linearity of narrative, that is fundamental to Jane Bowles's writing. This is perhaps paradoxically why her work cannot be strictly defined as travel writing. In her only finished novel *Two*

Serious Ladies and in her short stories, most of her characters are torn between the desire to go and the need for stability, between the necessity and hate of travel, the compulsion to face the unknown and a substantial repulsion for it. The two serious ladies of the novel are both travellers, but while Mrs Copperfield goes to Panama as a tourist and stays there, Miss Goering only moves to an island not far from home. Both reflect all the time on their contradictory attitudes to travelling. In both cases, travelling leads to romantic involvement. Christina Goering's minute movements are tied to tormented moral choices; she has created attachments from which she has fled, and has been on the threshold of absurd adventures with improbable men from which chance, or the blind fate that is guiding her, has mostly protected her.[23] Mrs Copperfield in Panama meets a young woman named Pacifica. She goes to live in the dubious Hotel de las Palmas owned by the bizarre Mrs Quill who becomes her friend, and eventually leaves her husband for Pacifica.

For the two women, as for Jane Bowles herself, travelling, leaving the safe shelter of their culture and home, is a moral imperative; Miss Goering repeatedly expresses the pains of this conflict. As soon as her *ménage à quatre* is established she feels the urgency to leave it.

> She decided that it was already necessary for her to take little trips to the tip of the island, where she could board the ferry and cross back over to the mainland. She hated to do this as she knew how upsetting it would be . . .
> 'It is not for fun that I am going,' said Miss Goering, 'but because it is necessary to do so.'[24]

The same contradiction – the urge to go and the need to stay – will tear apart other characters in the novel, mirroring the same division the young Jane must have felt in parting from the conventional rules of married life. In *Everything is Nice*, the 'strangeness' and the charm of the blue Muslim town on the edge of the sea, where Janie meets Zodelia and the other Arab women, is strongly felt by Jeanie, but on the other hand she still clings to the old world and her life is split in two separate halves. In *A Guatemalan Idyll*, the American traveller (he is never identified in any other way) is torn between a revulsion for the other place and the many attractions it has for him. The sexual involvement with Senora Ramirez and the burgeoning romance with Senorita Córdoba are accompanied by a deep sense of guilt, followed by the relief of escaping to his old world.[25]

Even when there is no actual travel, there is a little movement, a transit, a day trip, a temporary distancing from your usual milieu, or the attempt at one, as in *A Stick of Green Candy*, or in *Plain Pleasures*. In the former tale the reflection on travel is carried out by Alva Perry and her neighbour John Drake, who both love simple pleasures, like baking potatoes on a fire in the backyard; she talks about her restless sister Dorothy Alvarez.

> I warn Dorothy every time I see her that if she doesn't watch out her life is going to be left aching and starving on the side of the road and she's going

131

to get to her grave without it. The farther a man follows the rainbow, the harder it is for him to get back to the life which he left starving like an old dog.[26]

Despite this, Alva decides to accept John's invitation to eat out, gets drunk and stays overnight at the hotel in a room offered by its seedy proprietor, thus taking on her sister's identity. On the following morning she will not remember anything except a great feeling of tenderness for her neighbour who, once left alone, has gone away in frustration. '"John Drake", she whispered. "My sweet John Drake."'[27] At least for once, the trip has had an unequivocal liberating effect, though in a bizarre direction as Alva has probably slept with the wrong man. Both she and the reader do not know if that is the case: she does not remember anything on the following day, and Jane Bowles's reader is far from being omniscient, in fact most of the time is actually kept in utter darkness. Sex is an important element in all her works, even if perversely signalled by its absence.

Even in her play *In the Summer House* (1954), that takes place in southern California, there is a constant brooding on going away and travelling. Gertrude leaves for Mexico with her second husband, Mr Solares, but hates it and comes back to her daughter Molly. Lionel always dreams of getting away from the cocktail bar where he and Molly work, and will finally do it in order to free Molly from her past and her mother's dominance. Again he speaks about the difficulty of leaving, and at the same time, the dread of staying:

> They are harder to leave, Molly, places that don't work out. I know it sounds crazy, but they are. . . . I can explain it all in some other way. (*Indicates oyster-shell door*) Suppose I kept on closing that door against the ocean every night because the ocean made me sad and then one night I went to open it and I couldn't even find the door. Suppose I couldn't tell it apart from the wall any more. Then it would be too late and we'd be shut in here forever once and for all.[28]

This rupture – between the acceptance and the refusal of the journey, between heterosexual and homosexual love, and between other indistinct, inexpressible contradictions – is reflected in fragmentary narrative structures, in the obscure, elliptical language of a writer who is never afraid of appearing difficult to understand. Her strong elliptical style seems to be moving towards silence, constantly verging on it. King-Kok Cheung notes how in women's writing silences may be due to choice: '. . . silences – textual ellipses, nonverbal gestures, authorial hesitations (as against moral, historical, religious, or political authority) – can also be articulate. The art of silence, on the other hand, covers various "strategies of reticence" . . . used by women writers to tell the forbidden and name the unspeakable.'[29] In Jane Bowles's case, there is the refusal to appear as the voice of truth: 'To undercut narrative authority they frequently resort to such devices as dream, fantasy, and unreliable point of view; or even project their anxiety as authors onto demented characters.'[30]

The main tension in her narration comes from the split between the 'here and now' and the need to escape everyday life, that is, in the sudden alternating movement between abstract allegorical situations and minute, realistic details. This is one of the reasons why her works escape strict genre definitions, whether it is autobiography or travel writing. A good example of this is the disquieting relationship in *Two Serious Ladies* between Christina Goering and Miss Gamelon, her governess, and the description of their domesticity. It is in this juxtaposition that lies the original and peculiar character of her art, whose difficulties lie precisely in the unresolved tension between the necessity and the impossibility to leave everyday life.

Jane Bowles's writing is in many ways related to the events in her life but is never strictly autobiographical.[31] In *What does a woman want? Reading and Sexual Difference*, Shoshana Felman speaks of the impossibility for a woman to write her own autobiography. Jane has neither really written hers nor has wanted to write it. She was always in search of an unreachable objective correlative that would make her experiences 'concrete' and objective, distancing them from herself. And yet her writing is related to her travels in so many ways. Jane took her first novel *Le Phaeton Hypocrite*, written in French, to Paris to get it published and lost it there; many of her pages were either forgotten in a taxi or flew out of the window, according to what Paul says in one of his 'conversations': 'One time about 300 pages blew out the window, a novel she was writing in Mexico City.'[32]

She always wrote in utter solitude, except for the novel which was revised with her husband: this is mainly why she felt it was not what she had wanted it to be. From the start her relation to writing was extremely conflictual. In a short biography she dictated in 1968 for *World Authors*, she spoke of the torture of having to write school papers: 'I always thought it the most loathsome of all activities, and still do. At the same time I felt even then that I had to do it.'[33] She ends the biographical sketch by again connecting travel to writing: 'From the first day, Morocco seemed more dreamlike than real. I felt cut off from what I knew. In the twenty years that I have lived here I have written only two short stories, and nothing else.'[34]

With few exceptions (Williams and Capote among them), her works met largely with bemused reactions, all of which added to her solitude.[35] She herself had a detached, cold stance towards Carson McCullers, Djuna Barnes and other women writers and was rarely acknowledged by them. Her attitude is surprising as women have an all-important role both in her works and in her life, and may be explained by her sense of exclusion. In 1966, when the *Collected Works* were published, largely against her will, Carson McCullers wrote a congratulatory letter: 'your curious, slanted and witty style has always given me boundless delight. I am so pleased to know that a new and bigger audience can share my pleasure. Anyway, darling, bless you and thank you for your writing.'[36] Jane replies that had she known she would have asked her to write a blurb for the book. Then, according to the friend typing the letter for her, she is seized by emotion and falls silent.

As she said, after her arrival in Africa she will write only two short stories; she also finishes the play started in New York, and starts an ambitious autobiographical novel *Out in the World*, of which only notes and fragments remain. Her writing block coincides with her final encounter with the elsewhere which, in a mysterious correspondence with writing, is tinged with insecurity, confusion, uncertainty. Jane's conflictual relationship with writing – love–hate, acceptance–refusal, sense–nonsense – is reproduced in Mrs Copperfield's liaison with Pacifica that strangely anticipates Jane's with Cherifa, again with the curious inversion of the link between life and art.

All this is made more complex by the very intricate knot uniting Jane's writing to her husband's. Paul Bowles, a composer of considerable fame in the 1930s and 1940s, gave up music for writing after collaborating with Jane in the revision of her novel: 'It was this being present at the making of a novel that excited me and made me want to write my own fiction.' In another interview he says, 'I got really interested in the whole process, and thought, I wish I had written this book.'[37] In 1964 he wrote and published *Up Above the World*, a title recalling that of the novel Jane would not be able to finish. She is out of the world, he is up above it and everyday life: that everyday life that prevented her from writing, as happens to many women writers, that very same everyday life underlying, like a subterranean and unexpected vein, the great themes of sin and salvation that made her art so singular and genial.

THE JOURNEY TOWARDS PERDITION

> . . . who is the other woman? How am I naming her? How does she name me?
> Gayatri Chakravorty Spivak

The ghost wandering in the male authorial universe around Jane Bowles is that of her lesbian identity, a ghost that she has never really faced herself. In her published letters, it is a subject never hidden but neither discussed, always touched upon tangentially, as in the first joking description of the women's reactions in her family (her father had died when she was 13):

> they all sat down and said what a wonderful girl I was . . . – and that I was a grand normal girl – and that this Lesbian business was just an adolescent phase . . . and that if only I didn't have such an analytical mind I certainly would throw it off. . . .
> Aunt Flo suggested 130 men to straighten me out – Aunt Connie 135.[38]

Sexual ambiguity, in Jane Bowles's works, is often associated with ethnic difference. Her novels deal with the uncertain and ambivalent relationship between two or more women, in the background of racial hybridity. This is the case of Mrs Copperfield and Pacifica in *Two Serious Ladies*, or Gertrude and Mrs Lopez, who is constituted as the 'positive other' in the play. The encounter between Zodelia and Jeanie in *Everything is Nice* stresses the hybridity in a curious inversion of

roles and voices; the Arab woman gives a little histrionic show, imitating Jeanie telling a woman friend she has just met (a play of mirrors?) about her split life:

> 'Good-bye, Jeanie, where are you going?'
>
> 'I am going to a Moslem house to visit my Moslem friends, Betsoul and her family. I will sit in a Moslem room and eat Moslem food and sleep on a Moslem bed.'
>
> 'Jeanie, Jeanie, when will you come back to us in the hotel and sleep in your own room?'
>
> 'I will come back to you in three days. I will come back and sit in a Nazarene room and eat Nazarene food and sleep on a Nazarene bed. I will spend half the week with Moslem friends and the other half with Nazarenes.'[39]

This short delicate tale on a casual meeting between two women, a sort of interlude rather than a proper short story, touches the essence of Jane's life and writing, with her inability to live in either of the two worlds. As she says in the self-parody enacted by Zodelia, she will be living in neither place, neither in the concrete nor in the abstract, neither with the other nor without her. Zodelia/ Cherifa miming the other, the Western woman, is only the inverted image of the writer who, in her tales, 'mimics' the other woman, the foreigner, whether Arabian, Mexican or Guatemalan, by recreating her in fiction.

The relationship is not always tied to ethnic diversity, as in the case of Gertrude and Molly in the play, or of the two 'serious ladies' in the novel, but it always has a hybrid, 'interzone' character. In her works the difficulty, and at the same time absolute importance, of the relation between women is often a question of life and death. The younger sister in *Camp Cataract* will disappear behind the waterfall after she realises her sister is not going back with her, Mrs Copperfield changes her life for another woman, Gertrude and Molly have both killed the other woman – the killing is ritual but also real – and are tied by a heritage going from mother to daughter. This is always associated to the travel theme: the difference between the two sisters in *Camp Cataract* is mainly due to the fact that one wants to go and the other wants to stay, that one can live without the other (in fact needs to live away from her) and the other cannot. The inhumanity of those who travel and do not know any longer where their souls are is faced with the impossibility to survive for those who stay. The independent and the dependent are probably one, in an ambiguous tie. The multi-layered, confused, contradictory relations between women constitute the risky, dark journey without a port of call, the unfillable gap between two shores.

This fascination for the elsewhere is ultimately tied to a death drive.[40] In *Everything is Nice* Jeanie, after Zodelia leaves, goes over to the wall where they had met and leans on it.

> Although the sun had sunk behind the houses, the sky was still luminous and the blue of the wall had deepened. She rubbed her fingers along it: the

wash was fresh and a little of the powdery stuff came off. And she remembered how once she had reached out to touch the face of a clown because it had awakened some longing. It had happened at a little circus, but not when she was a child.[41]

Like the face behind the powder, the other always recedes into the shadow. Pacifica invariably has some young boyfriend to go back to. Cherifa escapes her and never really yields to her, Zodelia and her group of women never abandon a condescending and incomprehensible irony towards her. In the end, even for her, Muslim culture is a baffling mystery. For the other, one gives everything up including life. Of the other, one can die.

At the end of her novel, the two heroines meet again in a bar, after having gone their separate ways. Miss Goering sees Mrs Copperfield and Pacifica arrive elegantly dressed in black, one very emaciated and suffering from a skin problem, the other, whom she sees for the first time, very attractive. As Pacifica leaves, Mrs Copperfield confides how important this liaison is, how afraid she is of losing her, and how they will soon be going back to Panama to live together. To her friend who fears she has gone to pieces, she replies:

> I *have* gone to pieces, which is a thing I have wanted to do for years. I know I am as guilty as I can be, but I have my happiness, which I guard like a wolf, and I have authority now and a certain amount of daring, which, if I remember correctly, I never had before.[42]

After her departure, Miss Goering can only hope to lose herself as well. Paradoxically she discovers that salvation, her only interest in life, means going to pieces, the undoing and loss of the self. It seems to be at one with its opposite: perdition.

> 'Certainly I am nearer to becoming a saint,' reflected Miss Goering, 'but is it possible that a part of me hidden from my sight is piling sin upon sin as fast as Mrs Copperfield?' This latter possibility Miss Goering thought to be of considerable interest but of no great importance.[43]

THE CIRCLE IS PERHAPS CLOSED

The circle is perhaps closed: in an oblique play between reflections of subalternity, Jane is the irreducible alterity associated with death by the male look. In this complex knot, as Cronenberg shows, woman must be sacrificed to the flame of male inspiration, consigned to absence and silence and made immortal. Jane, in turn, has constructed the mysterious unattainable other as the space of her desire, the exotic and the archaic as the site of her dream. The thread of lack and desire guides these relationships between gender, ethnicity and subalternity, constituting an alterity sited in obscurity and mystery. As Iain Chambers says:

In absolute difference, the rhetoric of alterity locates a pure otherness waiting to be filled by the presence of our desires, a blank page awaiting our words, like the 'empty' wilderness – from the African *veldt* to the American West – waiting to be settled and domesticated and brought into the redemptive time of our history.[44]

It could be said that Jane Bowles embodies the Westerner's gaze on the other culture, to exercise her power and impress her presence on the subaltern woman, ultimately to possess or try to possess her. She could be described as the accomplice of imperialist discourse, a discourse that, according to Homi Bhabha, does nothing but search, in the analysis of the other, for the construction (and constrictions) of a 'regime of truth'.[45]

Mayda Yegenoglu sees Western women as complicitous in the Orientalist vision and conducts a lengthy analysis of Lady Mary Montagu's *Turkish Embassy Letters* to prove this and polemicise with Lisa Lowe (particularly her *Critical Terrains: French and British Orientalisms*), James Clifford, Mata Lani and others. She sees in this 'feminist' text a supplement to the male vision: 'The Western woman's descriptions of the harem and Oriental women, the supplement, this plus, by the very fact that it substitutes the lack of the Western subject, is also less than the original text.'[46] The opposition is between those who see in women's discourse a difference within male Orientalism – Lady Montagu identifies with Turkish women, adopting their clothes, admires their independence and accuses male accounts of being partial and false – and those who have seen in it merely a substantial re-affirmation of the Orientalist paradigm.[47]

My doubts are on the possibility of establishing the position 'from which one speaks' and of fixing origins and points of view in an unreal discursive coherence that ignores the multiple and shifting sites occupied by the speaking subject. Jane Bowles may have occupied the role of the American intellectual looking for meanings and certainties, evasions and escapes, in the Oriental woman but she never distanced herself from the object that is at the centre of her desire, or found in it that self-assurance that the West pursues in its construction of the Orient. She herself is the object of the gaze, at one with the Arab woman as we can see in many of Cronenberg's *master*-ful shots. The presence of the homoerotic look is such in this case as to make it difficult to distinguish the look of the observer from that of the observed. The difficulty of assigning clear and definite roles is one of the few and fundamental clarities that emerge from her writings.

So, it is with reluctance that I assign Jane to a part in a rigid script, as though a mere illustration of a paradigm. If, in these perceptive analyses, the Western vision of the East and the elsewhere finds a common denominator in the objectification of the other and the constitution of the imperialist subject, then it must be said that Jane Bowles *lives* and seeks the encounter with alterity rather than containing it in analysis; for she locates in it the undoing and the deconstruction of the Subject, thereby transgressing the fixity of that paradigm and confusing its terms.

It is difficult to place her within the tradition that fixes in the East the stereotypes of corruption and mysticism, feminine exoticism and sexual insatiability, crowded markets and magic lore. She did not produce texts that can be included in that genealogy; this is why my emphasis has often fallen on her life as the textualisation of her relationship with the Arab world. Jane Bowles has not offered a 'supplement' to the male vision; after all, she was not the spy from the Interzone. If at all, it is Paul Bowles with his numerous works on Africa who has supplemented her vision with an 'objectification' of the exotic other, however refined and proximate.

She has not confined her fascination for the 'other' woman to the dream alone, to the poetical vision of a black goddess or to an imaginary nymph of exoticism, in the manner of so many Western poets and artists. She lived out this experience in guilt and pleasure, in joy and pain, and drank its chalice to the last bitter drop.

The redemption of her 'little original sin' can perhaps be found in her feeling an integral part of the obscurity and the mystery she was searching for, ultimately in her illness and death. Millicent Dillon, in her biography, quotes a short poem written by Jane in a friend's album when she was twelve. It ends like this: '. . . there's nothing orriginal about me – But a little orriginal Sin.'[48] The sense of this original sin following her in her adult life – her diversity? the diversity of (from) the other? – is here marked by spelling mistakes, those mistakes to which she faithfully returned in the second part of her life, due to her illness, as though to a fatal and unavoidable appointment. The journey towards silence had started with the interruption in writing; it proceeds to illiteracy, the last mimesis with the Other.

NOTES

1 From *Naked Lunch*, a film by David Cronenberg, produced by J. Thomas, with Peter Weller, Judy Davis (Joan Lee and Joan Frost), Ian Holm, Julian Sands and Roy Scheider, 1991, based on the book by William S. Burroughs. The music is by Howard Shore.

2 From *The Sheltering Sky*, a film by Bernardo Bertolucci, with Debra Winger and John Malkovich, 1989, based on the book by Paul Bowles. The music is by Ryuichi Sakamoto, Paul Bowles appears as the narrator.

3 See P. Bowles, *Conversations*, ed. G. D. Caponi, Jackson, University Press of Mississippi, 1993, pp. 79, 104.

4 '. . . I wanted it to be about writing: the act of writing and creating something that is dangerous to you.' Chris Rodley (ed.), *Cronenberg on Cronenberg*, London & Boston, Faber & Faber, 1992, pp. 164–165. The fatal dangers connected to writing, the vision of imagination as a disease become physically present in the film: the giant centipedes, the Mugwumps, the Sex Blobs, the giant bugs mutating into typewriters and vice versa – all speaking through anus-like mouths – are potentially harmful creatures who represent, and at the same time defend, the dangers of the imagination.

5 W. Burroughs, *The Naked Lunch*, London, Corgi Books, 1969, pp. 37–38. That pimp and trombone player (probably Mexican) must be a western obsessive image for the white woman's seducer. It moves from high to popular culture as well as across genres. Italian consumers of both popular journalism and television saw 'the monster'

resurrected in the recent case around the disappearance of a young Italian tourist, Ylenia Carrisi, in Spring 1994 – only this time it was New Orleans and he was Jamaican. His image filled Italian screens with a frequency similar to that of O. J. Simpson on U.S. screens more or less at the same time. In this case the uproar was linked to her being the daughter of the quite famous (at least in Italy) pop music couple, Al Bano and Romina Power (the Hollywood actor's daughter), and the accusations were prompted by her father first of all.

6 P. Bowles, *The Sheltering Sky*, New York, Vintage Books, 1977, p. 190.

7 'They would spare no effort in seeking her out, they would pry open the wall she had built and force her to look at what she had buried there', ibid., p. 320.

8 'The Oriental was linked thus to elements in Western society (delinquents, the insane, women, the poor) having in common an identity best described as lamentably alien.' Edward Said, *Orientalism*, Harmondsworth, Penguin, 1978, p. 270.

9 M. Yegenoglu, 'Supplementing the Orientalist Lack: European Ladies in the Harem', *Inscriptions 6, Orientalism and Cultural Differences*, 1992, respectively p. 48 and p. 49.

10 D. Root, "Misadventure in the Desert: *The Sheltering Sky* as Colonialist Nightmare", *Inscriptions 6, 'Orientalism and Cultural Differences'*, 1992, p. 95, n. 2. The essay comments on the association of the exotic with sexuality: 'Irrationality, savagery, violence, chaos and death: the "native" man brings these to the white woman, yet for Bowles it is also Kit's sexuality that is her enemy, something that is at some level "alien" and destructive to her as the "native" . . .', ibid., p. 89. This point, with the one made by Yegenoglu about the Oriental woman as the symbol of the secret and the obscure, finds a correspondence in Jane Bowles's description of her Arab lover.

11 It seems that in reality the game was a more risky and cruel one and somewhat closer to the model since there may have been a child involved; a version goes that William Burroughs did not place an apple (or a glass) on his wife's head but their infant child, named William after his father. Thus he was at one and the same time aiming at himself and at his progeny, the 'apple' of his eye. This is how the fatal accident was related, or at least interpreted, by William Burroughs Junior, a drug addict and alcoholic who died an early death. I owe this information to Richard Wolhfeiler, a friend of his while he lived in Santa Cruz.

12 In *The Collected Works of Jane Bowles*, with an introduction by Truman Capote, New York, The Noonday Press – Farrar, Strauss and Giroux, 1966, p. 317.

13 *Out in the World – Selected Letters of Jane Bowles 1935–1970*, ed. M. Dillon, Santa Barbara, Black Sparrow Press, 1985, p. 85.

14 Ibid., pp. 81, 82.

15 Ibid., p. 85.

16 Ibid., p. 93. Tetum is the 'husband' in a small harem, first accepted as a necessary complement to Cherifa, then loved in spite of the cynical initial description, and, once her liaison with Cherifa is established, slowly forgotten.

17 Ibid.

18 Ibid., pp. 177–178.

19 Ibid., p. 180. Jane was always very lucid and clear on financial matters, not unlike most of her characters. Miss Goering in *Two Serious Ladies* is particularly aware that money is the main mediatory link between her and the other but is never put off by that.

20 Quoted in M. Dillon, *A Little Original Sin, The Life and Work of Jane Bowles*, London, Virago, 1988, p. 286. Malek Alloul in *The Colonial Harem* (Minneapolis, University of Minnesota Press, 1986) observes that the Oriental look is always neglected. The book collects the postcards representing Algerian women sent by the French from Algeria during thirty years of colonial presence and underlines the absence of photographic traces of the gaze of the colonized.

21 P. Bowles, *Conversations*, pp. 82–83.

22 Ibid., p. 222.

23 There is the feeling that it is all decided for her, even the way she must invariably accept men's approaches; men are for her a threat that cannot be avoided, like the rumble of thunder or a low dark cloud getting close:

> she felt for one desolate moment that the whole thing had been prearranged and that although she had forced herself to take this little trip to the mainland, she had somehow at the same time been tricked into taking it by the powers above. . . . She noticed with a faint heart that the man had lifted his drink from the bar and was coming towards her.
>
> (J. Bowles, *Two Serious Ladies*, in *Collected Works*, p. 144)

24 Ibid., p. 124.

25 The traveller was lying on his bed, consumed by a feeling of guilt. He had never done anything like this before. . . . He felt like a two-headed monster, as though he had somehow slipped from the real world into the other world, the world that he had always imagined as a little boy to be inhabited by assassins and orphans, and children whose mothers went to work.

> (J. Bowles, *A Guatemalan Idyll*, in *Collected Works*, p. 349)

In this case the swing is tipped in favour of the security of home and the portrait is probably satirical. Elements of parody are often present in her minor characters, especially men, and not unusual in her heroines; in the latter case parody is always veined with pathos.

26 J. Bowles, *Plain Pleasures*, in *Collected Works*, p. 302. He, too, has a restless brother – characters in Bowles often have an alter ego, sometimes two – and contrary to him he feels that 'if a man leaves home he must leave for some very good reason – like the boys who went to construct the Panama canal or for any other decent reason', ibid., p. 303.

27 Ibid., p. 312.

28 *In the Summer House*, in *Collected Works*, pp. 272–273.

29 King-Kok Cheung, *Articulate Silences. Hisaye Yamamoto, Maxine Hong Kingston, Joy Kogawa*, Ithaca and London, Cornell University Press, 1993, p. 4.

30 Ibid.

31 *Everything is Nice* is probably the closest she gets to autobiography, as, apart from the white woman's name Jeannie, it describes her first encounter with the group of Arabian women in Tangier. Tetum appears with her own name, 'an old lady in a dress made of green and purple curtain fabric. Through the many rents in the material she could see the printed cotton dress and the tan sweater underneath . . . her bony cheeks were tattooed with tiny blue crosses', in *Collected Works*, p. 317.

32 P. Bowles, *Conversations*, p. 27.

33 Quoted in M. Dillon, op. cit., p. 397. The description of her solitary battles is frequent in her letters and in the accounts given by Paul and her many close friends. Truman Capote, in his introduction to the *Collected Works*, writes:

> . . . both her language and her themes are sought after along tortured paths and in stone quarries: the never realised relationships between her people, the mental and physical discomforts with which she surrounds and saturates them – every room an atrocity, every urban landscape a creation of neon-dourness.
>
> (Dillon, *Out in the World*, viii)

34 Ibid.

35 She expresses her bitterness in a letter to Paul: 'The more I get into it, which isn't very far in pages . . . the more frightened I become at the isolated position I feel myself in

vis-à-vis of all the writers whom I consider to be of any serious mind . . .', op. cit., p. 33.

36 Quoted in Dillon, op. cit., p. 382.

37 P. Bowles, *Conversations*, respectively p. 124 and p. 187.

38 J. Bowles, *Letters*, op. cit., p. 14.

39 *Collected Works*, p. 314. This is certainly inspired by Cherifa's talent for mimicry: 'She was always getting dressed in costumes and doing imitations of American and Europeans or other Moroccans that she knew', Dillon, op. cit., p. 273. In this play of mirrors, Jane's great mimic and mimetic ability must be taken into account as well. Capote, who describes it in his introduction ('the stiff-legged limp, her spectacles, her brilliant and poignant ability as a mimic', op. cit., pp. vii–viii), reproduced it in the character of Mary O'Meaghan in *Among the Paths of Eden*.

40 This is certainly not related to the legend describing her life companion as casting a spell on her. In her letters there is a solar and loving image of Cherifa and the other Muslim women, and of Zodelia and Pacifica in her fiction. In *Two Serious Ladies*, shortly after their first casual encounter, Pacifica takes Mrs Copperfield to her hotel room and this is how their 'romance' starts: '"Now we rest a little while, yes?" The girl lay down on the bed and motioned to Mrs Copperfield to lie down beside her. She yawned, folded Mrs Copperfield's hand in her own, and fell asleep almost instantly. Mrs Copperfield thought that she might as well get some sleep too. At that moment she felt very peaceful.' *Two Serious Ladies*, in *Collected Works*, p. 50.

41 Ibid., p. 320.

42 Ibid., p. 197.

43 Ibid., p. 201.

44 Iain Chambers, 'Signs of Silence, lines of Listening', in this volume, pp. 57–58.

45 See Homi K. Bhabha, 'The Other Question: Stereotype, Discrimination and the Discourse of Colonialism', in Homi K. Bhabha, *The Location of Culture*, London & New York, Routledge, 1994.

46 Yegenoglu, op. cit., p. 54. It is strange that, in referring to Derrida's notion of the supplement, she does not consider that it might not compensate for a lack of phallogocentrism but rather overloads and swamps such a logic. The knowledge of what is 'hidden behind the veil' is not an indifferent addition and may be upsetting to the Orientalist vision. On the ambivalence of the veil see Trinh T. Minh-ha, 'Not You/ Like You: Post-colonial Woman and the Interlocking Questions of Identity and Difference', *Inscriptions*, 3/4, 1988, p. 73.

47 In this logic Montagu's letters are unavoidably implicated in 'the imperialist and masculinist act of cultural translation and Subject constitution', Yegenoglu, op. cit., p. 63. On the other hand, in *The Predicament of Culture* (Cambridge, Harvard University Press, 1988, p. 258) James Clifford, in reviewing Edward Said's *Orientalism*, polemicises with an 'intertextual unity . . . designed to emphasise the systematic and invariant nature of the Orientalist discourse'. For a discussion of attitudes on female Arab dress, see Vron Ware in this volume, pp. 150–154.

48 Quoted in Dillon, op. cit., p. 7.

DEFINING FORCES: 'RACE', GENDER AND MEMORIES OF EMPIRE

Vron Ware

Whatever the possibilities or limitations of the term 'post-colonialism', the concept of historical memory provides one useful way of trying to analyse the relationship between the imperial past and its legacies in the present. Living in Britain in the late twentieth century, it is difficult to move without being reminded of the importance of history and particularly the ways in which it is made to articulate a national identity premised on the country's former status as a world power. The different processes involved in the formation of a collective historical memory of empire can often reveal how this past can be reinvented to fit the exigencies of the present, while the present can also be made to fit the past. A critical awareness of how the past is continually reconstructed and referred to ought to be inseparable from debates on post-colonialism, especially as it complicates the notion of time being linear. Likewise it is essential to bring an informed historical perspective to an analysis of contemporary social relations which have been formed and contested throughout centuries of racial slavery and colonisation.

In this paper I want to explore specific questions of race and gender in relation to the historical memory of empire. I began this work originally through investigating how categories of racial, ethnic and cultural difference, particularly between women, have been constructed in the past, in order to explore how these categories continue to be reproduced in more recent political and ideological conflicts.[1] Such a project necessarily involves a consideration of the ways that feminist historiography has so far dealt with questions of difference. To put it another way, has 'women's history' provided feminism with sufficient theoretical or historical evidence to make sense of ideas about racial and cultural difference today? My response to this question would be that until very recently feminist theory relating to the writing of history has tended to emphasise questions of gender and their articulation with class, with the result that issues of 'race' have been overlooked. In 1988, for example, Joan Scott wrote that:

> The realization of the radical potential of women's history comes in the writing of histories that focus on women's experiences *and* analyze the

ways in which gender constructs politics and politics construct gender. Feminist history then becomes not the recounting of great deeds performed by women but the exposure of the often silent and hidden operations of gender that are nonetheless present and defining forces in the organization of most societies. With this approach women's history critically confronts the politics of existing histories and inevitably begins the rewriting of history.[2]

This is not to say that Scott herself has overlooked questions of 'race', either in her critique of the politics of existing histories or in her outline of the 'radical potential' of women's history. It is rather that her descriptive phrase 'often silent and hidden operations' could be applied just as well to other kinds of social relations in addition to gender, and the claim would have been all the more powerful if she had been able to be more explicit about 'race' and ethnicity as other kinds of 'defining forces' in women's lives.

WHITENESS

Before going on to discuss the 'radical potential' of women's history that addresses 'race' as well as gender and class, I want to clarify another area of concern that was a starting-point for this work. Basically I wanted to move away from a position that said that decent white people should/ought to be against white supremacy, or fight racism, in order to support black people, the victims of racism. This leaves room for thinking that racism is a political, social or economic issue for black people, and an exclusively moral one for whites.

It is important to recognise that racial domination is a system that positions or constructs everyone who falls within its orbit. Focusing on ideas about whiteness and the various constructions of white racial identity can offer new avenues of thought and action to those working to understand and hopefully dismantle systems of racial domination.[3] However, in a society habituated to dominant ideologies of white supremacy it is often easier for people who fall in the category 'white' to see themselves as merely 'normal' and therefore without a racialised identity.

In talking about the social construction of whiteness it is also important to acknowledge that it has certainly not been invisible to those identified as black. As bell hooks writes:

> black folks have, from slavery on, shared in conversation with one another 'special' knowledge of whiteness gleaned from close scrutiny of white people. Deemed special because it was not a way of knowing that has been recorded fully in written material, its purpose was to help black folks cope and survive in a white supremacist society.[4]

Thinking about whiteness in this way makes it nonsensical to identify 'race' as a matter of concern only to black people, and something that rarely impinges on the

lives of whites. This is not to advocate that people begin to think of themselves as white as a positive or even neutral attribute, nor to fall into the trap of reifying whiteness and thereby missing the processes involved in maintaining and re-newing it as a subject position. Here I would like to engage with Catherine Hall's suggestion that a 'reconstituted white identity', purged of any association with racial domination, is desirable or even possible.[5] In her archaeological approach to formations of ethnicity and gender in the nineteenth century she has raised the very pertinent question of how to interpret earlier attempts to disconnect what was perceived as white 'racial' identity from a supposedly natural impulse to dominate those deemed racially inferior. At the risk of trying to compress a difficult and provisional political argument, I would like to question whether whiteness, as a racialised category, can ever be redeemed from centuries of association with domination. Furthermore, unless one is essentialist about white-ness, attributing to those who are 'white' an innate way of thinking and acting, it follows that whiteness is ultimately about learned behaviour and social con-sciousness. Seeing a distinction between the idea of 'white' as a visible 'racial' type and as a way of thinking and acting in the world is an important step towards exposing the emptiness of the category. Despite the challenging problems that this produces, concerning new forms of identity and solidarity, for example, I believe it is more radical to reject whiteness and its privileges as far as possible. This means a political choice not to identify with whiteness, to repudiate white-ness as an ontological category, and to refuse to act white. James Baldwin writes eloquently and directly about the concept of choice in *Evidence of Things Not Seen*:

> The South, however, and the nation, are full of people who *look* White and *are* Black: some claim their ancestry and some seal it off with a change of address; nor are their new neighbors likely to challenge their identity, being so uncertain of their own. In the US, as in South Africa, one's color is a matter of legal definition, and/or experience, and/or, finally, choice.[6]

This statement echoes an earlier remark about whiteness that he made in the film *The Price of the Ticket*: 'As long as you think you're white, there's no hope for you.' David Roediger, referring to this second quote in the introduction to his book *Towards the Abolition of Whiteness*, discusses the 'highly poetic politics' of choice more fully in the context of the American labour movement. Here he describes whiteness as 'the empty and therefore terrifying attempt to build an identity based on what one isn't and on whom one can hold back'.[7]

Elsewhere I have discussed the social construction of whiteness in greater depth, emphasising ways in which it intersects with gender, class and sexuality.[8] In recent years the concept of difference, although important, is used almost ritualistically to evoke discourses of 'race' (and sometimes gender) often without discussing racism itself. In my view, an examination of the way that whiteness ('race') intersects with gender and sexuality can shift what can sometimes amount to an obsession with difference towards the less fashionable concept of

relational connectedness. For ideas about what constitutes white femininity/masculinity are constructed in relation to those about black femininity/masculinity, and vice versa. The different elements in this system of 'race' and gender identity have no intrinsic meaning; they work only in and through differentiation. Furthermore, the task of uncovering and making connections between these different constructions may lead to a more useful understanding of the social relations of both 'race' and gender. Here I would like to refer to Trinh Minh-ha's formulation of some groups of women being 'racialized as colored, sexualized as feminine' and to emphasise that, by the same process, others can be 'racialized as white, sexualized as feminine'.[9]

In an attempt to formulate a coherent response to the problems of positioning 'race' within feminist politics, I have begun to explore the various historical meanings of white womanhood – looking at moments when they were produced or when they emerged to articulate forms of white supremacy and male domination. This has meant adopting a perspective on history that takes into account not just gender and class but ideologies of racial difference as well. In many ways, this is precisely what black women and other women of colour have been doing in the process of developing a feminist politics that reflects their priorities. The last ten years have seen a growing body of work on historical constructions of black womanhood, some of which inevitably discusses the relationship between ideologies of deviant and normative, black and white, femininity. For instance, in her book on African-American women novelists, *Reconstructing Womanhood*, Hazel Carby writes:

> It is also necessary to situate narratives by black women within the dominant discourse of white female sexuality in order to be able to comprehend and analyze the ways in which black women, as writers, addressed, used, transformed, and, on occasion, subverted the dominant ideological codes.[10]

In the context of British history, black feminists have also dealt with the deconstruction of imagery of black women through an understanding of 'race', class and gender relations, recognising that in a racist society it would be totally inadequate to discuss images of non-white women and men without considering ideas about 'race'. Pratibha Parmar, for example, has argued that the representation of Asian women in Britain cannot be divorced from the social and political relations that sustain racism: 'Specific images of Asian women are mobilized for particular arguments. Commonsense ideas about Asian female sexuality and femininity are based within, and determined by, a racist patriarchal ideology.'[11]

The recognition that the lives of women of colour are inescapably prescribed by definitions of 'race' as well as gender can also be applied to women who fall in the category 'white'. In other words, any feminist historian wanting to adopt a perspective on 'race' and gender systems ought to use the example of black feminist criticism as a model.

REMAKING THE PAST

In the next part of this paper I want to recount two contemporary stories that recode and re-activate older, deeper structures of feeling about white women and empire. In doing so, I hope to demonstrate how memories of the past can transform understandings of current events. Both stories revolve around gruesome forms of violence carried out against women by men from countries once colonised by the British. In both there is a distraught parent battling against official apathy and interminable bureaucracy. Given these ingredients, it is hardly surprising that the British media should have followed both events so closely and, in some cases, so salaciously. These tragedies have also received longer-lasting treatment at the hands of journalists who have written books about their personal involvement in the investigations. Together with first-hand accounts written by a relative and a survivor, these works may still be found anywhere from feminist book catalogues to airport book stalls under the category 'True Crime'.[12]

The first narrative concerns a young, white, English woman called Julie Ward who 'fell in love' with Africa as an intrepid tourist. After travelling to East Africa with an overland safari group she set up home with expatriates in Nairobi, eking out her money so that she could make expeditions into the country to pursue her hobby of photographing wild animals. On the eve of her return to England she disappeared, and it was later discovered that she had been mysteriously killed as she drove on her own through a game reserve. Her story is about her father's attempts to prove that she had been raped and murdered by park rangers and to find the culprit in the face of apparent political apathy and intrigue in a former British colony, protective of its image as a tourists' haven. Julie Ward's death took place in 1988, but her father's pursuit of justice still continued five years later. In June 1992 he called for a fresh investigation after the acquittal of two game rangers on murder charges at the Nairobi Supreme Court, and in March the following year the Kenyan government agreed to reopen the case.[13]

Without wanting to diminish the tragedy endured by Julie Ward and those who knew her, it is worth looking more closely at some of the elements of the narrative that received attention from the Press. Here was a white woman – by all accounts a likeable and attractive person – travelling on her own in the African wilderness, a landscape described by *LA Times* writer, Michael Hiltzik, in the introduction to his book, as a 'place of primordial natural savagery'.[14] The trope of violence that characterises much European colonial fiction set in Africa is discussed by Hugh Ridley in an essay on imperial landscapes. He quotes Paul Vigné d'Octon's *La Gloire du Sabre* (1900) which begins:

> This is Africa, man-eater, soul-destroyer, wrecker of men's strength, mother of fever and death, mysterious ghost which for centuries has sucked the blood of Europeans, draining them to the very marrow, or making them mad.[15]

Compare the archetypal picture of 'primordial natural savagery' with the opening words of the first chapter of Hiltzik's book, describing Julie Ward's more

146

pastoral origins: 'Nestled neatly between Cambridge and the East Anglian coast, the little town of Bury St Edmunds is perhaps not as unique as it would like to believe.'

The bizarre claim by the local police that wild animals had feasted on her (white) body was immediately disproved by the discovery of half of her denim-clad leg near the charred remains of a fire. However, the first pathologist's report which stated that the leg had been severed from the body with a sharp instrument was swiftly rewritten under pressure from Kenyan officials to allow the possibility of her death among wild animals to persist as long as possible. John Ward, Julie's father, who was present at the scene shortly after the first remains were found, has described his battle with Kenyan authorities in minute detail in his book *The Animals Are Innocent*. His role in confronting endless officials with evidence that he had prepared with the help of his own lawyers has allowed the media to speculate on the wiles of an independent black African country resisting interference from white Englishmen telling them how to run their business. In his racy account of the murder inquiry, Hiltzik devoted several chapters to the history of colonial rule in Kenya which includes an attempt to portray the social relations of class and 'race' in Nairobi. His evocation of Isak Dinesen's *Out of Africa* in his own descriptions of the landscape provides further confirmation that colonial-ism does indeed provide a lens through which the mystery of Julie's murder is being viewed, almost thirty years after independence.

At the centre of the second 'post-colonial' narrative that I want to discuss are Zana and Nadia Muhsen, two sisters from Birmingham, England. At the ages of 15 and 14 they were taken on vacation to their immigrant father's homeland in North Yemen, only to be married off to boys scarcely older than themselves and held virtual prisoners in a remote mountainous area. Their father disappeared with the money he earned from this exchange, while their mother – who was not of Yemeni origin – tried in vain to get British officials to send a rescue party. In this incident, media interest was focused by the *Observer*, a liberal Sunday newspaper respected for its international coverage, which dispatched a female journalist and a male photographer to find the young women and bring out the story, seven years after they had first disappeared. The reporters were instructed not to try to rescue the pair because they would be shot, but from the moment they met them they were convinced that it was their duty to remove them from such a 'backward' culture and inhospitable environment. For one thing, the sisters begged Eileen MacDonald, the journalist, to take them away, recounting gruel-ling details of the deception that led to their forced marriages and resulting children. MacDonald evidently took on the task as a kind of personal crusade, writing a book-length report on her experiences travelling through North Yemen and her investigations into the bureaucratic diplomacy that led eventually to Zana's return to England. Her book, entitled *Brides for Sale?*, powerfully ex-pounds on the iniquities of patriarchy, attempting to take the girls' point of view throughout. North Yemen is seen as a country offering a bleak and unrewarding life for women, where the Western female traveller has to conform to restricting

codes of dress and behaviour in order not to attract the wrong sort of attention. The book ends on a bewildered note, however, as Zana is flown back to England to be reunited with her mother, but instead of expressing gratitude for her release she tries aggressively to convert her saviours to Islam, saying she didn't want to be a British woman.[16] Readers are left with the impression that something had gone terribly wrong with the mission and that it was likely that both of the young women would remain in North Yemen from choice. The book ends bitterly by saying: 'Zana's father is rejoicing. The Yemeni community have taken him to their hearts. It is them against Britain.'

This narrative that I have condensed from a longer and more complex account is substantially different from the Julie Ward murder in some respects. Though they hold British citizenship, these young women here are not white and the chief villain was their own father. The cruellest deception took place in the immigrant community in Birmingham, a colony within the workshop of the old empire, rather than a formerly colonised country struggling to assert its independence from British domination. Unlike Julie Ward, Zana and Nadia Muhsen lived to describe their terrifying experiences – the elder sister, Zana, was encouraged to publish her own account in an attempt to campaign for her sister's release. However, the point is not to try to connect the fate of these three young women but to consider how a feminist analysis would interpret the symbolic meanings that these narratives of culture and conflict may have in contemporary British society.

WILD MEN AND ANIMALS

As I have already said, both countries were former British colonies. This provides a direct link with the imperial past and means that neither place can be free of its associations with colonialism. By looking at the images of white femininity produced in these narratives it is possible to show how social memories of this past affect the way that they are read today. This is not a simple, straightforward process, but a question of 'seizing hold' of these fragmentary images as they occur in order to understand why the narratives continue to mediate important political questions. Julie Ward was alone and vulnerable in her broken-down jeep, and allegedly fell victim to the uncontrollable lust of black men, a point made by the judge at the trial of the park rangers accused of her rape and murder when he referred to the fact that one of the possible culprits who had escaped prosecution was 'fond of white women'.[17] The history of ideas and associations governing this particular couplet – lustful black man and defenceless white woman – means that the encounter cannot easily be stripped of its racialised and mythologised meanings. It is interesting to compare this construction of white femininity and black masculinity with that found in discourses of sex tourism in other parts of Africa. A recent issue of *Marie Claire*, for example, described how many white women travel to Gambia explicitly for sex and companionship with African men. The same story – but with a different twist – featured in the tabloid

newspaper, the *Sun*, suggesting that the white women did not so much go to Gambia for sex but, once exposed to the charms of the black men lying in wait on the beaches, were prepared to abandon their own husbands and live in shacks to be with their new lovers.[18] The connection between these representations of very different encounters between African men and English women is further underlined by the context of tourism which brings these groups together in idealised settings.

In spite of the construction of Julie Ward as a vulnerable white woman, her innocence is complicated by her act of driving unaccompanied through a game reserve. This suggests an element of foolhardiness, a readiness to trust the natives if trouble should arise. Here, the image of white femininity ties into those repeatedly found in colonial fiction, typified by Adela Quested in *A Passage to India*, whose trusting curiosity of the Indian landscape and its inhabitants ended in disaster of a different kind.[19] But Kenya is the land of safari rather than strange gods, a country routinely depicted in both travel brochures and fashion photography as being curiously empty of human inhabitants and cultures, save those whose native costume elevates them to the same exotic status as the wild animals roaming the reserves. Kenya provides the ideal backdrop for constructing an image of the white woman as explorer, suggesting strength, independence, a touch of androgyny, and even eccentricity, her vulnerability underscored by her proximity to lions, rhinos and Masai warriors. This construction stems partly from tales of colonial figures such as Isak Dinesen and Beryl Markham, and is constantly revitalised by glossy articles aimed at women in magazines such as *Vogue* and *Elle* as well as travel features in the pages of the so-called 'quality' Press.[20] By chance there happened to be such a spread in a Sunday newspaper the very week that the verdict in the first murder trial was reported. The travel feature was entitled 'Wild About Kenya' and was introduced by the following sentences: 'Kenya can still offer the authentic African experience. Angela Palmer samples some animal magic.' The first paragraph referred directly to the country's tarnished image as a tourist haven, delicately avoiding mention of the recent spate of assaults on tourists by local bandits:

> Poor Kenya: mention its name and the cynic will tell you it's finished – overrun by tourists packed into giraffe-print minibuses, forever shoving zoom lenses into the faces of bewildered animals. Not surprisingly, this image outrages the old Kenya hands, and none more than one Primrose Stobbs, an aristocratic ex-colonial farmer who is now a formidable force with Abercrombie and Kent, the African travel specialists.[21]

The article continues with an account of the better class of safari travel being offered by Ms Stobbs, full of sitings of rare birds and animals. The country itself does not merit a mention nor do its inhabitants, although there is the inevitable accompanying picture of the author astride a camel, watched over by two Masai men. The caption reads: 'Ride on the wild side: the author keeps her feet well away from creepy-crawlies'.

This kind of *double entendre* in which indigenous peoples are constructed as a form of wildlife, sometimes exotic and protected, sometimes threatening and dangerous, is highly relevant to this reading of the Julie Ward story. While fashion and travel literature construct the Masai as wild people whose presence merely adds to the fascination of the landscape, in the reporting of the Ward case they are depicted more ominously as living beyond the realm of civilisation, untouched by the requirements of modern rationalism and hence justice. Giving his final verdict after the eighteen-week trial, the judge criticised the London detectives sent out to investigate the case, saying that they 'forgot they were dealing with young Masai tribesmen from the wilderness'.[22] To coincide with the end of the trial *The Times* sent out a reporter to find out 'the truth'. Equipped with a translator and claiming to be sympathetic to the accused, the journalist found it difficult to get a 'straight answer':

> 'They say they don't gossip, and that's the truth – it's considered beneath them to talk about the affairs of other people,' the translator said. A wall of silence? The Masai closing ranks to protect one of their own, as if obeying a mafia code? No wonder the policemen from London found it baffling in the bush.[23]

Where the bestial Africans roam through a wild landscape, the presence of animals also serves to highlight aspects of the white woman's femininity. The cover of her father's book, pointedly called *The Animals Are Innocent* in an implicit suggestion that the people must therefore be guilty, bears a large photograph of Julie smiling happily with a chimpanzee in her arms. Donna Haraway has written at length about such images and the complex range of meanings suggested by this particular pairing of white woman and primate.[24] The juxtaposition of the title with this photograph – which has become the standard image used to portray Julie in the Press – effectively conveys the English woman's innocent and harmless fascination with wild animals and her ability to get close to them. This acts as a sinister reminder that it was this easygoing trust which was betrayed in her encounter with the wild men from the bush.

ARTICLES OF CLOTHING

The versions of white femininity that I have identified in the Julie Ward narrative are constructed mainly in relation to black men, animals and landscape. Turning now to the second narrative, I want to show how the representation of the Muhsen sisters' ordeal involves direct comparisons between different kinds of femininity as well. In *Beyond the Pale* I have suggested that, historically, the status of women in a culture has often been read as an index of relative civilisation, and that the figure of the white Christian woman contrasts favourably with the image of downtrodden, submissive, Oriental, invariably Muslim, female.[25] This discourse has a profound effect on the way the story of the Muhsen sisters has been told in the British Press. After all, the girls were virtually kidnapped, removed

from one country where women are supposed to be liberated and stranded in another where they were forced to live almost as slaves to men. The point is not that any criticism of Yemeni men is racist, but that a feminist analysis must be sensitive to the way that such stories can feed existing racist ideas about Islamic cultures.

The image of white liberated femininity in this story is provided by the journalist Eileen MacDonald, whose subjective account of the rescue operation provides its own commentary on cultural and ethnic difference between women. Her story is reminiscent of Victorian feminist philanthropist Annette Ackroyd's passage to India over 100 years earlier in that they both set out to liberate Eastern women from their tyrannical patriarchal menfolk but in doing so found themselves recoiling from elements of a culture that they could not comprehend.[26] MacDonald's venture is symbolic of a kind of feminism since her book has been recommended on the Women's Book Club mailing list, a well-known and widely circulated feminist mail-order catalogue operating in Britain.

Like many commentators on non-Christian societies, including Ackroyd, MacDonald focused on dress as a significant mark of cultural difference, clearly expressing her irritation at the limitations imposed on her own sartorial style when visiting North Yemen:

> I still found it uncomfortable being stared at by the men. I was hardly wearing a revealing bikini, after all. Because of the Foreign Office instruction to bring warm clothes, I had two pairs of thick cord trousers, and a pair of cotton trousers. I was wearing these, with boots of all things, in temperatures approaching 90 degrees Fahrenheit. I also wore a long blouse, buttoned to the neck, and had sunglasses on. Pretty safe, I would have thought.[27]

But MacDonald only found out later on that people continued to stare at her because her shirt was tucked into her trousers. She went on to complain: 'I got very fed up being touched, stared at and shouted at by men. The women, I noticed, would turn away their heads with a sort of scandalised sneer.' In passages like these, the reader, assumed to be British, is invited to share the writer's impatience with a society that appears to sanction the inhuman treatment of women by men, symbolised by the obligation to wear veils and 'tent-like' dresses. At various points in the book MacDonald draws attention to the clothes worn by the Muhsen sisters as a way of marking their passage from modern 'Western' culture to a 'backward' Islamic one. Before packing her holiday clothes in Birmingham, Zana, the older girl, was told by their father that 'Yemen is open to Western ideas about dress'; when she arrived in Taiz and went to stay with some relatives she interpreted the fact that they kept talking about her in corners as being a sign of curiosity at seeing 'a Western girl in her pencil skirt and blouse'.[28] The morning after her first traumatic night as a married woman, 'Zana's own clothes were taken away, and her mother in law pointed to a pile of Arab clothes and a head-dress'.[29] When the British journalists first met the sisters several years later,

they saw 'the girls covered from top to toe in Arab dress, their faces hidden by veils'.[30] The first sight of Zana on her arrival back in England was of 'a girl in white Arab clothes, including a veil'.[31] Within hours of her reunion with her mother and MacDonald herself, she announced, 'I want to go back to Taiz and get a job. I will visit England when I want to. I am not sure I want to be a British woman anyway. I don't like the short skirts; it's disgusting.'[32]

The English woman's emphasis on dress as an index of women's subordination evokes countless other travel narratives that record encounters between Europeans and 'the Orient'. Written as a breathless account of her mission as a journalist, and therefore full of subjective observations that provide atmosphere and suspense, her report manages to reinforce ideas about the backwardness of Arab cultures through repeating certain stereotypes of masculinity and femininity. It is interesting to compare her reactions to those of Annette Ackroyd, whose Victorian sensibilities are greatly offended by the clothing worn by her Indian benefactor's wife:

> She sat like a savage who had never heard of dignity or modesty – her back to her husband, veil pulled over her face – altogether a painful exhibition – the conduct of a petted foolish child it seemed to me, as I watched her playing with her rings and jewels.[33]

It is evident from the start that MacDonald had little time for Arab men, which again has the effect of confirming her own position as the liberated, independent, white woman. At several points she is exasperated when Yemenis make assumptions about her relationship to the male photographer, Ben Gibson, who is accompanying her:

> All conversation was directed towards Ben. When I spoke he was given amazed looks as if he was expected to keep me silent. We were, everyone assumed, man and wife, in spite of having different surnames. It would be unthinkable that we should travel together unless we were married.[34]

This kind of comment, made with undisguised hostility towards Arab men, reminds me again of Annette Ackroyd's more openly judgemental observations. After attending an open-air meeting in Calcutta, Ackroyd wrote:

> I do not think there were three women amongst the crowd, and certainly I was the only lady. In consequence of the infrequent appearance of a woman the people looked at me with profound amazement, and for the first time I realised how uncivilised are their notions about women. I read it in their eyes, not so much in the eyes of those who looked impertinently at me, for this is an expression not unknown to civilisation! as in the blank wonder with which most scrutinised me.[35]

MacDonald and Gibson ran into trouble when they tried to take photographs of women, despite having had it explained to them that it was considered bad for a woman to allow having her picture taken, especially by a stranger. Since their

assignment included a 'general piece on the sort of society the girls were living in', the intrepid journalists had to use speed and guile to snatch the visual material they considered relevant. The reader is incorporated into attempts to persuade their various escorts that they are innocent tourists, art students, or even doctors; anything but journalists. Their deceit in the name of tracking down the Muhsen sisters (not to liberate them initially, but to interview them) is justified by the representation of Yemeni men as accomplices in the subordination of all Yemeni women. The image of Arab masculinity both in the immigrant community in Birmingham and in the Yemen is constructed as duplicitous, irrational, prone to violence and extremely dominating of women. MacDonald's book also portrays Yemeni men as objects of ridicule. In one passage, for example, she recounts how a tense situation was averted by handing round a quantity of 'qat', described as:

> the mild narcotic which everyone from government minister to peasant chews in Yemen, and which we had brought with us. When it was handed round, the steady chewing began, making the men look like so many Popeyes, with their bulging cheeks.[36]

References to 'qat' as a factor to explain the irrational behaviour of the men crop up frequently in the book. In this last extract, MacDonald describes a journey through the mountains with an escort in a tone of utter disgust:

> His driving had become less good, though he seemed full of beans. One or two sharp mountain bends had been taken at break-neck speed – presumably the effect of qat. He kept adding more leaves to his mouth, but not spitting out those he already had in there. Occasionally he would spit out of the windows. Throughout Yemen we saw dried green liquid on the ground, the result of the population's chief pastime.[37]

The irony of MacDonald's book is that it ought to have ended with the Muhsen sisters returning thankfully to a liberated lifestyle in Birmingham, rescued from a life of submission to uncivilised men by an English woman. Instead there is only the bleak speculation that the young women will be 'lost' in either country, their experience of two such different cultures having ruined all prospect of happiness in both.

Although I am mainly concerned here with the constructions of femininity and cultural difference contained in the media account of this narrative, it is worth pointing out some of the discrepancies between the two versions: that of the 'victim' and that of the reporter. In Zana Muhsen's own account of her return to Britain, published three years after MacDonald's book, the ambivalence and ingratitude hinted at by the journalist are explained as the reactions of an emotionally exhausted and traumatised young woman who had escaped from eight years' captivity at the cost of abandoning her baby son and her younger sister – and who was being pursued by the world media for her story. The autobiography obviously supplies insights to the experience that no journalist could divine, but it also highlights the 'outsider' nature of the reporter's Eurocentric perceptions

and observations. Despite the sensationalist cover of Muhsen's book which shows the veiled face of a young Arab woman, eyes raised in anxious supplication, and the text 'From holiday to horror story; one woman's true account of modern slavery', the version that the authors have managed to reconstruct is full of interesting detail about everyday life both in remote Yemeni villages and in the more modernised towns, and about the friends and allies there – male as well as female – who sustained Zana's will to escape. Female Arab dress, for example, is represented both as a symbol of oppression *and* as a practical response to the rigours of the desert climate. The perspective of the wearer (who in this case is both outsider and insider), rather than the partial observer, manages to communicate something of the complex relationship between cultural identity and material culture. Reading *Sold* (which, we are told in the preface, 'topped the charts in every country from Sweden to Turkey, was a best seller in France and has been translated into 18 languages') against *Brides for Sale?* would make a fascinating exercise in comparing the representation of 'racialised' and 'sexualised' femininities that operate within Britain and the Arab world today.

In conclusion I want to return briefly to a discussion of feminist politics and historical memory of empire. In order to be alert to these multi-layered images of femininity and to understand their relationship to the past, feminism needs to reconstruct histories of ideas about women with a perspective that takes in not just the shifting parameters of gender itself but also the interrelated concepts of ethnic, cultural and class difference. The danger that arises from overlooking the 'often silent and hidden operations' of racial domination throughout women's histories poses a threat to the survival of feminism as a political movement. For it is partly through returning to the past that we are able to understand how those categories of difference between women and men, white and non-white, have emerged and how, why and where they continue to retain significance today.

A feminist politics that seeks to offer solidarity to women across differences of culture, ethnicity, class and sexuality needs to identify ways in which images of femininity activate contemporary political questions. Ideas about Arab cultures, for example, which I have discussed briefly through the narrative of the Muhsen sisters, play a part in reinforcing stereotypes that affect the lives of Muslim migrants or settlers within Britain and constantly appear in public discourses on racism and cultural difference. No doubt some of those ideas about the barbarity of Arab men were also instrumental in securing support for the British and American forces during the Gulf War, when distaste for certain kinds of Arab-ness reached new heights. Likewise, notions of black masculinity, constructed in relation to black and white femininity, help to shape perceptions of black men as marauders, proto-criminals or rioters, whether in Britain's inner cities, South Africa or South Central Los Angeles. If feminism is to fight for the legitimacy of its critical perspectives, then it must be able to intervene in debates about contemporary politics with a historically informed and 'anti-racist' perspective.

This paper is an edited and updated version of 'Moments of Danger: Race, Gender & Memories of Empire' in Ann-Louise Shapiro (ed.), *Feminists Revision History*, University of Rutgers Press, 1994.

NOTES

1 See Vron Ware, *Beyond the Pale. White Women, Racism and History*, Verso, London & New York, 1992.

2 Joan W. Scott, *Gender and the Politics of History*, Columbia University Press, New York, 1988, p. 27.

3 Here I see my work being in dialogue with other recent explorations of whiteness such as David R. Roediger, *The Wages of Whiteness: Race and the Making of the American Working Class*, Verso, London & New York, 1991 and *Towards the Abolition of Whiteness*, Verso, London & New York, 1994; Ruth Frankenberg, *White Women, Race Matters: The Social Construction of Whiteness*, Routledge, London & New York, 1993; bell hooks, *Black Looks: Race and Representation*, Turnaround, London, 1992, especially Chapter 11 'Representations of Whiteness in the Black Imagination'; and *Race Traitor*, journal of the new abolitionism, Cambridge, MA.

4 hooks, op. cit., p. 165.

5 Catherine Hall's talk, 'De-colonising knowledge: the case of the British Empire', at the conference 'The Post-colonial Question', Naples, May 1993.

6 James Baldwin, *Evidence of Things Not Seen*, Michael Joseph, London, 1986, p. 6.

7 David Roediger, *Towards the Abolition of Whiteness*, Verso, London & New York, 1994, p. 13.

8 Vron Ware, op. cit., Verso, London & New York, 1992. See also Les Back and Vron Ware, 'Whiteness', *Paragraph*, 7, 3, November 1994.

9 Trinh T. Minh-ha's talk, 'The undone interval', at the conference 'The Post-colonial Question', Naples, May 1993.

10 Hazel V. Carby, *Reconstructing Womanhood: The Emergence of the Afro- American Woman Novelist*, Oxford University Press, New York & Oxford, 1987, pp. 20–21.

11 Pratibha Parmar, 'Hateful Contraries: Media Images of Asian Women' in 'Critical Decade: Black British Photography in the 80s' *Ten.* 8, 2, 3, 1992, p. 54.

12 Michael A. Hiltzik, *A Death in Africa: The Murder of Julie Ward*, Bantam Books, London, 1991. The writer was at the time the Nairobi Bureau Chief of the *Los Angeles Times*. Jeremy Gavron, *Darkness in Eden: the Murder of Julie Ward*, HarperCollins, London, 1991. Gavron, a freelance journalist, was in Africa researching the 'elephant crisis'. Julie Ward's father, John Ward, also wrote a book, called *The Animals Are Innocent: The Search for Julie's Killers*, BCA, London & New York, 1991. Arising from the other story was Eileen MacDonald's *Brides for Sale? Human Trade in North Yemen*, Mainstream Publishing, Edinburgh 1988. MacDonald was a journalist working for the *Observer* newspaper in London. Zana Muhsen wrote her account (with Andrew Crofts) in *Sold: One Woman's True Account of Modern Slavery*, Little, Brown & Co, London, 1991.

13 *Independent*, 26 March 1993.

14 Hiltzik, op. cit., p. 4.

15 Hugh Ridley, *Images of Imperial Rule*, Croom Helm, London & Canberra, 1983, p. 70.

16 MacDonald, op. cit., pp. 207–211.

17 *Guardian*, 30 June 1992.

18 *Marie Claire*, May 1994; *Sun*, 7, 11 and 12 February 1994.

19 Jenny Sharpe, *Allegories of Empire: The Figure of the Woman in the Colonial Text*, University of Minnesota Press, Minneapolis, 1993.

20 Isak Dinesen's autobiography was immortalised in the film *Out of Africa*, starring Robert Redford and Meryl Streep; Stanley Crouch has written an essay eulogising the aviator Beryl Markham, calling her 'a mulatto by culture instead of by blood'. Stanley Crouch, 'African Queen', in *Notes of a Hanging Judge*, Oxford University Press, New York & Oxford, 1990, p. 146. Markham's eventful life is also to be the subject of a high-budget film. Also see, for example, the feature in *Vogue* (UK), December 1991.

21 *Observer*, 28 June 1992, pp. 44–47.

22 *Guardian*, 30 June 1992.

23 *The Times*, Saturday Review, 27 June 1992, p. 6.

24 Donna Haraway, 'The Promise of Monsters', in L. Grossberg, Cary Nelson and Paula Treichler (eds), *Cultural Studies*, Routledge, New York & London, 1992, p. 307.

25 Ware, op. cit., pp. 11–17.

26 Ibid., p. 117.

27 MacDonald, op. cit., pp. 86–87.

28 Ibid., pp. 28–29.

29 Ibid., p. 32.

30 Ibid., p. 9

31 Ibid., p. 204.

32 Ibid., p. 207.

33 Ware, op. cit., p. 139.

34 MacDonald, op. cit., p. 76.

35 Ware, op. cit., p. 146.

36 MacDonald, op. cit., p. 11.

37 Ibid., p. 88.

12

IDENTITY AND ALTERITY IN J. M. COETZEE'S *FOE*

Laura Di Michele

DIFFERENCE AND ALTERITY

Foe: the very title of the work published by J. M. Coetzee in 1986 invites the reader to explore the post-colonial themes of difference and alterity. A slim volume of little more than 150 pages, *Foe* is nonetheless a dense and problematic work which addresses questions of narrative and identity. It exposes the difficulties in reconciling the idea of belonging to a nation, or 'imagined community' (as proposed by Benedict Anderson and Homi Bhabha), with the wish to express singular cultural identities and differences. It is also an extremely rich literary text, assembling and reworking theories and modes of writing drawn from the extensive ideological and mythological archives of Western thought, including texts from the once hegemonic 'Great Tradition'.

The very name of the book clearly plays on at least two meanings which might be attributed to the author's choice. The term 'foe' once implied a foreigner; that is, one who does not belong to a clearly defined community and is thus considered a 'foreigner'. However, as the *Oxford English Dictionary* reminds us, 'foe' has for a considerable time also acquired the sense of 'enemy': one who belongs to hostile armed forces, peoples and nations. This brings us to the novelist Daniel Defoe whose family name resulted from the transformation of the original 'Foe' through the addition of an 'ennobling' De. This was to erase the humble social origins of the family and to super-impose another, more elevated one in keeping with that 'middling station of life' that the eighteenth-century writer both eulogised and mythologised. Daniel Defoe is best remembered as a chronicler of everyday life, founder of the new genre of the novel and, not least, satirical author of the pamphlet *The True-born Englishman* (1701) that debated, with some irony, the 'true' cultural and political identity of the English in the wake of the accession of the 'foreigner', William of Orange, to the throne. The name 'Defoe' seemed better suited than the somewhat lowly Foe to designate a new social standing, several steps higher in the social imaginary consonant with the writer's 'great chain of being'.

In Coetzee's text exist traces of the story of Robinson Crusoe exemplifying the power of *homo œconomicus*. White, European and English, Defoe's Crusoe expropriates Friday, the native of the island, making him subject and slave. In *Foe* there are also traces of the earlier spaces in which the narrated episodes take place (the island, the sea, the cities of London and Bristol), as well as some of the names of the characters: while Friday remains the same, Robinson Crusoe becomes Cruso. Naturally, these prints of the mother-text are opportunely used by Coetzee who gives the reader signals within the new text. His text can be considered new in its pro-minority stance, and in its post-modern mode of writing. It is, similarly, new in the post-colonial senses on which it feeds and which, at the same time, it helps to produce. In rewriting the tale *Foe* casts light on the deep forces that have driven a voice from the 'periphery' or 'edge' of the imperial world to engage in open and dialectic conflict with the voice of the 'centre'.

Manipulating the original name 'Defoe' by cutting away the 'De' imposed over two hundred years earlier is an important parodic gesture. It suggests an urgent political imperative: that of erasing an entire world and a mode of representation dictated by others. In the simultaneity of this ironic subtraction and the addition of further cultural identities and differences we witness a movement that is both narrative and ideological, constituting a new discursive centre. This implies the corroboration of what was once considered 'inferior', 'secondary' and 'marginal'. 'Foe', in partially substituting 'Defoe' (and what it represents), aims at suggesting a vision, a world and its inhabitants from a perspective that overturns aesthetic, linguistic, cultural and narrative codes. It is a discourse that questions the existing, the enclosed and the codified by offering discursive modes that are fluid, almost indefinable and continually renewable.

Coetzee's text could imply that the roots of narrative must be sought in indigenous territory; in a homeland. The intrusion of narrative modes imported from the hegemonic British tradition is imposed on a local world which is culturally colonised, losing its own identity and acquiring a different and 'alien' one. Resistance is organised in an attempt to repel the invasion of the 'foreigner' and the 'enemy'. It becomes possible to argue, then, that the South African writer, in contesting the logos of the West, had in mind a far-reaching political aim, more complex than would appear from the title alone.

Indeed, if one accepts the idea that Defoe is metaphorically transformed and (re)constituted as a foe, then the text of *Robinson Crusoe* as reworked by Coetzee becomes the chosen battleground for the conquest of the identity of difference. It is a place where the struggle between the I and the Other is ignited. In this struggle, indistinct noises are heard. These become the sound of interacting voices engaged in violent exchanges, each attempting to overwhelm the other. In this powerful cacophony, the voices from the margin grow ever stronger, ever more intelligible. They express themselves with the timbre and tonality of the female and with the inflexions and sonorous modulations of the black slave: 'a Negro'.

These voices belong to a woman and a man bonded by their subordination. They emerge through the account of Susan Barton in her tale 'The Female

Castaway. Being a True Account of a Year Spent on a Desert Island with Many Strange Circumstances Never Hitherto Related' (Coetzee 1986: 67). The words of a woman record the whole story of Foe. This wording of the world is later 'passed on' to Friday at the end of the novel.

Robinson Crusoe's old island is wiped clean of its previous signs and is planted with other literal and symbolic ciphers, sown with further meanings. It is inhabited by Cruso, an old, sick character destined to perish on the sea voyage taking him home to England. Both his servant Friday and his woman Susan survive him.

The shipwrecked Englishwoman, Susan Barton, comes ashore on to the island. Bold, ever ready to doubt and to dispute, her presence is highly significant and disruptive when set alongside Defoe's story, in which the protagonist is a solitary soul who dares not risk his rigorous Puritan ethic with the presence of a woman. In one of the letters that Susan sends to the writer Foe, she says:

> I write my letters, I seal them, I drop them in the box. One day when we are departed you will tip them out and glance through them. 'Better had there been only Cruso and Friday', you will murmur to yourself: 'Better without the woman.'
>
> (Coetzee 1986: 71–72)

The difference in Coetzee's text is made explicit in Susan's voice:

> Yet where would you be without the woman? Would Cruso have come to you of his own accord? Could you have made up Cruso and Friday and the island with its fleas and apes and lizards? I think not. Many strengths you have, but invention is not one of them.
>
> (Coetzee 1986: 72)

Friday, the docile, obedient black slave is also present on Coetzee's island. Perhaps an ex-cannibal and tongueless (in one of the many versions Cruso offers of Friday's history) he is at first Cruso's faithful servant and then becomes Susan's companion in misfortune after Cruso's death.

Having arrived in London, and by then despairing of meeting the author Foe (who has apparently gone into hiding to escape his many creditors), Susan and Friday clandestinely move into Foe's empty house in Stoke Newington. It is from there that Susan continues to write him letters in which she sends details and information which Foe, a successful hack writer, should use for the 'history of the island'. The exchange of letters between these two characters, both gifted by the power of the word (Susan, oral; Foe, written), establishes a non-symmetrical relationship. This, however, ends with the success of the female figure, who manages to find a voice, an outlook, a way of her own to tell her story. When this happens, Foe leaves the scene and in the end it is Susan who writes of her adventures on Cruso's island.

In this way, the old Subject (Defoe, the Western novel, the myth of the cultural supremacy of the white race, the male, power-based relationships between master

and slave) is displaced by the Other. Coetzee's text, however, goes beyond this point, as he notes poetically on his last page in a passage of great political force:

> But this is not a place of words. Each syllable, as it comes out, is caught and filled with water and diffused. This is a place where bodies are their own signs. It is the home of Friday.
>
> He turns and turns till he lies at full length, his face to my face. The skin is tight across his bones, his lips are drawn back. I pass a fingernail across his teeth, trying to find a way in.
>
> His mouth opens. From inside him comes a slow stream, without breath, without interruption. It flows up through his body and out upon me; it passes through the cabin, through the wreck; washing the cliffs and shores of the island, it runs northward and southward to the ends of the earth. Soft and cold, dark and unending, it beats against my eyelids, against the skin of my face.
>
> (Coetzee 1986: 157)

It would, however, be ingenuous to think that the question of alterity and difference is to be resolved by substituting the 'centre' with the 'periphery' or the 'margin'. It is not this, I believe, that is happening in *Foe*. Here, there is an attempt to create a notion of marginality (and thus of alterity) that differs from the prevailing one. As I see it, this is close to Gayatri Spivak, when she observes:

> I am beginning to think of the concept-metaphor of margins more and more in terms of the history of margins: the place for the argument, the place for the critical moment, the place of interests for assertions rather than a shifting of the center as I suggested in that essay ['Explanations of Culture'].
>
> (Harasym 1990: 156–157)

The 'margin' for Foe's characters is not a space of marginalisation but, rather, one of resistance; a space for creativity in which the binary 'colonised/coloniser' is put under erasure and overwritten by a plurality of multiple subjects. It is a territory in which the reader can draw out new ways of seeing, new ways of telling and, in the end, new ways of being. The idea of marginality constructed from an 'us-centred' vision disappears. With it disappears the image of an 'us' as a 'sole and exclusive body' contrasted to the configuration of a 'them' solely considered as food and sustenance for the identity and integrity of 'us' (Remotti 1992: 36).

'THE WORLD IS FULL OF ISLANDS'

I have chosen as the title for this section a fragment from the text of Foe. This fragment, which reads as follows – 'The world is full of islands, said Cruso once' (Coetzee 1986: 71) – seems to me particularly significant in the context of the 'spatial' distribution of the novel. This distribution is closely connected to questions of identity and alterity. What can Susan Barton mean in writing these

words in a letter to Mr Foe and revealing that these words of Cruso's sound authentic? Indeed, she says 'His words ring truer every day'(Coetzee 1986: 71). What is Coetzee inferring, attributing to Cruso words spoken centuries earlier, even though with an important variation, by Caliban in *The Tempest*? There, Caliban – in turn echoing Montaigne's essay 'Of Cannibals' – says to Stephano:

Be not afeard; *the isle is full of noises*,
Sounds and sweet airs, that give delight, and
 hurt not.
Sometimes a thousand twangling instruments
Will hum about mine ears; and sometimes voices,
That, if I then had wak'd after long sleep,
Will make me sleep again: and then, in dreaming,
The clouds methought would open, and show
 riches
Ready to drop upon me; that, when I wak'd,
I cried to dream again.

<div align="right">(III, 2, 132–141; my italics)</div>

In its inter-textual echoes, Coetzee's short work is not limited to setting out a series of suggestions for rereading and rewriting the myth of Creation and Earthly Paradise. The South African writer is more interested in confronting the theme of the production of a *plural* space by the bodies who dwell in it and mark it with their signs, and who describe it with their voices.

In Coetzee's work, Cruso's island is no longer Prospero's or the one coveted by Caliban. Initially 'the strange island' appears to the exhausted, shipwrecked Susan inhospitable and alien. She strives to describe it, inverting the conventional image of 'a desert island':

For readers reared on travellers' tales, the words desert isle may conjure up a place of soft sands and shady trees where brooks run to quench the castaway's thirst and ripe fruit falls into his hand, where no more is asked of him than to drowse the days away till a ship calls to fetch him home. But the island on which I was cast away was quite another place: a great rocky hill with a flat top, rising sharply from the sea on all sides except one, dotted with drab bushes that never flowered and never shed their leaves. Off the island grew beds of brown seaweed which, borne ashore by the waves, gave off a noisome stench and supported swarms of large pale fleas.

<div align="right">(Coetzee 1986: 7)</div>

It may be precisely this *non-being* of the island that is one of the keys to understanding Coetzee's work more fully. The island is many things, many other islands. Such a proliferation allows the characters, the readers and, naturally, the author, to explore different ways of perception and of giving it a spatial form. Thus, one needs not ask what the island is in absolute but, rather what it represents to the various characters who inhabit it, hear it, speak and read it.

To Cruso, the island is 'his island kingdom', just as the hut built among the rocks is 'his castle'. This is his world; all that he feels he needs to know. It is what he does not wish to abandon in order to return to England: the place one presumes is his 'centre'. But Cruso does not suffer from nostalgia. There on the island, where he lives alone with Friday (until Susan comes ashore), he has everything he needs. Cruso has built a dwelling that divides the island (almost forming an island within the island). The hut which he pompously calls his 'castle' is separated from the rest of the island by a palisade.

> A fence, with a gate that turned on leather hinges, completed an encamp-
> ment in the shape of a triangle which Cruso termed his castle. Within the
> fence, protected from the apes, grew a patch of wild butter lettuce. This
> lettuce, with fish and birds' eggs, formed our sole diet on the island . . .
>
> (Coetzee 1986: 9)

The words are Susan's, obviously. The hut, ringed with stakes like a stockaded fort, defends Cruso's private space from the enemy (the apes, cannibals and pirates; in short, the Other in whatever form). He inscribes on that territory the visible presence of the coloniser. For this reason he does not share Susan's urgency to leave other traces to indicate his presence on the island. For him, everything is already written on the island itself. Thus, he is irritated when Susan begs him, in vain, to narrate for others the story of his arrival on the periphery of the world and of his existence there with Friday. The means to write would not be lacking, Susan urges:

> Is it not possible to manufacture paper and ink and set down what traces
> remain of these memories, so that they will outlive you; or, failing paper
> and ink, to burn the story upon wood, or engrave it upon rock? We may lack
> many things on this island, but certainly time is not one of them.
>
> (Coetzee 1986: 17)

Cruso refuses, responding with Cartesian certainty: 'Nothing is forgotten . . . Nothing *I* have forgotten is worth the remembering'. To this, Susan replies:

> You are mistaken! . . . I do not wish to dispute, but you have forgotten
> much, and with every day that passes you forget more! There is no shame
> in forgetting: it is our nature to forget as it is our nature to grow old and pass
> away.
>
> (Coetzee 1986: 17–18)

With the passing of time memory tends to weaken and fade, to the point where it transforms a singular and perhaps unrepeatable experience into one that is gener-alised and is therefore devoid of any interest or truth. From here, Susan maintains, stems the need to record all the details, all the events and even all the thoughts of the inhabitants of that island. She adds, 'There is the bile of seabirds . . . There are cuttlefish bones. There are gulls' quills' (Coetzee 1986: 18). Cruso who, until that moment, had not deigned to respond to Susan, now forcefully asserts his dominant

position – the instance of the Subject, his checkmate *I*. There is no need for any autobiography; no need to write down memories or any other form of written report that recounts his life on the island. Cruso has left other traces; physical traces on the terrain of that island, visible to and certainly decipherable by all:

> Cruso raised his head and cast me a look full of defiance. 'I will leave behind my terraces and walls', he said. 'They will be enough. They will be more than enough.' And he fell silent again. As for myself, I wondered who would cross the ocean to see terraces and walls, of which we surely had an abundance at home; but I held my peace.
>
> (Coetzee 1986: 18)

These words warn the woman to maintain her dissenting silence and, in reality, push her into the position of 'his second subject, the first being his manservant Friday' (Coetzee 1986: 11).

Obviously, Susan's silence is not destined to last long and the arguments with Cruso intensify; above all because Susan wants to understand the significance of those pieces of terraced but uncultivated land to which Cruso seems so attached.

> Within each terrace the ground was levelled and cleared; the stones that made up the walls had been dug out of the earth or borne from elsewhere one by one. I asked Cruso how many stones had gone into the walls. A hundred thousand or more, he replied. A mighty labour, I remarked. But privately I thought: Is bare earth, baked by the sun and walled about, to be preferred to pebbles and bushes and swarms of birds?
>
> (Coetzee 1986: 33)

The fact is that Susan fails to realise that the 'useless' work of freeing the land from stones and weeds is, in Cruso's mind, a necessary activity in constructing a basic 'text' on which others can inscribe their 'signs', their 'alphabet', and thereby 'write' a meaningful story. On this circumscribed and clearly identifiable text, his compatriots who follow can engrave their story and plant seeds brought from the mother country; seeds that will bind this little island to the great island of England in an invisible, but highly resistant, umbilical cord. The discourse that drives Cruso's activity on the island is undoubtedly colonial:

> 'And what will you be planting, when you plant?' I asked, 'The planting is not for us', said he. 'We have nothing to plant – that is our misfortune.' And he looked at me with such sorry dignity, I could have bit my tongue. 'The planting is reserved for those who come after us and have the foresight to bring seed. I only clear the ground for them. Clearing ground and piling stones is little enough, but is better than sitting in idleness.'
>
> (Coetzee 1986: 33)

Susan fails to understand what the island is to Cruso, preoccupied as she is by her wish to return either to Brazil to search for her kidnapped daughter or to England where her long journey had begun. Yet she senses that this island is somewhat

'strange', has something that distinguishes it from England, the island of her birth. Here there is no *speech*. Cruso has nothing to say and Friday no tongue with which to speak. Susan has problems making these two her listeners, her inter-locutors. She feels the island is different and special, almost magical: it is an island that bestows on her a new awareness of her being a woman, of her feelings, her silences and her fears, her memories and her time. It is an extraordinary island that seems to slip gently into the waves.

> When I lay down to sleep that night I seemed to feel the earth sway beneath me. I told myself it was a memory of the rocking of the ship coming back unbidden. But it was not so: it was the rocking of the island itself as it floated on the sea. I thought: It is a sign, a sign I am becoming an island-dweller. I am forgetting what it is to live on the mainland. I stretched out my arms and laid my palms on the earth, and, yes, the rocking persisted, the rocking of the island as it sailed through the sea and the night bearing into the future its freight of gulls and sparrows and fleas and apes and castaways, all unconscious, save me. I fell asleep smiling. I believe it was the first time I smiled since I embarked for the New World.
>
> (Coetzee 1986: 25–26)

The island, then, is never still. Its movement is like that of the sea; one feeds the other and vice versa, in an unceasing meeting. The lapping of the waves is uninterrupted, the sea caresses the coastline and penetrates the island, which lets itself be rocked and moves to meet the sea water. It is a movement that eclipses memory, erasing the strong, long-established image of a closed space and a linear and stable temporality. It imposes the mobile dialectic of different moments and diverse types of temporality: Cruso's linear time; Susan's female, repetitive time; Friday's pre-verbal, indecipherable, native time. It is also the post-colonial time of the writer, Coetzee, who entrusts himself to Susan's changing, many-hued narrating voice, a voice woven through with sounds and other voices present in the text.

All her experiences on the island make Susan share in the fluidity and contra-diction of feeling. She perceives the instability of the limits of thought and realises that building fences is impossible. This drives her to make the choice of remaining on the border, as Raymond Williams would say, giving herself a double vision, one that offers the twofold temporality (and spatiality) of being, at the same moment, both outside and inside (1988). Through her sudden perception of the movement of the island Susan understands that, along with her biologically determined identity, another is being constituted, which also has temporal impli-cations. Julia Kristeva (1986) has written of this temporal dimension of women, and Frantz Fanon discusses it in proposing a post-colonial conception of time (1969). In the words of Homi Bhabha, this time 'questions the teleological traditions of past and present, and the polarised historicist *sensibility* of the archaic and the modern' (Bhabha 1990b: 304).

This creates an urge to experience and redefine the symbolic process through

which the social imaginary – nation, culture, community – becomes the subject of discourse and object of an identity. Thus, Susan finds herself reflecting sagely: 'They say Britain is an island too, a great island. But that is a mere geographer's notion. The earth under our feet is firm in Britain, as it never was on Cruso's island' (Coetzee 1986: 26). It is this type of stability that Susan is learning to reject on the island and wishes to deny once she returns to London and to her epistolary (and non-epistolary) meetings with Foe. The island then becomes what memory and imagination desire: for Foe, too, draws inspiration from it.

In long and impassioned discussions with Foe, and with herself in 'dialogues' with Friday, Susan shows that the real (the island?) has many facets. These are not always coherent: often ambiguity and contradiction prevail. There is always the risk of disorientation. For example, under the impact of the images and figures Foe evokes, Susan reacts with lively indignation, displaying a stubborn anxiety and pain, but not defeat. She wishes to assert her own identity and her own independence in choosing which segment of her own existence is to be the object of a tale.

> What can I do but protest it is not true? I am as familiar as you with the many, many ways in which we can deceive ourselves. But how can we live if we do not believe we know who we are, and who we have been? If I were ready to concede that, though I believe my daughter to have been swallowed up by the grasslands of Brazil, it is equally possible that she has spent the past year in England, and is here in this room now, in a form in which I fail to recognize her – . . . if I were a mere receptacle ready to accommodate whatever story is stuffed in me, surely you would dismiss me, surely you would say to yourself, 'This is no woman but a house of words, hollow, without substance?'
>
> (Coetzee 1986: 130–131)

It is indispensable for Susan to know herself, her own personal story, to construct her own identity and to make her own choices, even if this only means deciding what to recount of her own experience.

> I am not a story, Mr Foe. I may impress you as a story because I began my account of myself without preamble, slipping overboard into the water and striking out for the shore. But my life did not begin in the waves. There was a life before the water. . . . All of which makes up a story I do not choose to tell. I choose not to tell it because to no one, not even to you, do I owe proof that I am a substantial being with a substantial history in the world. I choose rather to tell of the island, of myself and Cruso and Friday and what we three did there: for I am a free woman who asserts her freedom by telling her story according to her own desire.
>
> (Coetzee 1986: 131)

And yet, despite this sense of security in her own 'authorship', Susan is cast into the deepest doubts. Why is she speaking? To whom are her words directed? Who

is speaking to her? To whom is she writing? Who is Foe? Why does he ask her to reflect on the reason why Friday cannot speak, except through other, non-verbal, languages? It is the love story with Foe and the intense dialogue that emerges which suggest the first answers. Foe tells her: 'In every story there is a silence, some sight concealed, some word unspoken, I believe. Till we have spoken the unspoken we have not come to the heart of the story' (Coetzee 1986: 141).

Susan listens, stunned, and Foe proceeds:

> I said the heart of the story, . . . but I should have said the eye, the eye of the story. Friday rows his log of wood across the dark pupil – or the dead socket – of an eye staring up at him from the floor of the sea. He rows across it and is safe. To us he leaves the task of descending into that eye. Otherwise, like him, we sail across the surface and come ashore none the wiser, and resume our old lives, and sleep without dreaming, like babes.
>
> (Coetzee 1986: p. 141)

Now Susan can enter the metaphorical discourse that Foe (no longer the enemy) has begun; she can even continue it:

> Or like a mouth', said I. 'Friday sailed all unwitting across a great mouth, or beak as you called it, that stood open to devour him. It is for us to descend into the mouth (since we speak in figures). It is for us to open Friday's mouth and hear what it holds: silence, perhaps, or a roar, like the roar of a seashell held to the ear.
>
> (Coetzee 1986: 142)

Together now, Susan and Foe attempt to relay Friday's vision and the sense of his 'words'. Foe is no longer an enemy and authoritarian narrator. He proposes a narrative mode which demands openness and flexibility in gathering (and communicating) variations in the sensibilities of the age and requires different ways of perceiving, writing and telling.

It is no longer a matter of establishing what is realistic or plausible, according to obsolete conventions; it is about indicating the voiceless space of those who, until that moment, have been denied speech; whether because they were robbed of a tongue or refused the instruments (paper, ink, pen) to write with. Though highly symbolic, it is not important that Friday dresses in Foe's clothes and takes possession of the writing desk, paper, ink and pen of the writer. Nor is it important that the scene assumes a grotesque character. What, by contrast, is central is that Susan seeks to open Friday's mouth.

> His teeth are clenched. I press a fingernail between the upper and the lower rows, trying to part them.
>
> Face down I lie on the floor beside him, the smell of old dust in my nostrils.
>
> After a long while, so long I might even have been asleep, he stirs and sighs and turns on to his side. The sound his body makes is faint and dry,

like leaves falling over leaves. I raise a hand to his face. His teeth part. I press closer, and with an ear to his mouth I lie waiting.

(Coetzee 1986: 154)

The wait is long and unnerving: 'Closer I press, listening for other sounds: the chirp of sparrows, the thud of a mattock, the call of a voice. From his mouth, without a breath, issue the sounds of the island' (Coetzee 1986: 154).

By now Friday too (like Susan before him) can give rein to his language: signs and sounds, alternative modes that go alongside the pre-existing ones, perhaps superseding them and perhaps, more simply, affirming their right to co-exist, without any pre-established hierarchy imposing order and rank.

TOGETHER, FROM THE MARGINS

Together, in their fleeting but intense affair which will bind them until death, Susan and Foe as storytellers seek to create, or rather plot, a new scenario for writing. The space of the margin is the hybrid space which allows them to continually destroy barriers of race, sex, gender and language: Cruso's language, as well as Susan's, Foe's and Friday's. Together, Susan and Foe understand the political importance of de-centring themselves and others. By placing themselves on the cultural edge they create for themselves an open vision, embracing change and fluidity rather than fixity. Equipped with such a vision they hear and recognise the gurgling of Friday's voice as it dissolves in the marine liquid that surrounds the island, and becomes one with it.

After all, what is an island if not the 'is-land' written of by Janet Frame in her autobiography *An Angel at my Table* (1982). Returning again to the *Oxford English Dictionary* we find that the word 'island' embraces both earth and sea: 'isle' in its older form was derived from a term which referred to water and meant 'watery', or 'watered'. The earth was compounded by water and the water by earth. Where then is the limen between these two elements? I believe that Friday's simultaneous presence on the island and in the water, this liquefying of his being and his voice as it swims in the water around the island, suggests that it is from there, from what Linda Hutcheon would term an ex-centric position, that one needs to operate.

To choose the margin is, in the final instance, a political act. This is what the characters in *Foe* do and, naturally, this is what Coetzee intends and is the goal of many contemporary non-white and feminist narrators. As bell hooks, the African-American writer, points out, to speak, write and place oneself in the margin does not mean to withdraw into marginality:

I am located in the margin. I make a definite distinction between that marginality which is imposed by oppressive structures and that marginality one chooses as site of resistance – as location of radical openness and possibility. This site of resistance is continually formed in that segregated culture of opposition that is our critical response to domination. We come

167

to this space through suffering and pain, through struggle. We know struggle to be that which gives pleasures, delights, and fulfils desire. We are transformed, individually, collectively, as we make radical creative space which affirms and sustains our subjectivity, which gives us a new location from which to articulate our sense of the world.

(hooks 1990: 153)

REFERENCES

Anderson, B. (1983) *Imagined Communities*, London, Verso and New Left Books.

Bhabha, H. (ed.) (1990a) *Nation and Narration*, London, Routledge.

—— (1990b) 'DissemiNation: Time, Narrative, and the Margins of the Modern Nation', in H. Bhabha (ed.) (1990a), pp. 291–322.

Bettini, M. (ed.) (1992) *Lo straniero, ovvero l'identita culturale a confronto*, Bari, Laterza.

Coetzee, J. M. (1986) *Foe*, Harmondsworth, Penguin.

Fanon, F. (1969) *The Wretched of the Earth*, Harmondsworth, Penguin.

Harasym, S. (ed.) (1990) *Gayatri Chakravorty Spivak, The Post-colonial Critic, Interviews, Strategies, Dialogues*, London & New York, Routledge.

hooks, b. (1990) 'Choosing the Margin as a Space of Radical Openness', in *Yearning. Race, Gender, and Cultural Politics*, Boston, South End Press, pp. 145–153.

Kristeva, J. (1986) 'Women's Time', in T. Moi (ed.), *The Kristeva Reader*, Oxford, Blackwell.

Remotti, F. (1992) 'L'essenzialità dello straniero', in M. Bettini (ed.) (1992), pp. 19–37.

Shakespeare, W. (1958) *The Tempest*, ed. F. Kermode, London, Methuen (The Arden Edition).

Williams, R. (1988), *Border Country*, London, The Hogarth Press.

13

THE SPACE OF CULTURE,
THE POWER OF SPACE

Lawrence Grossberg

Post-colonialism and cultural studies (and to some extent, postmodernism) intersect at a number of different sites, on a number of different planes.[1] And both face at least three immediate and serious challenges. First, both must confront the globalisation of culture, not merely in terms of the proliferation and mobility of texts and audiences but, rather, as the movement of culture outside the spaces of any (specific) language. Consequently, a critic can no longer confidently assume that he or she understands how cultural practices are working, even within their own territories. The new global economy of culture entails a deterritorialisation of culture and its subsequent reterritorialisation, and challenges culture's equation with location or place. Second, both cultural and post-colonial studies seem to have reached the limit – and hence must confront the limitations – of theorising political struggles organised around notions, however complex, of identity and difference. Politics of identity are synecdochal, taking the part (the individual) to be representative of the whole (the social group defined by a common identity). Such a logic not only too easily equates political and cultural identities, it makes politics into a matter of representation (or its absence). Moreover the only political strategies open to it are deconstruction, strategic essentialism and an unfocused alliance. Challenging culture's equation with and location in an identity (even when defined within a logic of difference) may enable us to think about the possibilities of a politics which recognises the positivity or singularity of the other.[2]

Third, both discourses are faced with the need to think through the consequences – and strategic possibilities of – articulation as both a descriptive and political practice. Articulation is not simply a matter of polysemy or decoding (notions which were already present in the founding texts of modern philosophy, including Spinoza's and Descartes') but the making, unmaking and remaking of non-necessary relations and hence of contexts. Articulation assumes that relations (identities, effects, etc.) are real but not necessary. It describes the relation of a non-relation, and transforms cultural politics from a question of texts and audiences to one of contexts and effects.[3] But it remains too often under-theorised, leaving its anti-essentialism strategic since it must reject the epistemological anti-essentialism of radical poststructuralist positions. As a result,

questions about the agencies, effectiveness and modalities of articulation remain largely unexamined.

All these problems have emerged as cultural and post-colonial studies have attempted to confront the apparently new conditions of globalisation imbricating all the peoples, commodities and cultures of the world. In these conditions, the traditional binary models of political struggle – simple models of coloniser/ colonised, of oppressor/oppressed – seem inapplicable to a spatial economy of power which cannot be reduced to simple geographical dichotomies – First/ Third, Centre/Margin, Metropolitan/Peripheral, Local/Global – nor, at least in the first instance, to questions of personal identity. This points to a possible misdirection of cultural studies, for even if we grant that much of contemporary politics is organised around identity, it does not follow that our task is to theorise within the category of identity. Instead, locating it within the broader context of this new spatial economy, we need to ask why identity is the privileged site of struggle. This emergent spatial economy, a particular form of internationalisation and globality, implies a new organisation/orientation, not only of power but of space as well.

The list of characteristics describing this economy is by now both highly predictable and extremely variable, and comprises two vectors: the increasingly apparent autonomy and, simultaneously, interdependence and intersection of local, regional, national and international flows, forces and interests, and the very real pain of such dislocations and relocations. In other words, there is, on the one hand, the increasing internationalisation of the circuits of mobility of capital, information, manufacturing and service commodities, cultural practices, populations and labour. I do not mean to suggest that all of these mobilities are the same, nor that any single circuit is realised in the same way in different places. Nor do I mean to accede to a description of this process as 'post-industrialisation'; it is more accurately thought of as 'hyper-industrialisation'. On the other hand, the various articulations of space which interrupt such international flows – various articulations of 'the local' – are simultaneously, and in decisive ways, more important than ever. Here, typically, I can point to the increasing promotion of urban and regional identities in a global competitive economy, the growing importance and power of political struggles organised around 'identities' (whether by race, gender, sexuality, ethnicity, age/generation, etc.), and the reassertion of nationalist discourses based less on the identification of the nation and the state than on the assumed identity between the nation and ethnicity.

My question in this paper involves how one does 'cultural studies' in such global – spatial – conditions, conditions in which we as intellectuals are implicated, at the very least, by the somewhat involuntary (albeit somewhat pleasurable) nomadic condition of our particular class fraction. I do not believe that the answers can be found simply through some acknowledgement of our locationality, or some renunciation of ethnocentrism, or some attempt to hide our ethnocentrism in more apocalyptic claims of postmodernity. This is a situation in which, as Meaghan Morris describes it, Euro-American culture can 'no longer experience itself as the sole subject of capitalism or as coextensive with it'.[4]

The path I propose to take involves reflecting on the complicity of both sides of Atlantic modernism (both the avant-garde and the mass-popular) with modern structures of power. I use 'modern' to signal the specific Euro-American articulation of culture, economics, society and politics, not as a simple unity but a complex set of often uncomfortable relations. My reflections will lead me explicitly into philosophical speculation as an attempt to begin rethinking the theoretical foundations of cultural studies. To put it simply, since the philosophies we have do not seem to describe our reality very well, perhaps it is necessary to imagine a different philosophy (which is not to say simply a new philosophy, since in many ways what I shall propose is a return to pre-modern philosophies). Such a philosophy may offer a way of describing/constructing a different reality, a reality which is ours but perhaps with a different future. Such work is, obviously, an ongoing and collective project, questioning concepts which, if not invented in the formations of modern thought, were radically reconceptualised and repositioned in them. In particular, I am interested here in the relation of space and time, of geography and history, in the modern.

This project points to a paradoxical feature inherent in many contemporary critical theories. Wary of first philosophies, they nevertheless condemn themselves to remain within the assumptive grounds of the 'first philosophies' constitutive of the modern. Unable to escape the rationality they condemn, they must be content with asking 'whose rationality is it?', with acknowledging the multiplicity of rationalities, with enquiring into the specific articulations by which the inherited discourses of rationality have been accomplished, even while remaining with the broad terrain of modern rationality. Nowhere is this paradox more evident than in the immediate response any effort to begin moving outside of the structures and categories of modern thought elicits. Obviously, modern thought and power tell us it is impossible (Derrida on the impossibility of thinking outside logocentrism is only the most explicit and recent example). But what else would you expect! The real irony of this response is that one of the major lessons of contemporary theory is that experience itself is constructed in relations of power and that, consequently, the more obvious experiences are, the more they must be seen as ideological. Yet often the most 'obvious' features of our experience – e.g. the distinction between space and time – are the least examined philosophically.[5] I believe these fundamental structuring categories have major consequences for many of the theoretical problems of cultural theory – meaning and representation, subjectivity and agency, culture and society, identity and power.

My argument will proceed as follows. First, I will discuss the paradigmatic form of the discussion of globalisation in terms of the distinction between the local and the global. Additionally, I will briefly consider how this discourse has entered into and defined recent reflections on the politics of contemporary intellectual work. Second, I will consider some of the dominant forms which the interest in space has taken in contemporary cultural theory and analysis. Thirdly, I will argue that these strategies are inadequate precisely because they continue

to rest upon the modern assumption of the distinction between time and space. I will briefly propose an alternative – a spatial materialism (as opposed to a historical materialism) by drawing on the work of Michel Foucault, Gilles Deleuze and Félix Guattari. Finally, I will return to the question of globalisation, presenting only the barest outlines of an alternative theoretical framework within which to discuss contemporary relations of culture and power.

1

'The global' appears to have become the dimension in which power is theorised, the plane in which a new social topography is mapped and the trajectory along which the specificity of the contemporary is described. But we must be careful to distinguish between the historical question of whether there are different forms of globalisation and the theoretical question of how to describe such forms. In both of these registers, the question of globalisation raises a number of crucial issues for cultural studies and simultaneously it poses some serious problems. It demands that cultural studies consider questions of space, spatial relations and the spatiality of power. But how serious is this challenge to the traditional categories within which power is conceived? Is the demand of space which globalisation puts to us merely an empirical one? Or does it demand a refiguration of our language, space becoming the new metaphor for the same old historical processes and struggles? Both of these strategies are likely to take the very meaning and materiality of space (and its articulation or configuration) for granted. Is it necessary to conceptualise space and allow it to reconceptualise other fundamental categories of thought? And even further, can we simply add space to the understanding of culture and power? Do we have to rethink time as well? How do we consider the relation between time and space? If cultural theory has thus far privileged time, does the demand of globalisation mean that we must now privilege space, if only as a politico-philosophical strategy?

Most of the current discussion of globalisation assumes two idealised models. On the one hand, there is a model of the entirely local or, in Abu-Lughod's terms, 'the cloisonné' world.[6] This is an obviously imaginary construction of a world in which there are no relations between locales, no traversing of space. On the other hand, there is a model of a totalised globality. This is an equally imaginary construction which sees the world as a single place, in which all (cultural) products are instantaneously and completely distributed, as if there were no space to be traversed. Obviously, the task is to explore the space between these two extremes, to recognise that there are increasingly rapid yet still incomplete flows, and that the space of globalisation is a space of struggle. In fact it is this in-between space that provides the most common terrain on which the debates over globalisation have taken place, usually framed as a relation between the national and the international, projected toward a new transnational context. But it is important to note that, within this discourse, globalisation is already conceptualised in terms of the differentiation between places and spaces.

In this middle ground, critics postulate two vectors: globalisation producing homogeneity, and local reproduction producing difference and transformation. The local site, usually located in so-called peripheral nations (or in 'communities' within the 'core' nations), constantly inflects global practices, resulting in a kind of syncretism or creolisation. The global production process is usually assumed to continue 'the ever rolling march of the old form of commodification, the old form of globalisation, fully in the keeping of the West, which is simply able to absorb everybody else within its drive'.[7] If too much attention to the global often leads critics to the unearned, pessimistic conclusion that the victory (of capitalism, of American imperialism, etc.) is already sewn up, too much attention to the local often means that critics lose sight of the fact that someone is winning the struggle, and it is rarely the 'periphery'. In this form, the debate over globalisation is merely a continuation of earlier debates over (cultural) imperialism.[8]

That is, this form of the debate assumes that the nature of globalisation itself has not changed; the difference is merely a matter of its relative degree, speed, intensity, etc. However, it is possible to argue that this model of globalisation is inappropriate to the contemporary world. In fact, it may even be inadequate as a model of older forms of globalisation because, to quote Stuart Hall,

> the more we understand about the development of capital itself, the more we understand that . . . alongside that drive to commodify everything, which is certainly one part of its logic, is another critical part of its logic which works in and through specificity . . . So that the notion of the ever-marching, ongoing, totally rationalising, has been a very deceptive way of persuading ourselves of the totally integrative and all-absorbent capacities of capital itself . . . As a consequence, we have lost sight of one of the most profound insights in Marx's *Capital* which is that capitalism only advances, as it were, on contradictory terrain.[9]

Whatever the nature of older forms of globalisation – often encapsulated in notions of mercantilism, colonialism, imperialism, and forced migrations (i.e., the beginning of the Jewish and Black diasporas) – perhaps we must construct a new and distinct model of contemporary globalisation. This new form of globalisation, with its different relations, rhythms and motivations, has been described in different ways, although such descriptions generally remain within a spatial topography that assumes the absolute difference between the local and the global (and equates this with the difference between place and space). For example, Hall describes it as a structure which is both global and local at the same time.[10] According to Hall, it involves new forms of the migration of labour and the flow of capital, new structures of relations between processes of globalisation and the construction of multiple levels of localities which both interrupt and amplify such flows – the erosion of the nation-state and national identities is counterbalanced by the even stronger return of 'defensive exclusions', new ecological relations and a new cultural practice which constructs unity through difference. This culture, which Hall calls the 'global postmodern', no longer speaks a single

ideology or a single language. Or rather, it is no longer able to construct a single dialect as the proper and normal version. It must pluralise and deconstruct itself, which is not to deny that it still originates from a position of power in the West, nor that it attempts to construct a peculiar form of homogenisation and even hegemony through difference.

Arjun Appadurai takes a more extreme view, coming close to equating the new globalisation with postmodernity: it is

> close to the central problematic of cultural processes in today's world . . . the world we now live in seems rhizomatic – calling for theories of rootlessness, alienation and psychological distance between individuals and groups on the one hand, and fantasies (or nightmares) of electronic propinquity on the other.[11]

This dilemma of postmodern or post-colonial identity is tied to larger global forces which Appadurai identifies as the forces of post-industrial (cultural) productions. In order to describe the dimensions of this global cultural flow, Appadurai introduces five '-scapes' which he offers as 'deeply perspectival constructs': ethnoscape, technoscape, finanscape, mediascape, ideoscape. These describe, respectively, the movements of peoples, technologies, monies and capital, entertainment and ideology/news/State politics.

There are a number of points, both supportive and critical, worth making about this description of globalisation. First, the selection is itself suspect. We might ask why such -scapes such as information, commodities, war, etc., have been ignored, or why the 'ethnoscape' seems to always appear first on every intellectual's list of global flows. Has this something to do with the situation of global and post-colonial critics and with the continued power, even through post-structuralism, of the assumption of a politics organised around identities and differences? Second, within the discussion of each -scape, Appadurai emphasises the transition from local to global forces. In a certain sense, this weighting contradicts the simultaneous emphasis on processes – or at least rhetorics – of deterritorisation, displacement, and disorganisation. Once again, the crucial question of the relation between these two opposing trajectories remains unexplored. Third, Appadurai emphasises questions of imagination (and culture, although it is not always clear what the relations between these two terms are). He not only talks about 'a new role of imagination in social life' but also about 'the imagination as a social practice' as if this has not always been the case.[12] But most importantly here, he describes the -scapes as 'the building blocks of imagined worlds – the multiple worlds which are constituted by the historically situated imaginations of persons and groups spread around the world.'[13] Here Appadurai is drawing on Benedict Anderson's notion of the nation as an imagined community; yet perhaps this notion needs to be criticised: why is the nation not a real community, always built on the basis of imagined commonalities? Or is there even another possibility for understanding such communities?

Fourth, there is an important ambiguity in the way Appadurai frames the problem. At one moment, he says that 'the central problem of today's global interaction is the tension between cultural homogenisation and cultural hetero-genisation' (or what he calls indigenisation).[14] This reproduces the older model of globalisation described above, although Appadurai makes an important and insightful qualification. He refuses to reduce the question of homogenisation to Americanisation, arguing instead that the forces of homogenisation are site-specific, always embodying a scalar dynamic. (That is, depending on where you are, different forces – always existing at a larger scale – will be trying to homogenise you.) Yet at another point, he clearly refuses this older model, claiming globalisation cannot be equated with homogenisation. Instead, he suggests that the process involves the State as 'the arbitrager of this *repatriation of difference*',[15] echoing Hall's view of the global postmodern.

Finally, and most interestingly, Appadurai offers some suggestions about how this formal model of -scapes might work. Not only do the various -scapes follow non-isomorphic paths, but because the sheer speed, scale and volume of these flows has become so great, the real object of study – what has become central to the politics of global culture – is not the individual -scapes but the (unpredictable) 'disjunctures' between them. This, Appadurai concludes, means that we need new models which can describe the space and shape of this economy of -scapes. He calls upon theorists to think in terms of fractals (scalar phenomena describing shapes which, while possessing no Euclidean boundaries, still exhibit among other things a constant degree of irregularity across different scales), chaos theory (a theory of 'nonlinear dynamic systems with sensitive dependence on initial conditions') and polythetic (overlapping) structures.[16] While it is not always obvious that he takes these any more literally than he takes 'rhizomes' (e.g. chaos theory is rigorously mathematical), his call is still important, for it suggests that perhaps what we need is less a theory of a rhizomatic world order than a rhizomatic theory of the changing world order, where rhizomatics and chaos/ fractals both suggest the need for new theorisations of space and change.

And it is to this question – the possibility of another way of conceptualising the global – that I want to turn, although my discussion will be sketchy and rather abstract. To begin, however, we must disentangle and deconstruct a number of different questions. One of the major assumptions in these discussions is that the field of culture and power is structured according to the difference and relation-ship between 'the local' and 'the global'. At the same time, spatiality itself is often divided into places and spaces – the former identifying sites of fullness, identity, 'the inside' and human activity, the latter identifying the emptiness between places in which nothing happens except the movement from one place to another. Often, these two pairs are simply identified, the local apparently equated with place and the global with space. But I want to disarticulate this equation – to see the organisation of space and place as a geography of belonging and identification, and the differentiation of local and global as a description of the changing nature of the deployment of forces – in order to begin understanding

how these relations are actually articulated.[17] Starting with their non-identity, we can enquire into their different productive organisations, the different ways they have been, are being and can be, brought into relationships.

There is in fact a third question involved here: namely, the question of locality as the specification of context, of the spatial frame within which particular events are to be understood. There is, implicit in the equation of the local and the context as the site of specificity, often a certain fetishisation of the local. Cultural analysts are constantly harangued to bring their analysis 'down' to the level of the specific; political activists seem to assume that they must 'act locally', etc. Yet such celebrations of the local are often untheorised, based on a particular defin-ition of knowledge as 'facts' and a model of inductive empiricism. Alternatively, the local is theorised only to the extent that it is identified as the site of agency (difference, resistance). But the only basis for such an identification seems to be the prior identification of subjectivity, subject-positions (identity) and agency. This in turn assumes that a theory of individual will (e.g. Wittgenstein's question: what is the difference between my raising my arm and my arm rising?) is the same as a theory of the articulation of particular social groups to struggles over power.[18] Such a system of identifications has resulted in a politics of location which examines how intellectuals are inserted into and positioned within global networks of power (including the dissemination of knowledge and culture) as an antidote to both explicit and unintended claims to represent the universal.[19]

But this leaves open the question of how the discourse of the local and the global is itself situated as a cultural practice of intellectuals: is globalisation a general phenomenon or is it an experience that belongs only to a specific class fraction – of global intellectuals, or a new metropolitan elite or a new information-service class.[20] In other words, whose reality, experience or imaginary is being described? And if globalism belongs only to a specific fraction, then are we simply describing the localism of that specific fraction?

Yet, as Bruce Robbins argues, 'the notion that certain classes of people are cosmopolitan (travellers) while the rest are local (natives) is only the ideology of one (very powerful) travelling culture'.[21] Consequently, the very binary of uni-versal and particular, of global and local, is inadequate, little more than the expression of the local self-interest of scholars. Or perhaps more accurately, the question is how the identification of the local and agency, and the fetishism of the local, are articulated to and articulate the political function of the contemporary intellectual. Why, Robbins asks, are certain kinds of work valorised in the contemporary context – in particular, work which celebrates (and identifies) the local, the specific and agency? Why do cultural critics continue to search for agency (or resistance) in 'text after text'? According to Robbins – and it is an analysis I support – it is a technology of power that legitimates the claim of criticism to 'public representativeness'; it justifies the labour of intellectuals by creating an apparent anchor in political reality. It makes critics appear to be, in some sense, 'organic intellectuals' speaking for a real population.

Moreover, within all this talk of the local and the global, locality is often

ambiguously defined and deployed. First, it is treated as an articulated context, as a site of the intersection of multiple determinations extending across a particular place. Second, it is taken to embody a methodological orientation which favours the particular over the general. But there is a contradiction between these, especially if context is understood as a variable level of abstraction so that it can describe a wide range within a scale of localities, stretching from the personal, through the domus, the neighbourhood, the community, the city, the nation, to the world. How can each of these be defined as the particular against some other 'general' term? And there is still a third use of the local as a discursive shifter or variable, but its functioning is rarely specified beyond the notion that it constructs a place (out of a broader empty space). But how place is constructed, how notions of belonging, identity (and difference) and experience are linked to the relations of place and space is rarely examined. In fact, part of what I want to propose is a new theory of context, not as place, but as the becoming of place and space. This theory – of the production of culture through a spatial becoming (which is not the empiricist deployment of space as the question of the travelling of culture) – depends upon a notion of identification and belonging which can disarticulate place and identity.

2

As Dick Hebdige has written,

> a growing scepticism concerning older explanatory and predictive models based in history has led to a renewed interest in the relatively neglected 'under-theorised' dimension of space . . . spatial relations are seen to be no less complex and contradictory than historical processes, and space itself is refigured as inhabited and heterogeneous.[22]

In fact, questions, descriptions and vocabularies of space have appeared with all the enthusiasm of an apparent revolution in a wide range of discourses and empirical researches. While we should welcome this proliferation, we must also be sensitive to and critical of the limits of such work, and of its continued allegiance to the discursive apparatuses, the philosophical assumptions, and, perhaps unintentionally, the structures of power of the modern.

I want briefly to make some generalisations about the strategies by which space is deployed in some of this work. The first puts space to work in the service of time; that is, it makes the power of space instrumental, raising important questions of how power uses, organises and works through space, yet reducing it to its role in securing the demands of temporal power (i.e. the reproduction of structure).[23] A second strategy chronologises space: for example, reprivileging history as the agency which has replaced history with geography. This is the strategy of most so-called 'post-modernisms'.[24] A third strategy, characteristic of only certain versions of postmodernism, argues that space has replaced, even annihilated time; in a sense, it reverses Marx's understanding of capitalism as the

annihilation of space by time. But usually, such work ultimately negates space itself by rendering it unmappable, or epiphenomenal.[25]

All these strategies tend to view space as passive and determined, largely because they treat space too empirically, viewing it as either an objective or an experiential reality. Researchers enquire into what kinds of practices take place where and who has what kinds of access to them (against the presumption of 'universal entitlement'); they study who or what moves, along what paths, with what frequency.[26] They ask about the sorts of spatial boundaries operating and how permeable they are.

Juxtaposed with this empirical approach to space is another body of discourse which needs to be acknowledged, analysed, appreciated and criticised. I will only acknowledge it here, for it poses more difficult and delicate questions. It involves the proliferation of spatial vocabularies as figures to describe discourses, power and even the Imaginary, vocabularies in which images of margins, boundaries, positions, etc. abound. This figural language functions, often insightfully, to describe everyday life, social relations of power and intellectual work. However, too often, its poetic language of travel – of homes, voyages and destinations – reconfigures metonymical systems into synecdochal images of identity which can function as judgements about what is normal and what is proper.

Perhaps the most visible site of such work has been the proliferating use of the diasporic model in discussion of race, ethnicity and post-coloniality. This discourse spatialises debates about the proliferating field of identities and antagonisms in the contemporary world. It includes a wide range of strategies, from Paul Gilroy's empirico-textual concern with 'the relationship between spatialization and identity-formation' to Stuart Hall's reconceptualisation of ethnicity as a politics of location, as a configuration of where one places oneself, to Trinh Minh-ha's evocative poetics of the diasporic experience, to James Clifford's construction of cultural identity as produced by travel.[27] Yet in each of these cases, identity is ultimately returned to history, for one's spatial place is subsumed by a diasporic history and a colonial experience which privileges particular exemplars as the 'proper' figure for identity.

3

The modern has often been identified as embodying a chronological logic as well as a specific temporality. But the relation goes deeper, for at the heart of modern thought is, I believe, the assumption of the difference between space and time, which plays itself out, for example, in the difference between structure and process. The bifurcation of time and space, and the privileging of time over space, was perhaps the crucial founding moment of modern philosophy.[28] It enabled the deferral of ontology and the reduction of the real to consciousness, experience, meaning and history (and it allowed the articulation of subjectivity, identity and agency to become an identification). In fact, most of contemporary cultural theory – including cultural studies – continues to accept the difference and, even

more importantly, continues to privilege time/history/process (as evidenced in the historicist notion of conjuncturalism often used to describe post-Gramscian cultural studies).

But what happens when we recognise that history 'both as a form of knowledge and as a primary state of being of empirical phenomena . . . is itself a historical phenomenon . . . even if its problematic of temporality spills over into many others'?[29] One possibility I will reject out of hand is to erase temporality in favour of spatiality, what Philo describes as 'a geographical way of looking at the world in which one sees *only* "spaces of dispersion": spaces where things proliferate in a jumbled-up manner on the same "level".'[30] Another inadequate, albeit more productive, strategy sees space as merely the particularity which specifies and fragments history. It starts and ends with 'the simple but telling "fact" that the phenomenon, events, processes and structures of history (however we may define them) are always fractured by geography, by the complicating reality of things always turning out more or less different in different places.'[31] But it fails to challenge the assumption that 'one and the same form of historicity operates upon economic structures, social institutions and customs, the inertia of mental attitudes, technological practice, political behaviors and subjects them all to the same type of transformation.'[32] The very functioning of temporality as a singular dimension of effects – across domains, levels and space – has to be challenged.

What is required then is for space itself to become a philosophical project, as in the work of Deleuze and Guattari. Their radically 'other' view of space entails 'a transformation of history into a totally different form of time'[33] in which 'history does not run through time but emerges from the relations of a time that is "spatialised".'[34] Such a project takes seriously Meaghan Morris' challenge: 'To act (as I believe feminism does) to bring about concrete social changes while at the same time contesting the very basis of modern thinking about what constitutes "change".'[35]

Such a project means challenging the modern tradition and, to this end, it is not sufficient to merely rethink the relation of time and space, to question the taken-for-granted ontology of space or even to acknowledge its sociohistorical construction. It is rather a question of the space of ontology which demands that we rethink 'the real' outside of the constitution of modern categories. We must move from talking about space to spatialising the real as the production of the singularity of the other. Consider the railway timetable which is often used as an obvious example of the rationalisation of time. And yet, as Greg Wise has pointed out, this is only true from the sedentary position of the person at the station.[36] From any other position, the timetable is better understood as the control of movements through space. Thus, a spatial materialism involves rethinking being in spatial terms where temporality is not outside of or even orthogonal to space. The spatialisation of being involves a spatial articulation and deployment of the notion of transformation: space as the milieu of becoming, a scalar event.[37]

Given, ironically, the limitations of space, I will satisfy myself with pointing

to some of the major assumptions and implications of such a spatial materialist (Deleuzean) philosophy.[38] First, as a philosophy of the real, it refuses the Kantian distinction between phenomenon (experience, discourse, meaning) and noumena (the real): 'How is it possible to speak without presupposing, without hypothe-sising and subjectivising or subjecting what one speaks about? How is it possible not to speak on the presupposition of a thing, but to say the thing itself?'[39] It refuses to reduce reality to a single dimension, whether semiotic, social, psycho-analytic or material. Reality – as assemblages or apparatuses of multiplicities – is constituted out of the relations between lines of force (scalar measures of effects). It is a question not of history but of orientations, directions, entries and exits. It is a matter of a geography of becomings, a pragmatics of the multiple.[40] Becoming is the spatialisation of transformation; it refuses, not only to privilege time, but to separate space and time. It is a matter of the timing of space and the spacing of time. To put it more simply, Deleuze and Guattari take reality to be both real (productive) and contingent (produced) – reality producing reality – and the production of reality is the practice of power. Reality is nothing but effects which can be measured only as lines, not points. In this sense, Deleuze and Guattari describe reality as machinic, differentiating it from the mechanical, the organic and the subjective. The machinic is agency without subjectivity, neither passive nor active.[41]

Every line of becoming involves two terms which define not predefined origins or destinations, but an 'aparallel evolution': each term becomes an other but never simply the other term. Emphasising the non-universal and non-individual nature of the intersection of lines, it is nevertheless the case that lines map out the actuality of the real: 'not what we are, but rather what we are becoming, that which we are in the midst of becoming, which is to say, Other, our becoming-other'.[42] This statement is easily misunderstood: Deleuze and Guattari are not suggesting that we literally become *the* other, especially when the other is identified with the different (as if it were literally the animal, the woman, the post-colonial, etc.). They are arguing that reality must be understood as con-tinually mutating within and across the space of existence. What is crucial is that it is the becoming that is real. Its reality is not defined by the points it connects but by the in-between or 'milieu' which it traverses.

Deleuze and Guattari's work theorises the various technologies and organ-isations of this becoming, of the production of the real, as maps of power. These machines, which can be understood as modalities of articulation, impose a particular 'conduct' and organisation, not only on specific multiplicities but also on particular planes (of effects). They define the 'geometric mechanisms'[43] by which different kinds of individualities and subjects (which implies neither identities nor subjectivities) are produced and articulated into specific configur-ations. Here we can distinguish three kinds of machines: abstract or stratifying, territorialising and coding; each of course is constantly involved in practices of de- and re-articulation. The most important for my present purposes – and the most difficult to present – is the abstract machine.

The abstract machine (or what Foucault calls a 'diagram') is what produces a particular configuration of reality or, to put it more paradoxically, it produces reality as it exists in a particular configuration:

An abstract machine is neither an infrastructure that is determining in the last instance nor a transcendental Idea that is determining in the supreme instance. Rather, it plays a piloting role . . . [It] constructs a real that is yet to come, a new type of reality.[44]

The abstract machine works through a double articulation. First, it organises and distributes 'particles' of reality (but of course, every such particle is itself made of other particles) into two distinct populations which Deleuze and Guattari call 'strata'. The reality of any 'particle' or individual is defined by its non-necessary location in one or the other of the strata; at the same time, particles may be imbricated in multiple stratifications since there are always multiple abstract machines operating in and on the real. What varies from one reality to another (or from one stratification to another) is the nature of this real distinction, the location of the line separating them, and the respective position of different individualities.

Turning Hjelmslev's linguistics (offered against structuralism) into an ontology, Deleuze and Guattari describe the strata as the plane of content and the plane of expression. The former constitutes the matter, or materiality, of the real (at least within this particular stratification); it is that which is acted upon. It

relates not to the production of goods but rather to a precise state of intermingling of bodies . . . including all the attractions and repulsions, sympathies and antipathies, alternation, amalgamations, penetrations and expansions that affect bodies of all kinds in the relations to one another.[45]

The latter constitutes the functions or transformations of the real. The two planes describe something like the active and the passive – although from the above descriptions we can see the inadequacy of this distinction. At the level of a human stratification, they describe something like the non-discursive (the knowable, the visible) on the one hand and the discursive (enunciation, the sayable, the articulatable).

The second articulation operates within each of the two strata, further dividing them into form and substance. Each strata has its own forms and substances. The forms of the plane of content, according to Deleuze and Guattari, impose a statistical order, while those of the plane of expression are functional structures. Content describes the plane of formed matter; expression the plane of formalised function: 'Every stratum operates this way: by grasping in its pincers a maximum number of intensities or intensive particles over which it spreads its forms and substances, constituting determinant gradients and thresholds of resonance.'[46]

In other words, the abstract machine produces an organisation of matter and functions. Such a stratification defines a practised (or practice-able) reality; each stratum defines a range of possible events or actions (for whatever individuals

constitute the population of the stratum) in the specific milieu of the strata, where a milieu is, as it were, the sum of the relations and possibilities for actions/events within a particular space ('in-between') of the strata. A milieu is not an historical construction but, rather, the becoming of a space of becoming. Similarly, consciousness (or intentionality) is not defined outside the milieu and the stratum but is rather the 'enfolding' of the milieu, the construction, within the milieu, of a space of internality (and potentially subjectivation which is not subjectification). Hence, the abstract machine also produces 'consciousness' (which varies with the stratum) in its various stratified existences. This means that while intentions, perceptions, experiences, etc. are real within the stratum and even determining within a milieu, they are never solely determining. They cannot be privileged above other determining articulations, other possibilities, practices and events. And while they may contribute to events which ultimately lead to the appearance of new abstract machines, they can never determine such machines. For Deleuze and Guattari, this practice-able reality is the real, for what could it mean to talk about a non-practised or non-eventful real?

The other two machines – coding and territorialising – operate on and across the strata. Consequently, each stratum is organised according to both a coding of forms and a territorialisation of substances. Territorialisation is a technology of becoming organised by a metonymic logic of proximity (and . . . and . . . and . . .) on and across the substance of the strata. It produces alterity, marked by lines of investment cutting across milieu and stratum. Alterity is here constituted as a distribution of places and spaces where each place is not only the site of substantive becomings but also of multiple hybridities and agencies. Coding is built on disjunctive lines which inscribe formal differences on and across the strata, producing a logic of propriety (either/or/or . . .). Codes bind apparently independent realms. A coding technology is a differentiating production of normalisation and a logic of identity and difference. I have elsewhere discussed the question of identity in relation to coding and territorialising machines, arguing that the relationship of places and spaces defines a geography of belonging and identification which is a function of territorialising machines.[47] It is also in terms of the relationships between specific coding and territorialising machines that we can begin to chart the distinction between societies of sovereignty, disciplinary societies of surveillance, and disciplined mobilisations as radically distinct structurations of social power.[48]

4

At this point, I want to return to the question of globalisation, and to the question of the local and the global. At first glance, it may seem that this question can be described as a matter of the technology of coding. After all, coding is a matter of the extension and construction of relations of the same and the different (including perhaps that between the local and the global). And, in fact, I think this does enable us to understand older form(s) of globalisation. For such organisations

of power as mercantilism and colonialism were matters, not only of extension but of the extension of particular forms. They involved decoding particular forms and recoding them according to the operational logics of the colonising power. In this sense, they also involved fairly simple relations of becoming: the English becoming the colonised and the colonised becoming the English.

But I am not convinced that this describes globalisation (and the economy of the local and global) as it is currently being re-produced. The older forms of globalisation, like the technology of decoding and recoding through which they were produced, worked on specific strata. Since each stratum demanded its own logic of coding, the stratum remained relatively intact and autonomous. While capital may have been its driving force, capital was produced as only one value, one version of formed matter, which could be contradicted by other values, including geographical expansion and empire, and the ideological values of 'civilisation'. While these values were most certainly articulated to one another, they were not – and cannot be – simply equated.

But the newer forms of globalisation seem to operate with a different logic and a different technology. For the moment, I can provide only the most abstract suggestions which are meant to provide new questions rather than new answers. First, as to the question of the logic of globalisation, Deleuze and Guattari distinguish between two states of the abstract machine which 'always co-exist as two different states of intensities':

> We may even say that the abstract machines that emit and combine particles have two very different modes of existence: the Ecumenon and the Plano-menon. Either the abstract machines remain prisoner to stratification, are enveloped in a certain specific stratum whose programme or unity of composition they define and whose movements of relative deterritorialisation they regulate. Or, on the contrary, the abstract machine cuts across all stratifications, develops alone and in its own right on the plane of consistency whose diagram it constitutes: the same machine at work in astrophysics and in microphysics, in the natural and the artificial, piloting flows of absolute deterritorialisation (in no sense, of course, is unformed matter chaos of any kind).[49]

The planomenological machine remains within and guarantees the unity of a particular stratification; taken to its extreme, it produces a reality in which relationships across stratifications are non-existent. The ecumenical machine operates across all strata destratifying every articulation according to its own diagram. All stratifications are worked and work in just the same way, according to the same diagram. Taken to its extreme, it produces a reality in which certain kinds of relationships are impossible because difference has itself disappeared from the milieu; all milieux have become the same (e.g. capital). Interestingly, these two forms of the abstract machine define two competing visions of the postmodern.

The older forms of globalisation were built on planomenological technologies,

operating through multiple planomenological machines, each of which operated by extending its coding machines across other milieux, annexing them into its own milieu. This extension was carried out, however, through coding machines rather than through the abstract machine itself. Thus, capitalism remained within the sphere of the economic, colonising other strata and milieu, decoding and recoding them. Of course, colonialism did not work only on the economic stratum; it worked in multiple strata. But the point is that while various strata were perhaps all essential to the success of the colonialist project, and while they no doubt had interstratal relations with one another, colonialism operated on each plane with a different project, and a different technology. This does not negate the possibility that all these operations were in the service of a primary stratification: namely, the production of the real as capital (expression) and resource/labour (content).

I want to suggest that the new forms of globalisation are not a matter of coding and decoding, nor are they based on planomenological technologies. They do not respect the stratifications that already exist, nor are they content to merely recode or even reterritorialise them. In some cases, they apparently do not even need to recode or reterritorialise them. Instead, the new forces of globalisation are more like ecumenical abstract machines which operate across all of the stratifications of reality, in every milieu, to destratify them and produce – what? Obviously, producing reality itself, but a different reality, a new relationship between the strata, between content and expression. But what is the diagram of this new abstract machine? I want to pose this as the first question that has to be answered in any attempt to understand contemporary globalisation and its relations of the local and the global. Too many critics and theorists, especially certain 'post-modernists', have answered this too quickly and reduced the ecumenical machine to the total collapse of difference. This third vision of the postmodern claims that reality is being reduced to the form of capital or its image. But while the differences across milieux (and stratifications) may disappear in an ecumenical machine, the difference between the strata, between content and form, remains; for without it there can be no practice-able reality.

My own hypothesis is that the new order of globalisation is built upon an ecumenical abstract machine that produces differences as the form of the plane of expression, and money as the substance of the plane of content. It is not merely a matter of capitalism reproducing itself as or across space, but of capitalism producing space as difference and difference as space as the new condition of possibility for its own ever-expanding monetarisation. This represents at least two significant shifts from older forms of globalisation. First, it is no longer a matter of capitalism having to work with and across differences. If, in the past, capitalism refused any coding (difference) which tied its productivity to an external code, today it works instead by a kind of recoding, i.e. precisely by the production of difference itself. But it is not the content of the differences but only their form that is relevant. It is the form of difference that is being produced everywhere, on every thing. In a sense, we might say that difference has been

commodified (but this is only a partial description of what I am describing), but this does not mean it has disappeared, since the commodity itself depends on the difference between use and exchange value. Rather, the new abstract machine of capitalism produces differences at the level of expression; it is difference which is now in the service of capital.[50] The new abstract machine makes capitalism into a technology of distribution rather than production by producing a stratification in which differences proliferate in a highly reterritorialised world. This obviously makes the current faith in difference as the site of agency and resistance problematic to say the least.

Second, what is to be produced is no longer the form of value (capital) but its substance (money), for it is as money that capital is most productive. Capital is always becoming, always 'begetting' itself; and it is as finance capital – in the banking system – that capital presents the purest form of its own self-production. Today, money itself has become the purest form of capital and, through it, capitalism effectuates an infinite debt which seems to guarantee the productivity, if not the stability, of capitalism. The capitalist economy is perpetually 'in need of monetarization',[51] for it is predicated on the co-existence of two fundamentally incommensurable flows 'that are nonetheless immanent to each other . . . the one measuring the true economic force, the other measuring a purchasing power determined as "income"'.[52] Of these two forms of money – financing and payment – financing is the form of productive capital, which is not income 'and is not assigned to purchases'. It is 'a pure availability'.[53] Consequently, what the circulation of money actually produces is 'an infinite debt' or at least 'the means for rendering the debt infinite'.[54] The contemporary ever-spiralling debt, which paradoxically includes both the poorest and the richest nations in the world, does not represent the failure of industrial capital but capitalism's unrestricted ability to create more money which is constantly owed to itself. It is possible, then, that the emergence of an international economy of debt financing, built upon the spatial displacement of production and the increasing centrality of services (including culture), is not some aberration or failure of capitalism but, to put it metaphorically, the beginning of a cycle of capital rejuvenation. Of course, this process is no more benign than previous articulations of capitalism and globalisation. On the contrary, it shows every promise of becoming the most devastating and exploitative form of social power the world has ever seen.

Only as we begin to recognise and map this abstract machine can we understand the articulation of the local and the global into relations of belonging (territorialisation) and identity (coding), to enquire into the placing and spacing of the local and the global, and the localising and globalising of the places and spaces of our belonging. After all, in the contemporary formation of globalisation, one can belong to the global as a place just as one can belong to the local as a space. This entails asking what it means to be situated in particular places, what it means to belong, and what different ways (or modalities) of belonging are possible in the contemporary milieu. It is no longer a question of globality (as homelessness) and locality (as the identification of place and identity), but of the

various ways people are attached and attach themselves (affectively) into the world. It is a question of the global becoming local and the local becoming global. If there is a new ecumenical abstract machine, then the very possibility of a practice-able world is no less at stake than the nature of belonging (territorial-isation) and difference (coding). If difference has become the geometrical mechanism of a new diagram of power, then the very meaning and possibility of social order is no less at stake than the meaning and possibility of social trans-formation, resistance and oppositional politics.

NOTES

1 I would like to thank Carol Stabile, Charley Stivale and Meaghan Morris for their helpful comments on an earlier draft. This paper is part of a larger work in progress on the philosophical underpinnings of cultural studies.
2 See, for example, Giorgio Agamben, *The Coming Community*, Minneapolis, University of Minnesota Press, 1993.
3 See Lawrence Grossberg, *We Gotta Get out of This Place: Popular Conservatism and Postmodern Culture*, New York, Routledge, 1992.
4 Meaghan Morris, 'On the Beach', in Lawrence Grossberg, Cary Nelson and Paula Treichler (eds), *Cultural Studies*, New York, Routledge, 1992.
5 While it was Kant who introduced the radical distinction between space and time into modern philosophy, Kant also knew that this would lead to what he called the antinomies.
6 Janet Abu-Lughod, 'Going Beyond Global Babble', in Anthony D. King (ed.), *Culture, Globalization and the World-system*, Houndsmill, Macmillan, 1991, pp. 131–138.
7 Stuart Hall, 'The Local and the Global: Globalization and Ethnicity', in King, op. cit., pp. 30–31.
8 The question of nationalism arises in this space: is the nation adequate to describe cultural identity and transnational relations? Is the politics of the nation necessarily bound up with a history of racism and colonialism? On the side of the local, for example, we can cite Barbara Abou El-Haj ('Languages and Models for Cultural Exchange', in King, op. cit., p. 142): 'Because the nation state has been the political form under which international capital expanded, it does not follow that this political form and its cultural expression arise only from the center.' On the other side, Paul Gilroy (in 'Cultural Studies and Ethnic Absolutism', in Grossberg *et al.*, op. cit., pp. 187–198), like the Subaltern Group, seems to suggest that nationality is necessarily bound up with racism and ethnic struggle, with sensibilities that depend on antagonistic relations with an external world and thus always feeds back into the question of colonial power. In between, Partha Chatterjee (*Nationalist Thought and the Colonial World*, Minneapolis, University of Minnesota Press, 1993) seems to believe that there is a relation of power involved in the very conception of the autonomy of cultures (i.e. of national cultures). Nationalist thought therefore does not and cannot constitute an autonomous discourse. On the contrary, it is a particular manifestation of the problem of the bourgeois rational conception of knowledge and in particular, of the search for a supposedly universal standard which would not be alien to any national culture. Thus Chatterjee seems to agree with Gilroy that insofar as nationalism is dependent on the view of the Enlightenment as a universal idea which nevertheless always needs its Other, it is locked into colonial relations. And yet in the concrete context of the struggle for Indian nationalism, Chatterjee leaves open

the possibility that nationalism was and can be rearticulated into Third World contexts in progressive and appropriate ways.

9 Hall, 'The Local and the Global', p. 29.

10 Ibid.

11 Arjun Appadurai, 'Disjuncture and Difference in the Global Cultural Economy', *Public Culture*, 2, 1990, pp. 2–3.

12 Ibid., pp. 4–5.

13 Ibid., p. 7.

14 Ibid., p. 5.

15 Ibid., p. 16.

16 Stephen H. Kellert, *In the Wake of Chaos*, Chicago, University of Chicago Press, 1993, p. 119.

17 See Lawrence Grossberg, 'Cultural Studies and/in New Worlds', *Critical Studies in Mass Communication*, 10, 1993, pp. 1–22.

18 Another way of looking at this which will become clearer later in the essay is that the two questions are operating in different stratifications.

19 See, for example, Aijaz Ahmad, *In Theory: Classes, Nations, Literatures*, London, Verso, 1992; and George Yudice, 'We Are Not the World', *Social Text*, 31/32, 1992, pp. 202–216. Carol Stabile has pointed out to me that thinking in terms of space demands that intellectuals think of themselves in relation to others in a way that temporal thinking does not permit. However, this politicisation of the intellectual is subverted by the fetishisation of the local.

20 See, for example, Manuel Castells, *The Informational City*, Oxford, Blackwell, 1989.

21 Bruce Robbins, 'Comparative Cosmopolitanism', *Social Text*, 31/32, 1992, p. 181.

22 Dick Hebdige, 'Subjects in Space', *New Formations*, 11, 1990, pp. vi–vii.

23 See Henri Lefebvre, *The Production of Space*, Oxford, Blackwell, 1991; Edward Soja, *Postmodern Geographies*, London, Verso, 1989; Ashraf Ghani, 'Space as an Arena of Represented Practices: An Interlocutor's response to David Harvey's "From Space to Place and Back Again"', in Jon Bird, Barry Curtis, Tim Putnam, George Robertson and Lisa Tickner (eds), *Mapping the Futures: Local Cultures, Global Change*, London, Routledge, 1993. David Harvey, 'From Space to Place and Back Again: Reflections on the Condition of Postmodernity', in Bird *et al.*, op. cit.; Doreen Massey, 'Power-geometry and a Progressive Sense of Place', in Bird *et al.*, op. cit.

24 See Michel Foucault, 'Of Other Spaces', *Diacritics*, 16, 1986.

25 See Celeste Olalquiaga, *Megalopolis: Contemporary Cultural Sensibilities*, Minneapolis, University of Minnesota Press, 1992.

26 Against the assumption of various postmodernists, we should remember that poor people often move more frequently, albeit involuntarily, than the wealthy. See Jacques Attali, *Millennium: Winners and Losers in the Coming World Order*, New York, Random House, 1991.

27 Paul Gilroy, 'It's a Family Affair', in Gina Dent (ed.), *Black Popular Culture*, Seattle, Bay Press, 1992, p. 303; Stuart Hall, 'The Question of Cultural Identity', in Stuart Hall *et al.* (eds), *Modernity and Its Futures*, Cambridge, Polity, 1992, pp. 273–325; Stuart Hall, 'Old and New Identities, Old and New Ethnicities', in King, op. cit., pp. 41–68; Trinh T. Minh-ha, *Woman Native Other: Writing Post-coloniality and Feminism*, Bloomington, University of Indiana Press, 1989; James Clifford, *The Predicament of Culture: Twentieth Century Ethnography, Literature and Art*, Cambridge, Harvard University Press, 1988.

28 While there is a long-standing tradition within the modern of privileging space over time, the crucial issue is the separation of the two.

29 Robert Young, *White Mythologies: Writing History and the West*, London, Routledge, 1990, p. 74.

30 C. Philo, 'Foucault's Geography', *Environment and Planning D: Society and Space*, 10, 1992, p. 139.
31 Ibid., p. 140.
32 Foucault, cited in ibid., p. 141.
33 Young, op. cit., p. 61.
34 Lemert and Gillan, quoted in Philo, op. cit., p. 154.
35 Meaghan Morris, '"Too Soon Too Late": Reading Claire Johnston, 1970–1981', *Dissonance*, forthcoming.
36 John MacGregor Wise, 'Towards a spatial view: Deleuze and Guattari on technology', unpublished manuscript, Urbana, 1993. For an excellent presentation of the dominant view, see James W. Carey, *Communication as Culture*, New York, Routledge, 1989.
37 Carol Stabile has suggested that the notion of space as becoming can be seen to be analogous to the distinction between speed (a scalar) and velocity (a vector) in temporal-based theories. Interestingly, most postmodernists are only concerned with speed.
38 My understanding of Deleuze and Guattari has depended quite heavily on the help (through writings, lectures, conversations and letters) of Meaghan Morris. Whatever flaws exist in my readings are not her responsibility, but whatever insight there may be is certainly due to her help.
39 Gilles Deleuze and Félix Guattari, *A Thousand Plateaus: Capitalism and Schizophrenia*, Minneapolis, University of Minnesota Press, 1987, p. 23.
40 For Deleuze and Guattari, multiplicity is a fundamental premise. Moreover, it is a positive term rather than a deconstructive notion. It can be achieved only by subtracting any claim to unity (rather than fracturing such claims).
41 Hayden White has suggested that this can be connected to the arguments about the 'middle voice'.
42 Deleuze and Guattari, op. cit., pp. 190–191.
43 The term is taken from Kellert's description of chaos theory. Geometrical mechanisms are neither causal nor predictive, but they are explanatory.
44 Deleuze and Guattari, op. cit., p. 142.
45 Ibid., p. 90. See also Gilles Deleuze, *Foucault*, Minneapolis, University of Minnesota Press, 1988. I want to thank Harris Breslow for his help in working through the arguments that follow.
46 Ibid., p. 54.
47 See Grossberg, 'Cultural Studies and/in New Worlds'.
48 See Grossberg, *We Gotta Get out of This Place*.
49 Deleuze and Guattari, op. cit., p. 56. The plane of consistency is that which is not productive, not yet stratified or articulated. It functions as a principle of anti-production.
50 Difference is used here as a logic of negativity as opposed to a logic of singularity which points to the positivity or exteriority of the Other.
51 Gilles Deleuze and Félix Guattari, *Anti-Oedipus: Capitalism and Schizophrenia*, New York, Viking, 1977, p. 239.
52 Ibid., p. 237.
53 Ibid.
54 Ibid., p. 197.

14

WRITERS FROM ELSEWHERE

Stefano Manferlotti

The definition 'writers from elsewhere' was used by Salman Rushdie when referring to those contemporary novelists, poets and playwrights who, although often not born into the English language have chosen it as the vehicle of their expression. Refusing the concept of a 'Commonwealth literature', Rushdie went so far as to give the name of English literature to all literature written in English. The main point of '"Commonwealth Literature" Does Not Exist' is to dismiss once and for all the label 'Commonwealth Literature', which, in spite of formal, and at times flattering appreciation, confines to ghettos many works of art, together with the cultures from which they originate.[1] These cultures, according to the author, are consequently oversimplified and trivialised. In my opinion, however, in several parts of the essay Rushdie plays the role of *agent provocateur*. If taken to an extreme, the idea that everything which is good comes 'from elsewhere' may establish a sort of inverted racism that ignores the often appreciable literary production of a good number of local, British-born writers.

Still, Rushdie's pamphlet is useful from the point of view of taxonomy: literature written in English after the Second World War is too vast a territory to be measured with any precision if we stick to narrow definitions like 'Commonwealth Literature'. Britain has provided the linguistic, literary and cultural context to what can broadly be called 'writers from elsewhere': Salman Rushdie, Kazuo Ishiguro, Timothy Mo, Hanif Kureishi and Ravinder Randhawa are some of the names I have in mind.

It is Rushdie who gives us a clear idea of the experience of the immigrant:

All migrants leave their past behind, although some try to pack it into bundles and boxes – but on the journey something seeps out of the treasured mementoes and old photographs, until even their owners fail to recognise them, because it is the fate of the migrants to be stripped of history, to stand naked amidst the scorn of strangers upon whom they see the rich clothing, the brocades of continuity and the eyebrows of belonging.[2]

The reader is easily seized by the visual strength of Rushdie's imagery: memory as a fading photograph, while the spiritual uneasiness of the newcomers is

highlighted by sumptuous garments and haughty eyes, as in a movie scene where a poor wretch stands in front of a moneybags. There is no doubt, however, that the key phrase of the whole passage is 'stripped of history', which does not refer to an irreversible snatching of private and public history, which would be logically impossible, but rather stresses the very moment when two cultures come into dramatic contact; and by 'dramatic' I mean here the impracticability of a neutral contact. Whatever his or her social class, his or her profession, his or her memories and past, an immigrant is a person whose existence is marked by an endless fluctuation between two polarities; or, to continue with the key phrase, between two histories. Such a duality may result in tragedy for many, and it is likely to have often taken this turn. Nevertheless, it can also give origin to a mutual enrichment: Rushdie, Ishiguro, Mo, Kureishi, Randhawa and others may be in fact divided selves, but it is precisely the relationship between two cultures or more that forms the basis and the subject-matter of their art.

As a consequence of the outcry caused by events connected with the social and political aspects of the question of migration, there has been a widespread tendency to ignore or underestimate the undeniable fact that we are dealing with *writers*, and that any object, as soon as it is turned into a poem, a novel, or a short story, comes, so to speak, under the jurisdiction of literature. Apart from good or bad faith shown by the people involved, the case of Rushdie's *The Satanic Verses* is the most obvious and extreme example of what may result from a failure to appreciate this distinction.[3]

Two fundamental directions emerge in analysing these novels: one leads to the relationships between two cultures, considered in the widest meaning of the word, the other to the equally complex though more specific relationships between two or more literatures. When asked by students or journalists to comment on this topic, these writers were unanimous in denying they belonged to any particular school of writing, club or sect. What Rushdie, Ishiguro, Mo, Kureishi and Randhawa cannot deny is the fact that their novels draw upon their cultures of origin as one of the main characters in the text, if not the most important one. The prominence that these cultures are given in most cases depends on the more or less marked importance attached by the individual author to the ideological message of the book. Like many other contemporary writers (here I am thinking of the British Peter Ackroyd, Julian Barnes, Antonia Susan Byatt, John Fowles, Graham Swift, together with Elias Canetti, Günter Grass and Gabriel García Márquez), Salman Rushdie, for instance, is obsessed with the political ideas of national and international history, and with the new, sometimes unprecedented forms it has taken in recent decades. Both *Midnight's Children* and *Shame* are highly sophisticated novels that make good use of dualities: ancient and modern, serious and facetious, fantastic and realistic, are constantly intertwined, and give form to stories that amuse and instruct the reader at the same time. In the end, however, the evils connected with the most cynical *Realpolitik* triumph over any humanistic ideal, as shown in the final chapters of both books, where the episodes taken from official sources crush any flight of the imagination. Thus, while the

overlapping of fantastic and realistic narratives allows Rushdie to reconcile his tendency for the concrete with the modernist and post-modernist claim to broken, irregular, non-syntagmatic description, his macrotext puts forth human beings devoid of any communal idea of *Gemeinschaft*, and offers a history which has been turned into self-parody.

Humiliated by 'our degraded, imitative times, in which clowns re-enact what was first done by heroes and by kings', Rushdie chooses to describe the rulers of India and Pakistan as grotesque bloody tyrants, thus depriving their stories and the history of both countries of any claim to an epic dimension: the writer has taken his vengeance on the obscenity of contemporary history.[4] If this is true, an alternative history has to hide somewhere in the text, in constant danger of being exploited or destroyed. In *Midnight's Children* and *Shame*, like one circle inscribed inside another, what makes a being 'round and human' (Brecht) takes up the space left to it by official barbarity: the richness of the five senses, and taste in particular, as the insistence on Indian food and cuisine clearly demonstrates; then hearing, enhanced by never-ending tales told by gripping story-tellers; then the constraining power of family, or, rather, clan habits, and the contradictory role of women in contemporary Indian and Pakistani society; the overcrowded streets and slums of towns as ancient as those who inhabit them. On the less visible side lies all that spiritual life is made up of: private and public memories, longings and affections projected, so to speak, on to the typically Indian vision of Time as a wheel that never stops and does not permit the individual to give too much importance to his present place in the world. Thus the reality of fiction and the fictionality of reality coexist or clash in a world that the Rushdian anti-heroes (Saleem Sinai, Omar Khayyam Shakil, Gibreel Farishta and Saladin Chamcha) watch as it unfolds towards folly and nothingness.

While Rushdie's novels intersect with trajectories first drawn by Sterne and Joyce (to these, as Rushdie acknowledges, the modern names of Gabriel García Márquez, Elias Canetti, Günter Grass, Saul Bellow, Heinrich Böll, Mario Vargas Llosa, Italo Calvino can also be added), the output of Ishiguro, Mo, Kureishi and Randhawa seems to show less interest in literary experimentalism. I use the word 'seems', because whenever we read a contemporary novel that might be labelled 'naturalistic', we quickly realise that such an adjective is inadequate to account for a fiction that even in its simplest forms does not overlook the irreversible changes which have occurred in the twentieth century both within and outside literature. If we consider, for instance, Ishiguro's *A Pale View of Hills* and *An Artist of the Floating World*, at first sight they exhibit a structure that could not be more simple. The former tells the story of a Japanese widow, Etsuko, who moves to England from destroyed Nagasaki, and indulges in reminiscences from which her private life dimly emerges (we learn, for example, that one of her two daughters killed herself while still a girl), together with images of post-war Japan and England. The second novel presents Masuji Ono, once a famous painter and an unflinching supporter of Japanese nationalism, as he watches with growing unease the Americanisation of his country and recalls his vanished fortune and

the many, recent pains he has had to bear. But Ishiguro's novels are much more than this. Their energy springs from the shadowy space in which the author sets both his characters and scenes.

Both books are interspersed with sentences like 'I am not sure now', 'I do not remember', 'It is possible that my memory of these events will have grown hazy with time', which underline how reckless our ambition of predicating reality and experiencing a clear-cut vision of it is, and consequently of being able to judge history, material objects and human beings.[5] The view of the hill is *pale*, the artist steps in a *floating* world. The various expressions of uncertainty and doubt converge in a vision of the world to become a *poesis* which turns them into many questions: Who in fact is Etsuko? How did the atomic bombing of Nagasaki affect her soul and the souls of those surrounding her? What is the real entity of the debt paid by Japan to the American occupation? What is Britain like in the eyes of an elderly Japanese woman? And for Masuji Ono, is he a survivor, is he the visible sign of the end of a culture, or a patriot who may have pursued absurd ideals in his youth but nevertheless maintains a love for his country that the new generations seem to ignore? In the purest modernist fashion (one thinks of Thomas Hardy, and Ian McEwan among his contemporaries), Ishiguro gives many answers and yet no answer at all. Paradoxically, the simplicity of his style, characterised by the prevailing presence of parataxis, offers no help in solving such problems. Its continuous alternating of told and untold, of episodes thoroughly explained or scarcely hinted at, makes the category of uncertainty all the more objective, and, to some extent, gives it an ontological dimension. The opening words of *An Artist of the Floating World* refer to a bridge that may be easily seen as a metaphor for an existential impasse of this kind:

> If on a sunny day you climb the steep path leading up from the little wooden bridge still referred to around here as 'the Bridge of Hesitation', you will not have to walk far before the roof of my house becomes visible between the tops of two gingko trees. Even if it did not occupy such a commanding position on the hill, the house would still stand out from all others nearby, so that as you come up the path, you may find yourself wondering what sort of wealthy man owns it.[6]

The plain style of Ishiguro's novels can also be considered in the wider perspective of the inherent ambiguity of signs. The absence of redundancy in his descriptions of landscape and interiors, and in the speeches of his characters, is as misleading as the seeming simplicity of Japanese painting and home-furnishing, both of which are forms of compressed energy or, if you like, stylised complexity.

When asked to point out what distinguishes him from other writers from elsewhere, Ishiguro mentioned the lack of a colonial past in his experience, together with the love–hate relations that often go along with it, and concluded by regretting that, unlike Rushdie and Timothy Mo, he cannot even speak the language of his native country. Timothy Mo may have experienced a colonial history, and be able to speak Chinese, but his relationships with his land of

'origin' are much less direct and intense than in Rushdie and Ishiguro, or, as we shall see later, in Kureishi and Randhawa. As a matter of fact, Mo does not hesitate to recognise the scholarly origin of what he knows about China: on the first page of *Monkey King*, his first novel, and before beginning the story, he acknowledges his debt to H. D. R. Baker's *A Chinese Lineage Village* and to J. L. Watson's *Emigration and the Chinese Lineage*, and he does something similar with his following and most famous novel, *Sour Sweet*, where he quotes W. Stanton's and W. P. Morgan's essays on the Triad Societies in Hong Kong. *Sour Sweet* (apart from its obvious symbolism, we may notice in the title of the book the recurring importance of national cuisine as a cultural marker) tells the story of a small Chinese family that moves from Hong Kong to London and, through hard work, succeeds in being integrated.

To be considered a major work of art, however, a humorous novel must be capable of attracting within itself all the diverging forces of reality, consequently making use of the most appropriate rhetorical devices to describe them with forcefulness. If we want to stay within the limits of our century, what gives comic works like Canetti's *Die Blendung*, or Grass's *Der Butt*, or Burgess's *A Clockwork Orange*, or Rushdie's *Midnight's Children* (because *Midnight's Children is* also a comic novel) the strength they have is precisely the incredible variety of forms, situations, styles employed, and tones that range from open coarseness to mock-heroic to surrealistic, all placed in a dialectic relationship with the sombre aspects of the contemporary world. In my opinion, however, this is not the case with *Sour Sweet*, which remains a valuable novel, but it never, or very rarely, succeeds in penetrating any chosen topic. The many-sided and extremely complex relationships between Chinese and British culture, and between the different ethnic groups that mingle in the contemporary British scene, are kept in the background or not announced at all, and the reader is left with a story that, brilliant though it is, stays within the limits of what might be called 'ennobled picturesque'.[7]

Somehow closer to a Dickensian model is Hanif Kureishi's *The Buddha of Suburbia*, with its display of human kindness, and especially in its use of the metropolis as one of the protagonists of the story. Unlike Mo, Kureishi's London is not a limb but a whole body that now rests and now runs, now flourishes and now decays, smiles and bleeds. Direct experience, and his activity as a scriptwriter (he wrote the screenplay for *My Beautiful Laundrette* and *Sammy and Rosie Get Laid*, both of them directed by Stephen Frears), must have helped Kureishi in his task. But the fact remains that throughout the adventures of Karim Amir and his matchless father – and he gives back to the word 'adventure' a meaning it seemed to have lost for ever – we are literally placed in the heart of the glitter and glam of London in the 1970s, in a scene that is both tale and history in motion:

> My name is Karim Amir, and I am an Englishman born and bred, almost. I
> am often considered to be a funny kind of Englishman, a new breed as it

were, having emerged from two old histories. But I don't care –
Englishman I am (though not proud of it), from the South London suburbs
and going somewhere.[8]

Needless to say, the keyword of the passage is 'almost': the adverb, placed in
ironic contrast with the syntagm 'born and bred', stresses the comic note of the
book, while immediately indicating its serious undertone. Once again, there is the
volatile coexistence of two cultures – 'having emerged from two old histories' –
and the emergence of the 'new breed' in a process of unprecedented hybridisation
that is developing along lines that can only be foretold in part. The author is fully
aware, for example, that the different cultures sometimes do not show their best
aspects, but their worst. Similiarly, in *The Satanic Verses* Rushdie had already
made the different cultures meet in the common ground of superficiality and
treachery in order to emphasise the continuous struggle between good and evil in
the most novel and diverse forms of contemporary life.

Choosing the form of the picaresque novel and rarely abandoning it, Kureishi
does not seek such moral heights. His characters, whatever their race and up-
bringing, are seen in their petty miseries and joys, and led through a city which
easily offers settings both for luxury and poverty. Some critics may turn up their
noses at Kureishi's shunning of moral edification, and at his perhaps unconscious
debunking of the whole inter-ethnical question, but this has little to do with the
value of the book, which cannot be reduced to its sociological and anthro-
pological dimension. After all, Karim, his father, his English friend Charlie, just
to mention three characters – sometimes generous, sometimes thoroughly selfish,
always ready to exploit any person who comes into contact with them – are funny
but credible figures, and the London where they play out their parts is just as
credible.

London is also the setting of *A Wicked Old Woman*, the novel written in 1987
by Ravinder Randhawa, who immigrated to Britain from her native Punjab when
she was only 7. Her political commitment (she is one of the chief representatives
of a feminist collective in London) explains her openly didactic attitude, or at
least the primary importance she attaches to the overall tone of the book. If I am
allowed a pun, she wants to give a clear picture of the darker side of immigration,
by foregrounding the world of the weak, the unemployed, the poor, of those who
give up all hope while still in their teens; of women, in particular, whose enemies
are doubled, because they are to be found in both cultures:

> A real dandy was me Daddy. I said to him, henna is part of our culture,
> when he was moaning about my streaks. He just snorted, said there were
> other things in the culture which were more important and why didn't I
> follow those things. Like what, I asked, hands on hips in indignation. He
> said: 'Respect, Obedience. Hard Work. The three penances for being born
> Indian you know!'[9]

By 'darker side', Randhawa also means the still indistinct character of the

ethnical hybridisation now taking place in Britain, which affects all aspects of life. Further, she warns against the illusion that a few limited changes, however profound, may be enough to guarantee a solution of the greater questions. The stick on which Kulwant, the Indian woman of the title, leans, is the visible, grotesque image (Kulwant, in fact, can walk perfectly) of the uncertainty I have been referring to. It can only be thrown away when she reaches a new self-consciousness.

Apart from her noble aims, Randhawa's novel is the typical example of that kind of militant literature which sacrifices both structure and style for the sake of the message. In Orwellian terms, it is a good bad-book: its formal sloppiness, underlined by the chaotic organisation of the story and by the amateurish quality of both description and dialogue, is redeemed by the passion that is revealed in every line, and by its importance as a document.

Coming now to a conclusion (which is obviously *not* a conclusion), what characterises the picture I have tried to describe is the fact that it is still in motion, and this makes the task of the critic harder.[10] It seems undeniable, however, that English literature has been powerfully enriched and interrogated by the 'writers from elsewhere'. They remind us of the contribution made to Latin literature by the so-called provincial writers, who did not take the place of the natives but, on a metaphoric level, co-operated with them in building up an edifice that is still standing. In the decades to come, whether they like it or not, the names of Rushdie, Ishiguro, Mo, Kureishi, and Randhawa will join those of Ackroyd, Amis, Carter, Fowles, Byatt, McEwan, Bailey and Parks, and others, in the histories of 'English literature': a sort of posthumous integration.

NOTES

1 S. Rushdie, '"Commonwealth Literature" Does not Exist' (1983), now in his collection of essays *Imaginary Homelands*, London, Granta, 1991, pp. 61–70.

2 S. Rushdie, *Shame*, London, Picador, 1984, pp. 63–64.

3 This is not to deny that a book dealing with political topics can and must be judged also from a socio-political point of view. The message of a book, however, is only one of its meanings.

4 S. Rushdie, *The Satanic Verses*, London, Viking, 1988, p. 424.

5 The first two sentences can be found throughout *A Pale View of Hills* and *An Artist of the Floating World*. The third quotation is from *A Pale View of Hills* (London, Faber & Faber, 1982), where it opens the third chapter.

6 K. Ishiguro, *An Artist of the Floating World*, London, Faber & Faber, 1986, p. 7.

7 A quality which is stressed by the spectacular though superficial film *Soursweet*, directed in 1989 by Mike Newell. The script was by Ian McEwan.

8 H. Kureishi, *The Buddha of Suburbia*, London, Faber & Faber, 1990, p. 3.

9 R. Randhawa, *A Wicked Old Woman*, London, The Women's Press, 1987, p. 187.

10 This and other points discussed in this article are more fully developed in S. Manferlotti, *Dopo l'impero. Letteratura ed etnia in Gran Bretagna*, Naples, Liguori, 1995.

Part IV

WHOSE WORLD, WHOSE HOME?

15

UNPACKING MY LIBRARY . . . AGAIN

Homi K. Bhabha

'I am unpacking my library. Yes, I am. The books are not yet on the shelves, not yet touched by the mild boredom of order . . . Instead I must ask you to join me in the disorder of crates'. With these words, borrowed from Walter Benjamin's essay 'Unpacking My Library', I ask you to participate momentarily in the 'dialectical tension between the poles of order and disorder' that have marked my life and my work, these past few months, since arriving in Chicago. As I drew out books from crates, in the most unlikely pairings – Maud Ellmann's *The Hunger Artists* interleaved with Peter Carey's *The Fat Man in History* – the questions pressed: Does the order of books determine the order of things? What kind of history of oneself and one's times is coded in the collecting of books? Driven by these thoughts I was led to a somewhat unlikely, yet intriguing, reading of Benjamin's concluding paragraphs. That inspired flâneur, you will remember, conjures up images of his wandering world through the cosmopolitan disorder and discovery of his old books: 'Riga, Naples, Munich, Danzig, Moscow, Florence, Basel, Paris . . . memories of the rooms where these books had been housed . . .' only to remind us, as Benjamin does, that for the collector, 'the acquisition of an old book is its rebirth'.

It was then that it struck me, unpacking my own library – memories of book buying in Bombay, Oxford, London, Hyderabad, Champaign-Urbana, Jyavaskala – that it is the 'disorder' of our books that makes of us unredeemable 'vernacular' cosmopolitans committed to what Walter Benjamin describes as 'the renewal of existence'. In subtle ways that disorder challenges the shelved order of the study, and displaces the Dewey decimal that persuades us that our cosmopolitanism is of a more 'universal', academic cast. The formal connection that I am suggesting between a kind of transdisciplinary pedagogy and a revisionary cosmopolitanism is part of a new book, and must wait for another occasion. My purpose here is more circumstantial, even anecdotal, but not without a relevance to a kind of contingent dis-ordered historical 'dwelling' bestowed upon us by many of the most interesting books that we collect today.

INHABITING THE SPACE OF THE UNSATISFIED

As I unpack my book crate, which is beginning to sound more and more like Pandora's box, two texts emerge in an unexpected synchronicity – one old, the other new: Adrienne Rich's 'Eastern War-time', from her volume *An Atlas of the Difficult World*, and Martha Nussbaum's essay 'Patriotism and Cosmopolitanism' published with wide-ranging responses in a recent issue of the *Boston Review*. In their different ways, Rich and Nussbaum propose that our contemporary historical moment requires to be read, and framed, in temporalities that articulate transition, or the uncanny moments in a process of social transformation: temporalities similar to what Stephen Greenblatt calls the 'new-old' or, what I've termed 'time-lag', or the 'projective-past', in *The Location of Culture*.

I was struck initially by a certain bookish 'dis-order' that becomes, in both texts, the primal scene for making a map of the late modern world: 'ignorantly Jewish', Adrienne Rich writes, trying to grasp the world through books: *Jude the Obscure*, *The Ballad of Reading Gaol*, Eleanor Roosevelt's *My Story*. For Martha Nussbaum, it is the Cynics, the Stoics, Kant and Rabindranath Tagore's novel *The Home and the World* – a motley, ill-fitting group despite their cosmopolitan sympathies as her critics have pointed out – that must be yoked together to revive the 'very old ideal of cosmopolitanism', the 'vivid imagining of difference'. It is the contingency of these 'un-packed books', through their concatenation and contestation, that produces a shared belief in the need for Walter Benjamin's ethical and aesthetic imperative: 'the renewal of life' through dislocation, translation and re-situation.

For both Rich and Nussbaum such a renewal leads to a 'global' reorientation of the patriotic or nationalist perspective. In both instances, however, difficult, unanswered questions remain: What is the sign of 'humanness' in the category of the cosmopolitan? Where does the subject of global enquiry or injury stand, or speak from? To what does it bear relation, from where does it claim responsibility? It is the unsatisfactory consideration of these issues that I wish to consider.

For Nussbaum, the 'identity' of cosmopolitanism demands a *spatial* imaginary: the 'self' at the centre of a series of concentric circles that move through the various cycles of familial, ethnic and communal affiliation to 'the largest one, that of humanity as a whole'. The task of the citizen of the world, she writes, lies in making human beings more like our 'fellow city dwellers', basing our deliberations on 'that interlocking commonality'. In her attempt to avoid nationalist or patriotic sovereignty, Nussbaum embraces a 'universalism' that is profoundly provincial. Provincial, in a specific, early imperial sense. Nussbaum too readily assumes the 'givenness' of a commonality that centres on a particular image of the 'empathetic' 'self' – as the Satrap of a belated liberal benevolence – as it generates its 'cosmopolitan' concentric circles, of equal measure and comparable worth. If Nussbaum's philosophical genealogy reaches back to the Stoics and Kant, the ethical urgency for revisioning cosmopolitanism for the contemporary world order takes its geopolitical bearings from global dialogue about global

planning, global knowledge and the recognition of a shared future – ecology, food supply and population. But who are our 'fellow city dwellers' in the global sense? The 18 or 19 million refugees who lead their unhomely lives in borrowed and barricaded dwellings? The 100 million migrants, of whom over half are women fleeing poverty and forming part of an invisible, illegal work-force? The 20 million who have fled health and ecological disasters?[1] Are the Stoic values of a respect for human dignity and the opportunity for each person to pursue happiness adequate cosmopolitan proposals for this scale of global economical and ecological 'disjuncture'?

These 'extreme' conditions – or awkward questions – do not stand at the limits of the cosmopolitan ideal. It has been one of the tensions internal to Enlightenment and post-Enlightenment cosmopolitanism – as Schlereth pointed out long ago in his classic study of Franklin, Hume and Voltaire – to attempt to grasp the unity of mankind without working through the relation of the part to the whole.[2] In Nussbaum's argument such a tension becomes emphasised as a certain liminality in the identity or subject of cosmopolitan process. It is a subject peculiarly free of the complex 'affect' that makes possible social identification and affiliation. She neglects 'Those identities . . . [that] arise from fissures in the larger social fabric', as Richard Sennet suggests in his response to Nussbaum, '[containing] its contradictions and injustices . . . remaining necessarily incomplete versions of any individual's particular experience'.

And here lies, I believe, the difference in Adrienne Rich's cosmopolitan meditations. Her poetic evocation does not provide us with pedagogical proposals for the good society, or social virtue, as Nussbaum attempts to do. What she allows us to envisage is a certain affective and ethical identification with 'globality', premised on the need to establish a transhistorical 'memory'. In some severe sense she is concerned to address that problem of an imagined and unimagined community from the place where the specific memory of traumatic historical 'events' accede to what Toni Morrison has called a 'rememory': an incantation, an iteration, of that position from which the subject speaks the present in the past.

> I'm a canal in Europe where bodies are floating
> I'm a mass grave I'm the life that returns
> I'm a table set with room for the Stranger
> I'm a field with corners left for the landless
> I'm accused of child-death of drinking blood
> I'm a man-child praising God he's a man
> I'm a woman bargaining for a chicken
> I'm a woman who sells for a boat ticket
> I'm a family dispersed between night and fog
> I'm an immigrant tailor who says *A coat*
> *is no a piece of cloth only* I sway
> in the learning of the master-mystics

I have dreamed of Zion I've dreamed of world revolution
I have dreamed that my children could live at last like others
I have walked the children of others through ranks of hatred
I'm a corpse dredged from a canal in Berlin
a river in Mississippi I'm a woman standing[3]

9
Streets closed, emptied by force Guns at corners
with open mouths and eyes Memory speaks:
You cannot live on me alone
you cannot live without me
I'm nothing if I'm just a roll of film
stills from a vanished world
fixed lightstreaked mute
left for another generation's
restoration and framing I can't be restored or framed
I can't be still I'm here
in your mirror pressed leg to leg beside you
intrusive inappropriate bitter flashing[4]

For Rich the boundaries and territories of the cosmopolitan 'concentric' world are profoundly, and painfully, underscored and overdetermined. The 'I' that speaks – its place of enunciation – is iteratively and interrogatively staged. It is poised at the point at which, in recounting historical trauma, the incommensurable 'localities' of experience and memory bear witness, side by side, but there is no easy ethical analogy or historical parallelism. For instance, in the deaths by water – the Jew once, now the Turk, offered up in the *Landswehrkanal* in Berlin, or the lynched body floating in the Mississippi. What we have is a form of repetition that provides a parallaxal shift in *the subject of the event as the enunciating 'I' shifts its geopolitical location and rhetorical locution*. It is this realignment of memory and the present as an atlas of the difficult world (the title of the volume) that articulates a defiant and transformative 'dissatisfaction', a dissonance at the heart of that complacent circle that constitutes 'our fellow city dwellers'. For it is precisely there, in the ordinariness of the day-to-day, in the intimacy of the indigenous, that, unexpectedly, we become unrecognisable strangers to ourselves in the very act of assuming a more worldly, or what is now termed 'global', reponsibility.

The subject of 'unsatisfaction' which Rich poetically prefigures out of the tattered materials of historical crisis and trauma – like the migrant tailor re-stitching the tattered coat that is not a piece of cloth only – keeps setting new, disjunctive scenes of repetition for the recognition, perhaps misrecognition, of the speaking 'I'. It is both a situational form of ethical-political discourse, and a kind of identity, or identification, that, in its iterative field of address – *I'm a table . . . a field . . . a man-child . . . a woman . . . an immigrant* – attenuates the sovereignty of a 'representative' human or world-subject authorised in its mastery of

202

events. This does not mean that we are being offered some postmodern *soufflé* of identity renowned for its lightness of being, or some naive and benevolent pluralism that is equally, reasonably visible from the empyrean heights and the Clapham omnibus (so beloved of ethical philosophers). Rich's mode of address attempts to open up an intervening space, a space of translation-as-transformation particularly apposite to the difficult, *transnational* world. And it is an approach that resonates with Walter Benjamin's description in 'On Language as such and the Language of Man', of that particular *temporality of translation* that ensues in the move between what he calls 'media of varying densities . . . Translation passes through *continua* of transformation, not abstract ideas of identity and similarity.' In emphasising the mediated nature of both identity and event, while stressing the crucial differential 'densities' that are involved in the process of designating a historical transformation, Benjamin alerts us to a way of reading *and being, or dwelling, 'in' History.* He insists on the need to recognise the 'human' (or the historical) as always in need of translation, or mediation, in order to accede to its historicity: the human as the cultural 'sign' of a social or discursive event, not simply the assumed abstract Idea or symbol of the universal similitude of all Humanity.

LIVING GHOSTS

The *continua of identification* that we hear in Rich's work, both here and else-where, do not simply bridge the local and general, the poetic and the political as an abstract identity. Historical memory, which she likens variously to film and photography, is a material 'medium' that must be 'restored and framed', cut and edited: its ethical importance lies in its being at once a form of presence – an 'exposure' – and a technology of 'processing', remembering, repeating and work-ing through. It eschews the easy equivalences of social 'victimage', or the abstract identification with universalising human worth. It is the agony of her ethical and political 'unsatisfaction' that is marked in the *continua* of the poem's iterative agency. Its rhetoric of repetition articulates varying social densities and personal destinies that haunt the event of history – death by bloating, beating water, survival by a mere stitch – but they contain no strong sense of the global cosmopolitan universalism that Nussbaum describes as 'learning to recognise humanity . . . undeterred by traits that are strange . . . to learn about the [culturally] "different" [in order to] . . . recognise common aims instantiated . . . in many cultures and histories'.

In my view it would be a minimal reading of Rich's transnational events, individuals and communities rendered through the poetic 'media' of memory to reduce the address of her verse to some shared sense of a 'common humanity'. For that would erase the tropic force of the verses themselves. The iterative 'I'm a /I'm a . . . I'm a????' – as in some bleak counting song of a monstrous child of our times, finds its spatial extension in an object, an attribute, or an event of world-historical significance – Slavery, War, Holocaust, migration, diaspora,

revolution. The 'I am' is less the instantiation of the commonality of history and culture (pace Nussbaum), as much as its insistent repetition emphasises 'starting again', re-visioning, so that the process of being subjected to, or the subject of a particular historicity, or system of cultural difference and discrimination, has to be, as they say, 'recounted' or reconstituted as a historical sign, 'in a continua of transformation, not abstract ideas of identity and similarity' (to echo Benjamin). This does not free Rich, however, from requiring a notion of 'generality' or 'authority' on the basis of which the narrative voice can move between the 'varied and various densities of transnational historical and cultural 'media', making its judgements, taking its stance – but on the basis of what?

Rich has placed us, quite literally in an intervening space – a space of intervention – *in between* past and present, haunted memory, its 'individuating' intensity, and some version of historical 'accounting for . . .', or at least, 're-counting' required for the world of transnational relations that we are poised to occupy, *if we belong to certain geopolitical and economic areas of influence*. The 'transnational' is not merely an abstract case, a neutral description of an emergent public sphere, a new empowering, universal dawn. It can also be a transitive verb: despite the currency of new technologies and itinerant, diasporic cultural signs, transnationality can be an experience of destitution and trauma. By drawing for us a memorial map of, what she calls, the difficult world, Rich will not allow us the vanity of transnational wishes, without casting the shadow of other dreams and nightmares produced through the demand for 'global' transformations.

The radical 'unsatisfaction' that we achieve is not simply a negative state, nor the denial of affirmation: it is the need to work through the problem of memory in reconstructing a 'sign' of history that may *not provide a causal or deterministic narrative*. What it does provide is a powerful and poignant description of a necessary 'dissatisfaction' that pulls at us as we try and articulate, or enunciate, a global or transnational imaginary and its 'cosmopolitan subjectivities'.

What does it mean, *for us*, to occupy the space of the 'unsatisfied' – which Adrienne Rich has poetically performed, rather than propositionally prescribed? I have talked of the human as a 'translational' sign, but what becomes of the 'subject' in this process? Many may want to question my proposal that in the process of cultural translation there opens up a 'space-in-between', an interstitial temporality, that stands in contention with both the return to an originary 'essentialist' self-consciousness as well as a release into an endlessly fragmented subject in 'process'. I want to try to occupy this hybrid, in between space to address the issue of the subject of a 'translational' rather than 'concentric' cosmopolitanism, conceived on the grounds of what I earlier described as 'the continua of transformation'. Now, this is not just an abstract problem for over-excited literary theorists such as myself. It has become one of the main areas of discussion and contention in the debate around 'what it means to be a citizen', between the communitarians and the cosmopolitans in the United States today. One of the most influential contributions to this debate by Berkeley law professor Jeremy Waldron explores the cosmopolitan perspective by taking his bearings

from Salman Rushdie's explication of the sense of 'self' displayed in *The Satanic Verses*:

> The Satanic Verses celebrates hybridity, impurity, intermingling, the trans-formation that comes of new and unexpected human beings, cultures, ideas, politics, movies, songs . . . Melange . . . is how newness enters the world. It is the great possibility that mass migration gives to the world, and I have tried to embrace it.[5]

Waldron particularly alights, as we have done, on the hybridisation of identity as an effect of the articulation of an 'unexpected transformation' in the very struc-ture of selfhood. Waldron is fair in suggesting that it hardly addresses the complex forms of social differentiation that inhabit contemporary society to suggest that 'the coherence that makes a particular community a single cultural entity will confer a corresponding degree of integrity on the individual self that is constituted under its auspices'. However, does Waldron himself provide a more adequate 'image' of the cosmopolitan self when he celebrates its 'limitless diversity of character' and its variety and open texture? Is this not in its own way gratuitous when we remember the agonistic, iterative self, the 'I' in Rich's poem that sought to articulate a cosmopolitan identification with transnational/transhistorical memory?

> . . .
> Memory speaks:
> You cannot live on me alone
> you cannot live without me . . .
> I can't be restored or framed
> I can't be still I'm here
> in your mirror pressed leg to leg beside you
> intrusive inappropriate bitter flashing

When memory speaks here, there is no limitless diversity of the self: there is a self that occupies a space of ambivalence, a space of agonism:

> Not all migrants are powerless, the still standing edifices whisper. They impose their needs on the new earth, bringing their own coherence to the new-found land, imagining it afresh. But look out, the city warns. Incoherence, too, must have its day.[6]

The enchantment of art lies in looking in a glass darkly – a wall, stone, a screen, paper, canvas, steel – that turns suddenly into the almost unbearable lightness of being. My mixed-media metaphor moves restlessly between a clichéd phrase from St Augustine to Milan Kundera's title, from the dark night of the soul and its shadows, to the obscure, dazzling object of desire, from philosophy to the films, from looks to books. In this interdisciplinary errancy, I seek a name for the visual arts between the two registers of light caught in my opening metaphor: lightness or 'lighting' as naturalised in the production of the visual image as a

205

form of likeness, a mimetic light; and a 'lightness of being' that is apparent in contemporary art practice – a 'lightness' that is neither levity nor devoid of agonism or suffering, a lightness that comes with ironic reversal, an alleviation and unburdening, a demotic defiance, a vernacular violence, a subversion of the sententious, a lightness, or a quality of *visible light*, that has its own specific gravity, and represents a struggle for survival.

It is precisely such a subversive light on the problem of personhood – on what it means to be a subject in our late modern age – that Barbara Kruger cast, when looking darkly through thick panes of mottled, bevilled glass, she suggested in one of her finest, earlier works that 'YOU THRIVE ON MISTAKEN IDENTITY'. Much radical, innovative art-practice today suggests that the subject is constituted as a discursive or ideological 'effect': 'The gaze is outside. I am looked at.' This is often misunderstood as producing a politically passive identity. It is implied that 'intentionality' requires a totalised, unitary consciousness. The importance – and disturbance – of placing the 'gaze' outside the intimation of individual identity is that it emphasises the fact that the position of the human subject is neither Inside (the psyche) nor Outside (in the social). Identity is an intersubjective, performative act that refuses the division of public/private, psyche/social. It is not a 'self' *given* to consciousness, but a 'coming-to-consciousness' of the self through the realm of symbolic otherness – language, the social system, the unconscious.

When the psychoanalyst Jacques Lacan fragments and hyphenates the word 'Photo-graph' in his discussion of how social subjects are formed, he provides us with a concise, if cryptic, cipher of the disjunctive conditions that inform the structure of social identification. For identity becomes the problem of negotiating and articulating photo – the lightening likeness of the image, the shutter speed of recognition – with graph: the deciphering of the inscriptive, the diachrony of narrative and historicity, the alterity of the sign. The gaze and the grapheme come together – are articulated – in an ambivalence and splitting of the subject that enables identity to be strategic and effective because of its structure as a contingent, 'double' consciousness.

The political effectivity of such a double consciousness, I learnt from a small photographer called Mr Styles in a cockroach-ridden studio in the New Brighton township of Port Elizabeth, South Africa. There is something quite campy about his name – Styles – something apposite to the themes of mimicry and camouflage, only he must use these devices of displacement in the milieu of the work camp and South African apartheid labour laws. In Athol Fugard's *Sizwe Bansi is Dead*, Styles, the photographer, recycles work permits. By replacing the identity photograph on a pass, a township worker is fitted out with a new identity. But, as one of his clients protests, that means living life as a ghost. Mr Styles shoots back:

When the white man looked at you at the Labour Bureau what did he see? A man with dignity or a bloody passbook with an N.I. number? Isn't that a ghost? . . . All I'm saying is to be a real ghost, if that is what they want . . . *Spook them into hell, man!*[7]

One way of concretely envisaging such an art practice – 'that spooks them into hell!' – is through the work of the African-American artist Adrian Piper. Her series *Pretend* stages the fetishistic dynamic of the sexual gaze across the history of the civil rights movement. Her work presents the portraits of black men – Martin Luther King amongst them – each of them bearing a piece of the text: Pretend not to know what you know. The unmarked icon at the end of the series shows three apes in the familar see-no-evil/hear no evil triptych. Piper substitutes the mother figure of the Freudian scenario of fetishism with the black father-figure of the civil rights movement. The signifier of sexuality, with its splitting of identity, haunts the male icon of racial victimage that seeks to constitute itself in a political/prophetic tradition of patriarchal activism. The spectator's identi-fication with the visual image cuts both ways, Janus-faced, across sexual and racial difference. The viewer cannot but occupy an ambivalent social position: there is, on the one hand, the identification with the visible African-American history of racial victimage and the struggle against it; there is, at the same time, an interrogation of the patriarchal sexual culture within black civil rights 'race' politics, and its historic erasure of the agency of women, gay and lesbian activists. Social splittings of form and content are at the core of Piper's work, as the critic Arlene Raven has written, and she instructs us in *Pretend*, I think, that 'what-we-see-is-not-what-we-need-to-get-or-desire' in both our psychic and political lives.

Why do these 'living ghosts' – in Mr Styles' sense – these culturally *hybrid* identities that are constituted in the cause of minority empowerment or social equity, why do they spook the hell out of the critic Hilton Kramer? Precisely because, I suggest, he is unable to tolerate the passing of an aesthetic and social value system based on grand oppositions – high art and populist culture, the 'artist' and the people. What he cannot represent – and radically misrepresents in his celebrated essay *Art and Its Institutions* – is a form of cultural value that does not depend on binary divisions. In objecting to the importation of the standards of the social sciences into the realm of aesthetic consideration, Kramer wants to disavow all those mediatory, articulatory elements – class, community, equity, access, race, sexuality – that define cultural production as an interdisciplinary structure continually involved in border crossings and intertextual negotiations.

The sense that value may lie in the articulation of 'unlikely' social institutions – the museum and the community centre, for example – becomes for him the occasion for a call to arms: 'the culture war is also a moral and social crisis of vast dimensions'. As everyday culture becomes more marked by what I have called a double or hybrid consciousness, Kramer resorts to the discourse of war and paranoia to redraw the binary boundaries between the nationalist interest and its core culture, and those disenfranchised 'affirmative action' cohorts who occupy the position of the minorities. His sense of an imagined community of cultural affiliation cannot now be conceived without reviving memories of Vietnam, and yearning for the metaphor of the cold war which kept the home fires burning clean.

SUBALTERN SECULARISM

Kramer may win some media battles but he is in danger of losing the culture war. There is an overwhelming apprehension that the 'new internationalism' is being inaugurated at a time of a peculiar historical *intermediacy*: the Sydney Biennial (1992–1993) was launched under the sign of 'the boundary rider' who, the curator writes, 'accepts that strangely constant, fluid state which exists between fixed concepts'(16). The controversial Whitney Biennial (1993) chose to explore the borderline communities that inhabit the world of contemporary American art while emphasising the failure of a new communitarian consensus. The 1993–1994 National Photography Conference in Bristol, England, was organised around the instructive ambivalence of 'disrupted borders': the title of a show that drew attention to those artistic practices and cultural communities that have been obscured by the 'international style' of modernism.[8] How do we conceptualise, and visualise, the *intermediacy*, the in-between borderline nature of our current historical phase – a phase that the influential British leftist journal *New Left Review* has recently described as a period that lies precariously somewhere between barbarism and the Enlightenment.

Carol Becker's introduction to *The Subversive Imagination* gives us a vital sense of the complex disagreements about the nature of democracy that underlie the culture wars. Her exemplary argument, that the most controversial works of art 'challenge the most originary notions of modern society, and risk the consequences', cites a range of works: prominent amongst them, collages of the Virgin of Guadalupe overlaid with the face of Marilyn Monroe, Martin Scorsese's *The Last Temptation of Christ*, and the fatwa pronounced against Salman Rushdie's *The Satanic Verses*. What has proved controversial about each of these works is, indeed, what characterises the *intermediate*, transitional and yet transformative social ethic of our times: living on the edge of the Enlightenment and being forced to re-examine the shibboleths of secularism.

The trouble with concepts like individualism, liberalism or secularism is that we think we understand them too well. These are ideas, and ideals, that are increasingly complicit with a self-reflective claim to a culture of modernity whether it is held by the elites of the East and West, or the North and South. We may define them in different ways, assume different political or moral positions in relation to them, but they seem 'natural' to us: it is as if they are instinctive to our sense of what civil society or a civic consciousness must be. Despite their limitations, they have a certain 'universal' historical resonance, a universality that comes from the origins of these concepts in the value-system of the European Enlightenment. It is such universality, argues Eric Hobsbawm, the greatest socialist historian of our own era, that stands as a bulwark between civility and 'an accelerated descent into darkness' (*New Left Review*, 206).

I would like to suggest that these concepts of a modern political and social lexicon have a more complex history. If they are immediately, and accurately, recognisable as belonging to the European Enlightenment, we must also consider

them in relation to the colonial and imperial enterprise *which was an integral part of that same Enlightenment*. For example, if liberalism in the West was rendered profoundly ambivalent in its avowedly egalitarian project, when confronted with class and gender difference, then, in the colonial world, the famous virtue of liberal 'tolerance' could not easily extend to the demand for freedom and independence when articulated by native subjects of racial and cultural difference. Instead of independence they were offered the 'civilising mission'; instead of power, they were proffered paternalism.

I want to suggest that it is this complex, self-contradictory history of 'universal' concepts like liberalism, *transformed through their colonial and post-colonial contexts*, that are particularly important to our current social and cultural debates in a multicultural, multi-ethnic society. In order to understand the cultural conditions, and the rights, of migrant and minority populations we have to turn our minds to the colonial past, not because those are the countries of our 'origins', but because the values of many so-called 'Western' ideals of government and community are *themselves* derived from the colonial and post-colonial experience.

The problems of secularism we confront today, particularly in relation to censorship, blasphemy and minority rights, may have a long history, but they have had a very specific *post-colonial* resonance since the fatwa against Rushdie. They are problems that have arisen through the cultural and political impact of migrant and minority communities on the British state and nation. We must be very cautious and circumspect in our use of the term 'secularism' after its abuse by many spokespersons of the Eurocentric liberal 'arts' establishment who have used it to characterise the 'backwardness' of migrant communities in the post-*Satanic Verses* cataclysm. Great care must be taken to 'separate' secularism from the unquestioned adherence to a kind of ethnocentric and Eurocentric belief in the self-proclaimed values of *modernisation*.

The traditional or classic claim to secularism is grounded in an unreconstructed liberalism of the kind I described above – a liberalism devoid of the *crucial interpolation* of its colonial history. So secularism often 'imagines' a world of equal individuals who determine their lives, and the lives of others, rationally and commonsensically. This is a 'secularism' of the privileged, a perspective far removed from the cultural and national context in which various minority groups like *Women Against Fundamentalism* are demanding an adherence to secularism. The secularism that is demanded by WAF, for instance, is a secularism which is based on an awareness of the gendered critique of rationalism (emphatically *not* 'rationality'), and the passion that is provoked by racism and sexism in the control of minorities: this control may be exerted by state institutions against minority groups, or by patriarchal and *class* structures within minority communities themselves. What we need is a 'subaltern' secularism that emerges from the limitations of 'liberal' secularism and *keeps faith* with those communities and individuals who have been denied, and excluded, from the egalitarian and tolerant values of liberal individualism. I am not using

209

the word 'subaltern' in its militaristic application. I am using it in the spirit of the Italian Marxist Antonio Gramsci, who used the term to define oppressed, minority groups whose presence was crucial to the self-definition of the majority group: subaltern social groups were also in a position to subvert the authority of those who had hegemonic power: YOU THRIVE ON MISTAKEN IDENTITY.

Now my attempt to 'translate' secularism for the specific *experiential* purposes of marginalised or minority communities who are struggling against various hegemonic oppressions of race, class, gender, generation – what I have called 'subaltern secularism' – is brought to life brilliantly in a few pages in Gita Sahgal's essay 'Secular Spaces: The Experience of Asian Women Organizing':

> Many women's centres are secular in their conduct rather than specifically in their aims or their constitution. Welcoming women from different religious backgrounds, they create the space to practice religion as well as challenge it. This is peculiarly difficult for multi-culturalist policy makers to grasp. Having abandoned the egalitarian ideal for a policy of recognizing cultural differences, they tend to have to codify, implement and reinforce these differences (as British colonialism did in relation to family law). For instance, a well-meaning social worker, enquiring into cooking arrangements, was told there were two kitchens. 'Ah, yes,' she said knowledgeably. 'One vegetarian and one non-vegetarian.' 'No,' We said, 'one upstairs and one downstairs.' . . . The difficulty for secularists, particularly those who have embraced a pluralist ideology rather than being complete atheists, is that they cannot offer a complete identity to people in search of their roots. With the breaking down of the traditional distinctions between public and private spheres, the idea itself is in the process of redefinition. Secularists can, however, raise awkward questions: for instance, about how the experience of domestic violence and the challenge to family values have radicalized many women. But their involvement in Southall Black Sisters or the Brent Asian Women's Refuge has not made women into clones of the feminists who run these projects. The engagement with the complexity of the response to religion is just beginning. It is only in a secular space that women can conduct the conversation between atheist and devotee, belief and unbelief, sacred and profane, the grim and the bawdy.[9]

What Gita Sahgal articulates through the 'space' of the refuge, which becomes a metaphor for the idea of an 'emergent' secular community, is an ethical freedom of 'choice'. Fundamentalism limits choice to a pre-given authority or a protocol of precedence and tradition. Secularism of the liberal variety, which I have criticised, suggests that 'free choice' is inherent in the individual – this, as I have argued, is based on an unquestioned 'egalitarianism' and a utopian notion of individualism which bears no real relation to the history of the marginalised, the minoritised, the oppressed.

But the secularism – the subaltern secularism – that I see defined in Sahgal's exemplary exposition of the politics of the 'everyday', and the politics of the

'experiential', is not a 'presupposed' or prescribed value. The process of choice, and the ethics of coexistence, come from the social space which has to be communally shared with 'others,' and from which solidarity is not simply based on similarity but on the recognition of difference. Such a secularism does not assume that the value of freedom lies within the 'goodness' of the individual; freedom is much more the testing of boundaries and limits as part of a *communal, collective* process, so that 'choice' is less an individualistic internal desire than it is a public demand and *duty*. Secularism at its best, I believe, enshrines this public, ethical duty of 'choice' precisely because it often comes from the most private experiences of suffering, doubt and anxiety. We need to 'secularise' the public sphere so that, paradoxically, we may be free to follow our strange gods or pursue our much-maligned monsters, as part of a collective and collaborative 'ethics' of choice.

NOTES

1 Herbert Gintis, 'A Defense of Communal Values', *Boston Review*, 19, 5, October/ November 1994.
2 Thomas J. Schlereth, *The Cosmopolitan Ideal in Enlightenment Thought: Its Form and Function in the Ideas of Franklin, Hume, and Voltaire, 1694–1790*, Notre Dame, Indiana, University of Notre Dame Press, 1977.
3 Adrienne Rich, 'Eastern Wartime', in Adrienne Rich, *An Atlas of the Difficult World*, p. 44.
4 Ibid., p. 43.
5 Salman Rushdie, 'In Good Faith', in Salman Rushdie, *Imaginary Homelands*, Harmondsworth, Granta/Penguin, 1992, p. 393.
6 Salman Rushdie, *The Satanic Verses*, London, Viking, 1988, p. 458.
7 A. Fugard, *Sizwe Bansi is Dead, The Township Plays*, Cape Town & Oxford: Oxford University Press, 1993, p. 185.
8 Stuart Hall, 'The New Europe', in Sunil Gupta (ed.), *Disrupted Borders*, London, Rivers Oram Press, 1993, p. 20.
9 Gita Sahgal, 'Secular Spaces: The Experiences of Asian Women Organizing', pp. 192, 197.

16

MASS EXOTICISMS

Clara Gallini

1

Recently – it was around Christmas time – I moved a drawing-room suite of furniture out of my parents' house. In its time it had survived a drastic house move, after which, pieces of it had been mixed with others from a modern sitting room and, as a result, had lost something of its original compact identity. In the great house of my childhood (I was born at the beginning of the 1930s) that drawing-room suite had a specific setting in a room all to itself, and this space and its furniture bore the exotic name of the Chinese drawing room.

At that time, as now, the suite included a divan, two armchairs and four wooden chairs with Viennese canework in the late Empire style with a swan design. A glass cabinet was part of the same set. I have always hated such cabinets, those idiotic glass booths containing objects to be observed and not touched. I was later to learn that this kind of object was conceived and began to be made at the time of the emergence of the bourgeois house as a revival in miniature of the splendid displays of objects which adorned the great houses of the aristocracy.

Within our glass cabinet there were the most minute and delicate examples of chinoiserie; *cloisonné* or fish-scaled vases, carved ivory, fans with mother-of-pearl appliqué, paintings, a doll, legendary to us, with a porcelain face and 'real hair', two black enamel chopsticks, two caskets (one basket-work, the other inlaid with mother-of-pearl), two bearded gentlemen in robes with fixed stares . . . dominating presences. These mingled with other minor exoticisms. India was represented by a small ivory elephant, the peasant folklore of Great Mother Russia by two wooden enamelled snuffboxes and a bowl which was also enamelled and painted with a troika drawn by galloping horses. Even Europe presented its most innocuous and genteel face through minuscule and precious porcelain knick-knacks – a winged cupid, a cherub with a goose, a little Bacchus with a bunch of grapes and finally a very desirable gold-lined coffee service. By contrast, the most terrible and menacing stares, fixed directly upon us, came from a highly coloured Japanese vase, encrusted with gold, its Samurais inevitably

212

brandishing their swords. As in a Salgari story, the dream of the cabinet wove between Eros and Thanatos, but the thrill of adventure in these foreign worlds was immediately dulled by the formal order of the objects within their spatial frame.

Perhaps within the glass cabinet the world, with all its countries, was set on stage. And we remained outside, contemplating it through the glass.

A strange fascination emanated from the stupid showcase, which was also emphasised by the taboo on not touching it and the ritual surrounding the opening of its small door, granted as an exceptional favour. A subtle, slightly sweet scent of spices wafted out . . . We were then allowed to delicately handle the fragile sandalwood rickshaw – with its Chinese man with a pigtail who held the poles and the other gentleman, also Chinese and pigtailed, who sat peacefully beneath its canopy – and put the unusual vehicle, so light and delicate, to our noses, inhaling the strange Far Eastern fragrancies. The exotic is also a smell.

Much of the olfactory sensitivity that has survived in our middle-class species is conserved thanks to our experiencing scents which turn our thoughts towards lands of forbidden pleasures.

The chinoiserie in our house had one source: Uncle Natale, musicologist and collector of old musical instruments. An eclectic character, he had experienced a period of enthusiasm for, and dealing in, objects of this type (among collectors the two never exclude one another).

This was a rather unusual and élitist field in the Italy of those days. Having entered the drawing room of our house, his taste had extended to our family and they drew pleasure and prestige from it; at least as much as they derived from the swans on the divan and armchairs. Like twins, the antiques market and the market in the exotic have separate specialisations but intertwined destinies. And so, the two co-ordinates of time and space, expanded vertically and horizontally, converged in our drawing rooms, ensuring our stability and certainties.

2

Amongst the various exoticisms colouring the history of the so-called West (which defines itself through the construction of the category of the Orient), the Chinese variety was by no means the first nor the only one to arrive. Early on in the modern era, exotic curiosities helped to form collections, later transformed into museums, set up for the most part by those belonging to the upper strata of the lay aristocracy and religious orders.

The fascination of the Orient was, however, a particular case. It signified refinement and luxury. There were swords from Damascus and silks from China. There were branches of knowledge that, in some cases, even exceeded our own. There were religions based on scriptures, albeit 'heretical' ones. There were also political powers whose dizzying extremes were to be deplored, yet envied.

The Ottoman and Chinese styles in various forms had pervaded the lifestyle of our eighteenth-century aristocracy. Turkish fashion was the rage in clothing and

contemporaries loved to have their portraits painted in Turkish dress. Manu-factured articles were easily imported from Ottoman craftsmen and were much in demand early on, being introduced to enrich domestic décor. Conversely, Sèvres and Capodimonte reinvented a 'Chinese style' and imitated a porcelain, otherwise too expensive for us; the alfresco landscapes in the boudoirs of our female ancestors underwent the same process.[1]

This must have been a very significant turning point. Up until then, the ware that had been arriving in Europe had been exotic for us but not for their producers, for whom these objects were meant either for daily use or to confer prestige. Now we manufactured exoticism at home. And at the same time we began to urge others to produce it for us.

The history of our literary and even our musical exoticisms is well known. But there are other exoticisms that are no less telling because they are based on production practices and exchanges of material goods that are both economic and symbolic, determining tastes and markets, and causing various transformations both in their places of origin and in their destination. If this history is beginning to be studied at the 'high' level of great collections and museums, it is decidedly less so at the level of wider consumption in our society where we assign even the exotic product to the field of 'pleasurable things of poor taste' which by now are installed in so many of our homes, helping to create today's identity and sense of otherness.

In this sense, it is time to reread the trade in the exotic that followed the colonialist leap forward of the last century, and the role of the Great Exhibitions (London, Paris, Philadelphia, Turin . . .) which concretely, in their great 'national pavilions', constructed the exotic in order to suggest it as practice for domestic use. The popularisation of exotic objects largely begins here, whereas, up until then, it had been a sign of privilege of aristocratic circles. From now on, North Africa and the Near and Far East proved to be inexhaustible sources on which to draw, and they themselves re-oriented their craft production, until then domestic in character, towards new forms in the division of labour, the exploitation of the workforce, and previously unused ways of representing themselves to us. It is, then, in this relationship that significant transformations are produced; not only in the economic and social sense but also in the symbolic one.[2]

For us, the arrival of these goods must have been immediately accompanied by the affirmation of our 'right' to possess the treasures sealed in their worlds of origin. In every ethnographic museum this right is celebrated by representing the acquisition as 'scientific'. But the theme of the 'legitimate theft' of the golden idol with the ruby eyes has run through our literary fiction for more than a hundred years. Indiana Jones, the last avatar in our long chain of adventurer-heroes has, in his turn, become the model for new fictional games. Very recently, for a whole year, the French channel Antenne 2 broadcast a competition game, 'Zapatan's Train', with Mexico as its setting and, as adversaries, demonic figures costumed as imaginary Aztecs. Symbolically at stake was an idol to be discovered and seized, the competitors making their escape by train. The voices raised to

denounce the pillage of the Third World's and now East Europe's cultural assets remain unheard.

This type of cultural appropriation can be seen as an act of acquisition, if not robbery, that reflects the dominance of one of the two partners in the transaction. This observation, though scarcely original, will be useful to us in better understanding the position of those who, like my parents, enriched the most socially representative room of their house with exotic objects.

In our Chinese drawing room, the presence of these prized goods had made no radical impact on any of our daily living habits. Indeed, we all continued to dream of the Orient seated on rigid Viennese cane-backed chairs. Perhaps even that rebellious dream had been called back to order. At the turn of the century, in effect, a certain nonconformity in clothing had moved towards Easternised fashion (never Far Eastern, though); it was the time of precious, flowing clothes, the use of perfumes and incense, the smoking of hashish, curled up on Ottoman low couches. But this had been a fashion of the intellectual fringe of the great European metropolises. Ours were the provincial drawing rooms of the respectable.

However, cultural appropriation must have moved extensively towards unchallenged forms of integration. From here came the distinctive branding of exotic objects, which ever more frequently enter our universe, as necessary goods but also accessories in the creation of our symbolic spaces. Indeed, it is the bourgeois drawing room which bends to its rules the presence of the different objects of which it is composed, reworking them in new symbolic keys.

Evidently the world was ours; more in terms of enjoyment than of knowledge. Yet, while gazing contentedly from our swan-patterned armchairs at the numerous exotic knick-knacks, never did we ask ourselves whether some destruction might not have occurred in those places where the objects came from, precisely on account of our growing demand. Phantoms of an elsewhere, they drew their new symbolic effectiveness precisely from the masking of their origins.

3

To my family, the chinoiserie of the drawing room gave pleasure and prestige. For me, instead, it created unease. Two red lacquer pieces of furniture overlaid with little golden men in poses that seemed to me absurd; pieces very rarely used, more to be seen than to contain objects used in daily life. The carved and lacquered black-wood wall lamps, dripping flakes, barely filtered the light which fell on the dark blue screen animated with images. The heavy brass incense burners did not send out scents, nor did they even hold a memory of them. On the walls, the prints, paintings and embroideries, even those of silk, seemed to me cold stereotypes or otherwise extreme refinements of execution behind which I discerned something inhuman and cruel, or at least cold and distant, which I did not know how to explain.

Fantasies of refined Chinese tortures, as we imagine all Oriental tortures to be,

like the pleasures of a perverted eros? Or perhaps this was the reality of an art whose creative properties were diminishing precisely because its customers had already disappeared and it was now identifying with western markets? Perhaps the one did not exclude the other. Later, in the Beijing museum, I was to see very different products: exquisite painted scrolls, porcelain along essential, classical lines, without the horrible redundancy which overlaid our chinoiserie, perhaps to boast of our parvenu riches and able to satisfy two bourgeoisies at once: within and beyond the Great Wall. I was to read in history books on China that precisely with our 'Ottocento' their art went into decline, becoming banal as it imitated itself, even lowering itself to produce work to place on the Western market.

Perhaps we got precisely what we deserved. And they, perhaps, in offering us their products on our dictated terms, entered a dead-end street.

Today, increasingly, I find myself coming across these same objects, crammed together in shop windows. When we went as a 'delegation' to Mao's China in the 1970s we saw little of furniture or household goods of the sort, and what we saw was only in those shops for foreigners where purchases were made in dollars. Now they have invaded the shops of London, Paris and New York, even eventually arriving in Rome and Milan. By a twist of fate, a wholesale dealer in the stuff has set up shop right on the ground floor of my block of flats in Rome! And every day, crammed into a four-window spread, myriad mass chinoiserie objects stand on offer. A tide of little sniggering men. It is no longer rare merchandise. The taste is that of my childhood, the quality apparently inferior. Even chinoiserie has been transformed into mass consumer goods, minting the image that an ever larger stratum of society has of itself and of others.

I am not merely expressing an aesthetic judgment. If it is true that art is polysemic, what are the few but essential signs which can reduce a piece of merchandise represented as exotic to a mass market object? Exoticism, in Fanon's words, is a form of simplification. It encapsulates, imprisons, encrypts . . . (these are his words and I like to remember them in these times of senseless oblivion). Exoticism, then, generates the stereotype, and mass production reproduces it in its numerous variations.

The outcome of this process can, in turn, be evaluated in terms of an ethnicity that is symbolically represented in objects that are specifically stamped as local, regional or national. Let us take, for example, the doll.

4

The 'Chinese' doll with the almond eyes and the 'real' hair which was in our cabinet is made of expensive material and wears a dress that resembles a kimono. Its identity, for us, oscillated between China and Japan, and deciding on its original purpose also presented a problem. For whom had it been made? For a little girl who really played with it, or for us, who looked at it without being able to touch it because it was finally in its resting place?

A little woman, miniaturised face and dress, perhaps our 'little Chinese girl'

had already been born, like many of her little sisters dispersed all over the world, to represent that close connection between a land and its people that only a woman's image, it is thought, can symbolise. Although this was by no means clear to us, it assumed the idea of an ethnic belonging, transmitted through blood and generations and evident not only in physical traits but in cultural ones also.

Our 'little Chinese girl' is not of European manufacture. But what seems very significant is the fact that it is precisely with the figure of the doll that our production of the exotic object took on explicitly ethnic connotations. Indeed, in the second half of the last century, in certain European cities (in France and Germany above all), the doll-character industry began, with the doll becoming more ornamental than ludic in nature. Among the 'characters' represented there were also 'typical' national or regional dolls – regional in European terms (Tyrolean, Breton costumes, etc.), and national in the context of the so-called Orient: Turkey, Egypt, Tunisia or Morocco.[3]

Clearly reinvented typified faces and hairstyles (costume as a sign of a more restricted village identity) distinguish dolls produced for use in the European market. As with postcards, the identity nexus between object and ethos is constructed according to the distribution network, given that the product designated as 'ethnic' is put on sale only in the place where this is significant for the buyer.

From the character doll to the airport doll, more than a century has elapsed. This is a history that today passes through Taiwan, rather than Nuremberg, and is also split into many local sub-variants. These do not always necessarily depend on industrial production or multinational capital. But these aspects have yet to be explored. Our own consumerism, ever more closely linked to the tourist trip and 'the institution of the souvenir-gift', is increasingly trivialised, as generic 'ethnic' costumes abound. Our little girl already seems to end up in drawing rooms that are less well-to-do than those of my childhood. Removed from its previous isolation, it will live in the sitting room, or even in the kitchen or bedroom, often in the company of other little women who are like her, however hard they try to be different.

5

The objects presented in 'the Chinese drawing room' represent the more precious aspects of exoticism. But there were also poor relations. In the room next door, my father's study, the chairs – in deco style and thus very hard – were softened by Moroccan cushions. 'Moroccan' defined a material, a style of workmanship and an ethos. The Moroccan was considered less noble than the Chinese, being scorned and considered vulgar. It was not there to create an impression but for our comfort. Being somewhat worn out it was inevitably destined for an inglorious end. During the war we were all barefoot and my mother took the two cushions to a shoemaker who made us shoe uppers. But the shoemaker erred in his measurements and barefoot we remained. To our protests he replied: 'What are three shoe uppers when we could all be dead!'

Between the two Veblenian poles of the function of ostentation and use, there

were, even in our home, evident hierarchies of objects that necessarily implied hierarchies of peoples. I clearly remember the respect with which the great 'Persian carpet' had to be treated while the 'Moroccan rug' was treated contemptuously, always at the bottom on the scale of values, reflecting the image of its desolate itinerant seller. I increasingly ask myself whether, in the microcosm of our drawing room, the world was not only represented, but also had its peoples and cultures hierarchically ranked.

But other tendencies were gaining ground and I could already discern this in the multicoloured bazaar of our glass cabinet. Over time, new, unimaginable examples of junk slipped in, like the little wooden heart, roughly painted with flowers with the inscription Uhreske Hradiste, the name of a Czechoslovakian friend's village. Uncontainable now, the objects were bursting out of an ever more crowded cabinet, threatening the very élitist principles on which it was constructed.

This apparent collapse of hierarchies in favour of a more pronounced relativism were all prefigured in the style of D'Annunzio. In the rooms of the 'Vittoriale' one saw the plethora of objects and the absolute mixing of the most diverse styles and exoticisms. Here, the matching of Chinese and Moroccan broke down every distinction between precious and vulgar. An essence of the world, the kitsch of D'Annunzio not only gave a foretaste of the excesses of the modern mass market but helped to form the new taste.

6

The open-air stalls of the Roman market of Porta Portese, in this regard, provide an extremely interesting observatory. There, as an assiduous visitor, I have been able to observe developments which in other markets (the Paris flea market for example) perhaps began earlier and were more gradual. The objects that might be deemed exotic began to arrive in the years of the economic boom, coming in waves that can be traced in roughly the following pattern. Latin America began the process: Mexico with carpets, weaving and its figures, Peru with its alpaca sweaters. Turkey and North Africa, with their jewellery and silver, already had a market but it was not by then as extended as it was later to become. Then came Black Africa, with its masks and necklaces, China with its craft work, the East European countries with not only their *matrioskas* but their compasses and thermometers too, signs of past technologies that other countries had not known. Now, a third of the immense marketplace is occupied by this type of product, beginning to be seen as 'ethnic' on the lines of the term 'ethnic art' coined in the United States to indicate the various examples of tourist souvenirs with 'ethnic' connotations.

The image that remains after a visit to Porta Portese, or to one of the many 'living rooms' of our homes of today, is that of a multicoloured melting-pot which constructs and emphasises difference, only to deny it immediately afterwards. But the D'Annunzio drawing room, like the Porta Portese market and the modern

living room, overladen with objects, also demonstrates the great fragmentation of an 'ethnicised' world; one that is impossible to put together again except in the utopia of an individual gesture which constructs aesthetic rhythms and harmonies.

On the other hand, this same market is today, more than ever, a victim of its success, obliged to simultaneously play the two games that characterise every mass good: confirmation (or homogenisation) and difference. On the one hand this is the impetus that stamps the product as 'ethnic', on the other there is the inevitable recourse to now-standard materials and technologies, and a system of distribution that constantly expands the market. This is seen in the wares offered and in their increasingly diverse range of sources of production. Stuffed into urban wholesalers' warehouses these goods pass along a mysterious chain of distribution to end up finally on the carpets of ambulatory street vendors.

We need to examine this type of commerce more closely to understand the new modes in which mass exoticisms are constructed: the pearled purses, the embroidered hats, the wooden elephants and those *kuphiye* so widely worn by the young. Here, exceptions apart, the signs of ethnicity seem to be lost in a vague and generic exoticism, suitable for all markets and at the limits of its own semantic dispersion.

We also need to understand better why this 'ethnic' small trade takes place in the same space, on the same stalls as that of imitation merchandise – false Vuitton, false Yves Saint-Laurent, pirate videotapes – products that sometimes faithfully reproduce the original, and at other times play irreverently with distorted brand names to take the deception full circle, beckoning to the, by now, wily and knowing buyer.

The category of the 'authentic' was conceived very differently in the construction of our drawing room, both in its antique furniture and aesthetic décor. Put at risk in the mass-produced object, authentication moves its signs elsewhere: on to the vendor, the black-skinned twenty-year-old boy; and on to his patter where he swears that the model elephant was really produced in his country by his uncle.

Stretched between two poles: an excess of 'ethnicisation' and a void of meaning, the 'ethnic' market suffers from an excess of supply. In overproducing goods, it runs a serious risk of extinction that could mean further misery for the producing countries.

But having said this, the end of the 'ethnic' is by no means decreed. We are well aware of the routes of the objects and their respective images. It is only in our consumption that exoticism is running the risks mentioned above. It is perhaps not incidental that the clothing industry has tried to take the path of 'multi-ethnic' fashion, also connecting it to world music and anti-racism like Benetton. And so it is the cultural mix that offers a new formula, the contents of which have yet to be examined.

But the buyers of the goods we produce and export are to us – the dominators of the universe – seen as stereotyped ethnicities. Advertising spots are very

instructive in this regard. In the hallowed tradition of all advertising with colonial origins, these adverts, usually set in exotic spaces among highly 'ethnic' characters, advertise more than just the exotic product (bananas, chocolate, coffee) identified in the person of the native.

It is, increasingly, our own products (automobiles, washing machines, canned food, backpacks) which are reaching the most exotic and strange lands, demonstrating the global extension and craving of the market.

And in this universe of images – once enclosed in a glass cabinet – we can experience new, exhilarating adventures and perhaps even encounter the terrifying cannibal who, his mouth watering, contemplates our hero, the new Indiana Jones with his hunting knife spearing the contents of a can of exquisite, unsurpassable Palmera tuna fish.[4]

NOTES

1 See Gereon Sievernich and Hendrick Budde (eds), *Europa und der Orient. 800–1900*, Berliner Festspiele, Bertelsman Lexicon Verlag, 1989 (a richly illustrated and commented catalogue of the Berlin Exhibition, 28 May–29 August 1989).
2 For an anthology of case-studies see Arjun Appadurai (ed.), *The Social Life of Things. Commodities in Cultural Perspective*, Cambridge, Cambridge University Press, 1986; for Great Exhibitions see Raymond Corbey, 'Ethnographic Showcases, 1870–1930', *Cultural Anthropology*, 5, 3, 1993, pp. 338–369.
3 See Laura Indrio and Elisabetta Silvestrini (eds), *Bambole. Tradizioni, costumi, cultura di popoli*, Roma, La Linea, 1985 (a catalogue of the exhibition held in Rome, Palazzo Barberini, 13 December 1984–18 February 1985).
4 This is a television commercial for a well-known brand of canned tuna fish.

17

SOME TROUBLED
HOMECOMINGS

Demetrio Yocum

Et surtout mon corps aussi bien que mon âme, gardez-vous de vous croiser
les bras en l'attitude stérile du spectateur, car la vie n'est pas un spectacle,
car une mer de douleurs n'est pas un proscenium, car un homme qui crie
n'est pas un ours qui danse.

Aimé Césaire[1]

Flaschenpost, a 'message in a bottle', is the metaphor which the Jewish poet Paul
Celan adopts to define poetic writing:

> The poem – a manifestation of language and therefore essentially dialogic
> – can be a 'message in a bottle' thrown into the sea with a hope, surely often
> thin, that it might one day arrive in some land, maybe the land of the heart.
> Poems, are thus en route: they move toward something.[2]

Celan here suggestively expresses the nomadic destiny of poetic language 'en route';
an intense movement which enacts 'the secrecy of an encounter'.[3] The poetic route
frames the opening and the deliberate departure of the self approaching otherness
and, in the dialogic space of the encounter with alterity, simultaneously articulates a
re-turn, a 'distantiating' journey back to 'oneself', towards home:

> The paths in which language becomes sound are encounters, paths of a
> voice going forth, a 'you' to perceive, creative routes, projects of existence
> maybe, a throwing oneself forward, toward oneself . . . a sort of coming
> back home.[4]

In the transitory nature of poetic writing, in its ex-centric and restless *re-turning*
'back home', there emerges a threshold, a suspended space in which the subject
inhabits an ambivalent position. Martin Heidegger, in *Return to the Native Land*
on Hölderlin's poetry, argues that there is no primary original home; such a place
will never be found. Like the traveller's journey, the poet is consumed in the
separation from the lost homeland and *articulates its absence*. Only in this
manner might the poet approach it. Therefore poetic writing delineates the
impossibility of a 'the return to a homeland', of a final voyage home.[5]

These words would seem to imply that there is no originary home or identity to return to. Yet they powerfully intimate the capacity of the subject to inhabit a new 'home', and his/her being and be-coming, by inscribing the 'self' in poetic discourse: writing as the suspended space of the *re-turn* to selfhood through the dialogic and interrogative encounter in language of the subject with an internal/external other; writing as the territory of loss and memory, as the site of an imaginary and unfulfilled journey home.

Poetic traces of impossible homecomings are crossed by the internal and external 'distances' of a migrating self. To explore the idea of poetic discourse as the 'lacerated' space of exile and migration is to venture into the complex temporal and spatial dimension between the memory of 'there' and the time of 'here'. It is to follow a distressful and suffering path streaked by displaced existence; a passage experienced by exiled and migrating peoples who are neither totally removed from their historical antecedents, nor completely assimilated to where they are expected to go.[6] What is at stake here is an attempt to voice the condition of alienation and displacement from both a native and adopted 'land'. Better still, it is to recover an often obscured and submerged *cry*. It requires careful listening and attention in order to respond to the sound of this *cry*, to feel the torments of being on the edge, living in the gap, in the interstices between two or more worlds, cultures and races. For the uprooted subject – moving through the uncertain paths of the world – negotiates and articulates in the poetic text the dramatic experience of a precarious condition. Across an ocean of internal fractures, the space of poetic writing unveils a new territory for the relocation and the reinscription of the scattered fragments of the subject's dissonant and conflictual identities, a territory for the enunciation of a liberating yet painful recuperation of its dispersed self. The poetry of the uprooted subject evokes primary loss, and a world of memory and nostalgia; at the same time, rewriting the dramatic conditions of alterity, re-citing the experience of unassimilated lives, also offers a way of survival, a way of seeking another sense of 'home' on the borderline between belonging and exclusion.

Approaching the erratic movement of the poetic language which powerfully expresses the condition of exile and displacement, this paper deliberately migrates through mutilated fragments that are never fully brought within textual boundaries, and which are themselves dispersed and exiled from their 'originary' textures: Aimé Césaire's 'Cahier D'un Retour au Pays Natal' will open the path and bridge the link between Derek Walcott's 'A Far Cry from Africa' and 'Wightman Road' by Yvonne Weekes.[7]

'Cahier D'un Retour au Pays Natal' offers a trace of the phenomenological capacity of the subject to constitute itself in writing: by opening up a 'distantiating' act of meditation on its self, on its homeland as though through 'estranging' eyes, the poetry of the alienated and displaced subject says 'je est un autre'. Who speaks in the poetic space recognises itself as estranged and divided, for the colonial and uprooted condition from which the *cry* emanates is a dramatic and conflictual one:

Je force la membrane vitelline qui me
sépare de moi-même,
Je force les grandes eaux qui me ceinturent de sang . . .
Que de sang dans ma mémoire!
Dans ma mémoire sont les lagunes . . .
Ma mémoire est entourée de sang. Ma mémoire a sa ceinture de cadavres![8]

CON-FUSION, BODY DIS-MEMBERMENT, SUBJECT RE-MEMBERED: 'A FAR CRY FROM AFRICA'

. . . I who am poisoned with the blood of both,
Where shall I turn, divided to the vein? . . .
Between this Africa and the English tongue
 I love? . . .
Betray them both, or give back what they give?
How can I turn from Africa and live?

Shaped as a restless interrogation, these lines by Derek Walcott offer in their dialectical structure a powerful account of the tensions implied in the dynamics of exile–homeland, alienation–identification, culture–history. The questions are fragments of a dichotomous state of mind caught in a painful dilemma. The subject is called upon to face its own alienation and to find a 'place' where to put itself in touch with its 'other'; there to establish a 'silent dialogue' between the subject and its dispersed self.

In an initial reading the displaced 'I' appears to travel across the sea of space of the white paper surrounded by the inscription of the words, oscillating dramatically, far from a stable position. The impossibility of finding a place to rest, and to take root, converges in the tragic intensity of these lines: the subject has no place to locate itself. The fragmented poetic 'corpus' reflects the subject's own split body, its unstable position, ambiguous status, and 'dis-memberment': 'divided to the vein'.

The image of a 'physical' fracture and con-fusion resounds strongly in the word 'poisoned': the mixed blood is 'corrupted', 'infected'. This vision of internal disjunction enhances the image of the subject's uncertain terms, its precarious and flawed status:

. . . fragmentary, more than instability (the non-fixation) announces dis-orientation, the absence of collocation.[9]

'Between this Africa and the English tongue I love?': the image of internal, corporeal laceration is further inscribed in the geographical and cultural fracture between two apparently irreconcilable ideological positions – a place called 'Africa', and a language, 'English'. The 'ex-isled' subject appears textually delimited within the poem's spatialisation, moving in between a geographical and colonial space, 'English', 'Africa' and the lost, absent native land: St Lucia, a

'splinter' of the Caribbean islands. These elements embody the scattered 'mosaic' of migration and of colonial subjugation where European cultural authority and the African history of enslavement blended: 'one monopolising our minds submitted to its torture, the other living in our flesh ridden by its scars, each inscribing in us in its own way its keys, its codes, its numbers'.[10]

In the figurative space of poetic writing, geography and identity are vividly intertwined, for the poetical journey of the alienated subject across the sea of alterity toward the shores of selfhood is simultaneously a reintegration with 'home': the fractured body recalls the distant and absent native land, what may be defined in Cesaire's words as the 'intime patrie'.[11]

> Partir. Mon coeur bruissait de générosités emphatiques. Partir . . . j'arriverais lisse et jeune dans ce pays mien et je dirais à ce pays dont le limon entre dans la composition de ma chair: 'J'ai longtemps erré et je reviens vers la hideur désertée de vos plaies'.[12]

The very posing of the question 'where shall I turn?' in the poem by Walcott quoted above is central to the problematic of self-reconnection. The verb 'turn' conjures up the restless movement of the 'I' between the textual borders, while the interrogative form expresses the impossibility to 'choose', the inability to bridge the gap, to suture the wound between 'English' and 'Africa'. The line seems to imply that there is no escape out of the traumatising past of colonisation into a different language and culture, out of the diasporic history of enslavement and exile. It is within these boundaries that the tension between self and its otherness is inscribed: the subject is burdened by a double belonging. But moving through the interstices of this self-interrogating space, the subject opens up the limits of alienation to turn 'inward', in a movement of intense confrontation and recuperation of its dispersed fragments. The impossibility to inhabit, to 'stand rooted' at one or other position, is what informs the unanswered questions: the recognition to be part of both oppressor and oppressed, coloniser and colonised, permits the unstable 'I' to accomplish a dialectical synthesis, a new re-appropriation of its inner self and outer world.

'Betray them both, or give back what they give?' The question is left unanswered. 'Betray' and 'give' delineate a possibility, the freedom of a choice, but the final line – 'How can I turn from Africa and live?' – articulates the ultimate and final voyage. The question posed here is crucial. The subject's re-memberment, its re-turn 'home' to selfhood is achieved in the reclamation of Africa, in the embrace of the history of colonisation, in the memory of migration and enslavement; by re-membering and incorporating into the present the fragments of its dispersed cultural and historical identities, and in 'the assimilation of the features of every ancestor'.[13] The subject appropriates its self across the provisional, fluctuating time-space of the poetic text. The tension between the self's African history and its 'affiliate' colonial culture is not resolved but reinforced by inhabiting both in the integrative space of language, of English, in 'the writer's creative use of his schizophrenia, the electric fusion of the old and the new'.[14]

The harsh confrontation of the divided subject with the 'estranging' sea of words here delineates a dialogic encounter of the self with its 'otherness', represented by the native land, an imposed culture and an historical past. Within these geographical and cultural parameters, the subject's poetic voyage comes to be located as a restless, unsettled being in the world. There is no final homecoming, no fixed or final position. Yet to leave is to *re-turn*. For it is to articulate the absent. As Heidegger reminds us, the nomadic writing of exile is both the space of alienation and reconnection, the space where the 'far cry' still resounds: 'only our own strenuous hearing, could make sense of the sounds we made'.[15]

> Des mots? quand nous manions des
> quartiers de monde, quand nous épousons
> des continents en délire, quand
> nous forçons de fumantes portes,
> des mots, ah oui, des mots! mais
> des mots de sang frais, des mots qui sont
> des raz-de-marée et des érésipèles
> des paludismes et des laves et des feux
> de brousse, et des flambées de chair,
> et des flambées de villes . . .[16]

A POST-COLONIAL LANDSCAPE: 'WIGHTMAN ROAD'

I used to live in this world
But I moved to Wightman Road . . .
Now my universe is an estate
Of multi-cultural, multi-racial, multi-ethnic
 MULTI-

Multi-smells, multi-faces
Cats crying, girls giggling
Amusement arcades, flashing lights, space invaders
Blood c-l-a-t! knives flashing
Men slashing, pregnant women
Dirty old men spitting, playing
 Multi-FUCKING!

I used to live in this world
Then I moved to Wightman Road
A hundred and fifty feet high
And these four brown walls
A hundred and fifty feet high
Is my universe

IS MY GRAVE

Through 'Wightman Road', we move now from the textual 'inner' spazialisation of the exiled subject's voyage across the sea of memory towards its reunification with a lost geographical landscape and a fractured cultural 'body' to a different articulation of a subjective poetic. Yvonne Weekes' extreme and powerful words chart another journey of the divided subject and migrating self through language. They provide a highly problematical locality around which theoretical categories of multiculturalism and politics of migration can be measured.

The verses are structured in three stanzas. The first and the last modulate and repeat a movement, or better a chiasmatic regression of the narrating 'I' from a 'world', left behind to an enclosed and vertical 'universe' represented by 'an estate . . . four brown walls. A hundred and fifty feet high'. This is built on the mixing of cultural, racial and ethnic groups erected on the edge of a contemporary Western metropolis where the subject seems caught in the web of the accumulating formula of the 'multi' which simultaneously delimits and frames the space for the second strophe. The 'Amusement arcades, flashing lights . . .' of the metropolis are physically run-down and threatened by the 'border' images of human misery and poverty, environmentally polluted by social violence and urban distress. The reader is thrown into an atmosphere of suffocation, closure, imprisonment. The tone induces desperation, reinforced by the conclusive image of death, 'MY GRAVE'. Yet, beyond the subject's frustration and resignation, the text articulates a strenuous resistance and struggle against the processes of undifferentiated assimilation in totalising systems of knowledge – the categories of the *multi* – and the neutralising enclosure of difference in the slums and ghettos of the metropolitan 'centre'.

Beyond the 'map' of ideal metropolitan harmony, these words give voice to the intensification of barriers between social classes and racial groups in Western cities. As words of rage and anger they embody the *cry* of a transplanted community of immigrants. Refugees engulfed in the experience of ghetto life, they exist on, and outside, the threshold of the flat landscape of pluralist societies and its carefully monitored mixing of ethnic groups in First World national and metropolitan bodies:

> Et dans cette ville inerte, cette foule criarde si étonnamment passée à côté de son cri comme cette ville à côté de son mouvement, de son sens, sans inquiétude, à côté de son vrai cri, le seul qu'on eut voulu l'entendre crier parce qu'on le sent lui seul . . . Dans cette ville inerte, cette étrange foule qui ne s'entasse pas, ne se mêle pas . . .[17]

A lost subject, a broken voice which echoes among the invisible fractures of a desolate metropolitan landscape. There is no final escape, no flight from these 'four brown walls' of enclosure. Still, if the process of poetic inscription is discomforting and not always liberating for the self, it is also, simultaneously, the articulation of a dialogue in which the alienated subject offers its being in a divided world to the gaze of the reader, multiplying and liberating its self through the eyes of the other. The text-map expands its own borders by moving and

opening up the territory of a possible 'encounter', a *road* which invites us to rethink our stable positions, to cross our own boundaries, and to take a journey towards diversity. In this manner we may abridge the distances and trespass the ultimate barrier between 'us' and 'them', breaking ground for a new territory of *differences*.

The 'decolonising', liberating movement enacted by the poetic journey of Derek Walcott's fragments has ploughed the turbulent sea of an 'inter-personal' journey through 'Wightman Road' towards our shores. The Celanian 'message in a bottle' bobs in the harbour of the heartland of an 'approachable you', moving through the shifting inner/outer boundaries of alterity, finally establishing a fluctuating home in 'the secret of the encounter' among: 'Cette foule qui ne sait pas faire foule cette foule, on s'en rend compte, si parfaitement seule sous ce soleil. . .'[18]

NOTES

1 Aimé Césaire, 'Cahier d'un Retour au Pays Natal', in C. Eshelman and A. Smith (eds), *The Collected Poetry, Aimé Césaire*, Berkeley, University of California Press, 1983, p. 44.

2 Paul Celan, quoted in Hans Georg Gadamer, *Chi sono io, chi sei tu*, Genova, Marietti, 1989, p. 119. My translation.

3 Paul Celan, *Le Méridién*, Paris, Mercure de France, 1971, p. 191.

4 Ibid., p. 201.

5 See Martin Heidegger, *Saggi sulla poesia di Hölderlin*, Milan, Adelphi, 1981, pp. 10–31.

6 For reflections on the condition of uprootedness and displacement, see Iain Chambers, *Migrancy, Culture, Identity*, London & New York, Routledge, 1994. I have found this book extremely suggestive.

7 Derek Walcott, 'A Far Cry from Africa', in *Collected Poems 1948–1984*, London, Faber & Faber, 1986; Yvonne Weekes, 'Wightman Road', in *Charting the Journey*, London, Sheba, 1988, p. 32–33.

8 Aimé Césaire, op. cit., pp. 56, 58.

9 Maurice Blanchot, *La scrittura del disastro*, Milan, SE, 1988, p. 18. My translation.

10 Jean Bernabé, Patrick Chamoiseau and Raphael Confiant, *Éloge de la Créolité*, Paris, Gallimard, 1993, p. 80.

11 Aimé Césaire, op. cit., p. 266.

12 Ibid., p. 44.

13 Derek Walcott, 'The Muse of History', in Orde Coombs (ed.), *Is Massa Day Done?*, Anchor/Doubleday, New York, 1974, p. 1.

14 Derek Walcott, *Dream on Monkey Mountain and Other Plays*, New York, Farrar, Strauss & Giroux, 1970, p. 11.

15 George Lamming, *The Pleasures of Exile*, Ann Arbor, University of Michigan Press, 1992, p. 9.

16 Aimé Césaire, op. cit., p. 56.

17 Ibid., p. 34.

18 Ibid.

A TRIBE CALLED EUROPE

Marina De Chiara

A short tale by the Argentinean writer Julio Cortázar will help me to introduce some observations on Caryl Phillips's book *The European Tribe*. Cortázar's tale is called 'Axolotl'.[1]

> There was a time when I thought a lot about the axolotl. I went to see them in the aquarium in the Jardin des Plantes and remained there for hours looking at them, observing their immobility, their obscure movements. Now I am an axolotl.
>
> Sheer chance brought me to them one spring morning in which Paris opened its peacock tail after the slow winter . . . I chose to visit the aquarium, there leaving aside the common fish until I found myself, unexpectedly, among the axolotl. I stayed an hour watching them and left incapable of thinking of anything else. In the Sainte-Geneviève library I consulted a dictionary and learned that the axolotl are larval forms equipped with gills and are of a batrachian species of the ablistoma type. That they were Mexican I knew from the axolotl themselves; from their small, golden Aztec faces and from the sign above their tank. I read that they had found examples in Africa capable of living on dry land in times of drought, and who continue their life in the water when the rainy season arrives.
>
> I leaned on the iron bar that runs around the tanks and settled down to watch them. There was nothing strange in this because, from the first moment, I understood that we were bound together; that something infinitely lost and distant continued, in spite of everything, to keep us united.
>
> I had only to stop that first morning, in front of the glass where the small bubbles slipped through the water. . . . There were nine specimens and some leaned their heads against the glass, regarding those who approached with their golden eyes. Disturbed, almost ashamed, I felt a certain indecency in spying on these silent and motionless figures, grouped at the bottom of the tank. . . . An inexpressive face, with no other feature but the eyes; two holes like pinheads, all of transparent gold; completely lifeless

yet watching while letting themselves be penetrated by my gaze which seemed to pass through the golden point to lose itself in a diaphanous inner mystery. A very delicate black halo surrounded the eye, inscribing it in the pink flesh, in the pink stone of the head, which was roughly triangular but with curved and irregular sides, giving them a perfect resemblance to a statuette corroded by time . . . Occasionally a foot moved slightly and I saw the minuscule toes rest softly among the algae. It's not that we don't like to move but that the tank is so small; as soon as we move forward slightly we bump our heads or tails against each other; difficulties arise, we argue, we feel tired. If we stay still we feel the passing of time less.

It was their quietness that made me approach them, fascinated, the first time I saw the axolotl. Obscurely, I seemed to understand their secret desire; to abolish space and time through an indifferent mobility . . . The eyes of the axolotl told me of a different life, another way of seeing.

Pressing my face to the glass (sometimes the attendant coughed uncomfortably) I tried to get a better view of the tiny golden points, the entrance to the infinitely slow and remote world of these rose-coloured creatures. It was useless tapping one's finger on the glass in front of their faces; one never noticed the slightest reaction. The golden eyes continued to glow with their soft, terrible light; they continued to regard me from an unfathomable depth that made my head spin. And yet they were around me. I knew before this, before being an axolotl. I knew it the day I approached them for the first time . . . I began to see in the axolotl a metamorphosis that failed to nullify a mysterious humanity. I imagined them as conscious, slaves of their bodies, condemned for infinity to an abysmal silence, to desperate reflection. Their blind gaze, the little golden disc, inexpressive yet terribly lucid, penetrated me like a message: 'Save us, save us'. I was surprised to find myself murmuring words of consolation, transmitting childish hopes. They continued to gaze at me, immobile; suddenly the small pink branches of the gills straightened. In that instant I felt something like a silent pain; perhaps they saw me and grasped my effort to penetrate the impenetrable of their lives . . . The axolotl were like witnesses and, at times, like terrible judges. I felt ignoble before them, there was such a frightening purity in their transparent eyes . . . Behind those Aztec faces, expressionless and yet implacably cruel, what image was awaiting its hour? . . . Far from the aquarium I could do nothing but think of them; it was as if they dominated me from a distance . . . Perhaps their eyes saw in the darkest night and, for them, day continued for ever . . .

Every fibre of my body told me; they suffered. A gagged suffering, a rigid torture in the depth of the water. They espied something; a remote annihilated kingdom, a time of freedom in which the world belonged to the axolotl. It seemed impossible that such a terrible expression, one that managed to conquer the inexpressive force of their stone faces, did not transmit a message of pain; the proof of that eternal sentence, the liquid hell

they suffered. . . . My face was pressed to the glass of the tank, my eyes sought once more to penetrate the mystery of those golden eyes with neither pupil nor iris. I saw, from very close, the face of an immobile axolotl near the glass. Without transition, without surprise, I saw my face against the glass. I saw it outside the tank. I saw it from the other side of the glass. Then my face moved away and I understood.

Only one thing was strange; to continue to think as before, to know. Realising was, at first, like the horror of someone buried alive who wakes up to his destiny. Outside, my face again came close to the glass and I saw my mouth with its lips shut tight from the effort of understanding the axolotl. I was an axolotl and I only knew now, in an instant, that no understanding was possible. He was outside the tank. . . . He returned many times, but now he comes less often. For weeks he does not appear. Yesterday I saw him. He looked at me for a long time and suddenly left. . . . But the bridges between he and I are down, because what was his obsession has now become an axolotl, alien to his life as a man . . . Now I am definitely an axolotl and if I think like a man it is because every axolotl thinks like a man, within his image of pink stone.

The tale is woven on the imperceptible movement of silent ways of seeing, whose oscillating play brings on vertigo and confusion. From the outside to the inside of the tank, and vice versa, it is impossible to identify the true source of the narrating voice: is it the curious visitor who is speaking or is it the axolotl, right from the beginning, who breaks the infinite silence of the strange creatures of the aquarium?

The voice in the story fluctuates uninterruptedly from one point to the other, from inside to outside, making it impossible to distinguish the precise observation point. But perhaps the movement of the voice from axolotl to visitor is only apparent, since it is, instead, a single inter-action; part of the same process wherein the observer is at the same moment the observed.

The aquarium, with the transparency of its glass and the silent gaze of its aquatic dwellers, is an ideal metaphor for undermining the indisputable absoluteness of the viewpoint; to destroy the falsehood of any presumed primacy of the observing eye: who is watching whom cannot be established since what occurs is of an exquisite reciprocity, where the two roles of watcher and watched perfectly merge.

It is precisely this image of the aquarium that the anthropologist James Clifford adopts in his article 'Travelling Cultures' to unhinge the habitual and the pre-supposed in anthropological studies.[2] As Malinowski wished it, modern ethnological studies foresee participant observation by the scholar; that is, his total sharing of life in the village under examination. The researcher's tent is to be pitched right at the heart of the village and remains there like a great scrutinising eye. Here begins the systematic attempt to place on the habits and beliefs of village life labels that familiarise the observer with what initially is the

absolute Other. This process consists in representing the unknown, taming the strange, making difference disappear under accepted labels and conventional definitions; the images of the Other are comfortably neutralised through an interpretative process that decontextualises them entirely.[3]

But it is precisely the researcher's tent, as the indisputable dispenser of meanings, that raises for James Clifford one of the key questions of the post-colonial dilemma: who is the real observer when the ethnologist pitches his tent at the centre of the village? Who, exactly, is being observed? Who is localised when the ethnographer's tent is permitted in the centre of a village? Cultural observers and anthropologists are often themselves in the fish-bowl, under surveillance (for example, by the omnipresent kids who won't leave them alone). So who is being observed when that tent is pitched in the middle of the village? What are the political locations involved?[4]

The traditional image evoked is now stood on its head; anthropologists are put under glass, as in an aquarium. But Western history has always given us a single way of seeing: the villages inhabited by the 'natives' have always been the appointed places for the visits of Western anthropologists, and spatially identifiable, 'mappable' locations for a culture that has produced its 'natives' according to the primarily spatial criteria of 'non-Westernness'. As Serge Gruzinski writes:

> From Columbus to Pané, from Anghiera to Oviedo, the gaze of the West, resting on the objects of the islands, progressively crystallized in the double certainty of finding an image and of recognizing in it the devil.[5]

Overcoming the shock of the unknown and Columbus' first uncertain and flexible interpretation, the framework takes shape (Anghiera), the field shrinks, the vision becomes stylised and is exaggerated so as to allow the 'American vision' to emerge; a pure and simple reproduction of a European déjà-vu. The coloniser's vision imprints on the native the reductive but convenient and effective stamp of the demonic.

Westernisation, destined to extend over the entire planet, is thus born from the fundamental imposition of images incurred in the conquest of territory. Space and power are revealed as the primary co-ordinates in the affirmation of a Eurocentric vision. The explorer-observer is established as the unquestioned source of knowledge and power, right from the first voyages made by Europeans towards a geography that was all to be 'discovered'. Beginning with the diaries of Columbus' voyage, what is sealed for posterity is the conception of a traveller who by birth, race and culture is cosmopolitan compared to the 'savage', the 'native', who neither travels nor explores but remains firmly in one place, almost as if waiting to be 'discovered' and dissected according to the cultural standards of a Western elsewhere.

But if the typically Western journey of the discoverer is inverted and Europe comes to be 'explored' by the Other, then new 'tribes' are discovered.

With his travel report *The European Tribe* (1987), the writer Caryl Phillips, who is originally from St Kitts in the Lesser Antilles but has lived in England

since his youth, presents himself as traveller-discoverer of a Europe that reveals itself to him as a single tribe; to be precise, the 'European tribe'.[6]

Having grown up in the cultural confusion of being at the same time 'Black' and 'British', in his journey Caryl Phillips seeks an answer to a vital question:

> The fundamental problem was, if I was going to continue to live in Britain, how was I to reconcile the contradiction of feeling British, while being constantly told in many subtle ways that I did not belong.
>
> (1987: 9)

The journey is, above all, a search for his own identity in metropolitan Europe. Before 'exploring' Europe, the author made his return to the Caribbean, his birthplace, only to discover that he felt like a tree transplanted that had been unable to take root in a foreign soil (p. 9).

The Caribbean journey only seemed to deepen his desire to understand Europe and the Europeans. He found a Europe far vaster than its simple geographical boundaries; a Europe that is an intricate game of inclusions and exclusions, which still speaks of its colonial history of abuse and oppression. France, Morocco, Spain, Italy, Gibraltar, Ireland, Holland, Norway and Germany bear witness to an imperialism which consists not only of the opposition of oppressed and oppressor but is the fruit of a history that has always been 'Eurocentric' and selfish, and that has always known how to impose its own images of power, be it through violent or underhand means.

In his 'discovery' of Europe, Caryl Phillips, while perfectly able to appreciate Western cultural traditions, found it impossible to feel enthusiasm for the cultural achievements of a European past:

> . . . as I walked the tiny streets of Venice, with all their self-evident beauty, I felt nothing. . . . Nothing inside me stirred to make me rejoice, 'Ours is a rich culture', or 'I'm part in this'. I responded coldly to the aesthetics, but recognised the traditions. I could find little empathy with the cultural bravado of a Eurocentric past. . . . Despite my education I found myself then, and still now, unable to engage with a Eurocentric and selfish history. Black people have always been present in a Europe that has chosen either not to see us, or to judge us as an insignificant minority, or as a temporary, but dismissable, mistake.
>
> (p. 128)

Europe's history is a false one; for it is a history that asks itself no questions and withdraws into itself, as if into a white prison. This was the true discovery of the voyage made by a black-skinned Christopher Columbus; an anthropological journey that lays bare the greatest myth of the 'European tribe': its history.

But a history that speaks solely of the drive of knowledge for power is, and will always remain, a reductionist history, made up of empty spaces and silences. Yet there are words that can help one to escape from the oblivion of silence, from the 'white prison' of history. These are the words of literature, that writing which

232

makes history out of a people, when their history has never been written:

> I had learnt that in a situation in which history is distorted, the literature of a people often becomes its history, its writers the keepers of the past, present, and future. In this situation a writer can infuse a people with a sense of their own unique identity and spiritually kindle the fire of resistance.
>
> (p. 99)

This is the vital task of every writer: to rekindle the fire of resistance in the vision of those peoples who for so long, for too long, have remained mute, voiceless, buried like the axolotl in the silent abyss of History.

NOTES

1 This short story, here translated by me and slightly abbreviated, appears in Julio Cortázar, *Cerimonias*, Barcelona, Seix Barral, 1975.
2 James Clifford, 'Travelling Cultures', in Lawrence Grossberg, Cary Nelson and Paula Treichler (eds), *Cultural Studies*, New York & London, Routledge, 1992.
3 See Serge Gruzinski, *La guerra delle immagini. Da Cristoforo Colombo a 'Blade Runner'*, Milan, SugarCo Edizioni, 1990. Gruzinski traces the diffusion of the image of Europe, and the sacrifice of the image of the other, as an essential element in the imposition of occidental culture.
4 Clifford, op. cit., p. 98.
5 Gruzinski, op. cit., p. 32.
6 Caryl Phillips, *The European Tribe*, London, Faber & Faber, 1987. Subsequent quotations are from this edition.

19

MY SON THE FANATIC

Hanif Kureishi

Surreptitiously the father began going into his son's bedroom. He would sit there for hours, rousing himself only to seek clues. What bewildered him was that Ali was getting tidier. Instead of the usual tangle of clothes, books, cricket bats, video games, the room was becoming neat and ordered; spaces began appearing where before there had been only mess.

Initially Parvez had been pleased: his son was out-growing his teenage attitudes. But one day, beside the dustbin, Parvez found a torn bag which contained not only old toys, but computer discs, video tapes, new books and fashionable clothes the boy had bought a few months before. Also without explanation, Ali had parted from the English girlfriend who used to come often to the house. His old friends stopped ringing.

For reasons he didn't himself understand, Parvez wasn't able to bring up the subject of Ali's unusual behaviour. He was aware that he had become slightly afraid of his son, who, alongside his silences, was developing a sharp tongue. One remark Parvez did make, 'You don't play your guitar any more,' elicited the mysterious but conclusive reply, 'There are more important things to be done.'

Yet Parvez felt his son's eccentricity as an injustice. He had always been aware of the pitfalls which other men's sons had fallen into in England. And so, for Ali, he worked long hours and spent a lot of money paying for his education as an accountant. He had bought him good suits, all the books he required and a computer. And now the boy was throwing his possessions out!

The TV, video and sound system followed the guitar. Soon the room was practically bare. Even the unhappy walls bore marks where Ali's pictures had been removed.

Parvez couldn't sleep; he went more to the whisky bottle, even when he was at work. He realised it was imperative to discuss the matter with someone sympathetic.

Parvez had been a taxi driver for twenty years. Half that time he'd worked for the same firm. Like him, most of the other drivers were Punjabis. They preferred to work at night, the roads were clearer and the money better. They slept during the day, avoiding their wives. Together they led almost a boy's life in the cabbies'

office, playing cards and practical jokes, exchanging lewd stories, eating together and discussing politics and their problems.

But Parvez had been unable to bring this subject up with his friends. He was too ashamed. And he was afraid, too, that they would blame him for the wrong turning his boy had taken, just as he had blamed other fathers whose sons had taken to running around with bad girls, truanting from school and joining gangs.

For years Parvez had boasted to the other men about how Ali excelled at cricket, swimming and football, and how attentive a scholar he was, getting straight 'A' in most subjects. Was it asking too much for Ali to get a good job now, marry the right girl and start a family? Once this happened, Parvez would be happy. His dreams of doing well in England would have come true. Where had he gone wrong?

But one night, sitting in the taxi office on busted chairs with his two closest friends watching a Sylvester Stallone film, he broke his silence.

'I can't understand it!' he burst out. 'Everything is going from his room. And I can't talk to him any more. We were not father and son – we were brothers! Where has he gone? Why is he torturing me!'

And Parvez put his head in his hands.

Even as he poured out his account the men shook their heads and gave one another knowing glances. From their grave looks Parvez realised they understood the situation.

'Tell me what is happening!' he demanded.

The reply was almost triumphant. They had guessed something was going wrong. Now it was clear: Ali was taking drugs and selling his possessions to pay for them. That was why his bedroom was emptying.

'What must I do then?'

Parvez's friends instructed him to watch Ali scrupulously and then be severe with him, before the boy went mad, overdosed or murdered someone.

Parvez staggered out into the early morning air, terrified they were right. His boy – the drug addict killer!

To his relief he found Bettina sitting in his car.

Usually the last customers of the night were local 'brasses' or prostitutes. The taxi drivers knew them well, often driving them to liaisons. At the end of the girls' night, the men would ferry them home, though sometimes the women would join them for a drinking session in the office. Occasionally the drivers would go with the girls. 'A ride in exchange for a ride', it was called.

Bettina had known Parvez for three years. She lived outside the town and on the long drive home, where she sat not in the passenger seat but beside him, Parvez had talked to her about his life and hopes, just as she talked about hers. They saw each other most nights.

He could talk to her about things he'd never be able to discuss with his own wife. Bettina, in turn, always reported on her night's activities. He liked to know where she was and with whom. Once he had rescued her from a violent client, and since then they had come to care for one another.

Though Bettina had never met the boy, she heard about Ali continually. That late night, when he told Bettina that he suspected Ali was on drugs, she judged neither the boy nor his father, but became businesslike and told him what to watch for.

'It's all in the eyes,' she said. They might be blood-shot; the pupils might be dilated; he might look tired. He could be liable to sweats, or sudden mood changes. 'Okay?'

Parvez began his vigil gratefully. Now he knew what the problem might be, he felt better. And surely, he figured, things couldn't have gone too far? With Bettina's help he would soon sort it out.

He watched each mouthful the boy took. He sat beside him at every opportunity and looked into his eyes. When he could he took the boy's hand, checking his temperature. If the boy wasn't at home Parvez was active, looking under the carpet, in his drawers, behind the empty wardrobe, sniffing, inspecting, probing. He knew what to look for: Bettina had drawn pictures of capsules, syringes, pills, powders, rocks.

Every night she waited to hear news of what he'd witnessed.

After a few days of constant observation, Parvez was able to report that although the boy had given up sports, he seemed healthy, with clear eyes. He didn't, as his father expected, flinch guiltily from his gaze. In fact the boy's mood was alert and steady in this sense: as well as being sullen, he was very watchful. He returned his father's long looks with more than a hint of criticism, of reproach even, so much so that Parvez began to feel that it was he who was in the wrong, and not the boy!

'And there's nothing else physically different?' Bettina asked.

'No!' Parvez thought for a moment. 'But he is growing a beard.'

One night, after sitting with Bettina in an all-night coffee shop, Parvez came home particularly late. Reluctantly he and Bettina had abandoned their only explanation, the drug theory, for Parvez had found nothing resembling any drug in Ali's room. Besides, Ali wasn't selling his belongings. He threw them out, gave them away or donated them to charity shops.

Standing in the hall, Parvez heard his boy's alarm clock go off. Parvez hurried into his bedroom where his wife was still awake, sewing in bed. He ordered her to sit down and keep quiet, though she had neither stood up nor said a word. From this post, and with her watching him curiously, he observed his son through the crack of the door.

The boy went into the bathroom to wash. When he returned to his room Parvez sprang across the hall and set his ear at Ali's door. A muttering sound came from within. Parvez was puzzled but relieved.

Once this clue had been established, Parvez watched him at other times. The boy was praying. Without fail, when he was at home, he prayed five times a day.

Parvez had grown up in Lahore where all the boys had been taught the Koran. To stop him falling asleep when he studied, the Moulvi had attached a piece of string to the ceiling and tied it to Parvez's hair, so that if his head fell forward, he

would instantly awake. After this indignity Parvez had avoided all religions. Not that the other taxi drivers had more respect. In fact they made jokes about the local mullahs walking around with their caps and beards, thinking they could tell people how to live, while their eyes roved over the boys and girls in their care.

Parvez described to Bettina what he had discovered. He informed the men in the taxi office. The friends, who had been so curious before, now became oddly silent. They could hardly condemn the boy for his devotions.

Parvez decided to take a night off and go out with the boy. They could talk things over. He wanted to hear how things were going at college; he wanted to tell him stories about their family in Pakistan. More than anything he yearned to understand how Ali had discovered the 'spiritual dimension', as Bettina described it.

To Parvez's surprise, the boy refused to accompany him. He claimed he had an appointment. Parvez had to insist that no appointment could be more important than that of a son with his father, and, reluctantly, Ali accompanied him.

The next day, Parvez went immediately to the street where Bettina stood in the rain wearing high heels, a short skirt and a long mac on top, which she would hopefully open at passing cars.

'Get in, get in!' he said.

They drove out across the moors and parked at the spot where, on better days, with a view unimpeded for many miles by nothing but wild deer and horses, they'd lie back, with their eyes half-closed, saying 'this is the life'. This time Parvez was trembling. Bettina put her arms around him.

'What's happened?'

'I've just had the worst experience of my life.'

As Bettina rubbed his head Parvez told her that the previous evening, as he and his son studied the menu, the waiter, whom Parvez knew, brought him his usual whisky and water. Parvez was so nervous he had even prepared a question. He was going to ask Ali if he was worried about his imminent exams. But first, wanting to relax, he loosened his tie, crunched a popadom and took a long drink.

Before Parvez could speak, Ali made a face.

'Don't you know it's wrong to drink alcohol?' he said.

'He spoke to me very harshly,' Parvez said to Bettina. 'I was about to castigate the boy for being insolent, but managed to control myself.'

He had explained patiently that for years he had worked more than ten hours a day, had few enjoyments or hobbies and never went on holiday. Surely it wasn't a crime to have a drink when he wanted one?

'But it is forbidden,' the boy said.

Parvez shrugged, 'I know.'

'And so is gambling, isn't it?'

'Yes. But surely we are only human?'

Each time Parvez took a drink, the boy made, as an accompaniment, some kind of wince or fastidious face. This made Parvez drink more quickly. The waiter, wanting to please his friend, brought another glass of whisky. Parvez knew he

was getting drunk, but he couldn't stop himself. Ali had a horrible look, full of disgust and censure. It was as if he hated his father.

Halfway through the meal Parvez suddenly lost his temper and threw a plate on the floor. He felt like ripping the cloth from the table, but the waiters and other customers were staring at him. Yet he wouldn't stand for his own son telling him the difference between right and wrong. He knew he wasn't a bad man. He had a conscience. There were a few things of which he was ashamed, but on the whole he had lived a decent life.

'When have I had time to be wicked?' he told Ali.

In a low monotonous voice the boy explained that Parvez had not, in fact, lived a good life. He had broken countless rules of the Koran.

'For instance?' Parvez demanded.

Ali didn't need to think. As if he had been waiting for this moment, he asked his father if he didn't relish pork pies.

'Well?'

Parvez couldn't deny that he loved crispy bacon smothered with mushrooms and mustard and sandwiched between slices of fried bread. In fact he ate this for breakfast every morning.

Ali then reminded him that Parvez had ordered his own wife to cook pork sausages, saying to her, 'You're not in the village now, this is England. We have to fit in!'

Parvez was so annoyed and perplexed by this attack that he called for more drink.

'The problem is this,' the boy said. He leaned across the table. For the first time that night his eyes were alive. 'You are too implicated in Western civilisation.'

Parvez burped; he thought he was going to choke. 'Implicated!' he said. 'But we live here!'

'The Western materialists hate us,' Ali said. 'Papa, how can you love something which hates you?'

'What is the answer then?' Parvez said miserably, 'According to you.'

Ali didn't need to think. He addressed his father fluently, as if Parvez were a rowdy crowd that had to be quelled and convinced. The Law of Islam would rule the world; the skin of the infidel would burn off again and again; the Jews and Christers would be routed. The West was a sink of hypocrites, adulterers, homosexuals, drug-takers and prostitutes.

As Ali talked, Parvez looked out of the window as if to check that they were still in London.

'My people have taken enough. If the persecution doesn't stop there will be jihad. I, and millions of others, will gladly give our lives for the cause.'

'But why, why?' Parvez said.

'For us the reward will be in paradise.'

'Paradise!'

Finally, as Parvez's eyes filled with tears, the boy urged him to mend his ways;

'How is that possible?' Parvez asked.

'Pray,' said Ali. 'Pray beside me.'

Parvez called for the bill and ushered his boy out of there as soon as he was able. He couldn't take any more. Ali sounded as if he'd swallowed someone else's voice.

On the way home the boy sat in the back of the taxi as if he were a customer.

'What has made you like this?' Parvez asked him, afraid that somehow he was to blame for all this. 'Is there a particular event which has influenced you?'

'Living in this country.'

'But I love England,' Parvez said, watching his boy in the mirror. 'They let you do almost anything here.'

'That is the problem,' he replied.

For the first time in years Parvez couldn't see straight. He knocked the side of the car against a lorry, ripping off the wing mirror. They were lucky not to have been stopped by the police: Parvez would have lost his licence and therefore his job.

Getting out of the car back at the house, Parvez stumbled and fell in the road, scraping his hands and ripping his trousers. He managed to haul himself up. The boy didn't even offer him his hand.

Parvez told Bettina he was willing to pray, if that was what the boy wanted, if it would dislodge the pitiless look from his eyes.

'But what I object to', he said, 'is being told by my own son that I am going to hell!'

What finished Parvez off was that the boy had said he was giving up accountancy. When Parvez had asked why, Ali said sarcastically that it was obvious.

'Western education cultivates an anti-religious attitude.'

And in the world of accountants it was usual to meet women, drink alcohol and practise usury.

'But it's well-paid work,' Parvez argued. 'For years you've been preparing!'

Ali said he was going to begin to work in prisons, with poor Muslims who were struggling to maintain their purity in the face of corruption. Finally, at the end of the evening, as Ali went up to bed, he had asked his father why he didn't have a beard, or at least a moustache.

'I feel as if I've lost my son,' Parvez told Bettina. 'I can't bear to be looked at as if I'm a criminal. I've decided what to do.'

'What is it?'

'I'm going to tell him to pick up his prayer mat and get out of my house. It will be the hardest thing I've ever done, but tonight I'm going to do it.'

'But you mustn't give up on him,' said Bettina. 'Many young people fall into cults and superstitious groups. It doesn't mean they'll always feel the same way.

She said Parvez had to stick by his boy, giving him support, until he came through.

Parvez was persuaded that she was right, even though he didn't feel like giving his son more love when he had hardly been thanked for all he had already given.

Nevertheless, Parvez tried to endure his son's looks and reproaches. He attempted to make conversation about his beliefs. But if Parvez ventured any criticism, Ali always had a brusque reply. On one occasion Ali accused Parvez of 'grovelling' to the whites; in contrast, he explained, he was not 'inferior'; there was more to the world than the West, though the West always thought it was best.

'How is it you know that,' Parvez said, 'seeing as you've never left England?'

Ali replied with a look of contempt.

One night, having ensured there was no alcohol on his breath, Parvez sat down at the kitchen table with Ali. He hoped Ali would compliment him on the beard he was growing but Ali didn't appear to notice.

The previous day Parvez had been telling Bettina that he thought people in the West sometimes felt inwardly empty and that people needed a philosophy to live by.

'Yes,' said Bettina. 'That's the answer. You must tell him what your philosophy of life is. Then he will understand that there are other beliefs.'

After some fatiguing consideration, Parvez was ready to begin. The boy watched him as if he expected nothing.

Haltingly Parvez said that people had to treat one another with respect, particularly children their parents. This did seem, for a moment, to affect the boy. Heartened, Parvez continued. In his view this life was all there was and when you died you rotted in the earth. 'Grass and flowers will grow out of me, but something of me will live on.'

'How?'

'In other people. I will continue – in you.' At this the boy appeared a little distressed. 'And your grandchildren,' Parvez added for good measure. 'But while I am here on earth I want to make the best of it. And I want you to, as well!'

'What d'you mean by "make the best of it"?' asked the boy.

'Well,' said Parvez. 'For a start . . . you should enjoy yourself. Yes. Enjoy yourself without hurting others.'

Ali said enjoyment was a 'bottomless pit'.

'But I don't mean enjoyment like that!' said Parvez. 'I mean the beauty of living!'

'All over the world our people are oppressed,' was the boy's reply.

'I know,' Parvez replied, not entirely sure who 'our people' were, 'but still life is for living!'

Ali said, 'Real morality has existed for hundreds of years. Around the world millions and millions of people share my beliefs. Are you saying you are right and they are all wrong?'

And Ali looked at his father with such aggressive confidence that Parvez could say no more.

One evening Bettina was sitting in Parvez's car, after visiting a client, when they passed a boy on the street.

'That's my son,' Parvez said suddenly. They were on the other side of town, in a poor district, where there were two mosques.

Parvez set his face hard.

Bettina turned to watch him. 'Slow down then, slow down!' She said, 'He's good-looking. Reminds me of you. But with a more determined face. Please, can't we stop?

'What for?'

'I'd like to talk to him.'

Parvez turned the cab round and stopped beside the boy.

'Coming home?' Parvez asked. 'It's quite a way.'

The sullen boy shrugged and got into the back seat. Bettina sat in the front. Parvez became aware of Bettina's short skirt, gaudy rings and ice-blue eye-shadow. He became conscious that the smell of her perfume, which he loved, filled the cab. He opened the window.

While Parvez drove as fast as he could, Bettina said gently to Ali, 'Where have you been?'

'The mosque,' he said.

'And how are you getting on at college? Are you working hard?'

'Who are you to ask me these questions?' he said, looking out of the window. Then they hit bad traffic and the car came to a standstill.

By now Bettina had inadvertently laid her hand on Parvez's shoulder. She said, 'Your father, who is a good man, is very worried about you. You know he loves you more than his own life.'

'You say he loves me,' the boy said.

'Yes!' said Bettina.

'Then why is he letting a woman like you touch him like that?'

If Bettina looked at the boy in anger, he looked back at her with twice as much cold fury.

She said, 'What kind of woman am I that deserves to be spoken to like that?'

'You know,' he said. 'Now let me out.'

'Never,' Parvez replied.

'Don't worry, I'm getting out,' Bettina said.

'No, don't!' said Parvez. But even as the car moved she opened the door, threw herself out and ran away across the road. Parvez shouted after her, several times called after her, but she had gone.

Parvez took Ali back to the house, saying nothing more to him. Ali went straight to his room. Parvez was unable to read the paper, watch television or even sit down. He kept pouring himself drinks.

At last he went upstairs and paced up and down outside Ali's room. When, finally, he opened the door, Ali was praying. The boy didn't even glance his way.

Parvez kicked him over. Then he dragged the boy up by his shirt and hit him. The boy fell back. Parvez hit him again. The boy's face was bloody. Parvez was panting, he knew the boy was unreachable, but he struck him nonetheless. The boy neither covered himself nor retaliated; there was no fear in his eyes. He only said, through his split lip, 'So who's the fanatic now?'

20

WHEN WAS 'THE POST-COLONIAL'? THINKING AT THE LIMIT

Stuart Hall

Necessarily, we must dismiss those tendencies that encourage the consoling play of recognitions.

Michel Foucault, 'Nietzsche, Genealogy, History'

When was 'the post-colonial'? What should be included and excluded from its frame? Where is the invisible line between it and its 'others' (colonialism, neo-colonialism, Third World, imperialism), in relation to whose termination it ceaselessly, but without final supersession, marks itself? The main purpose of this paper is to explore the interrogation marks which have begun to cluster thick and fast around the question of 'the post-colonial' and the notion of post-colonial times. If post-colonial time is the time *after* colonialism, and colonialism is defined in terms of the binary division between the colonisers and the colonised, why is post-colonial time *also* a time of 'difference'? What sort of 'difference' is this and what are its implications for the forms of politics and for subject formation in this late-modern moment? These questions increasingly haunt the contested space in which the concept of the 'post-colonial' now operates and they cannot be satisfactorily explored until we know more about what the concept means and why it has become the bearer of such powerful unconscious investments – a sign of desire for some, and equally for others, a signifier of danger.

This interrogation can most usefully be done by engaging with the case against the 'post-colonial' which has been rapidly taking shape in a series of critical commentaries in recent months. Ella Shohat, whose work in this field has been exemplary for critical scholars, has taken it to task for a variety of conceptual sins. She criticises the 'post-colonial' for its theoretical and political ambiguity – its 'dizzying multiplicity of positionalities', its 'a-historical and universalizing displacements' and its 'depoliticizing implications' (Shohat, 1992). The post-colonial, she argues, is politically ambivalent because it blurs the clear-cut distinctions between colonisers and colonised hitherto associated with the paradigms of 'colonialism', 'neo-colonialism' and 'Third Worldism' which it aims to supplant. It dissolves the politics of resistance because it 'posits no clear domination and calls for no clear opposition'. Like the other 'posts' with which

it is aligned, it collapses different histories, temporalities and racial formations into the same universalising category. This is a critique shared by Anne McClintock, another of the original scholars working in this field, who criticises the concept for its linearity and its 'entranced suspension of history' (McClintock, 1992). For both critics, the concept is used to mark the final closure of a historical epoch, as if colonialism and its effects are definitively over. 'Post', for Shohat, means *past*: definitively terminated, closed. But this too, for Shohat, is part of its ambiguity since it does not make clear whether this periodisation is intended to be epistemological or chronological. Does 'post-colonial' mark the ruptural point between two epistemes in intellectual history or does it refer to 'the strict chronologies of history *tout court*'? (Shohat, 1992: 101)?

In his recent polemical contribution to this debate, the distingushed scholar of modern China, Arif Dirlik (1994), not only cites many of the criticisms of Shohat and McClintock with approval – he too finds the concept 'celebratory' of the so-called end of colonialism – but adds two substantial critiques of his own. The first is that the post-colonial is a post-structuralist, post-foundationalist discourse, deployed mainly by displaced Third World intellectuals making good in prestige 'Ivy League' American universities and deploying the fashionable language of the linguistic and cultural 'turn' to 'rephrase' Marxism, returning it 'to another First World language with universalistic epistemological pretentions'. The second and related argument is that the 'post-colonial' grossly underplays 'capitalism's structuring of the modern world'. Its notion of identity is discursive not structural. It repudiates structure and totality. Post-colonial discourse, he says blankly, is 'a culturalism' (Dirlik, 1994: 347). Lurking within the first of Dirlik's arguments is a refrain which is common to all these recent critiques: namely, the 'ubiquitous academic marketability' of the term 'post-colonial' (McClintock, 1992) and the prominent position in its deployment of 'academic intellectuals of Third World origin . . . [acting as] pace-setters in cultural criticism' (Dirlik, 1994: 347).

Let us leave aside the latter point, with its whiff of politically correct grapeshot and the unwelcome glimpse it unconsciously affords into (as well as the bizarre preoccupation of American-based critical intellectuals with) the 'ins' and 'outs' of American Academia. There are larger issues hovering in the shadows here to which we will have to return – such as, for example, the reductionism of Dirlik's proposition that post-colonial criticism 'resonates with the conceptual needs' of global relationships caused by shifts in the world capitalist economy (when last have we heard *that* formulation!) which, he says, explains why a concept which is intended to be critical 'should appear to be complicitous in "the consecration of hegemony"' (Dirlik, 1994: 331, quoting Shohat; see also Miyoshi, 1993).

Of course, when one looks at these arguments carefully in context, there is less underlying agreement between them than sometimes appears. The 'multiplicity of positionalities' which Shohat finds disquieting in the post-colonial may not be all that different from the 'multiplicity' McClintock regards as a worrying absence: 'I am struck by how seldom the term is used to denote *multiplicity*.' The assault on post-structuralism in Dirlik does not actually square with what we

know of McClintock's substantive work, which is profoundly 'post-foundational' in inspiration (for example, the brilliant essay on 'The Return of Female Fetishism' in *New Formations*, 1993; see also 1995). Though Shohat ends her critique with the recognition that one conceptual frame is not necessarily 'wrong' and the other 'right', her criticisms are so extensive and damaging that it is difficult to know what of substance she would like to see rescued from the debris. But this is nit-picking. The case against the post-colonial advanced by these critics and others is substantial and must be taken seriously in its own terms.

A certain nostalgia runs through some of these arguments for a return to a clear-cut politics of binary oppositions, where clear 'lines can be drawn in the sand' between goodies and baddies (Shohat's article starts with the 'clarifying' instance of the Gulf War). This is not as compelling an argument as it seems at first sight. These 'lines' may have been simple once (were they?), but they certainly are so no longer. Otherwise, how are we to understand the general crisis of politics on the left except as some sort of simple conspiracy? This does not mean that there are no 'right' or 'wrong' sides, no play of power, no hard political choices to be made. But isn't the ubiquitous, the soul-searing, lesson of our times the fact that political binaries do not (do not any longer? did they ever?) either stabilise the field of political antagonism in any permanent way or render it transparently intelligible? 'Frontier effects' are not 'given' but constructed; consequently, political positionalities are not fixed and do not repeat themselves from one historical situation to the next or from one theatre of antagonism to another, ever 'in place', in an endless iteration. Isn't that the shift from politics as a 'war of manoeuvre' to politics as a 'war of position', which Gramsci long ago, and decisively, charted? And are we not all, in different ways, and through different conceptual spaces (of which the post-colonial is definitively one), desperately trying to understand what making an ethical political choice and taking a political position in a necessarily open and contingent political field is like, what sort of 'politics' it adds up to?

There may indeed be differences of response here between the US and Britain. Without going to great lengths, I find myself insisting that what the Gulf War provided was not the clarifying political experience of 'lines . . . drawn in the sand' but the difficulties which arose in opposing the Western war in the desert when manifestly the situation in the Gulf involved *both* the atrocities which the Alliance committed in defence of Western oil interests under UN cover against the people of Iraq (in whose historic 'under-development' the West is deeply implicated); *and* the atrocities committed against his own people and against the best interests of the region, not to speak of those of the Kurds and the Marsh Arabs, by Saddam Hussein. There is a 'politics' there; but it is not one from which complexity and ambiguity can be usefully expunged. And it isn't an untypical example, randomly chosen, but characteristic of a certain kind of political event of our 'new times' in which *both* the crisis of the uncompleted struggle for 'decolonisation' *and* the crisis of the 'post-independence' state are deeply inscribed? In short, wasn't the Gulf War, in this sense, a classic 'post-colonial' event?

Ella Shohat, of course, at one level, clearly understands this argument, if not endorsing all of its implications. The last three decades in the 'Third World', she observes, have

> offered a number of very complex and politically ambiguous developments . . . [including] the realization that the wretched of the earth are not unanimously revolutionary . . . and [that] despite the broad patterns of geo-political hegemony, power relations in the Third World are also dispersed and contradictory.

She refers to conflicts 'not only between . . . but also within nations, with the constantly changing relations between dominant and subaltern groups . . .' (Shohat, 1992: 101). However, instead of this observation provoking an examination of the potential value of the term 'post-colonial' in precisely referencing this shift theoretically, she ends this part of the discussion with a polemically negative observation about the visibility of the 'post-colonial' 'in Anglo-American academic cultural studies'. In short, where she could easily have concluded with a conceptual reflection, she chose instead a polemical closure.

As to whether the concept 'post-colonial' has been confusingly universalised: there is undoubtedly some careless homogenising going on, as the phrase has caught on and become widely and sometimes inappropriately applied. There are serious distinctions to be made here which have been neglected and which do weaken the conceptual value of the term. Is Britain 'post-colonial' in the same sense as the US? Indeed, is the US usefully thought of as 'post-colonial' at all? Should the term be commonly applied to Australia, which is a white settler colony, and to India? Are Britain and Canada, Nigeria and Jamaica 'equally "post-colonial"', as Shohat asks in her article? Can Algerians living at home and in France, the French and the *Pied Noir* settlers, *all* be 'post-colonial'? Is Latin America 'post-colonial', even though its independence struggles were fought early in the nineteenth century, long before the recent stage of 'decolonisation' to which the term more evidently refers, and were led by the descendants of Spanish settlers who had colonised their own 'native peoples'? Shohat, in her article, exploits this weakness effectively and it is clear that, in the light of this critique, those deploying the concept must attend more carefully to its discriminations and specificities and/or establish more clearly at what level of abstraction the term is operating and how this avoids a spurious 'universalisation'. Anne McClintock also persuasively distinguishes between a number of different trajectories in global domination, in the course of making a valid and important general point about the need to think the 'continuities and discontinuities of power' together (p. 294). Lata Mani and Ruth Frankenberg, in their carefully argued assessment (1993) are particularly helpful here in reminding us that it need not follow that all societies are 'post-colonial' *in the same way* and that in any case the 'post-colonial' does not operate on its own but 'is in effect a construct internally differentiated by its intersections with other unfolding relations'.

So, a more careful discrimination is in order between different social and racial

formations. Australia and Canada, on the one hand, Nigeria, India and Jamaica on the other, are certainly not 'post-colonial' *in the same way*. But this does not mean that they are not 'post-colonial' *in any way*. In terms of their relation to the imperial centre, and the ways in which, as C. L. R. James put it about the Caribbean, they are 'in but not of the West', they were plainly all 'colonial', and are usefully designated now as 'post-colonial', though the manner, timing and conditions of their colonisation and independence varied greatly. So, for that matter, was the US, whose current 'culture wars', conducted throughout with reference to some mythicised Eurocentric conception of high civilisation, are literally unintelligible outside the framework of America's colonial past.

There are, however, some ways of discriminating between uses of the term which are not, in my view, helpful. Some would deny it to white settler colonies, reserving it exclusively for the non-western colonised societies. Others would refuse it to the colonising societies of the metropolis, reserving it for the colonies of the periphery only. This is to confuse a descriptive category with an evaluative one. What the concept *may* help us to do is to describe or characterise the shift in global relations which marks the (necessarily uneven) transition from the age of Empires to the post-independence or post-decolonisation moment. It may also help us (though here its value is more gestural) to identify what are the new relations and dispositions of power which are emerging in the new conjuncture. But as Peter Hulme has argued recently,

> If 'post-colonial' is a useful word, then it refers to a *process* of disen-gagement from the whole colonial syndrome which takes many forms and is probably inescapable for all those whose worlds have been marked by that set of phenomena: 'post-colonial' is (or should be) a descriptive not an evaluative term . . . [It is not] some kind of badge of merit.
>
> (Hulme, 1995)

This thought also helps us to identify, not only the level at which careful distinctions have to be made, but also the level at which 'post-colonial' is *properly* 'universalising' (i.e. a concept which is referring to a high level of abstraction). It refers to a general process of decolonisation which, like colonisation itself, has marked the colonising societies as powerfully as it has the colonised (of course, in different ways). Hence the subverting of the old colonising/colonised binary in the new conjuncture. Indeed, one of the principal values of the term 'post-colonial' has been to direct our attention to the many ways in which colonisation was never simply external to the societies of the imperial metropolis. It was always inscribed deeply within them – as it became indelibly inscribed in the cultures of the colonised. This was a process whose negative effects provided the foundation of anti-colonial political mobilisation, and provoked the attempt to recover an alternative set of cultural origins not contaminated by the colonising experience. This was, as Shohat observes, the critical dimension of anti-colonial struggles. However, in terms of any absolute return to a pure set of uncontaminated origins, the long-term historical and

cultural effects of the 'transculturation' which characterised the colonising experience proved, in my view, to be irreversible. The differences, of course, between colonising and colonised cultures remain profound. But they have never operated in a purely binary way and they certainly do so no longer. Indeed, the shift from circumstances in which anti-colonial struggles seemed to assume a binary form of representation to the present when they can no longer be represented within a binary structure, I would describe as a move from one conception of difference to another (see Hall, 1992), from difference to *différance*, and this shift is precisely what the serialised or staggered transition to the 'post-colonial' is marking. But it is not only not marking it in a 'then' and 'now' way. It is obliging us to re-read the very binary form in which the colonial encounter has for so long itself been represented. It obliges us to re-read the binaries as forms of transculturation, of cultural translation, destined to trouble the here/there cultural binaries for ever.

It is precisely this 'double inscription', breaking down the clearly demarcated inside/outside of the colonial system on which the histories of imperialism have thrived for so long, which the concept of the 'post-colonial' has done so much to bring to the fore. (See, on this historiographical point and its implications for a politics of the present, Catherine Hall's essay in this volume.) It follows that the term 'post-colonial' is not merely descriptive of 'this' society rather than 'that', or of 'then' and 'now'. It re-reads 'colonisation' as part of an essentially transnational and transcultural 'global' process – and it produces a decentred, diasporic or 'global' rewriting of earlier, nation-centred imperial grand narratives. Its theoretical value therefore lies precisely in its refusal of this 'here' and 'there', 'then' and 'now','home' and 'abroad' perspective. 'Global' here does not mean universal, but it is not nation- or society-specific either. It is about how the lateral and transverse cross-relations of what Gilroy calls the 'diasporic' (Gilroy, 1994) supplement and simultaneously dis-place the centre-periphery, and the global/local reciprocally re-organise and re-shape one another. As Mani and Frankenberg argue, 'colonialism' always was about, and 'post-colonial' certainly is about, different ways of, 'staging the encounters' between the colonising societies and their 'others' – 'though not always in the same way or to the same degree' (Mani and Frankenberg, 1993: 301).

This argument connects with another strand of the critique – namely, the 'post-colonial' as a form of periodisation, and what Shohat calls its 'problematic temporality'. What 'post-colonial' certainly is not is one of those periodisations based on epochal 'stages', when everything is reversed at the same moment, all the old relations disappear for ever and entirely new ones come to replace them. Clearly, the disengagement from the colonising process has been a long, drawnout and differentiated affair, in which the recent post-war movements towards decolonisation figures as one, but only one, distinctive 'moment'. Here, 'colonisation' signals direct colonial occupation and rule, and the transition to 'post-colonial' is characterised by independence from direct colonial rule, the formation of new nation states, forms of economic development dominated by the

growth of indigenous capital and their relations of neo-colonial dependency on the developed capitalist world, and the politics which arise from emergence of powerful local elites managing the contradictory effects of under-development. Just as significant, it is characterised by the persistence of many of the effects of colonisation, but at the same time their displacement from the coloniser/colonised axis to their internalisation within the decolonised society itself. Hence, the British, who were deeply implicated with the regional economies, the ruling factions and the complex politics of the Gulf States, Persia and Mesopotamia through the network of mandates and protected 'spheres of influence' after World War One, withdrew in the decolonising moment 'west of Suez'; and the 'after-effects' of this pervasive type of indirect colonial hegemony is then 'lived' and 're-worked' through the various 'internal' crises of the post-colonial states and societies of the Gulf States, Iraq, Iran and Afghanistan, not to speak of Palestine and Israel. In this scenario, 'the colonial' is not dead, since it lives on in its 'after-effects'. But its politics can certainly no longer be mapped completely back into, nor declared to be 'the same' in the post-colonial moment as it was during the period of the British mandate. These complexities and re-stagings have become a common feature in many parts of the 'post-colonial' world, although there have also been other 'decolonising' trajectories, both earlier ones and ones with significantly different outcomes.

One could ask – it seems some of the critics are asking – why then privilege this moment of the 'post-colonial'? Doesn't it, with its preoccupation with the colonised/colonising relationship, simply revive or re-stage exactly what the post-colonial so triumphantly declares to be 'over'? Dirlik, for example, finds it strange that the post-colonial critics are so preoccupied with the Enlightenment and with Europe, the critique of which seems – oddly – to be their central task. McClintock also criticises the 'recentering of global history around the single rubric of European time' (p. 86). It is true that the 'post-colonial' signals the proliferation of histories and temporalities, the intrusion of difference and specificity into the generalising and Eurocentric post-Enlightenment grand narratives, the multiplicity of lateral and decentred cultural connections, movements and migrations which make up the world today, often bypassing the old metropolitan centres. Perhaps, however, we should have been warned by other theoretical examples, where the deconstruction of core concepts undertaken by the so-called 'post-' discourses is followed, not by their abolition and disappearance but rather *by their proliferation* (as Foucault warned), only now in a 'decentred' position in the discourse. 'The subject' and 'identity' are only two of the concepts which, having been radically undermined in their unitary and essentialist form, have proliferated beyond our wildest expectations in their decentred forms into new discursive positionalities.

At the same time, there is someting to the argument that, as Lata Mani and Ruth Frankenberg remark in their critique of Robert Young's *White Mythologies* (1990), sometimes the *only* purpose which the post-colonial critique seems to serve is as a critique of western philosophical discourse, which, as they observe, is like 'merely [taking] a detour to return to the position of the Other as a resource

for rethinking the Western Self'. It would, as they say, be a turn-up for the books if the 'key object and achievement of the Algerian War of Independence was the overthrow of the Hegelian dialectic' (1993: 101)! In fact, in my view, the problem with *White Mythologies* (1990) is not that it sees the connection between the post-colonial and the critique of the western metaphysical tradition, but that it is driven by a Promethean desire for the ultimate theoretically correct position – a desire to out-theorise everyone else – and, in so doing, sets up a hierarchy from the 'bad' (Sartre, Marxism, Jameson) through the 'not-too-bad-but-wrong' (Said, Foucault) to the 'almost-OK' (Spivak, Bhabha) without ever once putting on the table for serious critical inspection the normative discourse, the foundational figure – i.e. Derrida – in relation to whose absence/presence the whole linear sequence is staged. But that is another story – or rather the same story in another part of the forest. . .

Many of the critiques of the 'post-colonial', then – paradoxically, given its post-structuralist orientation – take the form of a demand for more multiplicity and dispersal (though Dirlik, with his stress on the structuring force of capitalism, is deeply suspicious of this kind of post-structuralist flirtation). Yet, while holding fast to differentiation and specificity, we cannot afford to forget the over-determining effects of the colonial moment, the 'work' which its binaries were constantly required to do to *re-present* the proliferation of cultural difference and forms of life, which were always there, within the sutured and over-determined 'unity' of that simplifying, over-arching binary, 'the West and the Rest'. (This recognition goes some way to rescuing Edward Said's 'Orientalism' from the critique that it fails to discriminate between different imperialisms.) We have to keep these two ends of the chain in play at the same time – over-determination and difference, condensation and dissemination – if we are not to fall into a playful deconstructionism, the fantasy of a powerless *utopia* of difference. It is only too tempting to fall into the trap of assuming that, because essentialism has been deconstructed *theoretically*, therefore it has been displaced *politically*.

In terms of periodisation, however, the 'post-colonial' retains some ambiguity because, in addition to identifying the post-decolonisation moment as critical for a shift in global relations, the term also offers – as all periodisations do – an alternative narrative, highlighting different key conjunctures to those embedded in the classical narrative of Modernity. Colonisation, from this 'post-colonial' perspective, was no local or marginal sub-plot in some larger story (for example, the transition from feudalism to capitalism in western Europe, the latter developing 'organically' in the womb of the former). In the re-staged narrative of the post-colonial, colonisation assumes the place and significance of a major, extended and ruptural world-historical event. By 'colonisation', the 'post-colonial' references something more than direct rule over certain areas of the world by the imperial powers. I think it is signifying the whole process of expansion, exploration, conquest, colonisation and imperial hegemonisation which constituted the 'outer face', the constitutive outside, of European and then Western capitalist modernity after 1492.

This re-narrativisation displaces the 'story' of capitalist modernity from its European centring to its dispersed global 'peripheries'; from peaceful evolution to imposed violence; from the transition from feudalism to capitalism (which played such a talismanic role in, for example, Western Marxism) to the formation of the world market, to use shorthand terms for a moment; or rather to new ways of conceptualising the relationship between these different 'events' – the permeable inside/outside borders of emergent 'global' capitalist modernity. It is the retrospective re-phrasing of Modernity within the framework of 'globalisation' in all its various ruptural forms and moments (from the Portuguese entry to the Indian Ocean and the conquest of the New World to the internationalisation of financial markets and information flows) which is the really distinctive element in a 'post-colonial' periodisation. In this way, the 'post-colonial' marks a critical interruption into that whole grand historiographical narrative which, in liberal historiography and Weberian historical sociology, as much as in the dominant traditions of Western Marxism, gave this global dimension a subordinate presence in a story which could essentially be told from within its European parameters.

Colonisation, understood or re-read in this sense, was only intelligible as an event of global significance – by which one signals not its universal and total-izing, but its dislocated and differentiated character. That is to say, it had to be understood then, and certainly can only be understood now, in terms, not only of the vertical relations between coloniser and colonised, but also in terms of how these and other forms of power-relations were *always* displaced and decentred by another set of vectors – the transverse linkages between and across nation-state frontiers and the *global/local* inter-relationships which cannot be read off against a nation-state template. It is in this reconstitution of the epistemic and power/knowledge fields around the relations of globalisation, through its various historical forms, that the 'periodisation' of the 'post-colonial' is really challenging. However, this point hardly surfaces in any of the critiques. And when it does (as in Dirlik, 1994), its effects are contradictory for the run of the argument, as I hope to demonstrate below. What's more, to jump several stages ahead for a moment, it is precisely because of this critical re-lay through the global that the 'post-colonial' has been able to become so sensitively attuned to precisely those dimensions which Shohat, for example, finds problematic – questions of hybridity, syncretism, of cultural undecidability and the complexities of diasporic identification which interrupt any 'return' to ethnically closed and 'centred' original histories. Understood in its global and transcultural context, colonisation has made ethnic absolutism an increasingly untenable cultural strategy. It made the 'colonies' themselves, and even more, large tracts of the 'post-colonial' world, always-already 'diasporic' in relation to what might be thought of as their cultures of origin. The notion that only the multi-cultural cities of the First World are 'diaspora-ised' is a fantasy which can only be sustained by those who have never lived in the hybridised spaces of a Third World, so-called 'colonial', city.

In this 'post-colonial' moment, these transverse, transnational, transcultural movements, which were always inscribed in the history of 'colonisation', but carefully overwritten by more binary forms of narrativisation, have, of course, emerged in new forms to disrupt the settled relations of domination and resistance inscribed in other ways of living and telling these stories. They reposition and dis-place 'difference' without, in the Hegelian sense, 'overcoming' it. Shohat observes that the anti-essentialist emphasis in 'post-colonial' discourse sometimes seems to define *any* attempt to recover or inscribe a communal past as a form of idealisation, despite its significance as a site of resistance and collective identity. She makes the very valid point that this past *could* be negotiated differently, 'not as a static fetishized phase to be literally reproduced but as fragmented sets of narrated memories and experiences' (1992: 109). I would agree with this argument. But this is to take the double-inscriptions of the colonising encounter, the dialogic character of its alterity, the specific character of its 'difference' and the centrality of questions of narrative and the imaginary in political struggle seriously (see, for example, Hall, 1990). However, isn't that precisely what is meant by thinking the cultural consequences of the colonising process 'diasporically', in non-originary ways – that is, *through*, rather than around 'hybridity'? Doesn't it imply trying to think the questions of cultural power and political struggle *within* rather than against the grain of 'the post-colonial'?

The way difference was lived in the colonised societies after the violent and abrupt rupture of colonisation, was and had to be decisively different from how these cultures would have developed, had they done so in isolation from one another. From that turning point in the closing decades of the fifteenth century forwards, there is, of course, no 'single, homogeneous, empty (Western) time'. But there are the condensations and ellipses which arise when all the different temporalities, while remaining 'present' and 'real' in their differential effects, are also rupturally convened *in relation to*, and must mark their 'difference' in terms of, the over-determining effects of Eurocentric temporalities, systems of representation and power. This is what is meant by placing colonisation in the framework of 'globalisation' or rather by the assertion that what distinguishes modernity is this over-determined, sutured and *supplementary* character of its temporalities. Hybridity, syncretism, multidimensional temporalities, the double inscriptions of colonial and metropolitan times, the two-way cultural traffic characteristic of the contact zones of the cities of the 'colonised' long before they have become the characteristic tropes of the cities of the 'colonising', the forms of translation and transculturation which have characterised the 'colonial relation' from its earliest stages, the disavowals and in-betweenness, the here-and-theres, mark the *aporias* and re-doublings whose interstices colonial discourses have always negotiated and about which Homi Bhabha has written with such profound insight (Bhabha, 1994). It goes without saying that they have, *of course*, always to be set within and against the over-determining power-knowledge discursive relations by which imperial regimes were stitched or laced

together. They are the tropes of supplementarity and *différance* within a dis-located but sutured global system which only emerged or could emerge in the wake of the onset of the colonising expansionist process which Mary Louise Pratt calls the Euro-imperial adventure (Pratt, 1992).

Since the Sixteenth Century, these differential temporalities and histories have been irrevocably and violently yoked together. This certainly does not mean that they ever were or are *the same*. Their grossly unequal trajectories, which formed the very ground of political antagonism and cultural resistance, have nevertheless been impossible to disentangle, conceptualise or narrate as discrete entities: though that is precisely what the dominant western historiographical tradition has often tried to do. No site, either 'there' or 'here', in its fantasied autonomy and in-difference, could develop without taking into account its significant and/or abjected others. The very notion of an autonomous, self-produced and self-identical cultural identity, like that of a self-sufficient economy or absolutely sovereign polity, had in fact to be discursively constructed in and through 'the Other', through a system of similarities and differences, through the play of *différance* and the tendency of these fixed signifiers to float, to go 'on the slide'. The Other ceased to be a term fixed in place and time external to the system of identification and became, instead, a symbolically marked 'constituitive outside', a positionality of differential marking within a discursive chain.

It is possible, now, to answer the question posed earlier about the 'post-colonial's' preoccupation with Eurocentric time. The Enlightenment returns, in the discourse of the 'post-colonial', in its decentred position, because it represents a critical epistemic shift within the colonising process, understood in this wider sense, whose discursive, power-knowledge, effects are still in play (how, in western discourses dominated by Science and the Social Sciences, could it fail to be?). Until the Enlightenment, difference had often been conceptualised in terms of different orders of being – 'Are they True Men?' was the question which Sepulveda put to Bartholome de Las Casas in the famous debate at Vallodolid before Charles X in 1550. Whereas, under the universalising panoptic eye of the Enlightenment, all forms of human life were brought within the universal scope of a single order of being, so that difference had to be re-cast into the constant marking and re-marking of positions within a single discursive system (*différance*). This process was organized by those shifting mechanisms of 'otherness', alterity and exclusion and the tropes of fetishism and pathologis-ation, which were required if 'difference' was ever to be fixed and consolidated within a 'unified' discourse of *civilisation*. They were constitutive in the symbolic production of a constitutive outside, which however has always refused to be fixed in place and which was, and even more today is, always slipping back across the porous or invisible borders to disturb and subvert from the inside (Laclau, 1990; Butler, 1993).

The argument is not that, thereafter, everything has remained the same – colonisation repeating itself in perpetuity to the end of time. It is, rather, that colonisation so refigured the terrain that, ever since, the very idea of a world of

separate identities, of isolated or separable and self-sufficient cultures and econo-mies, has been obliged to yield to a variety of paradigms designed to capture these different but related forms of relationship, interconnection and discontinuity. This was the distinctive form of dissemination-and-condensation which colonisation set in play. It is in privileging this missing or downgraded dimension in the official narrative of 'colonisation' that the discourse of 'post-colonial' is conceptually distinctive. Although colonisation's particular forms of inscription and subjection varied in almost every other respect from one part of the globe to another, its general effects also require to be crudely but decisively marked, theoretically, alongside its pluralities and multiplicities. That, in my view, is what the anomalous signifier 'colonial' is doing in the concept of the 'post-colonial'.

What, then, about the more troubling question of the prefix, the 'post'? Shohat, for example, acknowledges that the 'post' signals both the 'closure of a certain historical event or age' and a 'going beyond . . . commenting upon a certain intellectual movement' (1992: 101, 108). She clearly prefers the latter meaning to the former. For Peter Hulme (1995), however, the 'post' in 'post-colonial'

> has two dimensions which exist in tension with each other: a temporal dimension in which there is a punctual relationship in time between, for example, a colony and a post-colonial state; and a critical dimension in which, for example, post-colonial theory comes into existence through a critique of a body of theory.

Moreover, the tension, for Hulme, is productive, whereas for Shohat it produces a structured ambivalence. In this respect, she seems to argue that the 'post-colonial' is different from the other 'posts' in attempting to be both epistemic and chronological. It is both the paradigm and the chronological moment of the 'colonial' which the 'post-colonial' claims to be superseding.

However, it seems to me that, in this respect, the 'post-colonial' is no different from the other 'posts'. It is not only 'after' but 'going beyond' the colonial, as post-modernism is both 'going beyond' and 'after' modernism, and post-structuralism both follows chronologically and achieves its theoretical gains 'on the back of' structuralism. The trickier question is whether in fact these two could ever be separated, and what such a separation would imply about the way 'colonisation' itself is being conceptualised. 'Colonialism' refers to a specific historical moment (a complex and differentiated one, as we have tried to suggest); but it was always also a way of staging or narrating a history, and its descriptive value was always framed within a distinctive definitional and theoretical paradigm. The very succession of terms which have been coined to refer to this process – colonisation, imperialism, neo-colonial, dependency, Third World – shows the degree to which each apparently innocent descriptive term carried in its slipstream powerful epistemological, conceptual and indeed political baggage: the degree, in short, to which each has to be understood discursively. Indeed, the distinction which this critique seems to be trying to enforce between 'power' and 'knowledge' is exactly what the discourse of the post-colonial (or rather, what

253

thinking both 'the colonial' and 'the post-colonial' discursively) has displaced. With 'colonisation', and consequently with the 'post-colonial', we are irrevocably within a power-knowledge field of force. It is precisely the false and disabling distinction between colonisation as a system of rule, of power and exploitation, and colonisation as a system of knowledge and representation, which is being refused. It is because the relations which characterised the 'colonial' are no longer in the same place and relative position, that we are able not simply to oppose them but to critique, to deconstruct and try to 'go beyond' them.

But what exactly might be meant by this 'after' and 'going beyond'? Shohat argues that 'The operation of simultaneously privileging and distancing the colonial narrative, moving beyond it, structures the "in-between" framework of the "post-colonial"' (1992: 107). She is not very sympathetic to this un-decid-ability. But it is possible to argue that the tension between the epistemological and the chronological is not disabling but productive. 'After' means in the moment which follows that moment (the colonial) in which the colonial relation was dominant. It does not mean, as we tried to show earlier, that what we have called the 'after-effects' of colonial rule have somehow been suspended. It certainly does *not* mean that we have passed from a regime of power-knowledge into some powerless and conflict-free time zone. Nevertheless, it does also stake its claim in terms of the fact that some other, related but as yet 'emergent' new configurations of power-knowledge relations are beginning to exert their distinctive and specific effects. This way of conceptualising the shift between these paradigms – not as an epistemological 'break' in the Althusserian/structuralist sense but more on the analogy of what Gramsci called a movement of deconstruction-reconstruction or what Derrida, in a more deconstructive sense, calls a 'double inscription' – is characteristic of all the 'posts'.

Gramsci, speaking about transformations in the field of practical common sense, observes that they have to be thought as

> a process of distinction and of change in the relative weight possessed by the elements of the old ideology . . . what was secondary or even incidental becomes of primary importance, it becomes the nucleus of a new doctrinal and ideological ensemble. The old collective will disintegrates into its contradictory elements so that the subordinate elements amongst them can develop socially . . .
>
> (Gramsci, 1975, 1979. See also Hall, 1988: 138)

What, in their different ways these theoretical descriptions are attempting to construct is a notion of a shift or a transition conceptualised as the re-configuration of a field, rather than as a movement of linear transcendence between two mutually exclusive states. Such transformations are not only not completed but they may not be best captured within a paradigm which assumes that all major historical shifts are driven by a necessitarian logic towards a teleological end. Lata Mani and Ruth Frankenberg make the critical distinction

254

between a transition which is 'decisive' (which the 'post-colonial' certainly is) and one which is 'definitive'. To put this another way, all the key concepts in the 'post-colonial', as in the general discourse of the 'posts', are operating, as Derrida would put it, 'under erasure'. They have been subjected to a deep and thorough-going critique, exposing their assumptions as a set of foundational effects. But this deconstruction does not abolish them, in the classic movement of supersession, an *Aufghebung*. It leaves them as the only conceptual instruments and tools with which to think about the present – but only if they are deployed in their deconstructed form. They are, to use another, more Heideggerean, formu-lation, which Iain Chambers, for example, prefers, 'a presence that exists in abeyance' (Chambers, 1994).

In a now-famous exchange about 'thinking at the limit' – which seems to me a good description of the status of 'the post-colonial' as an episteme-in-formation – Derrida once defined the limit of philosophical discourse as 'the episteme, functioning within a system of fundamental constraints, conceptual oppositions outside of which philosophy becomes impracticable'. He spoke of 'a necessarily double gesture marked in certain places by an erasure which allows what it obliterates to be read, violently inscribing within the text that which attempted to govern it from without' and of trying to respect as rigorously as possible 'the internal, regulated play of philosophemes . . . by making them slide . . . to the point of their non-pertinence, their exhaustion, their closure'.

> To deconstruct philosophy thus would be to think – in the most faithful interior way – the structured genealogy of philosophy's concepts but at the same time to determine – from a certain exterior that is unquantifiable or unnameable in philosophy – what this history has been unable to dis-simulate or forbid. By means of this simultaneously faithful and violent circulation between the inside and the outside of philosophy . . . there is produced a certain textual work . . .
>
> (Derrida, 1981)

When his interlocutor, Ronse, asked him whether by this means there could be 'a surpassing of philosophy', Derrida remarked,

> There is not a transgression if one understands by that a pure and simple landing into the beyond of metaphysics . . . But by means of the work done on one side and on the other side of the limit, the field inside is modified and a transgression is produced that consequently is nowhere present as a *fait accompli* . . .
>
> (Derrida, 1981)

The problem, then, is not that the 'post-colonial' is a conventional paradigm of a logico-deductive type which erroneously confuses the chronological and the epistemological. Lying behind this is a deeper choice between epistemologies: between a rational and successive logic and a deconstructive one. In this sense, Dirlik is correct to pinpoint the question of the post-colonial's relation to what

can be broadly called 'post-structuralist' ways of thinking as a central issue which its critics find particularly troubling. Larger issues are thus 'at stake' in this debate than the criticisms which have been widely signalled sometimes suggest.

Dirlik is particularly ferocious in this area and for reasons which are not difficult to identify. Discovering that the term 'post-colonial' is applied to many writers who do not necessarily agree with one another, some of whom Dirlik likes and others he does not, he is driven to the polemical conclusion that the 'post-colonial' is not the description of anything or anyone in particular but rather 'a discourse that seeks to constitute the world in the self-image of intellectuals who view themselves or have come to view themselves as post-colonial intellectuals [and] . . . an expression . . . of [their] new found power' in First World Academe. This rather crude *ad hominem* and *ad feminam* name-calling disfigures the argument of a distinguished scholar of modern China and it would perhaps be wise to think of it as 'symptomatic'. But of what? We get a clue to an answer when he takes Gyan Prakash's elegant post-structuralist defence of the post-colonial', 'Post-colonial Criticism and Indian Historiography' (1992) as his principal stalking horse. Let us leave the many local criticisms of this article, some of which we have already mentioned, to one side. The main burden of the charge is that the post-colonial, like the post-structuralist discourse which provides its philosophical and theoretical grounding, is anti-foundational and, as such, cannot deal with a concept like 'capitalism' and with 'capitalism's structuring of the modern world' (p. 346). Moreover, the 'post-colonial' is 'a culturalism'. It is preoccupied with questions of identity and the subject and hence cannot give 'an account of the world outside the subject'. Attention is shifted from national origin to subject position and 'a politics of location takes precedence over politics informed by fixed categories (in this case the nation, though obviously other categories such as Third World and class are also implied)' (p. 336). The 'post-colonial' presents the coloniser equally with the colonised with 'a problem of identity' (p. 337).

This is all going with a remarkable swing for twenty pages when, on page 347, a by now somewhat characteristic 'turn' begins to reveal itself. 'These criticisms, however vehement on occasion, do not necessarily indicate that post-colonialism's critics deny it all value . . .' The 'post-colonial' discourse, turns out, after all, to have something to say about 'a crisis in the modes of comprehending the world associated with such concepts as Third World and nation state'. Nor, apparently, is it to be denied that

> as the global situation has become more blurred with the disappearance of the socialist states, with the emergence of important differences economically and politically between so-called Third World societies and the diasporic motions of peoples across national and regional boundaries, fragmentation of the global into the local has emerged into the foreground of historical and political consciousness.

> (Dirlik, 1992: 347)

This may appear to innocent eyes like recuperating a good deal of already repudiated territory, apart from containing in itself some questionable formulations. (Some post-modern critics *may* believe that the global has fragmented into the local but most of the serious ones argue that what is happening is a mutual reorganisation of the local and the global, a very different proposition: see Massey, 1994; Robins, 1991; Hall, 1992). But let that pass. For it is followed, in the second section of the article, by a long, detailed and persuasive account of some of the main features of what is 'variously' described as 'late capitalism, flexible production or accumulation, disorganised capitalism and global capitalism'.

These include: the new international division of labour, the new global information technologies, a 'de-centering of capitalism nationally', the linkage provided by the transnational corporation, the transnationalisation of production, the appearance of the capitalist mode of production, 'for the first time in the history of capitalism' (p. 350), as an 'authentically global abstraction', cultural fragmentation and multi-culturalism, the re-articulation of native cultures into a capitalist narrative (the example here being the Confucian revival amongst the rising South East Asian capitalist elite), the weakening of boundaries, the replication internally in once-colonial societies of inequalities once associated with colonial differences, the 'disorganization of a world conceived in terms of three worlds', the flow of culture which is 'at once homogenizing and heterogenizing' (p. 353), a modernity which 'is no longer just Euro-American', forms of control which cannot just be imposed but have to be 'negotiated', the reconstitution of subjectivities across national boundaries, and so on . . .

It is not only an impressive, and impressively comprehensive, list. It also, I think incontrovertibly, touches at some point every single theme which makes the 'post-colonial' a distinctive theoretical paradigm, and marks decisively how radically and unalterably *different* – that is to say, how incontrovertibly *post-colonial* – is the world and the relations being described. And, indeed, to the reader's astonishment, this is also acknowledged: 'post-coloniality represents a response to a genuine need, the need to overcome a crisis of understanding produced by the inability of old categories to account for the world' (p. 353). Is there a 'post-colonial' critic in the house who would dissent from that judgement?

Two arguments could follow from this second half of the essay. The first is a serious one – indeed, the most serious criticism which the post-colonial critics and theorists have urgently now to face – and it is succinctly put by Dirlik. 'What is remarkable . . . is that a consideration of the relationship between postcolonialism and global capitalism should be absent from the writings of postcolonial intellectuals.' Let us not quibble and say of *some* post-colonial intellectuals. It *is* remarkable. And it has become seriously damaging and disabling for everything positive which the post-colonial paradigm can, and has the ambition to, accomplish. These two halves of the current debate about 'late modernity' – the post-colonial and the analysis of the new developments in global capitalism – have indeed largely proceeded in relative isolation from one another,

and to their mutual cost. It is not difficult to understand why, though Dirlik does not seem interested in pursuing this as a serious question (he does have a trivial answer to it, which is different). One reason is that the discourses of the 'post' have emerged, and been (often silently) articulated against the practical, political, historical and theoretical effects of the collapse of a certain kind of economistic, teleological and, in the end, reductionist Marxism. What has resulted from the abandonment of this deterministic economism has been, not alternative ways of thinking questions about the economic relations and their effects, as the 'conditions of existence' of other practices, inserting them in a 'decentred' or dislocated way into our explanatory paradigms, but instead a massive, gigantic and eloquent *disavowal*. As if, since the economic in its broadest sense, definitively does *not*, as it was once supposed to do, 'determine' the real movement of history 'in the last instance', it does not exist at all! This is a failure of theorisation so profound, and (with very few, still relatively sketchy, exceptions: see Laclau, 1990, but also Barrett, 1991) so disabling, that, in my view, it has enabled much weaker and less conceptually rich paradigms to continue to flourish and dominate the field. (Dirlik himself makes, at one point, an interesting observation that he prefers 'the world system approach', even though, like the post-colonial, it 'locates the Third World discursively' [p. 346], but this interesting and fruitful line of discussion is not pursued.)

Of course, it is not simply a matter that the relationship between these paradigms has been left to one side. This is itself partly an institutional effect – an unintended consequence, some would say, of the fact that the 'post-colonial' has been most fully developed by literary scholars, who have been reluctant to make the break across disciplinary (even post-disciplinary) boundaries required to advance the argument. It is also because there may well be some conceptual incompatibility between a certain kind of post-foundationalism and the serious investigation of these complex articulations. But this cannot yet be accepted as an unbridgeable philosophical chasm, especially because, though they do not address the question of the conceptual role which the categeory 'capitalism' may have in a post-foundationalist 'logic', certain articulations of this order are *in fact* either implicitly assumed or silently at work in the underpinning assumptions of almost all the post-colonial critical work.

Dirlik has therefore put his finger squarely, and convincingly, on a serious lacuna in the post-colonial episteme. To have concluded with the implications for the future of the post-colonial paradigm of this critique would indeed have served a very important, timely and strategic purpose. And had this been the conclusion to his essay, one could have overlooked the curiously broken-backed and internally contradictory nature of the argument (the second half repudiating in effect much of the substance and all of the tone of the first half). However, it is not. His conclusion takes the second path. Far from just 'representing a response to a genuine [theoretical] need', he ends with the thought that 'Post-coloniality resonates with the problems thrown up by global capitalism', is 'attuned' to its issues and hence *serves its cultural requirements*. The post-colonial critics are, in effect,

unwitting spokespersons for the new global capitalist order. This is a conclusion to a long and detailed argument of such stunning (and one is obliged to say, banal) reductionism, a functionalism of a kind which one thought had disappeared from scholarly debate as a serious explanation of *anything*, that it reads like a echo from a distant, primeval era. It is all the more disturbing because a very similar line of argument is to be found from a diametrically opposite position – the inexplicably simplistic charge in Robert Young's *Colonial Desire* (1995) that the post-colonial critics are 'complicit' with Victorian racial theory *because both sets of writers deploy the same term – hybridity – in their discourse*!

Here, then, we find ourselves between Scylla and Charybdis, between the devil and the deep blue sea. We always knew that the dismantling of the colonial paradigm would release strange demons from the deep, and that these monsters might come trailing all sorts of subterranean material. Still, the awkward twists and turns, leaps and reversals in the ways the argument is being conducted should alert us to the sleep of reason that is beyond or after Reason, the way desire plays across power and knowledge in the dangerous enterprise of thinking at or beyond the limit.

REFERENCES

Barrett, M. *The Politics of Truth*, Polity, Cambridge, 1991.

Butler, J. *Bodies That Matter*, Routledge, London, 1993.

Bhabha, H. *The Location of Culture*, Routledge, London, 1994.

Chambers, I. *Migrancy, Culture, Identity*, Routledge, London, 1994.

Derrida, J. *Positions*, 1981.

Dirlik, A. 'The Postcolonial Aura: Third World Criticism in the Age of Global Capitalism', *Critical Inquiry*, Winter, 1992.

Foucault, M. 'Nietzsche, Genealogy, History', in D. Bouchard (ed.), *Language, Counter-memory, Practice*, Blackwell, Oxford, 1977.

Frankenberg, R. and Mani, L. 'Crosscurrents, Crosstalk: Race, 'Postcoloniality' and the Politics of Location', *Cultural Studies*, 7, 2, 1993.

Gilroy, P. *The Black Atlantic: Modernity and Double Consciousness*, Verso, London, 1993.

Gramsci, A. *Quaderni* III (1875), quoted in C. Mouffe, *Gramsci and Marxist Theory*, Lawrence and Wishart, London, 1979.

Hall, S. *The Hard Road to Renewal: Thatcherism and the Crisis of the Left*, Verso, London, 1988.

Hall, S. 'Cultural Identity and Diaspora', in Rutherford, J. (ed.), *Identity*, Lawrence and Wishart, London, 1990.

Hall, S. 'The Question of Cultural Identity', in Hall, S., Held, D. and McGrew (eds), *Modernity and Its Futures*, Polity, Cambridge, 1992.

Hulme, P. 'Including America', *Ariel*, 26, 1, 1995.

Laclau, E. *New Reflections on the Revolution of Our Time*, Verso, London, 1990.

McClintock, A. 'The Myth of Progress: Pitfalls of the Term Post-colonialism', *Social Text*, 31/32, 1992.

McClintock, A. 'The Return of Female Fetishism and the Fiction of the Phallus', *New Formations*, 19, Spring, 1993.

McClintock, A. *Imperial Leather*, Routledge, London, 1995.

Massey, D. *Space, Place and Gender*, Polity, Cambridge, 1994.

Miyoshi, M. 'A Borderless World? From Colonialism to Transnationalism', *Critical Inquiry*, Summer, 1993.

Prakash, G. 'Post-colonial Criticism and Indian Historiography', *Social Text*, 31/32, 1992.

Pratt, M. L. 'Imperial Eyes'. *Travel Writing and Transculturation*, Routledge, London & New York,1992.

Robins, K. 'Tradition and Translation: National Cultures in a Global Context' in Corner, J. and Harvey, S. J. (eds), *Enterprise and Heritage*, London, 1991.

Shohat, E. 'Notes On the Postcolonial', *Social Text*, 31/32, 1992.

Young, R. *White Mythologies*, Routledge, London, 1990.

Young, R. *Colonial Desire*, Routledge, London, 1995.

INDEX